WITHDRAWN

# The Third Reich and the Palestine Question

# The Third Reich and the Palestine Question

By Francis R. Nicosia

 UNIVERSITY OF TEXAS PRESS, AUSTIN

CALVIN T. RYAN LIBRARY
KEARNEY STATE COLLEGE
KEARNEY, NEBRASKA

Copyright © 1985 by the University of Texas Press
All rights reserved
Printed in the United States of America

First Edition, 1985

Requests for permission to reproduce material from this work should be sent to Permissions, University of Texas Press, Box 7819, Austin, Texas 78713.

Library of Congress Cataloging-in-Publication Data

Nicosia, Francis R., 1944–
    The Third Reich and the Palestine question.

    Bibliography: p.
    Includes index.
    1. Germany—Foreign relations—Palestine.
2. Palestine—Foreign relations —Germany.   3. Germany—
Foreign relations—1933–1945.   4. Jewish-Arab relations—
1917–1949.   5. National socialism.   6. Jews—
Germany—Migrations.   7. Zionism.   I. Title.
DD120.P19N53   1985      327.4305694      85-11271
ISBN 0-292-72731-3

*For my parents*

# Contents

# Preface

The Arab-Israeli conflict did not begin with the proclamation of the state of Israel and the ensuing first Arab-Israeli war in 1948. Known as the Palestine question before 1948, the conflict was and still is composed of three basic elements: Zionism, Arab nationalism and Great Power interest in the Middle East. The Zionist factor has been the process of establishing first a Jewish national homeland and then an independent Jewish state in the ill-defined part of old Syria known as Palestine, a process that has been accomplished through large-scale Jewish immigration from Europe and the Middle East. The Arab factor stems from the beginnings of an Arab nationalist movement in Palestine as part of a larger movement throughout the Arab world during the years immediately before and after World War I. This movement sought to maintain the essentially Arab character of Palestine and to keep Palestine as an integral part of an emerging independent Arab world. Thus, a natural, fundamental component of Arab nationalism in Palestine and throughout the Arab world has always been the rejection of an independent Jewish state in Palestine. The Great Power factor has involved the decisive influence of a particular power or powers on events in Palestine, specifically, on the conflict between Arabs and Jews over ultimate control of Palestine as a whole. Before 1948, the primary Great Power components in the Palestine triangle were Great Britain and, to some extent, France; since 1948, the main components have been the United States and the Soviet Union. Throughout the twentieth century, the Palestine question and the Arab-Israeli conflict have reflected the competing claims of Jews and Arabs on the same piece of real estate, within the context of Great Power efforts to manipulate the conflict in such a way as to ensure their particular strategic interests.

This is a study of the relationship of one of the Great Powers to the Palestine question during the period between the two world wars. It is first and foremost a study of German policy during the

pre – World War II National Socialist period, and only indirectly of the Palestine question itself. It seeks to define that policy precisely by examining the relationship of National Socialist Germany with each of the three components of the Palestine triangle during the 1930s, namely, Zionism, Arab Nationalism and British imperialism. This study also places that very real, very active policy within the context of a line of continuity in German interests and policy aims in Palestine and throughout the Middle East from the Wilhelminian through the Weimar periods to the Third Reich. Finally, and perhaps most importantly, the Palestine policy of the Hitler regime provides a clear reflection of the central racial/ideological and geopolitical calculations of the National Socialist state during the 1930s. While Palestine and the Middle East as a region were of little interest to Hitler and all but a few government and Party officials in Berlin, the Palestine question and its component elements were of considerable importance in the formulation of domestic and foreign policies. Zionism and the Zionist movement became significant instruments in the implementation of Nazi Jewish policy, which sought the dissimilation and removal of the Jewish community from Germany, preferably to destinations outside Europe. Moreover, some form of accommodation with England had been a cornerstone of Hitler's strategic and ideological calculations since the early years of the movement and remained so at least until the outbreak of World War II. Hitler enthusiastically accepted the integrity of the British Empire, including the British position in the Middle East, and was loath to consider any action that might be construed as undermining the security of the British Empire anywhere in the world. The Nazi distaste for Arab national self-determination in Palestine or elsewhere in the Middle East reflects an aversion to anything that might impede the modest flow of Jews from Germany to Palestine during those years or Hitler's campaign to win favor with Great Britain. Policies toward England and Arab nationalism also reflect a racist *Weltanschauung* that considered perpetual white European domination of the world both natural and necessary.

This is the first comprehensive study of German policy toward the Palestine question during the 1930s. It represents the first exhaustive analysis of the abundant, and in part hitherto unused, archival resources in Germany, Israel, Great Britain and the United States. It seeks to eliminate the many inferences, misconceptions and unsubstantiated conclusions about German Palestine policy that result from the absence of just such a comprehensive treatment of the subject. It is to be hoped that this study will dispel some of the myths of German ambition and intervention in Palestine and throughout the

Middle East during the 1930s that are the consequence of a lack of scholarly inquiry.

Interested scholars have tended to concentrate on the Middle East in German strategy during World War II, while some have treated individual aspects of German policy toward Palestine and the Middle East during the 1930s in separate essays. The studies by Mohamed el-Dessouki, Lukasz Hirszowicz, Robert Melka, Bernd Schröder and Heinz Tillmann concentrate on the war years, and Germany's belated, halfhearted and ultimately futile efforts to use Arab nationalism as a weapon in the war effort against Britain. They call particular attention to the activities of the exiled Grand Mufti of Jerusalem and the events surrounding Rashid Ali's pro-Axis government in Iraq in 1941. These studies do not address themselves with any degree of adequacy to the aims of German policy in the Middle East before 1939, which were quite different from those during the war; nor do they treat Palestine as a unique element in German Middle East policy.

Palestine's peculiar position in the Hitler regime's approach to the Middle East during the 1930s stemmed in large measure from the domestic considerations of its Jewish policy, with the primary goal of forcing the rapid dissimilation and emigration/deportation of Jews from Germany, stripped of virtually all their assets. The German Zionist movement and Palestine played key roles in the pursuit of that goal during the six years preceding the outbreak of World War II. None of the brief surveys of the 1930s mentioned above even begins to provide adequate consideration of the role of Nazi Jewish policy, and its use of Zionism and Palestine, in Germany's overall approach to the Middle East. While David Yisraeli's two essays do concentrate on Palestine policy during the 1930s, and the question of Zionism in National Socialist Jewish policy, they do not do so within the broader context of Anglo-German relations, German attitudes toward the Arab world and the general racial and geopolitical aims of the Hitler regime before World War II. Harald Neubert's dissertation isolates the German decision-making process in response to the Peel partition plan of July, 1937, while Alexander Schölch's article emphasizes the critical role of National Socialist Germany in the Palestine question between 1933 and 1945 through a summary of the existing literature on the topic. Finally, my essays are brief, for the most part isolated, treatments of different aspects of German Palestine policy during the 1930s, specifically, the attitudes and policies of the Hitler regime toward Zionism and Arab nationalism. Some of the research and conclusions of those essays form but a part of the more extensive research and broader conclusions of this study.

All of the authors rely in varying degrees on the records of the German Foreign Office that are housed at the Politisches Archiv des Auswärtigen Amts in Bonn. Most have virtually ignored the records of the National Socialist German Workers' party (NSDAP), particularly those of the Reichsführer-SS, which are kept at the Bundesarchiv in Koblenz, due to a failure adequately to consider the role of Zionism in Nazi Jewish policy and its effect on German Palestine policy. Tillmann and Hirszowicz have had the good fortune of gaining access to the records stored at the Deutsches Zentralarchiv in Potsdam, although the material cited in the introductory chapters offers nothing of importance that cannot be obtained from the archival resources in the west. Except for myself, no one uses British and American diplomatic records, the files of the former German Consulate-General of Jerusalem housed in the Israel State Archives in Jerusalem or the remnants of the files of the Nazi party organization in Palestine that are held by the Yad Vashem Institute in Jerusalem. Tillmann's work reflects a Marxist point of view that attaches "imperialist" motives to German Middle East policy before 1939, when in fact there was relatively little interest in the area, even after 1941.

This study also relies heavily on the records of the German Foreign Office in Bonn, which contain the basic documentation necessary to establish the attitudes and policies of the various government and Party agencies interested in the Palestine problem. However, these records must be supplemented with the SS and other Party files in Koblenz and on microfilm in Washington, D.C., which are of particular importance in understanding the role of Zionism and Nazi Jewish policy in the German approach to Palestine and the Middle East. Moreover, the British Foreign Office files at the Public Record Office in London and the U.S. State Department Decimal Files at the National Archives in Washington, D.C., are useful in clarifying and supplementing the German records on issues such as German emigration policies and Germany's weapons export policies in the Middle East before 1939. The German Consulate-General records and the NSDAP/Landesgruppe-Palästina (NSDAP/Palestine Branch) files are especially useful in ascertaining the position of the German Christian communities in Palestine and their role in German Palestine policy before World War II. I was not able to obtain permission to use the records of the Deutsches Zentralarchiv in Potsdam and the Hagana Archives in Tel Aviv. It is difficult to ascertain the value of the relevant files housed in each institution. The former contain records that might shed further light on German weapons export policy in the Middle East. They also possess the records of Goebbels's Propa-

ganda Ministry, which warrant investigation. The Hagana Archives contain files pertinent to SS involvement in the illegal immigration of Jewish refugees to Palestine during the late 1930s and other possible areas of SS-Zionist contact. However, it is not certain that these files would reveal more than I was able to find in the relevant German records. Finally, several key British Foreign Office files in the Public Record Office in London remain classified. These pertain mainly to matters of German involvement in illegal Jewish immigration to Palestine between 1937 and 1940.

I wish to acknowledge with sincere appreciation the kind assistance and support of the many distinguished individuals and institutions that made the preparation of this study, beginning in dissertation form, possible. First and foremost, I want to thank Professor Peter C. Hoffmann of McGill University for his patience, advice and unfailing support. The generous advice and encouragement of Professor Charles Burdick of San Jose State University, Professor Andreas Hillgruber of the University of Cologne and Dr. Arnold Paucker of the Leo Baeck Institute in London are gratefully acknowledged. I also wish to express my gratitude to Dr. Richard Otto Hoffmann of the Temple Society of Australia and to several persons who are or were contemporaries to the events described in this study. These especially include the late Dr. Werner-Otto von Hentig, the former head of the Middle East section (Politische Abteilung VII) of the German Foreign Office, the late Dr. Fritz Grobba, the German ambassador to Iraq and later Saudi Arabia during the 1930s and Dr. Werner Feilchenfeld, a former official of Haavara Ltd., as well as the late Dr. Albert Speer, Dr. Ernst Woermann and retired General Gerhard Engel.

It has been my good fortune to have received generous financial assistance from the Faculty of Graduate Studies and Research, the Social Science Research Committee and the F. W. McConnell foundation of McGill University, the Deutscher Akademischer Austauschdienst (German Academic Exchange Service) of the Federal Republic of Germany and the Office of the Academic Dean of St. Michael's College. I am grateful for their support.

This study relies for the most part on archival resources, and I would like to express my gratitude to the archives, research institutes and libraries that made their collections available to me during the research process. My sincere appreciation is extended to the staffs at the Politisches Archiv des Auswärtigen Amts (Political Archive of the Foreign Office) in Bonn, the Bundesarchiv in Koblenz, the Geheimes Staatsarchiv (Secret State Archive) in Berlin, the Bundesarchiv-Militärarchiv (Federal Archive–Military Archive)

in Freiburg im Breisgau, the Hauptstaatsarchiv (Central State Archive) in Stuttgart, the Institut für Zeitgeschichte (Institute for Contemporary History) in Munich, the Tempelgesellschaft in Deutschland (Temple Society in Germany) in Stuttgart/Degerloch and the Germania Judaica in Cologne. I am also grateful for the assistance of the Israel State Archives, the Central Zionist Archives, the Yad Vashem Institute and the Central Archives for the History of the Jewish People/Hebrew University in Jerusalem and that of the National Archives in Washington, D.C., the Public Record Office in London, the Leo Baeck Institute in New York and London and the Centre de Documentation Juive Contemporaine (Center of Contemporary Jewish Documentation) in Paris. The cooperation and assistance of the McLennan Library of McGill University, the library of Concordia University and the history seminar and the library of the University of Bonn are gratefully acknowledged. Most of all, I would like to thank my wife, Sally, for her patience and support.

"Die Zukunft riecht nach Juchten,
nach Blut, nach Gottlosigkeit und
nach sehr vielen Prügeln. Ich rate
unsern Enkeln, mit einer sehr dicken
Rückenhaut zur Welt zu kommen."

[The future smells of Russia
leather, of blood, of Godlessness
and of very many beatings. I
advise our grandchildren to
come into the world with a
very thick back skin.]

<div align="right">Heinrich Heine</div>

# 1. Imperial and Weimar Precedents

Germany's relationship to the Palestine question can be traced to its developing political and economic ties to the Ottoman Empire during the approximately thirty years before World War I and to the emergence of Berlin as an important center of a fledgling international Zionist movement late in the nineteenth century. Although the idea of *Drang nach Osten* (eastward expansion) was not new in Germany in 1890, it was not until Wilhelm II dismissed Bismarck as chancellor that a pro-Ottoman orientation became a fundamental element in German foreign policy.[1] It was mainly within the context of German strategic aims in the Middle East that the Zionist movement sought to become a willing instrument in the formulation and pursuit of German foreign policy.

Zionist leaders had realistically accepted the necessity of securing the sponsorship of at least one of the European Great Powers for the establishment of a Jewish homeland in Palestine. The Ottoman government was never inclined to foster the national identity or autonomy of any of its subject peoples, least of all one that was to be imported for the most part from Europe. Moreover, Zionists were Europeans, and their movement a European national movement, inclining its leadership to look to the European powers for support and protection. At the turn of the century, Zionist leaders had placed much of their hope on the sponsorship and support of Germany. Throughout the nineteenth century, Germany had been a haven for persecuted Jews from eastern Europe, as well as a cultural and spiritual beacon for the masses of Jews in the ghettos of eastern Europe. Mainly east European in origin and leadership, the Zionist movement was based in central Europe. Its leadership was almost entirely German or German-educated Jews from eastern Europe, despite the overwhelmingly liberal/assimilationist, anti-Zionist inclinations of German Jews.[2]

The interests and aims of the Zionist movement and the Ger-

man government appear to have coincided at the end of the nine-
teenth century. This resulted in an informal alliance that, in spite of
occasional difficulties, was to last through World War I and the Wei-
mar period. Theodor Herzl sought to enlist the support of Kaiser
Wilhelm II in an effort to obtain from the sultan a charter for the
establishment of an autonomous Jewish commonwealth in Pales-
tine.[3] Herzl's strategy, and that of his successors, was to persuade the
government of a Great Power that Jewish settlement in and develop-
ment of Palestine would be an invaluable asset in the pursuit of its
policy in the Middle East. In this instance, Herzl asserted that a Jew-
ish Palestine would be the financial salvation of the bankrupt Otto-
man Empire, suggesting that the expected influx of Jewish capital
into Palestine as well as the assumption of the entire Ottoman debt
by the Jewish world community would greatly strengthen Germany's
weak eastern ally, and thus strengthen Germany's strategic position
in the international balance of power.

The German government had indeed been mindful of the vari-
ous signs of weakness of its Ottoman protégé since the late 1880s
and the resulting opportunities this had created for other powers, no-
tably Britain and France, in the eastern Mediterranean.[4] There was
also an awareness of the potential benefits that Germany might reap
in the Middle East through close links with the Zionist movement.
Count zu Eulenburg, the kaiser's close friend and adviser, outlined
the threefold advantages of a German-Zionist link to Wilhelm II on
several occasions. These included not only Herzl's idea of strength-
ening the Ottoman Empire, but also hopes of gaining a firmer foot-
hold for Germany in the Middle East and, at the same time, contrib-
uting to the resolution of the Jewish question in Germany. This last
possibility held considerable appeal for Wilhelm II, as well as for
many influential leaders, both Jewish and non-Jewish, in late nine-
teenth century Germany. The prospect of halting the flow of east Eu-
ropean Jewish refugees into Germany, and redirecting it to Palestine,
was greeted with enthusiasm by some German Jews and anti-Semites
alike.[5]

By the time of Wilhelm's state visit to the Ottoman Empire in
the autumn of 1898, a pro-Zionist component had already become
evident in Germany's Middle East policy. In 1893, Germany had
been the only power to advocate the cancellation of an Ottoman de-
cree that prohibited Jews from further land purchases in Palestine.[6]
It briefly appeared that Germany might be on the verge of a public
declaration of support and sponsorship for Zionist efforts in Pales-
tine. The kaiser's Ottoman visit included several days in Palestine,
where he met briefly with Herzl and appeared favorably disposed to-

ward Zionist activities. During his talks with the sultan, Wilhelm spoke favorably of Zionism, its quest for a Jewish homeland in Palestine and the potential economic benefits of Jewish settlement in Palestine for the Ottoman Empire. Opposed, however, to any form of autonomy for subject nationalities, the Ottoman government rejected the kaiser's bidding on behalf of the Zionist movement. Wilhelm immediately lost his initial enthusiasm for Zionist endeavors, and the German Foreign Office concluded that the matter should be officially dropped so as not to alienate the Ottoman government.[7] The importance of Germany's developing political, economic and military relationship with the Ottoman Empire appeared to require public support for its internal status quo, leading Berlin to the conclusion that the avoidance of policies to which the sultan might object would ensure the continued success of Germany's ambitious economic projects in the Ottoman Empire.[8]

Between 1898 and 1917, the Zionist movement was unable to budge the Ottoman and German governments from their respective positions of outright opposition to and sympathetic aloofness from Zionist aims in Palestine. The Zionist argument that Germany's overall strategic interests in the Middle East were best served by the realization of Zionist aims in Palestine was reluctantly ignored by Berlin until late 1917, when the British government assumed sponsorship of the Zionist cause through the Balfour Declaration. Indeed, as early as December, 1898, Herzl had indicated in a letter to his friend the grand duke of Baden that the Zionist movement might seek the support and protection of Great Britain.[9] Moreover, the German Zionist Executive in Berlin warned the German Foreign Office as late as the summer of 1917 that the western powers would soon come out publicly in favor of a Jewish homeland in Palestine, and thereby enhance Allied prestige among the Jewish masses of central and eastern Europe and North America.[10] They pressed in vain for an official declaration of support from the German government to head off the anticipated western initiative.

Britain, on the other hand, was beginning to realize that much might be gained by a declaration of support for Jewish efforts in Palestine.[11] It was hoped that Jewish opinion in central and eastern Europe as well as in America might be turned away from its traditional sympathy for Germany, and antipathy for Russia, and encouraged to rally to the Allied cause. Moreover, by the summer of 1917, the British offensive from Egypt under Allenby had moved into Palestine, and the German-Turkish position in the Middle East theatre was beginning to collapse. The new military and political realities in the Middle East, coupled with Britain's apparent willingness to cooper-

ate with the Zionist movement, inclined many Zionists somewhat reluctantly to begin looking to Great Britain and away from Germany for the fulfillment of their hopes. The German Zionist Richard Lichtheim observed:

> We owed Germany very much, but the course of events in the war compelled Zionism to seek a connection with and help from the Anglo-Saxon Powers. . . . In 1917 the center of gravity of Zionist policy was moving more and more toward London and Washington. This was the necessary result of military and political developments, as well as the evident readiness of the British and American governments to support Zionist wishes.[12]

On October 4, 1917, Lord Balfour spoke to the War Cabinet in London, arguing that Germany was seeking to enlist the support of the Zionist movement. He urged haste in preparing an official British declaration of support for the Zionist cause. Balfour's information on German intentions was erroneous. Official German attitudes toward the Zionist movement, always sympathetic if somewhat aloof, had cooled by mid-1917 with America's entry into the war.[13] Years of German propaganda aimed at American Jewry with hopes of strengthening American neutrality had failed. The Balfour Declaration was approved by the War Cabinet in London on October 31 and made public in Balfour's famous letter to Lionel Walter Rothschild (the second Baron Rothschild and honorary president of the Zionist Federation of Great Britain and Ireland) on November 2, 1917. It seems to have had the desired impact on Jewish public opinion and to have enhanced Allied prestige among the Jews of central and eastern Europe.[14] Much of Palestine had already been overrun by Allenby's army and his Arab allies, and Jerusalem was to fall a month later. The British Foreign Office set up a special branch for Jewish propaganda within the Department of Information, under the direction of an active Zionist, Albert Hyamson.[15] Propaganda materials were distributed to Jewish communities around the world through local Zionist organizations and other intermediaries, while leaflets containing the text of the Balfour Declaration were dropped over German and Austrian territory.[16] After the capture of Jerusalem in December, 1917, pamphlets were circulated among Jewish troops in the German and Austrian armies, which read:

> Jerusalem has fallen! The hour of Jewish redemption has arrived. . . . Palestine must be the national home of the Jewish people once more. . . . The Allies are giving the land of Israel

to the people of Israel. Every loyal Jewish heart is now filled
with joy for this great victory. Will you join them and help to
build a Jewish homeland in Palestine? . . . Stop fighting the Al-
lies, who are fighting for you, for all Jews, for the freedom of all
small nations. Remember! An Allied victory means the Jewish
people's return to Zion.[17]

The impact of the Balfour Declaration on world Jewish opinion,
although difficult to measure, abruptly ended Germany's previous
aloofness from the Zionist movement. The press and public opinion
in Germany, both Jewish and non-Jewish, began calling for German
action to counter what was perceived to be an English propaganda
victory; the lament suddenly arose that Germany had failed to use
traditional Jewish sympathy for Germany.[18] After some debate in the
German Foreign Office, the government decided to press its Otto-
man ally to issue a declaration in favor of Zionist aims in Palestine,
which the Ottoman government reluctantly did on December 12.[19] A
similar statement had been issued by the Austro-Hungarian govern-
ment on November 21, and Berlin followed with its own declaration
on January 5, 1918:

> We deem worthy the wishes of the Jewish minority to develop
> their own culture and individuality in those lands in which the
> Jews have a strongly developed, distinct way of life. We extend
> to them our full understanding, and are prepared to extend our
> benevolent support for their efforts in this direction.
>    With regard to Jewish efforts in Palestine, especially those of
> the Zionists, we support the declaration recently made by the
> Grand Vizier, Talaat Pasha, and in particular the intention of
> the Imperial Ottoman government, in keeping with their
> proven friendly disposition toward the Jews, to promote the
> flourishing Jewish settlements in Palestine by granting free im-
> migration and settlement limited only by the absorptive capac-
> ity of the land, the establishment of local self-government in
> keeping with the laws of the land and the free development of
> their cultural individuality.[20]

The belated attempts of the Central Powers to neutralize what-
ever advantages the Allies gained from the Balfour Declaration were
to no avail. It was primarily military necessity and imperial ambi-
tion in the Middle East that had prompted Britain to support Zionist
aims in Palestine; Germany's political obligations to its Ottoman
ally had precluded similar initiatives from Berlin before 1917, de-

spite its natural inclination. The result was a shift in the center of gravity of the Zionist movement from central Europe to London and the United States, or from its former German orientation to an Anglo-American one. The war and the Balfour Declaration made political Zionism more popular among Jews around the world. Although the majority remained non-Zionist, many Jews developed a sense of protective responsibility for and loyalty to the National Home once it became a reality. If Germany retained the goodwill of Jews around the world, it nevertheless forfeited its special relationship with European Jewry, and with the Zionist movement, to the western powers. The Zionist movement had become an instrument for the promotion of British, not German, imperial interests.

The German government tried to regain some of the advantage lost to Britain with measures that paralleled those carried out in London after the Balfour Declaration. Early in 1918, the German Foreign Office created a special department for Jewish affairs under Professor Moritz Sobernheim. The government also encouraged German Zionists and their supporters in their efforts to set up a German equivalent to the British Palestine Committee, a group of prominent Jews and gentiles within and outside the government, designed to mobilize public support for the Zionist cause. In May, 1918, with the full support of the German government, the Deutsches Komitee zur Förderung der jüdischen Palästinasiedlung (German Committee for the Promotion of Jewish Settlement in Palestine), also known as the Deutsches Pro-Palästina Komitee (German Pro-Palestine Committee), was established in Berlin. It attracted prominent Jewish and non-Jewish Germans of all political and ideological shades, brought together by the common conviction that Germany's political, economic and strategic interests were best served by promoting the Zionist cause in Palestine.[21] The Pro-Palästina Komitee described its convictions and task "to promote Zionist efforts to create a national Jewish Commonwealth in Palestine. . . . that the Jewish settlement of Palestine is a phenomenon of great historical significance that must be of extraordinary interest for German policy."[22]

The Pro-Palästina Komitee used the arguments with which German Zionists for years had tried to enlist the support of the imperial German government. It stressed the political, economic and cultural advantages that Germany would reap in the strategically important Middle East and the importance of strengthening Jewish sympathy for Germany around the world. Like Britain, Germany sought to use the Zionist movement as a weapon against the other side, not merely for war advantage, but, as Zechlin observes, even more for the post-

war world in which Germany would be involved in a continuing po-
litical and economic struggle.[23]

With the end of the war, Germany's defeat, the disintegration of
the Ottoman Empire and the establishment of British power in Pales-
tine, the brief formal alliance between the German government and
German Zionism ended as abruptly as it had begun a year earlier.
The Pro-Palästina Komitee quickly disbanded, as the common inter-
est in a German victory and Germany's imperial advantage in the
Middle East, which held its members together for a year, was no
longer applicable. The temporary unity and cooperation among Zi-
onists, non-Zionists and even some anti-Zionists within the Ger-
man Jewish community lapsed as the old ideological cleavages,
which had divided the German Jewish community in the past, re-
emerged. However, the reasons that had prompted the German gov-
ernment to identify its interests with the Zionist movement, in
varying degrees both before and during the war, were not lost on sub-
sequent governments during the Weimar period.

Germany's defeat in 1918 neutralized the political and eco-
nomic advantages it had accumulated in the Ottoman Empire prior
to World War I. Yet German prestige and popularity, well established
in Syria and Palestine before 1914, remained high after the war. The
numerous German schools, hospitals, institutes and orphanages, as
well as the presence of some 2,000 German Christian residents, in-
cluding the approximately 1,800 members of the Protestant Tem-
pelgesellschaft (Temple Society), ensured the continued goodwill of
all segments of Palestinian society, Muslim, Christian and Jewish.[24]
Although German property in Palestine was confiscated by British
authorities as they moved into Palestine in 1917 and 1918, and some
850 Templers were interned in Egypt, these Palästinadeutsche (Pal-
estinian Germans) were returned to Palestine and their property was
restored by the end of 1920.[25]

The Palästinadeutsche were by no means the only agents of Ger-
man influence in Palestine, nor were they a significant economic
factor. They were a rather small vehicle for the promotion of Ger-
man political, economic and cultural interests, while the growing
number of central and east European Jewish immigrants, still cultur-
ally oriented to the German-speaking world, came to be viewed as an
ideal instrument for the promotion of German interests in Palestine.
As early as September, 1920, the German Foreign Office began to
consider renewing active support for the German and international
Zionist movements as a means of rebuilding German influence in

Palestine.[26] Karl von Schubert, state secretary in the German Foreign Office between 1924 and 1930 and an active supporter of German Zionism, circulated a memorandum in September, 1920, in which he stressed the positive effects that German support for Zionist efforts in Palestine would have on attempts to regain influence in the Middle East.[27]

It took more than four years for the German Foreign Office to pick up the threads of the policy that had emerged in Berlin in reaction to the Balfour Declaration. On May 8, 1922, its first policy statement on Palestine was issued to all German diplomatic missions abroad.[28] The statement addressed itself to the advantages reaped by Britain in Palestine and throughout the Middle East at the end of the war, citing the strategic value of the new Mandates and the sympathy of the world's 14 million Jews stemming from the Balfour Declaration and its postwar implementation. Considerable attention was paid to Germany's current position and potential gains in the Palestinian economy. It was noted that Germany had already established a favorable trade position in postwar Palestine, with German imports into the expanding Palestine market fourth in total volume behind imports from Great Britain, Egypt and the United States. While most of the imports from Germany's competitors were in the form of consumer goods that Germany was not in a position to export in 1922, Germany had demonstrated that it was able to provide much of the machinery, heavy industrial products and building materials needed in Palestine in ever greater volume as more and more Jewish capital and immigration stimulated the economic development of the country.[29] The statement further asserted that the spiritual and cultural ties between Germany and the growing numbers of central and east European Jewish immigrants in Palestine would afford German business the ideal means for promoting German exports to Palestine and to the rest of the Middle East. It spelled out in detail what was to be the major thrust of German Palestine policy during the Weimar years, namely, that "friendly relations with the Jewish movement, as will doubtless be pursued by their leaders, could be of significance for Germany's economic and even political position."

The May 8 memorandum signaled the renewal of an active German policy in Palestine with the aim of securing primarily economic ends. The Zionist movement had been made the main vehicle for securing those ends. The immediate implementation of that policy is evident in German efforts to intercede on behalf of the Zionist cause in its rift with the Vatican after World War I.[30] Vatican disapproval of the Balfour Declaration, expressed in a Pro-Memoria deliv-

ered to the League of Nations in June, 1922, led to an unsuccessful attempt by the German Foreign Office to temper Vatican hostility toward the Zionist movement. The German government feared that Rome might exercise an anti-Zionist influence at least on German Catholics and thus jeopardize efforts to forge an alliance between Germany and the Zionist movement.

It was not until the end of 1924 and the spring of 1925 that a comprehensive German policy on the increasingly difficult Palestine question, with its British, Arab and Jewish components, emerged. In December, 1924, Professor Sobernheim of the Jewish Affairs Section and Baron von Richthofen of the Orient-Abteilung (Orient Section) of Abteilung III circulated a memorandum in the German Foreign Office that outlined in detail Germany's rejection of the Arab position in the emerging Palestine conflict.[31] The memorandum noted that the Arabs had done nothing for centuries to develop the land and thus had forfeited their rights to the Jews, who, with their skill, energy and resources, had already demonstrated their capacity for developing Palestine and making it prosper. Moreover, it was asserted that the Arabs of Palestine were not ready for self-government in view of widespread illiteracy and lack of education. German interests and aims in Palestine were defined as primarily economic in nature; the Jews, not the Arabs, were considered most capable of creating conditions in Palestine conducive to those interests and aims.

Just four months later, Sobernheim filed a lengthy report in the German Foreign Office shortly after his return from a trip to Palestine in March and early April. His report defined Germany's mainly economic interests in postwar Palestine, attitudes toward the issues in the Palestine conflict and policies to be pursued based on those attitudes and interests.[32] He, too, dismissed the Arabs as unable and unwilling to do anything to develop Palestine and credited the growth and development of the country since the war to the strength and dynamism of Jewish capital and labor. In Sobernheim's judgment, Germany's major interest in Palestine and elsewhere was the quest for markets for German goods. Admitting that Palestine was relatively insignificant in the overall picture of world trade, he nevertheless argued that it was a land rapidly developing as a result of Jewish efforts, and one that would have substantial economic needs in the coming years. Palestine would provide an expanding market for the kinds of goods Germany exported most, and the natural trade ties between Jewish businesses in Germany and Palestine would enable Germany to corner a considerable share of this market. The Jews of Palestine, industrious, dynamic, progressive, driven by an ideal and financed by a prosperous Jewish community in the west—not the

backward, indolent Arabs—would be the buyers of ever-increasing amounts of German goods.

Sobernheim also stressed the necessity of rebuilding and expanding German cultural interests and prestige in Palestine and the Middle East as the best means of achieving German economic ends. He asserted that Zionist success and the eventual emergence of a predominantly Jewish Palestine would guarantee a strong German cultural influence. Sobernheim identified the small nucleus of German Zionist leaders in Palestine and the masses of German-oriented east European Jewish immigrants as agents of German culture in the Middle East. Moreover, Britain was singled out in the report as the most important element in the Palestine situation for Germany. Sobernheim reminded the German Foreign Office that friendly relations and cooperation with Great Britain were prerequisites for the attainment of Germany's relatively limited aims in Palestine, as well as its more immediate aims in Europe. He urged continued support for and cooperation with British authorities in carrying out the provisions of the Mandates in Palestine and elsewhere in the Middle East.

Sobernheim's report reflected policies that for the most part were already being pursued by the German government and would continue to be pursued until the end of the Weimar Republic. It showed an acceptance of the two basic political realities in Palestine and the rest of the fertile crescent after World War I, namely, the creation of a Jewish national homeland in Palestine and Britain's imperial presence through the Mandates. Yet, before Germany's entry into the League of Nations in October, 1926, there was no formal treaty commitment binding Germany to these postwar realities. League membership and acceptance of the Covenant formally committed Berlin to the provisions of the postwar settlement in the Middle East. Germany became bound to the Mandate system as outlined in article 22 of the Covenant, and to the British Mandate over Palestine as adopted by the League on July 24, 1922. Moreover, as a member of the League of Nations, Germany was treaty-bound to support the implementation of the Balfour Declaration, which had been incorporated into the preamble of the Palestine Mandate and into articles 2, 4, 6, 11, 22 and 23.[33] Germany received a permanent seat on the League Council and, as a member of the Permanent Mandates Commission, became directly involved in the issues and administration of the Palestine Mandate. Although Palestine was not as important to Germany as the administration and eventual return of its own former colonies, the Commission afforded it a position from which better to protect

and promote German interests in Palestine and throughout the Middle East.

On the domestic front, the German government pursued its Palestine policy through the German Zionist movement. It proved to be a difficult task in view of the cleavages within the German Jewish community between the anti-Zionist, liberal/assimilationist majority and the minority Zionists.[34] To this animosity was added the increasing virulence of an anti-Semitism that, as a political weapon and a sociopolitical force, achieved an unprecedented level of intensity and public tolerance during the Weimar years and tended to politicize the Jewish community as never before. As a result, most Jews became either more militant in their Zionism or more militant in their opposition to it.[35]

Seeking to generate greater domestic popular support for its endorsement of the Zionist cause and the British Mandate, the German Foreign Office participated in the reestablishment of the Pro-Palästina Komitee in December, 1926.[36] Similar to its short-lived wartime predecessor, the Pro-Palästina Komitee was again composed of prominent Jews and gentiles and adopted the goals of the first Komitee as its own.[37] The official program of the Pro-Palästina Komitee called for the promotion of Zionist goals in Palestine and concluded that "Jewish development work in Palestine is an excellent means for the economic and cultural development of the East, for the expansion of German economic relations and for the reconciliation of the people."[38] Count Johann von Bernstorff, the first chairman of the resurrected Pro-Palästina Komitee, repeatedly emphasized the economic, political and cultural advantages that support for Zionism would bring to Germany; he also pointed to the obligations that Germany had incurred as a member of the League of Nations to uphold the Palestine Mandate and implement the Balfour Declaration. In a letter to Georg Mecklenburg of the liberal/assimilationist Centralverein deutscher Staatsbürger jüdischen Glaubens (Central Association of German Citizens of the Jewish Faith) in October, 1927, Bernstorff concluded that "the promotion of Jewish settlement in Palestine is an undertaking to be welcomed from the standpoint of German foreign policy."[39]

The long list of prominent personalities from the major political parties, the Foreign Office and other government agencies who held membership in the Pro-Palästina Komitee reflected the broad and continuing support within the German government for the Zionist movement before 1933.[40] The list includes such figures as the state secretary in the Reichskanzlei (Reich Chancellery), Hermann

Pünder, Mayor Konrad Adenauer of Cologne and former Chancellor Josef Karl Wirth of the Catholic Center party, Count von Bernstorff, President Hermann Hausmann and Prussian Minister of Public Worship and Education Karl Heinrich Becker of the German Democratic party (DDP), Rudolf Breitscheid, Prussian Prime Minister Otto Braun, Reichstag President Paul Löbe and Chancellor Hermann Müller of the Social Democratic party (SPD), as well as several members from the conservative parties, including the German People's party (DVP) and the German National People's party (DNVP). The crucial support of the German Foreign Office was reinforced by the membership of Assistant Secretary Hartmann Baron von Richthofen of the Orient-Abteilung and State Secretary Karl von Schubert. Other key figures who became members include Germany's representatives at the League of Nations and on the Permanent Mandates Commission, Drs. Ludwig Kastl and Julius Ruppel, as well as the German consul-general in Jerusalem, Erich Nord, and Dr. Kurt Prüfer of the Orient-Abteilung.

The only serious opposition to the pro-Zionist policy of the government and the creation of the Pro-Palästina Komitee came from within the predominantly liberal/assimilationist German Jewish community itself. Seeking to counter Jewish charges that Zionism denied the Jews of Germany their legitimate national identity as Germans, and that it merely played into the hands of the anti-Semites, government officials and members of the Pro-Palästina Komitee counseled that Zionism was perfectly compatible with the German nationality, patriotism and loyalty of the Jewish community in Germany.[41]

Membership in the organization continued to grow after 1926; by 1932, it had secured the active participation of 217 of the most prominent German citizens, Jewish and non-Jewish. Not only was the Pro-Palästina Komitee instrumental in spreading information about the Zionist movement and its efforts in Palestine, but it actively promoted the pro-Zionist policies of the German government as well, particularly in its assistance to the German Foreign Office in cultivating friendly relations with the World Zionist Organization. Foreign Minister Stresemann, State Secretary von Schubert and Professor Sobernheim emphasized the need for close contacts with the leadership of the World Zionist Organization and therefore attached considerable importance to several visits to Germany by Dr. Chaim Weizmann and other leaders of the World Zionist Organization during the 1920s.[42]

The strong Zionist component in German policy during the Weimar years was matched by an equally determined rejection of

the efforts of Arab nationalists to undo the postwar settlement in the Middle East. These efforts included attempts to enlist German diplomatic and material support in the struggle against the Mandate system and its English and Zionist sponsors in Palestine and elsewhere in the Middle East. In spite of its alliance with the Ottoman Empire during the war, Germany had not lost the general friendship and goodwill of Arabs that had existed prior to the war. The bitterness and sense of betrayal among Arab nationalists contributed to an emerging perception of Germany as a fellow-victim of the hated settlement and as the only major European power without imperial ambitions in the Middle East. This view was expressed late in the summer of 1921 by members of an Arab delegation from Palestine in London for negotiations with the British government on the future Palestine Mandate. The German ambassador in London, Dr. Friedrich Stahmer, reported to Berlin on the substance of his talks with the delegation, particularly the Arab view of the past Arab-German relationship, as follows: "They have never had hostile feelings for Germany, having instead trusted Germany more than other Great Powers because of their impression that, in the pursuit of its interests, Germany has never acted in a purely selfish manner, having instead respected the interests of the indigenous inhabitants." [43]

Stahmer's meeting with the Arab delegation in London was followed by a series of Arab overtures to Berlin for sympathy as well as for diplomatic and material support against the British and French Mandates and the Zionist effort to create a National Home in Palestine. On several occasions during the Weimar period, German assistance was solicited by Arab nationalist groups in Syria and Palestine.[44] In 1921 and again in 1927, Syrian Orthodox Christian and Arab nationalist groups sought to enlist German diplomatic and weapons support in order to end French rule in Syria. Furthermore, the violence in Palestine in 1929 generated considerable Arab pressure for some measure of German support against the British Mandate.

On these and other occasions, the German government adamantly refused to provide any kind of assistance to the Arab cause in Palestine, Syria or elsewhere in the Middle East. The reasoning behind this position is abundantly clear in Sobernheim's April, 1925, report and in the above-cited policy statements of the German Foreign Office, as well as in the official response of German consular officials in Syria and Palestine to Arab overtures.[45] German interests in the Middle East, primarily economic and cultural, were deemed best served by supporting Zionist aims in Palestine and Anglo-French predominance through the Mandates. Weimar Germany's overriding

political aim was the revision of the Versailles settlement in Europe, which, along with its extremely vulnerable postwar position in general, precluded any form of *Prestige-Politik* in opposition to Great Britain and France in the Middle East or elsewhere.

As the level of violence and corresponding international debate over Palestine intensified during the late 1920s and early 1930s, the main ingredients of German Middle East policy, particularly with regard to Palestine, were tested and implemented. The Arab-Jewish violence of those years was viewed by Berlin as detrimental to German interests in Palestine and throughout the Middle East because it impeded economic activity and expansion. Its tendency to discourage prospective Jewish immigrants, and to induce some Jewish settlers in Palestine to leave, was bound to have a negative impact on the volume of trade between Germany and Palestine. With these considerations in mind, the German Foreign Office concluded in a memorandum late in 1929 that "Germany's main interest is that order will soon be restored in Palestine, and that economic development will be promoted."[46] There was little inclination to sympathize with Arab efforts to dismantle the postwar settlement in Palestine and throughout the Middle East.

As a permanent member of the League Council, and of the League's Permanent Mandates Commission, the German government was in the thick of the international debate over Palestine after 1926. It was the League that was ultimately responsible for each of the Mandates, and Germany was bound to the Mandate system as outlined in article 22 of the League Covenant, to the British Mandate over Palestine as adopted by the League on July 24, 1922, and to the provisions embodied in the Balfour Declaration, which had been incorporated into the Palestine Mandate.[47] The German government was forced publicly to define its position on the basic issues of the Anglo-Arab-Jewish conflict in Palestine, given these commitments and obligations. Moreover, this had to be done within the context of the increasingly evident contradictions that characterized British wartime and postwar policy in the Middle East, particularly in Palestine.

German support for the British Mandate in Palestine and for the Jewish National Home was clearly demonstrated throughout the debate. At the Sixteenth Session of the permanent Mandates Commission from November 6 to 26, 1929, the German government took a position that was mildly critical—yet totally supportive—of British policy and conciliatory—yet noncommittal—toward the Arab position.[48] German loyalty to the basic elements of the post–World War I settlement in the Middle East is also evident in the full support

given to the recommendations of the Shaw Commission after the violence of 1928–1929 in Palestine, recommendations that preserved the Jewish National Home and the British Mandate in Palestine.[49]

A line of continuity is evident in German Palestine policy during the imperial and Weimar periods. It is reflected in the support for Zionist efforts in Germany and Palestine and in the recognition of Zionism as an effective instrument of German foreign policy. The notion of a Jewish national homeland or commonwealth in Palestine received the tacit if not always explicit acceptance of the imperial German government from Herzl's day through the waning months of World War I; and the reality of the National Home initiated by the Balfour Declaration enjoyed the open support and encouragement of Weimar foreign policy from Rathenau through Stresemann and Schubert to Neurath and Bülow. Moreover, German Middle East policy during both eras was predicated on an accommodation between the Zionist movement and the dominant power in the fertile crescent. For imperial Germany, the desired accommodation between Zionism and the Ottoman Empire did not materialize until late in 1917, when it was too late to be of any value to Germany; for the governments of the Weimar Republic, however, the Anglo-Zionist alliance in Palestine that emerged from World War I became the framework for the pursuit of German interests and aims in the Middle East.

# 2. Early National Socialist Attitudes toward Zionism

## The Anti-Semitic Background

There can be little doubt that the *völkisch* concepts of German nationality and anti-Semitism were the only relatively consistent ideological currents of the National Socialist movement from its earliest days until Hitler's last testament in April, 1945.[1] The subject of Hitler's anti-Semitic heritage has been pursued at some length and has produced numerous accounts of the origins and development of anti-Semitism in Germany before World War I.[2] It is still not certain how much direct exposure Hitler had to the racial theories of Arthur de Gobineau, Eugen Dühring, Paul de Lagarde, Houston Stewart Chamberlain and the other nineteenth-century intellectual and spiritual fathers of modern racism and anti-Semitism; much of it must have filtered down to him through the pamphlets, newspapers and conversations to which he was exposed in pre–World War I Vienna. Nevertheless, it appears that he did possess a comprehensive ideological approach to the Jewish question by 1920, one that embodied all of the basic tenets of the anti-Semitic theorists of the nineteenth century.[3]

The postwar bitterness and upheaval in Germany provided Hitler with the means to channel his racist impulses into effective political action.[4] His role as speaker and propagandist in the Deutsche Arbeiterpartei (German Workers' party) in the latter part of 1919 and 1920 and his association with Dietrich Eckart, Gottfried Feder, Alfred Rosenberg and others provided him with the framework for an anti-Semitic program that was to be incorporated into the Party Program of February 24, 1920, into *Mein Kampf* and finally into the laws of the Reich after 1933.[5] In the end, Hitler's contribution to German anti-Semitism was to have a more profound and lasting impact than the pseudo-scientific theories of those who preceded him and those around him. His determination to translate the theories and

emotions of the past into concrete, planned political action that would eliminate the Jews from German and European life was expressed as early as 1919. In his well-known letter of September 16, 1919, to a former liaison officer of the Munich district headquarters of the German army, Hitler wrote: "Anti-Semitism, based purely on emotion, will always manifest itself in the form of pogroms. However, a rational anti-Semitism must lead to a well-planned, legal struggle against and elimination of the special rights of the Jew that he, unlike other aliens who live among us, possesses. Its end must be irrevocably the complete removal of the Jews."[6]

This study seeks to provide a comprehensive analysis of National Socialist attitudes toward Zionism from the early years of the movement to World War II, including the role of Zionism in National Socialist Jewish policy from the *Machtergreifung* (seizure of power) to the onset of the "final solution." As one of the developing *völkisch* nationalisms of central and eastern Europe in the nineteenth century, and as a response to the anti-Semitic content and excesses of those national movements, Zionism has accepted the premise that the Jewish people, for racial, religious, cultural or historical reasons, should not be assimilated. Early Zionist leaders accepted the desirability of national separateness, while rejecting the Social Darwinist theories of racial superiority and struggle that were becoming the cornerstone of anti-Semitic political ideology in the second half of the nineteenth century.[7]

Among German nationalists and Zionists, there was a common acceptance of the *völkisch* inviolability and separateness of the peoples of the world and the necessity of a *völkisch* basis for the state. Herder's concept of nationhood best illustrates their common ground: "The most natural state is one nationality with one national character. . . . Nothing therefore appears so indirectly opposite to the end of government as the unnatural enlargement of states, the wild mixing of all kinds of people and nationalities under one scepter."[8] In his *Rom und Jerusalem*, published in 1862, Moses Hess, one of the first important proponents of political Zionism, argued against emancipation and assimilation as the solution to the Jewish question in Europe. He asserted that for Jews as well as gentiles, race and racial separateness should be fundamental considerations in all political and social institutions and on this basis called for a separate national existence for the Jewish people in Palestine:

> The present international situation should encourage the immediate founding of Jewish colonies on the Suez Canal and on the banks of the Jordan. Stress will be laid on the heretofore

neglected proposition that behind the problem of nationalism and freedom, there remains the profound question of race. This question, which is as old as history, must first be solved before a definite solution to the political and social problems can be worked out. Social institutions, like spiritual outlooks, are racial creations. All past history was concerned with the struggle of races and classes. Race struggle is primary; class struggle is secondary. When racial antagonism ceases, class struggle also ceases. Equality of all social classes follows on the heels of equality of all races and finally remains merely a question of sociology.[9]

The Zionist rejection of the liberal/assimilationist position of the majority of central and west European Jews was firmly rooted in the conviction that the Jews constituted a unique race.[10] Even the ideas of the important nineteenth-century racial theoretician Joseph Arthur de Gobineau were enthusiastically received by a few German Zionists before World War I. In 1902, the Zionist newspaper *Die Welt* accepted Gobineau's theories on racial degeneration and the desirability of maintaining racial purity, noting that Gobineau had pointed to the Jews with admiration as a strong people that believed in the necessity of maintaining its own racial purity.[11] Elias Auerbach and Ignaz Zollschan, central European Zionists during the years before World War I, pointed to the desirability of racial purity and national homogeneity.[12] Auerbach used Gobineau's theories to support his contention that a people would never die so long as it was able to maintain its purity and uniqueness. Zollschan went so far as to praise much of the racial philosophy of the famous nineteenth-century anti-Semitic philosopher and historian Houston Stewart Chamberlain. While supporting Chamberlain's argument that racial purity conferred nobility on a people, he argued that Chamberlain's essentially correct approach to race was flawed by mistaken notions of Jewish depravity and inferiority. Even Martin Buber used the concept of a "community of blood" as a metaphor to describe the strong national bonds from which the Jewish people have historically derived their strength.[13]

If many Zionists believed in the reality of race, the great majority did not believe in the superiority of one race over another. The profound distinction between most Zionists and the growing body of racial nationalists in Germany during the last decades of the nineteenth century lay in the Social Darwinist principles of the latter. While Herder's dictum led Zionists and some German nationalists to favor separate but not necessarily unequal national entities, each

with its own state preserving its own separate *völkisch* character, the anti-Semites made qualitative distinctions between the racial or national groups of the world, specifically, between Germans and Jews. Their relationship was soon defined as one of hostility and struggle between the superior and the inferior, between good and evil. For all of them, however, the liberal concept of a pluralistic so- ciety, supported by the overwhelming majority of Jews in Germany throughout the nineteenth century, was unacceptable.

Support for Zionism from the non-Jewish world has been motivated through the years by a variety of factors, ranging from a sense of justice, sympathy, idealism and guilt on the part of liberals to the imperial interests of the Great Powers in the Middle East and elsewhere to the anti-Semitic inclinations of nationalist and racist ideologues and politicians. As early as 1799, a sense of Jewish attachment to Palestine was recognized by one European Great Power as a possible instrument for the promotion of its imperial ambition. Campaigning in Palestine in 1799, Napoleon called on the Jews of Africa and Asia to join him in his war against the Ottoman Turks and for the resurrection of a Jewish Palestine.[14] Although Zionism and the fledgling Zionist movement remained relatively insignificant throughout the nineteenth century among Jews and gentiles alike, they emerged with the disintegration of the Ottoman Empire during World War I as phenomena deemed worthy of support in the promotion of Great Power imperial interests in the Middle East.

The Zionist concept of the Jews as a distinct national or racial community, deserving its own homeland or state, held considerable appeal for many nationalists and anti-Semites in Germany during the nineteenth century. Its appeal lay in the Zionists' ultimate acceptance of the exclusion of the Jewish people from the German *Volksgemeinschaft* (racial community) and the necessity of a Jewish homeland in Palestine or elsewhere overseas, capable of drawing Jews away from Europe. Recognizing a common aversion to the process of Jewish emancipation and assimilation, as well as the common view of the Jews as a distinct political entity, Theodor Herzl identified a community of interests between Zionists and anti-Semites and reasoned that the Zionist movement could expect considerable support from anti-Semitic nationalists in central and eastern Europe.[15] Herzl worked on the premise that the uniqueness of the Jews and their strong sense of community and separateness lay at the root of an anti-Semitism that could be contained and neutralized only by emphasizing that uniqueness, community and separateness.[16]

Much of the support that Herzl expected from nationalists and anti-Semites was indeed forthcoming in nineteenth-century Ger-

many. As Johann Gottlieb Fichte called on Germans early in the century to cherish and revere the German *Volksgeist* (national spirit) as the foundation of all good culture and civilization, he also warned against the evils of Jewish emancipation and suggested the return of the Jews to Palestine.[17] Later in the century, Fichte's intellectual disciples would lend their support to his suggestion that a solution to the Jewish question might be reached by removing Jews from Germany and the rest of Europe to a separate Jewish homeland.

Eugen Dühring proposed solving the Jewish question by herding the Jewish people together in a state somewhere outside of Europe.[18] Heinrich von Treikschke regarded anti-Semitism as a necessary evil, a natural reaction of the German *Volksgefühl* (consciousness) against a foreign element that itself never intended to assimilate. Asserting that there was no room in Germany for dual loyalty, his solution was also Jewish emigration and the creation of a Jewish homeland in Palestine or elsewhere.[19] Heinrich Class of the Pan-German League linked the solution of the Jewish question to the idea of German expansion in eastern Europe, a combination that was to be the central element in the foreign policy of the Third Reich. Class proposed sending Jews to Palestine, and pushing the Poles and Russians further east.[20] Ludwig Woltmann's "political anthropologists," a school of thought at the turn of the century devoted to the principles of racial purity and Germanic superiority, supported the Zionist goal of resurrecting Jewish national life in a separate Jewish homeland. Wilhelm Marr maintained that Jewish emancipation was leading to the complete Judaization of Germany.[21] He claimed that the Jews had no fatherland of their own and lamented the fact that they had become estranged from their Biblical homeland in Palestine. Marr's views were echoed by the political theorist and critic of Bismarck Konstantin Frantz, who advocated the removal of Germany's Jewish population to Palestine.[22] The historian Johannes Scherr argued that the Jews were entitled to a form of nationhood of their own, in Palestine or elsewhere, while Adolf Stoecker's Christian Socialist movement favored a return of German Jews to Palestine.[23] The first Pro-Palästina Komitee in Germany during World War I attracted support from conservative politicians who hoped to divert the flow of east European Jews away from Germany, if not to encourage German Jews themselves to leave for Palestine.[24] Finally, during the Weimar years, prominent anti-Semites such as Wilhelm Stapel, Hans Blüher, Max Wundt and the Evangelical pastor Johann Peperkorn looked to Zionism as the only realistic solution to the Jewish question in Germany.[25]

Both Eugen Dühring and Houston Stewart Chamberlain provided the basis for the subsequent ideological hostility of National

Socialism to the ultimate aim of political Zionism, the creation of an independent Jewish state in Palestine. In Chamberlain's *Grundlagen des 19. Jahrhunderts*, first published in 1899, as well as in Dühring's above-cited *Die Judenfrage*, the existence of a Jewish conspiracy to dominate the world was postulated.[26] The conspiracy theory became one of the central concepts upon which National Socialist Jewish policy was based, making the idea of an independent Jewish state in Palestine objectionable because of fear that it would become a base for such a conspiracy. Yet both were inclined to support the use of the Zionist movement for the practical aim of removing Jews from Germany.

### Alfred Rosenberg, Zionism and the Conspiracy Theory

One author has divided Hitler's developing approach to the Jewish question into two phases.[27] The first concerns Hitler's views prior to the publication of the Party Program in February, 1920; it is characterized by an emphasis on the Jewish question in Germany alone, including alleged Jewish responsibility for Germany's defeat, the revolution and the Weimar Republic. In the second phase, there is an increasing inclination to emphasize the international dimensions of the Jewish question, particularly the theory of an international Jewish conspiracy to dominate Germany and the rest of the world. It is the second phase that is of primary concern here, for according to National Socialist dogma after 1920, the alleged Jewish conspiracy was being promoted through the dual instruments of international Bolshevism and the international Zionist movement. The person most responsible for developing this idea and for incorporating it into Nazi dogma was Alfred Rosenberg.

The Party Program of February 24, 1920, dealt with the Jewish question as a matter of domestic German politics. Points 4 and 5 define citizenship in terms of blood, which would have excluded Jews from full citizenship, but would have permitted them to remain in Germany as guests, subject to the laws governing other aliens in the country. Point 8 demands a halt to the immigration of all non-Germans (a euphemism for the *Ostjuden*—Jews who had been arriving in Germany from the ghettos of eastern Europe for decades); it also called for the deportation of all Jewish immigrants who had arrived in Germany by August 2, 1914.[28]

Hitler's speeches in late 1919 and early 1920 also considered the Jewish question in Germany as a domestic matter. Issues such as citizenship, alleged Jewish responsibility for Germany's defeat and postwar plight, the *Ostjuden*, alleged Jewish domination of the cul-

tural and economic life of the country and the desirability of forcing Jews out of Germany were the subject matter of many of Hitler's speeches. The emigration or deportation of Jews from Germany appears to have been the main theme of his speeches on racial policy and the Jews during the spring of 1920. In Munich on April 6, Hitler again asserted that, rather than cultivate a pogrom atmosphere against the Jewish community, National Socialism should concentrate its efforts toward the complete removal of Jews from Germany.[29] Moreover, he argued that all means to this end would be justified "even if we must cooperate with the Devil himself." In another speech in Munich on April 29, Hitler concluded, "We will carry on our struggle until the last Jew is removed from the German Reich."[30] By the end of May, however, Hitler had not only dropped the distinction between eastern and western Jews, but had begun to place his struggle against the Jews on the international level for the first time. At a Party meeting in Munich on May 31, Hitler argued that the solution to the Jewish question in all of Europe was of primary importance, and that no distinction could ever be made between eastern or western Jews, or between Jews who were rich or poor, good or evil.[31] He concluded that the major enemy of Europe was the Jewish race in its totality. From the end of May, 1920, Hitler's speeches on the Jewish question began to assume a new dimension, one that bore the stamp of Alfred Rosenberg's ideas and influence.

Rosenberg left his native Estonia for Germany in November, 1918.[32] After a brief stay in Berlin, he came to Munich early in 1919. Through a friend, he was put in touch with Dietrich Eckart, editor of the anti-Semitic newspaper *Auf Gut Deutsch* and a member of the Thule-Gesellschaft, a patriotic, anti-Semitic order created in 1918 by Rudolf Baron von Sebottendorf in Munich.[33] It was through Eckart, the job with his newspaper and the contacts made through the Thule-Gesellschaft that Rosenberg emerged in 1919 as a leading anti-Semitic theorist in Munich. It was also through Eckart that Rosenberg met Hitler later that year.

Rosenberg brought to Munich both theories about and experiences in Bolshevik Russia. He had developed his major theoretical contributions to National Socialism before he left Estonia in 1918, namely, that Bolshevism and Zionism were instruments of a Jewish world conspiracy.[34] His ideas were readily accepted by Eckart, who had been preaching the conspiracy theory in his newspaper before Rosenberg arrived in Munich. Rosenberg provided Eckart with some substance for those ideas and, at the same time, an apparently legitimate source with firsthand experience.

There can be little doubt that Rosenberg, as a Baltic German and

subject of the old Russian Empire, had an important impact on the limited, more parochial outlook of Hitler and the essentially southern German membership of the Deutsche Arbeiterpartei in 1919 and 1920.[35] He was not responsible for Hitler's profound hatred of Jews, nor had a vague concept of a Jewish conspiracy been unknown to Hitler. Both had been influenced in this direction by Chamberlain and similar notions expressed by Theodor Fritsch during the years before World War I.[36] It would also appear unlikely that Hitler needed Rosenberg to become an anti-Marxist. With help from Eckart, Rosenberg provided Hitler and the Deutsche Arbeiterpartei with an ideological framework, based on the conspiracy theory, through which Jewish policy was to be formulated and carried out until 1945. Substance was added to the conspiracy theory by using Bolshevism and Zionism as its instruments. The significance of the alleged Jewish-Bolshevik link for future Nazi propaganda and policy cannot be overestimated, while the connection between Zionism and the alleged conspiracy was to generate an important ideological and policy debate in government and Party circles in Germany during the years prior to World War II.[37]

The basis of Rosenberg's conspiracy theory was the so-called "Protocols of the Elders of Zion," with which he had become familiar as a student in Moscow during the summer of 1917.[38] The "Protocols" first appeared in Russia in 1905 in a version ascribed to Sergei Nilus, a pious extremist in the Russian Orthodox Church. The pamphlet purported to be the record of a secret meeting in 1897 of Jewish leaders from around the world who were in Basle for the first Zionist Congress. At this meeting, Theodor Herzl and other Jewish leaders were alleged to have planned the domination and destruction of the gentile world and to have resolved to unleash a terrible war to attain their ends.[39] The "Protocols" were brought to Germany by refugees fleeing from the Bolshevik revolution, among them Alfred Rosenberg, and a German translation first appeared in 1919.[40] In that same year, the burden of war guilt was placed on Germany's shoulders by the Paris Peace Conference, a burden very few Germans were willing to accept as legitimate. Adherents of the "Protocols" asserted that the Jews had started the war and had been its sole beneficiaries. Charges such as this were bound to find a high degree of acceptance among the German people immediately after the war and, at the same time, provide a useful propaganda weapon for the anti-Semitic Right in its campaign against the Versailles Treaty and the Jewish community in Germany.

The "Protocols" provide the link between Rosenberg's imagined Jewish conspiracy and the Zionist movement. Three of his early

works, as well as several articles in the *Völkischer Beobachter* during those years, provide a comprehensive presentation of his approach to Zionism.[41] The ideas outlined in these works would become the basis of National Socialist policy toward Zionism and the Zionist movement in Germany until the early years of World War II, which is essential for a broader understanding of the Jewish policy of the Hitler regime during the 1930s and of its position on the Palestine question during those years.

*Der staatsfeindliche Zionismus*, published in 1922, was Rosenberg's major contribution to the National Socialist position on Zionism. It represented in part an elaboration on ideas already expressed in articles in the *Völkischer Beobachter* and in other published works, notably *Die Spur*. The title provides the gist of a thesis that Rosenberg sought to convey to his readers: "The Zionist organization in Germany is nothing more than an organization that pursues a legalized undermining of the German state."[42] He accused German Zionists of having betrayed Germany during the war by supporting Britain's Balfour Declaration and pro-Zionist policies and charged that they had actively worked for a German defeat and the Versailles settlement to obtain a Jewish National Home in Palestine.[43] He went on to assert that the interests of Zionism were first and foremost those of world Jewry, and by implication the international Jewish conspiracy. He further claimed that loyalty to Zionist and other Jewish interests precluded loyalty to the German fatherland, that in fact Zionists in Germany did not pretend to possess a dual loyalty to both a Jewish and a German fatherland.[44] Notwithstanding the above factors, it would appear that Rosenberg's attitude toward Zionism was conditioned primarily by the unshakable conviction that the alleged Jewish world conspiracy was a monolithic phenomenon, uniting Zionists and assimilationists alike in a common effort.[45]

Rosenberg also dismissed Zionists' claims that they merely wanted to create a refuge in Palestine for persecuted Jews. He made this assertion within the context of traditional anti-Semitic notions about Jewish inferiority and treachery. According to Rosenberg, Jews had neither the capability to create a state in the European sense nor the intention of making that an end in itself; he concluded that they would seek to create an independent base in Palestine, a "Jewish Vatican," from which to carry out their plans to subvert and dominate the rest of the world.[46]

These theories represent one side of what was to be the double-edged nature of the Nazi approach to Zionism and the Palestine question after 1933. They demonstrate a fundamental ideological hostility and incompatibility between National Socialism and a Zi-

onist movement that was considered to be merely an instrument of a monolithic Jewish world conspiracy. They represent a significant departure from those nineteenth-century anti-Semites who were content simply to accept the Zionist aim of separating Jews from non-Jews and to fulfill Leo Pinsker's dream of emancipating the Jewish nation as a whole within the world community of nations, rather than the individual Jew within the society of his or her native land.[47]

Nevertheless, it appears that Rosenberg did recognize from the beginning the utility of encouraging the Zionist movement in Germany as a means of facilitating the removal of Germany's Jewish population. In *Die Spur*, written in late 1919 and published in 1920, Rosenberg concluded, "Zionism must be vigorously supported in order to encourage a significant number of German Jews to leave for Palestine or other destinations."[48] He further singled out the Zionists from other Jewish organizations in Germany as a group with at least some potential for short-term cooperation with a future National Socialist Germany in halting Jewish assimilation and influence and in promoting Jewish emigration.[49] Rosenberg's argument that the Zionist movement could be utilized to promote the political, economic, social and cultural segregation of Jews in Germany, as well as their emigration, was eventually transformed into policy by the Hitler regime after 1933.

Rosenberg also intended to use Zionism as legal justification for depriving German Jews of their civil rights. The Zionist position that there existed a separate Jewish *Volk* with its own cultural and national interests could be used against what was considered to be a monolithic Jewish community in Germany. He argued that when an organization within the German state declares that the interests of the German Reich are not its prime concern, then its members cannot claim their full civil rights.[50]

One finds in Rosenberg's early writings the basic elements of what was to become National Socialist policy toward Zionism during the 1930s, in terms of both domestic Jewish policy and the Palestine question as an issue of strategic and foreign policy. There emerged the conviction that, for cultural, racial and historical reasons, the Jews were not capable of building a state; moreover, it was believed that the Zionist goal was not merely the creation of a Jewish state or National Home, but rather the creation of a power base from which to conduct the conspiracy against Germany, allegedly outlined in the "Protocols of the Elders of Zion." This approach was maintained by Rosenberg in his later writings and speeches that referred to Zionism and Palestine.[51] At the same time, he sanctioned the use of the Zionist movement in the future drive to eliminate Jewish rights, Jewish

influence and eventually the Jewish presence in Germany. This du-
ality is considered in greater detail below in light of events during
the 1930s.

### The Emergence of Hitler's Attitude toward Zionism

Adolf Hitler probably said and wrote more about Zionism during the
period 1920–1924 than during the twenty-one years of his life that
followed. Indeed, the paucity of statements by Hitler on Zionism and
Palestine during the 1930s has posed a serious research problem for
this kind of study.[52] His first major speech alluding to an interna-
tional Jewish conspiracy, delivered in Munich on May 31, 1920,
warned against the twin evils of international capitalism and the
international working-class movement, which Hitler considered in-
struments of the conspiracy.[53] His anti-Semitism had achieved an
international dimension, based on the conspiracy theory, that was to
be evident in all of his actions on the Jewish question up to and in-
cluding his political testament of April 29, 1945.[54] Rosenberg's initial
ideological influence on Hitler was to stay with him to the end.

On August 13, 1920, Hitler delivered his first comprehensive
speech on the Jewish question at an NSDAP meeting at the Hofbräu-
haus in Munich.[55] Entitled "Warum wir gegen die Juden sind" (Why
We Are against the Jews), the speech contained Hitler's first observa-
tions on the Zionist movement as an arm of the international Jewish
conspiracy, observations that Rosenberg had already made in *Die
Spur* and then elaborated on two years later in *Der staatsfeindliche
Zionismus*. In his speech, Hitler started from the premise that con-
cepts such as love of work, racial purity, cultural creativity and the
capacity to build states (*Fähigkeit zur Staatenbildung*) were inher-
ently Aryan and thus totally alien to the Jews. He made the last con-
cept dependent on the first three.[56] He asserted that the Aryan alone
had the capability to build states because of his historic acceptance
of the concept of work, his adherence to the principles of racial
health through racial purity when dealing with the inferior "faulen
Südrassen" (lazy southern races) and his superior culture.

Hitler went on to apply his criteria for *Staatenbildung* to the
Jews and found them wanting in the necessary prerequisites for the
creation of their own territorial state. He attempted to substantiate
his arguments historically: "If a people lacks these three qualities, it
cannot ever be capable of building its own state. For the Jew was al-
ways a nomad through the centuries. . . . He never had what we
would call a state. And today the greatest of all illusions is being
spread among us, that Jerusalem will become the capital of a Jewish

state of Jewish nationality."[57] When confronting the matter of Zionism and the idea of a Jewish state in Palestine, Hitler concluded, "Thus, we can immediately understand why the whole notion of the Zionist state and its establishment is nothing more than a comedy."[58]

To reach this point in his overall assessment of Zionism and the idea of a Jewish state, Hitler synthesized concepts borrowed from Gobineau, Chamberlain, Dühring, Fritsch and Adolf Wahrmund, whose theories attributed certain characteristics to Aryans and withheld them from Jews, characteristics that, according to Hitler, were absolutely necessary for the building of territorial states.[59] Hitler's following arguments must be attributed largely to Alfred Rosenberg and the conspiracy theory based on the "Protocols of the Elders of Zion." With the assertion that the Jews were incapable of building a territorial state, and the Zionist claim that they were in fact working toward that end, the conspiracy theory provided an apparently rational basis for the ideological opposition of National Socialism to the aims of the Zionist movement. This opposition, in spite of the Zionist willingness to help remove Jews from Germany, reflected all the traditional anti-Semitic biases against the Jewish people. To admit that Zionism was merely what the Zionists claimed it was—and, as such, a suitable solution to the Jewish question—would have negated the Social Darwinist theories of anti-Semitic ideology, undermined the supposedly monolithic nature of the racial enemy and forfeited the propaganda advantages that could be derived from the alleged existence of an international Jewish conspiracy. Indeed, theories of international conspiracy have often provided totalitarian movements with a useful propaganda weapon in the pursuit and preservation of power, and the National Socialist movement was no exception.

In his August 13 speech, Hitler argued that the Zionists were not interested merely in providing a refuge for the persecuted Jews of the world. Echoing Rosenberg, he asserted that the Jews were seeking to establish an independent power base from which to promote the very conspiracy outlined in the "Protocols."[60] Moreover, he reiterated these arguments in *Mein Kampf* and later in his *Secret Book*, concluding in the former:

A part of his race even admits quite openly that it is a foreign people, however not without lying in this respect. For while Zionism tries to make the other part of the world believe that the national self-consciousness of the Jew finds satisfaction in the creation of a Palestinian state, the Jews again most slyly dupe the stupid goiim. They have no thought of building up a

Jewish state in Palestine, so that they might perhaps inhabit it, but they only want a central organization of their international world cheating, endowed with prerogatives, withdrawn from the seizure of others—a refuge for convicted rascals and a high school for future rogues.[61]

There is evidence that Hitler, like Rosenberg, found some utility in Zionism and was willing to encourage Jewish emigration from Germany to Palestine, in spite of the apparent ideological incompatibility engendered by the conspiracy theory. In a speech at the Bürgerbräukeller in Munich on July 6, 1920, Hitler called for the removal of Jews from Germany; when someone in the audience interrupted him with shouts about human rights, Hitler responded that Jews should seek their human rights in their own state in Palestine, where they belong ("Menschenrechte soll er sich da suchen, wo er hingehört, in seinem eigenen staat Palästina").[62]

Apparent inconsistencies in the National Socialist approach to Zionism during the early years of the movement are an important point of analysis in this study. From 1933 through the early years of World War II, the Hitler regime favored and actively promoted Jewish emigration from Germany to Palestine through the German Zionist movement. At the same time, it maintained an ideological hostility to the creation of an independent Jewish state in Palestine that was based on the conspiracy theory embodied in the "Protocols." The duality of the National Socialist approach was clearly established by Hitler and Rosenberg during the 1920s and conditioned the policies eventually pursued after 1933.

# 3. The Development of the Haavara Transfer Agreement

## The Economic Background

One cannot speak of a comprehensive National Socialist plan to overcome the economic crisis of the early 1930s. Upon his assumption of power in 1933, Hitler saw two basic problems, unemployment and depressed agricultural prices, that had to be dealt with in order to pull Germany out of the economic quagmire.[1] The methods used by Hitler's government in its efforts to solve the economic crisis and combat unemployment were essentially the same Keynesian methods used by other industrialized nations, namely, the injection of public funds into the economy in order to stimulate economic activity and thereby create jobs for the unemployed.[2]

This similarity did not go beyond the Keynesian principle of increased government spending and the initiation of public works projects; in Hitler's Germany, rearmament and the creation of a mass army, not an increase in the production of consumer goods and civilian jobs, were meant to be the key to recovery.[3] Hitler considered economic matters subsidiary to the political and geopolitical questions that occupied his thoughts. Economics was to be used in the pursuit of purely political ends.[4] In *Mein Kampf*, he addressed himself to the causes of the German collapse in 1918:

> . . . but that also in the circle of the intelligentsia the German collapse is looked upon primarily as an economic catastrophe, and that therefore the cure is expected to come from economy, is one of the reasons why so far recovery has been impossible. Only if one realizes that here, too, economy is only of second or even third importance, but that political, ethical-moral, as well as factors of blood and race, are of first importance, then one will strive at an understanding of the causes of the present

misfortune, and with it, one will be able to find means and ways to recovery.[5]

In his famous speech before the Düsseldorf Industrial Club on January 27, 1932, Hitler argued that the causes of the German crisis should not be attributed to the worldwide depression, but rather to the mistakes of German politics.[6] The political democracy of the Weimar system and the consequent rejection of the racial factor were cited as the chief causes for Germany's economic plight. In his presentation to the Reichswehr (Armed Forces) generals on February 3, 1933, Hitler stated in no uncertain terms his plans for future expansion in the east, through war if necessary.[7] He told the generals that the German economic crisis would never be completely solved through domestic measures and increased exports, but would require the expansion of German *Lebensraum* (living space).[8]

Nevertheless, the elimination of certain immediate economic problems was essential in Hitler's efforts to create the necessary political and military conditions for expansion in eastern Europe. Germany's foreign trade position was perhaps the single most important element in any economic policy for several reasons.[9] A relatively high proportion of Germans worked in industries primarily dependent on the export market. The volume of German foreign trade had dropped from a high of RM 26.9 billion in 1929 to a mere RM 10.4 billion in 1932 as a result of the worldwide depression and the disappearance of many of Germany's former export markets.[10] This resulted in the loss of many jobs in the export industries. A more important factor was German reliance on foreign sources of food and raw materials, especially in light of the losses of land, people and resources in the Versailles settlement. The depression severely reduced worldwide demand for German goods, which meant that the greatly reduced level of foreign currency earnings limited Germany's ability to adequately feed its people and provide its industries with the necessary raw materials.[11] Thus, to reduce unemployment, to secure the raw materials necessary for large-scale rearmament and eventual war, as well as to provide an adequate food supply for the German people until *Lebensraum* was achieved, Hitler's most important initiatives in the economic sphere between 1933 and 1936 involved the promotion of German exports around the world.

On February 23, 1933, the Deutsche Industrie- und Handelstag (German Industry and Trade Convention) pressed the German government to push exports as the best means of reducing unemployment and restoring the health of the economy.[12] One month later, in an effort to neutralize domestic and foreign fears concerning the Na-

tional Socialist affinity for autarky, Hitler stated: "the Reich government is not opposed to promoting German exports. We know that we need close ties to the rest of the world, and that the consumption of German goods throughout the world helps to feed many millions of German fellow-citizens . . . the geographical position of a raw material–poor Germany precludes a policy of Autarky."[13] Two years later, Hitler again stressed the necessity of promoting German exports as the key element in Nazi economic policy.[14] He maintained that critically needed foreign raw materials could only be secured through the promotion of ever greater amounts of German exports.

The Foreign Office under Neurath took steps in 1933 to utilize German consular missions abroad for the promotion of German exports. In a circular to German consular missions in non-European countries in July, 1933, Neurath described the very negative position of the German export trade at that point and ordered full-scale reviews and analysis of the German trade position in the respective countries, as well as concrete suggestions as to how German exports might be increased.[15] Even as late as 1937, Neurath insisted that all Foreign Service officers demonstrate a minimum level of economic expertise; he stressed that one of the prime tasks of German representatives abroad was to help secure markets for German exports.[16]

Extraordinary measures were adopted in 1934 in an effort to reduce the level of imports to essential food and raw materials and to increase exports as much as possible in order to pay for essential imports. Schacht's so-called New Plan of September, 1934, was a major step in this direction.[17] It imposed complete government management on German foreign trade and sought to improve the German balance of trade through a bilateralization of relations between Germany and its trading partners. Strict limits on imports were imposed so that the raw materials necessary for German industry, especially armaments, and the food supply took precedence over imported manufactured goods. At the same time, exports were to be directly promoted by the government through a complicated system of differentiated currency exchange rates for the Reichsmark, tax benefits and export levies in domestic industry, preferential treatment for export industries in the rationing of raw materials, and, significantly, a general shift in German foreign trade from its traditional trading partners in western Europe and North America to northern, eastern, and southeastern Europe, the Middle East and South America. These new areas would provide less competitive and more accessible markets for German manufactured goods and, at the same time, sources of food and raw materials.

The results of the Schacht plan over the ensuing years, remark-

able to the extent that both raw material imports and exports of manufactured goods did dramatically rise, proved to be totally inadequate for the goals of the German economy, as indicated by the more extreme measures of the Four-Year Plan of 1936. The New Plan of 1934 managed to shift a good deal of German trade to less industrialized, raw material–rich parts of the world between 1934 and 1938.[18] Countries in those parts of the world, which had taken 18.3% of all German exports in 1932, were receiving 40.3% in 1938, while western Europe and the United States, which had taken 44.6% of German exports in 1932, took only 30.3% in 1938. At the same time, imports from western Europe and the United States declined from 33.3% of Germany's total in 1932 to 24.5% of the total in 1938, while those from the other areas rose from 23.5% to 39.9% in the same period. The volume of German exports rose 19% between 1934 and 1936, and, although the volume of imports rose substantially as well, the rise was accounted for by increased raw material and food imports, while the import of manufactured goods declined dramatically throughout the 1930s.[19] The provisions of the Schacht plan probably would have been sufficient to ensure a healthy peacetime economy by providing the necessary means to cover Germany's raw material imports.[20] However, the German economy was not a peacetime economy, given the intensity of the rearmament program and its claims on precious supplies of raw materials. There were also dramatic price increases for raw materials around the world in 1935, coupled with an increased need for imported foodstuffs, and a general decline in the price of exported manufactured goods.[21] The result was Hitler's proclamation of a new Four-Year Plan on September 9, 1936, at the Reichsparteitag (Party Day) at Nürnberg, in which he declared:

> In four years, Germany must be completely independent of all foreign raw materials that in any way can be produced through German capability, through our chemical and machine industries, as well as through our mining resources. With this, we hope to be able to increase the national production in many areas, and indeed the internal vitality of our economy, and to reserve the income generated by our exports primarily for the procurement of foodstuffs as well as other raw materials that we still lack.[22]

## The Impact of the Anti-German Boycott

The German government considered several factors detrimental to efforts to increase the volume of exports. A report on German foreign trade was prepared for Hitler in the Reichskanzlei by Franz Willuhn in May, 1933.[23] In his report, Willuhn painted a rather bleak picture of future prospects for German exports. He observed that the unsatisfactory export situation was due to protectionist measures of other nations in efforts to create or maintain their own favorable trade balances and to the small but growing international boycott of German goods that had begun shortly after Hitler's assumption of power in early 1933. The boycott was a reaction by a combination of Jewish groups and labor unions to the anti-Marxist and anti-Jewish excesses of the new regime in Germany and was organized primarily in England and the United States. Foreign Minister von Neurath addressed himself on several occasions in 1933 to the factors that appeared to be hampering German efforts to promote exports. At a cabinet meeting in April, he alluded to Germany's precarious financial position, caused in part by the country's balance of trade problems.[24] He pointed to the continuing critical need for imports, especially costly amounts of raw materials, and to the difficulty of promoting exports in an economic situation in which all countries were trying to achieve favorable trade balances in the international exchange of goods. In June of that year, while in London for the World Economic Conference, Neurath noted in a letter to President von Hindenburg the alarmingly negative impact of anti-Jewish measures in Germany on attitudes and public opinion in England and the United States, a phenomenon that could adversely affect German foreign trade.[25] In his July 19 circular to selected consular missions abroad, already referred to above, Neurath warned of the possible consequences of the growing boycott.[26]

Anti-Jewish outbursts and measures inside Germany were beginning to cause alarm in the Economics Ministry, the Foreign Office and the Reichskanzlei because of their negative impact on the economy. It was becoming clear to Hitler and others that boycotts of Jewish businesses and attempts to close many of them down would greatly hamper efforts to consolidate the economy from within and promote exports abroad.[27] In a speech before his Gauleiter (district leaders) on July 6, 1933, Hitler declared that the national revolution had been brought to a successful conclusion and stressed the need for an undisturbed economy.[28] He seemed to recognize that the Jewish stake in the German economy was far too great to be destroyed overnight, and that any efforts to do so would be counterproductive

and would damage the economy as a whole. As long as Schacht was able to exert a strong influence on Hitler as director of the Reichsbank and later as minister of economics, the government practiced considerable restraint toward Jewish businesses and Jewish participation in the economy.[29] In spite of Göring's slow Aryanization efforts after 1936, Jewish business was for the most part allowed to function and play its part in the overall plans for economic recovery and expansion until the spring of 1938. This policy was due mainly to Schacht, who recognized the dangers that radical anti-Jewish measures would pose for German economic plans and for the rearmament program.[30]

In the eyes of Schacht, the Reichsbank, the Economics Ministry and the Foreign Office, public opinion and government attitudes toward Germany abroad, in the light of Hitler's anti-Jewish measures, were critical. The goals of the Ministry of Economics and the Foreign Office, coupled with the mythology of National Socialist anti-Semitism, caused the worldwide boycott of German goods to be viewed with considerable alarm. As mentioned above, the boycott was initiated by Jewish as well as non-Jewish organizations, including churches, trade unions, and business competitors in Britain and the United States, as retaliation against the policies of the new regime in Germany. It was hoped that sufficient pressure to restore Jewish rights might be exerted on Germany by boycotting German goods and thus reducing the volume of German exports.[31] The boycott generated fears in Berlin about possible setbacks in government efforts to increase the volume of German exports;[32] these fears were probably magnified in Party circles by the myth of an international Jewish conspiracy. With Nazi illusions about Jewish control and influence in England, America and elsewhere in the democratic west, Berlin considered the boycott a potent weapon against Germany.

One cannot accurately assess the impact of the boycott on German foreign trade. No statistics were kept, and the boycott itself appears to have been a hit-or-miss effort, very difficult to coordinate in the various countries of eastern and western Europe, North and South America, the Middle East and elsewhere. By January, 1934, the organizers and supporters of the boycott believed that it was not having the desired effect. At a meeting of the World Boycott Committee in Brussels in January, 1934, a listing of the problems and weaknesses of the movement included a lack of funds for promotion, public affinity for and trust in the quality of German goods, the difficulty in getting substantial non-Jewish backing, problems in obtaining the support of the business communities in the various countries and a host of other minor obstacles.[33] Without the effective support of

their respective governments in the form of tariffs and other barriers against German goods, the boycott leaders could not hope to achieve their aim of eroding German export markets and seriously disrupting the German economy. As a result, the boycott accomplished little beyond calling attention to events in Germany.[34]

For purposes of this chapter, the significance of the boycott lies not in the actual effect it might have had on the level of German exports over the years, but rather in the real or imagined dangers it posed for German economic policy as perceived by government and Party leaders in Berlin. On March 25, 1933, Hermann Göring summoned leaders from the various Jewish organizations to a meeting at the Prussian Interior Ministry. He pressed them to use their influence with fellow-Jews in England and America in order to dispel allegations that Jews were being mistreated in Germany and to try to bring an end to anti-German propaganda and the anti-German boycott movement. He also made threats against the safety of Jews in Germany if they should fail.[35] Since the Zionists were the only German Jews with connections abroad, Martin Rosenblüth and Richard Lichtheim of the Zionistische Vereinigung für Deutschland (Zionist Association for Germany, ZVfD), along with Ludwig Tietz of the Centralverein, were sent to London with instructions from ZVfD and Göring to argue against the anti-German propaganda and boycott campaigns.[36] In a telegram dated July 12, 1933, to Lord Melchett, chairman of the English Committee for the Boycott of German Goods, the Reichsvertretung der Juden, the umbrella organization set up shortly after Hitler's assumption of power to unite all Jewish groups, protested: "We emphatically reject renewed boycott efforts that, according to press reports, are planned for forthcoming economic congress. We demand that—if congress cannot be canceled— all proposals and resolutions damaging to Germany be dropped."[37] Fear of harsher anti-Jewish measures in Germany naturally prompted all German Jewish organizations to oppose anti-German propaganda and boycotts abroad; this fear can best be understood in terms of the importance attached by top officials in the Party and government to ending the anti-German campaigns abroad.

Further efforts were made by the government in 1933 to counter the boycott. On March 30, a meeting was held at the Foreign Office in Berlin, also attended by representatives from the Transport Ministry, the Ministry of Economics, the Ministry of the Interior and the Propaganda Ministry, in order to devise ways of dealing with the boycott movement.[38] Reports from German consular missions from around the world on boycott measures in their respective countries were discussed, and it appears that the boycott movement was of

rather limited scope at that time. Alarm was expressed over the fact that some non-Jewish businesses were involved in the boycott for purely competitive reasons. The participants realized that official protests or overtures to foreign governments were out of the question unless it could be established that those governments were supporting or publicly sympathizing with the boycott. They concluded that anti-boycott propaganda measures overseas would have to be continued and intensified. However, by the middle of May, the German propaganda effort to counter the boycott apparently was not having the desired effect. According to Referat Deutschland, the Foreign Office department responsible for Jewish affairs, the Foreign Office was unable to secure effective cooperation from the Propaganda Ministry in providing propaganda materials to German diplomatic missions around the world.[39] The Foreign Office was flooded with letters from German firms with branches abroad, expressing alarm over the intensity of anti-German feeling and propaganda over alleged atrocities against Jews in Germany. Moreover, they expressed fears that such propaganda would eventually influence foreign businesses to take part in the boycott movement.[40] Referat Deutschland called for a more concerted effort to neutralize the effects of anti-German propaganda and the boycott abroad,[41] including campaigns in the foreign press, the distribution of propaganda material, articles, statistical reports, and so forth—all in an effort to deny that Jews were being persecuted in Germany. German consular missions would be encouraged to cultivate ties and friendly relations with foreign firms in an effort to influence public opinion abroad in Germany's favor. Finally, it demanded greater coordination and cooperation between the Foreign Office and the Propaganda Ministry in these efforts.

Foreign Minister von Neurath also attempted to enlist the support of the U.S. government to assist in efforts to end anti-German propaganda and the boycott. In talks with U.S. Ambassador Dodd on March 31, Neurath requested that the U.S. government make a public declaration opposing the propaganda and boycott campaign against Germany and hinted that the planned boycott of Jewish businesses in Germany the following day might be stopped as a result.[42]

### Consul-General Wolff and the Role of Palestine

In view of the necessity to increase exports, the German government took the international movement to boycott German goods seriously in 1933, although its eventual impact on the overall volume of German foreign trade was limited. Fears of a reduced level of German exports on international markets, coupled with a more specific con-

cern regarding markets in the Middle East, influenced the German government in its decision to sign the Haavara transfer agreement with Zionist representatives in the summer of 1933.[43]

The Middle East began to occupy a more important place in German foreign trade during the early 1930s.[44] Schacht's efforts to shift much of Germany's foreign trade away from the industrialized nations of western Europe and North America to the less industrialized parts of Europe, the Middle East and South America have been mentioned. The latter, in need of German industrial exports and short of foreign exchange, would be in a position to pay for those goods with raw materials, thus helping to conserve Germany's meager monetary reserves. The German export drive in the Middle East was especially directed toward Iraq, Iran and Egypt, because of both their relatively large populations and their relative independence from Britain and France. From 1933 to 1936, German exports to Iraq doubled.[45] Sharp increases in exports to Egypt were also recorded during the first years of Nazi rule.[46] At the same time, imports from those countries decreased, as the Middle East as a whole was not a prime source of raw materials. Germany under Hitler never demonstrated an interest in Middle East oil, the one major raw material there, preferring instead closer sources in the Soviet Union and Rumania, as well as greater exploitation of the limited domestic supply and heavy investment in the synthetic fuel industry.[47] An indication of this was Hitler's rejection of a proposal to Germany from King Ibn-Saud of Saudi Arabia in 1933 for greater German participation in the search for and exploitation of Saudi oil, in return for large quantities of oil.[48] Hitler reasoned that, in the event of war, Germany would never be able to defend its oil concessions there or elsewhere in the Middle East in the face of British supremacy and that Germany couldn't come up with the necessary capital to invest heavily in new oil concessions.[49] Such problems would not have arisen with Rumania and the USSR.

Palestine's role in German export policy in the Middle East was determined primarily by its position as the Jewish National Home and the rapid development of the country by Zionists. After 1933, the Zionist movement became a vehicle through which German exports were promoted, just as it had been an instrument to the same end during the Weimar years. In short, the National Socialist goal of pushing Jews out of Germany could be utilized to promote another goal, namely, to increase German exports to Palestine and the rest of the Middle East.

After reaching its lowest ebb in 1928, Jewish immigration into Palestine began picking up again in 1929 and, with the economic cri-

sis in Europe and elsewhere, increased slightly between 1930 and 1933.[50] Palestine was hardly affected by the worldwide depression because of a steady stream of Jewish immigrants and increasing amounts of Jewish capital flowing into the country.[51] The ambitious building and development schemes, the resulting job opportunities and the incoming capital to pay for it all made Palestine a boom country. The Berlin publication *Industrie und Handel* carried a report compiled by German economic circles in Haifa, which was also published in the *Vossische Zeitung* and the *Jüdische Rundschau* in 1933.[52] The report noted that Palestine was in a state of intensive development and was considered an island in the ocean of the world economic depression. It was also noted that Palestine was an important customer for machines, pipe, automobiles, pumps and building materials, thanks to an uninterrupted flow of Jewish capital into the country, and that Germany, traditionally one of the leading sources of imports for Palestine, must make every effort to maintain and improve its trade position in Palestine.

Just as in Europe and North America, anti-German boycotts were sporadically organized in Palestine and in other countries in the Middle East. On March 28, Consul-General Heinrich Wolff in Jerusalem sent a warning to the Foreign Office in Berlin that the momentum for a boycott of German goods in Palestine was growing.[53] Several German firms with business connections in Palestine expressed their alarm over the growing boycott sentiment there.[54] Leaflets were distributed by action groups in Palestine urging people to boycott German goods, films, and so forth.[55]

Boycott sentiment was by no means unanimous among the Jewish population in Palestine, perhaps even less so than in other countries. The minority Revisionist Zionists were the most ardent proponents of the boycott movement, while most of the newly arrived immigrants from Germany, hopeful of maintaining some ties and of transferring at least some of their assets to Palestine, were opposed.[56] Most political and business leaders in Palestine, unlike those in Jewish communities elsewhere, were convinced that cooperation and negotiation rather than confrontation with the Nazi leadership in Berlin would be the best way to get Jews and some of their property safely out of Germany and thus salvage something from an otherwise hopeless situation. Aside from the Revisionists and some Majority Zionists, mostly in the United States, there was generally a split between Zionists and non-Zionists in Europe and America on the issue of boycotting German goods. With some exceptions on both sides, non-Zionists tended to be pro-boycott, hoping their pressure would help to restore Jewish rights in Germany, while the Ma-

jority Zionists were inclined to accept the ugly reality of the situation in Germany and to work to obtain the most favorable conditions possible for an orderly emigration of Jews. Many of them would come to Palestine and, with whatever assets they might bring, help to build up the National Home. This could only be accomplished with the cooperation of the regime in Berlin. Sam Cohen of Hanotaiah Ltd. of Tel Aviv, a private citrus growing company, had negotiated an agreement with the Ministry of Economics in Berlin in March, 1933. It provided for the transfer to Palestine of RM 1 million belonging to German Jews in the form of equipment for citrus groves, to be purchased in Germany and sold on the Palestine market.[57] For Zionists in Palestine, the Jews from Germany, along with their assets in the form of goods to be transferred from Germany to Palestine, represented a stimulus for the development of the country. This was recognized at the Eighteenth World Zionist Congress in Prague in August–September, 1933, where resolutions supporting the worldwide boycott of Germany were rejected in favor of the transfer approach.[58]

Besides the Zionist leadership in Palestine, an ardent supporter of the transfer approach was Heinrich Wolff, the German consul-general in Jerusalem from November, 1932, until September, 1935. He worked to make the emigration of Jews from Germany to Palestine as smooth as possible through a transfer agreement and tried to expand it to cover other countries in the Middle East. He was a firm believer in the Zionist cause and indulged in the dream of an eventual reconciliation between a Jewish state in Palestine and National Socialist Germany. His views were precisely those of the leadership of Weimar Germany, and he envisioned the kind of political, economic and cultural cooperation between Germany and a Jewish Palestine that had been pursued during the 1920s.[59] It is doubtful that he fully understood the new leadership in Germany or the nature of the anti-Semitism that motivated it. Although Wolff remained a firm opponent of the anti-Semitic policies of the National Socialist regime, he did try to reconcile the irreconcilable by giving in to Foreign Office pressures to apply for membership in the NSDAP. He was rejected and dismissed from active service in September, 1935, because his wife was Jewish.[60]

Late in April, 1933, Wolff began his tireless efforts to achieve an arrangement suitable both to the Zionists and to the Nazi regime, one that would ensure an orderly and peaceful exodus of Jews from Germany and simultaneously torpedo the worldwide boycott movement against German goods. On April 24, Wolff again warned Berlin about boycott tendencies in Palestine, as well as the more serious

boycott efforts in Britain and the United States.[61] He cautioned against German countermeasures against Jews in Germany, such as the brief anti-Jewish boycott of April 1, and warned that such actions would push Germany into a damaging economic confrontation with the governments of the west, particularly Great Britain and the United States. He went on to advise Berlin to conduct its own propaganda initiative to demonstrate to the world that the Jewish question in Germany would be handled in a positive, constructive manner.

Wolff believed that policies that were not hostile to Jews would better serve the goals of encouraging Jews to leave Germany and safeguarding German foreign trade. Again in late April, he sent a lengthy report to Berlin with a general outline of his ideas on how Germany might achieve its aims through an accommodation with the Zionist movement.[62] It appears that Wolff had already developed a working relationship with Sam Cohen and Hanotaiah Ltd. Wolff and Cohen were working on plans to expand the limited transfer scheme of March into a more comprehensive plan through which a large number of German Jews could emigrate from Germany to Palestine under conditions favorable to the German government and the German economy. In his report of April 25, Wolff reasoned that Germany had a definite interest in any plan that would not only promote the export of German goods to Palestine and the Middle East, but would, at the same time, facilitate the emigration of Jews from Germany to Palestine in a way that would enable them to start a new life there. After summarizing the activities of Hanotaiah Ltd. in the importation of goods from abroad, as well as in various development schemes, particularly in agriculture, Wolff reported that Hanotaiah was willing to import more and more of its needs from Germany so that it could be of assistance in the transfer of Jews and Jewish assets to Palestine. Wolff's plan meant that the goods exported to Palestine would be paid for with Jewish assets, or Reichsmark, in Germany, and not with the foreign currency that Germany desperately needed. On the other hand, it partially solved the problem of pushing Jews out of the country in a way that avoided the flight of huge amounts of capital that would normally accompany such an emigration process, a situation that would have been harmful to Germany's anemic, capital-short economy.

Like most officials in Berlin, Wolff was fearful of the possible consequences of a worldwide anti-German boycott. He believed that through a more accommodating policy toward the Jews and the Zionist movement in Germany, the German government might neutralize the effects of the boycott and, at the same time, promote German exports in the Middle East and create favorable conditions for

Jewish emigration from Germany. Wolff felt that Palestine was in a unique position to offer Berlin the means through which it could achieve these ends and was particularly assertive in his view that Palestine was the weapon with which Germany could wreck the boycott movement.[63]

## The German Government and the Haavara Transfer Agreement of 1933

The initial idea for a transfer agreement between Germany and Zionist authorities in Palestine predates Hitler's assumption of power and the initiation of anti-Jewish measures in Germany. In 1931, the Brüning government imposed a ban on the removal of capital from Germany because of the world economic crisis. In 1932, Cohen of Hanotaiah Ltd. initiated negotiations with the German government in an effort to enable some German Jews who wished to emigrate to Palestine to transfer at least some of their assets from Germany.[64] Hanotaiah's aim in 1932 was to plant orange groves in Palestine for a few German Jews and to purchase the necessary machinery and other requirements in Germany with blocked Jewish funds. Negotiations continued after Hitler came to power, in the belief that the export of goods from Germany would benefit German Jews if it enabled them to carry out their intention of settling in Palestine. Hanotaiah also believed the development of the Jewish National Home would be greatly enhanced by providing Jews in Germany with the opportunity to invest their capital in Palestine. Cohen's efforts resulted in the above-mentioned limited agreement signed with the Ministry of Economics in March, 1933.

While Zionist interest in an arrangement with Germany was originally inspired by Germany's adverse economic conditions, the initiation of anti-Jewish measures in 1933 necessitated a more ambitious scheme to begin the rescue of German Jews from their uncertain fate. As mentioned above, many Zionist officials in Palestine and Germany approached the Jewish problem in Germany in terms of stabilizing an already disadvantageous Jewish position. They hoped to secure an orderly emigration to Palestine, while mainly non-Zionists, for the most part outside of Germany, pursued the futile hope of restoring Jewish rights in Germany through the pressures of the boycott movement. Most Zionists worked from the premise that the Jewish position in Germany was irrevocably lost and that emigration to Palestine was their only option. The situation in Germany was also viewed as a positive stimulus to Zionist efforts in Palestine, a chance to interest the traditionally liberal/assimila-

tionist Jewish community in Germany in the Zionist cause, as Kurt
Blumenfeld, chairman of the ZVfD, noted in April, 1933: "Neverthe-
less there exists today a unique opportunity to win over the Jews of
Germany for the Zionist idea. We have the obligation today to act in
an informative and persuasive manner."[65] Consul-General Wolff re-
ported on the practical attitude taken by many Jews in Palestine re-
garding the National Socialist phenomenon, noting: "Even here they
have recognized . . . very quickly the opportunities for Zionism and
the development of Palestine that have emerged from the misfortune
of the Jews in Germany."[66]

Zionist policy in Germany was summarized in a memorandum
sent to Hitler by the ZVfD on June 22, 1933.[67] The memorandum
dismissed the emancipation of Jews in the nineteenth century as the
cause of the Jewish problem in Germany. Moreover, it seemed to pro-
fess a degree of sympathy for the *völkisch* principles of the Hitler
regime and argued that Zionism was compatible with those prin-
ciples in the following way:

> Zionism believes that the rebirth of the national life of a
> people, which is now occurring in Germany through the em-
> phasis on its Christian and national character, must also come
> about among the Jewish people. For the Jewish people, too, na-
> tional origin, religion, common destiny and a sense of its
> uniqueness must be of decisive importance to its existence.
> This demands the elimination of the egotistical individualism
> of the liberal era, and its replacement with a sense of commu-
> nity and collective responsibility.

The memorandum further outlined plans to create a Jewish home-
land in Palestine through the immigration of Jews from Germany
and eastern Europe and concluded by condemning all anti-German
propaganda and boycott measures around the world. It also suggested
that the interests of the new Germany and of the Zionist movement
were not incompatible and that active cooperation would be mutu-
ally advantageous. Of course, this is not to say that the Zionists
accepted the new conditions under which Jews in Germany were
forced to live. Zionist strategy was certainly meant to placate the
Nazi leadership in order to obtain the cooperation of the government
and to protect those Jews still in Germany.[68] On the other hand, it
had always been a Zionist goal to neutralize the traditional assimi-
lationist tendencies of German Jews, to instill a new sense of Jewish
identity and community in them and to involve them in Zionist
efforts to create a Jewish National Home in Palestine.

In the first month or so of its existence, the Nazi-dominated coalition government pursued a relatively cautious policy toward the Jewish population.[69] Concentrated efforts against political opponents were the order of the day, while the Jews were for the most part ignored. By March, however, increased physical violence was carried out by the SA against Jews all over Germany, followed by the brief anti-Jewish boycott of April 1 and a spate of anti-Jewish legislation. The measures taken by the regime to eliminate Jews from the professional and cultural life of Germany, as well as from certain economic activities, resulted in the loss of livelihood for thousands of Jews and consequently in a dramatic rise in Jewish emigration. Originally, it was a confused escape to the frontiers of the Reich, a spontaneous refugee movement that could not accurately be described as emigration.[70] The uncontrolled violence and legislative measures against the Jews threatened to have a negative impact on the weak German economy, on government efforts to achieve full economic recovery and on Germany's political and economic relations with the outside world. There was also a realization that the Jews of Germany could not simply be terrorized into leaving the country. The process of emigration was complicated and required organization and orderly procedures in order to ensure that Jews were pushed out of the country in a manner most beneficial to the political and economic interests of the new Germany.

Plans to promote Jewish emigration from Germany, regardless of how elaborate, could not escape the realities that made emigration especially difficult during the 1930s.[71] The depression and the resulting high levels of unemployment made receiver countries reluctant or unwilling to open their doors to an influx of immigrants and encouraged them to maintain strict quotas. Another barrier was the occupational and class background of the majority of German Jews. They were mostly middle-class business and professional people whose skills were not needed in most receiver countries. The anti-Semitic policies pursued by eastern European governments further increased the number of Jewish refugees looking for homes, causing quotas in receiver countries to fill up quickly. The deep attachment of most German Jews to Germany and their reluctance to leave their homeland made it more difficult for the regime to achieve its goal of a *judenrein* (free of Jews) Germany. Until the late 1930s, hope persisted among Jews in Germany that the Nazi regime would pass and that the Jewish position and Jewish rights would be restored. Perhaps the most immediate obstacle to an orderly and rapid emigration was Germany's economic position in the 1930s. In order to be accepted by a new country, immigrants had to have a limited amount of capi-

tal to meet entry requirements so as not to become wards of the state in their new homes. However, the restrictions on the removal of capital from Germany after 1931 made it extremely difficult for most Jews to meet the immigration requirements of many receiver countries, unless they already possessed assets abroad.[72]

Palestine offered a unique opportunity to avoid some of these barriers during the first five years of Nazi rule. So long as immigrants and capital flowed into the country, economic activity and employment remained high. Moreover, while the British administration did impose immigration restrictions and quotas in 1931 as a result of the violence and unrest of 1929–1930, Palestine remained almost exclusively an immigration goal of Jews. Unlike the situation in other receiver countries, particularly in North America, Jews did not have to compete in Palestine with other immigrant groups before quotas were filled. Finally, Zionist development plans and the relatively steady economic expansion in Palestine created a demand for imported manufactured goods that did not exist in Europe and North America. Therefore, Palestine could accept immigrants with their assets in the form of German exports, while most of the actual capital of the immigrants would remain in Germany.

Pressure for a major transfer agreement was applied by both Hanotaiah Ltd. and Consul-General Wolff in Jerusalem in May and June, 1933. Wolff sent a barrage of letters and reports to Berlin, reemphasizing the dangers of the Jewish boycott against Germany and the potential advantages for German exports in Palestine.[73] In a personal letter to Kurt Prüfer of the Orient-Abteilung in the Foreign Office, Wolff appealed for Foreign Office support for Sam Cohen's efforts to negotiate a comprehensive transfer agreement with the Ministry of Economics, arguing that this was the only way to act effectively against the boycott movement.[74] In a note to the Economics Ministry three days earlier, the Foreign Office had indicated its agreement with Wolff's views.[75] The Ministry of Economics, already involved in negotiations with Cohen and Hanotaiah, was urged to accept Wolff's arguments.

The Foreign Office and the Ministry of Economics, with its subdivision the Reichsstelle für Devisenbewirtschaftung (Office of Foreign Currency Control), along with the Reichsbank were the agencies involved in the promotion and realization of the agreement that eventually emerged. While matters of economic and monetary policy were subject to the decision of the latter two, the Foreign Office concerned itself with the repercussions of the settlement of numerous German Jews in Palestine on German foreign policy, commercial policy and foreign trade in Palestine and the Middle East and the

boycott movement against German goods, especially in the Anglo-Saxon countries. The Foreign Office accepted the significance of Palestine in the promotion of Jewish emigration and believed that effective emigration procedures were in the German interest and that an agreement with Zionist authorities in Palestine would have a favorable impact on German exports to the Middle East.[76] Foreign Minister von Neurath remained a firm supporter of the transfer idea throughout his term of office.[77] The role of the Foreign Office in Berlin, especially that of Consul-General Wolff in Jerusalem, in working toward a more comprehensive transfer agreement with Cohen cannot be overestimated. Their influence on the Ministry of Economics was conceded by Dr. Hans Hartenstein of the Reichsstelle für Devisenbewirtschaftung in the Ministry of Economics in a note to the Foreign Office on July 22.[78]

The Ministry of Economics under Alfred Hugenberg and the Reichsbank under Hjalmar Schacht were also quite receptive to the ideas of Cohen and Consul-General Wolff and added their support in the pursuit of an agreement.[79] The negotiations began in Berlin sometime in May, 1933, and were conducted by Sam Cohen of Hanotaiah Ltd. and Dr. Hans Hartenstein of the Office of Foreign Currency Control. It appears that the foundations of an agreement were established by the middle of May, as confirmed in a note from the Economics Ministry to Hanotaiah Ltd. in Tel Aviv dated May 19.[80] Negotiations continued under Hugenberg's successor, Dr. Schmitt, and culminated in a preliminary agreement in July. This agreement was outlined in another letter from the Economics Ministry to Hanotaiah on July 18:

> Jewish emigrants who desire to build a new life in Palestine through the transfer of a portion of their assets over and above the letter of credit required by immigration authorities—1,000 £pal—will receive from the Foreign Currency Control Office upon application permission to deposit an appropriate surplus in a special account that the Reichsbank will set up for the Anglo-Palestine Bank and the Temple Society Bank. German citizens of Jewish origin who cannot yet emigrate, but who wish to prepare for a new life in Palestine and to participate in the development of Palestine, may receive the same permission. The amounts deposited here for their benefit will be credited to them by you according to normal business principles, and will be made available to the emigrants. You may have at your disposal the amounts in the special accounts in order to pay for future exports of German manufactured goods to Pales-

tine as invoices and bills of lading from German firms are pro-
vided. . . . I have taken note that you will set up an office with
the Zionist Organization for Germany, Berlin, Meineckestr. 10,
which will be responsible for regulating the deposits here.[81]

While this agreement provided only for the transfer of a total of RM
3 million, the option was left open for future extension.

An analysis of this agreement is not necessary here, because it
was superseded less than a month later by a new accord, in which
little was changed. The Zionist leadership in Germany and Zionist
agencies in Palestine had taken an interest in Cohen's operations and
negotiations with the German Ministry of Economics. They were
concerned that a private company, Hanotaiah Ltd., should be the in-
strument through which Jewish property would be transferred from
Germany to Palestine, ensuring a monopoly for Hanotaiah.[82] At a
meeting in Berlin on August 7, attended by representatives of the
Ministry of Economics, Sam Cohen of Hanotaiah Ltd., Mr. Hoofien
of the Anglo-Palestine Bank of Tel Aviv, Dr. Arthur Ruppin of the
Jewish Agency for Palestine and representatives of the Zionistische
Vereinigung für Deutschland, it was agreed that a public trust com-
pany would be created in Palestine under Hoofien, which would take
over from Hanotaiah Ltd. the sale of German goods and the capital
disbursements to the immigrants upon arrival in Palestine.[83] The
Economics Ministry favored this approach as an even more effective
way of neutralizing the anti-German boycott and, at the same time,
compensating Jews emigrating to Palestine without loss to the Ger-
man economy.[84] The Anglo-Palestine Bank of Tel Aviv was recog-
nized as the competent authority in all matters affecting the transfer
of Jewish assets to Palestine, and, along with Hanotaiah and other
institutions in Palestine, it established a special trust company
known as the Haavara Trust and Transfer Company Ltd.

The final details of the transfer agreement between the Ministry
of Economics and the Zionist representatives of Germany and Pales-
tine were outlined in letters from the Ministry of Economics to
Hoofien of the Anglo-Palestine Bank on August 10, from Hoofien to
the Ministry of Economics on August 22 and in a final note from the
Economics Ministry to Hoofien on August 25.[85] On August 28, the
Ministry of Economics issued a circular to all currency control of-
fices in Germany, informing them of the recently concluded agree-
ment with Zionist authorities.[86] The circular explained Germany's
motives for concluding the agreement: "In order to promote the emi-
gration of German Jews to Palestine through the allocation of the
necessary amounts without excessive strain on the currency hold-

ings of the Reichsbank, and at the same time to increase German exports to Palestine, an agreement based on the following principles has been concluded with the responsible Jewish agencies." The circular goes on to describe in detail the provisions of the agreement and the way in which they were to be implemented. Two clearinghouses were set up, one in Germany known as the Palästina-Treuhandstelle zur Beratung deutscher Juden GmbH (Palestine Advisory Trust for German Jews, Ltd.) and one in Palestine known as the Trust and Transfer Office Haavara Ltd. With the cooperation of two Jewish banking houses, M. M. Warburg and Co. of Hamburg and A. E. Wassermann of Berlin, the former was responsible for collecting the assets of Jewish emigrants before they left Germany. The latter had the task of providing the immigrants upon their arrival in Palestine with a portion of their blocked capital in the form of Palestinian currency, imported goods from Germany or property somewhere in Palestine. Blocked Jewish assets, up to a value of RM 50,000, were deposited in a special Haavara account at the Reichsbank in Germany. Importers in Palestine who wished to purchase goods in Germany simply deposited the cost of those goods in £pal with the Anglo-Palestine Bank, the banking section of Haavara Ltd. in Palestine. Provisions were made for partial payment in £pal so that Germany would earn some foreign currency on the goods exported through Haavara. The goods were paid for in Reichsmark from the blocked Jewish assets in the special account, or Sonderkonto-I, at the Reichsbank and in Palestinian currency. The emigrants in turn received partial compensation for their blocked assets from Haavara Ltd. when they arrived in Palestine. This compensation came from the remainder of the initial purchase funds originally deposited by Palestinian importers who received German goods for their initial deposits.

Jewish immigrants were never completely reimbursed for their blocked assets in Germany when they arrived in Palestine. This would have required the purchase by Palestinian importers of a much higher volume of German goods than was in fact required by the relatively small Palestinian economy in order to permit the transfer of a larger portion of Jewish assets. The original agreement permitted the transfer of only RM 3 million worth of German goods, although it was periodically renewed when the limit was reached. The Ministry of Economics was mindful of the fact that, while German exports to Palestine were being increased as a result of the agreement, these exports were earning only about half of their value in the foreign currency Germany needed to help pay for imported raw materials. Upon arrival in Palestine, Jewish immigrants from

Germany received at least the £pal 1,000 (RM 12,500) required by British authorities for the so-called capitalist class of immigrants who were not subject to quotas, and, in most cases, amounts above the initial £pal 1,000 up to a maximum amount of £pal 2,000 (RM 25,000). The amount they received over and above the initial £pal 1,000 depended on the amount of German goods ordered through Haavara.[87] By September, 1939, some 50,000 Jews had migrated from Germany to Palestine, and more than RM 100 million in Jewish assets had been transferred to Palestine in the form of German goods.[88]

On the German side, the advantages of the arrangement had been outlined by the Ministry of Economics in its August 28 circular. The emigration of Jews was to be promoted without a corresponding flight of capital. German exports would increase and, although they did not earn their full value in sorely needed foreign currency, jobs would be created in Germany's export industries. At the same time, it was believed that a wedge had been driven into the international anti-German boycott. In commenting on the final agreement after its conclusion, the Foreign Office again stressed its hope that the boycott movement against Germany would be neutralized by the success of the Haavara transfer agreement.[89] There were also advantages to be reaped by both sides when the Haavara agreement was eventually expanded into neighboring Egypt, Syria and Iraq in 1934 and 1935. Both Jewish and Arab importers in those countries were encouraged by Haavara officials to purchase German goods through the Haavara at lower, subsidized prices, and the Haavara enjoyed the support of the Foreign Office in Berlin and German consular officials in those countries.[90] Berlin viewed the attempts by Haavara officials to extend their operations into neighboring countries as an excellent means of stimulating German exports to the Middle East, while Haavara officials reasoned that more German exports to the Middle East through Haavara in Palestine would mean the release of more blocked Jewish assets in Germany for transfer to Palestine.[91]

The Haavara agreement began functioning in November, 1933, and continued to be used as a vehicle for the emigration of German Jews to Palestine and the transfer of a portion of their assets until December, 1939. Its utilization diminished in 1938 and 1939 as a result of Palestine's decline as a desirable destination for Jewish emigrants. This was due to the violence of the Arab revolt of 1936–1939 and the resulting immigration restrictions imposed by British authorities, as well as to the repercussions of the strategic and ideological debate in Germany in 1937 and 1938 over the recommendations of the Peel Commission in July, 1937, for an independent Jewish

state in Palestine and to the new forced emigration policies of the SS in 1938 and 1939.[92] Those policies included the speedy confiscation of all Jewish property and the immediate expulsion of German Jews regardless of immigration opportunities abroad, making the slow but relatively orderly procedures of Haavara seem like a waste of time. These matters are considered below.

As a result of Haavara, German exports to Palestine increased considerably. Germany rose from fourth position in 1933 among countries exporting to Palestine to second position behind Great Britain in June, 1936; by June, 1937, Germany moved into first position, accounting for 16.1% of all imports into Palestine.[93] Still, Palestine remained a relatively small and insignificant market in Germany's overall foreign trade. The Haavara agreement did drive a wedge into the worldwide anti-German boycott by neutralizing boycott tendencies among Zionists. At the same time, it promoted the relatively orderly emigration of Jews from Germany in a manner that conformed to the economic necessities and realities of Germany in the 1930s. For a time it seemed to conform to National Socialist ideology and the aim of removing the Jewish population of Germany; but the Haavara system became a major factor in the debate in 1937 and 1938 over the possible creation of an independent Jewish state in Palestine and the role of Haavara in contributing to that possibility, a question considered below. Haavara represents a first step in an uneven six-year process whereby the Zionist movement and Palestine were used in varying degrees by the Hitler regime in its efforts to solve the so-called Jewish question in Germany through emigration.

# 4. The Zionist Connection, 1933–1937

## The Position of the German Foreign Office

The Haavara transfer agreement of August, 1933, placed Palestine in a unique position in the emigration policies of the German government. It meant that emigration to Palestine would be given preference over other destinations, particularly those on the European continent.[1] Many German Jews naturally preferred neighboring countries such as France, Holland, Switzerland and Czechoslovakia. They generally preferred European destinations over Palestine or South America in order to be close to Germany, to the property, businesses, family and friends left behind.[2] Many felt that the Hitler phenomenon would pass and that they would be able to return home. The German government was not at all happy with the prospect of German Jews joining the ranks of Jewish communities in neighboring countries that were involved in the international anti-German boycott and propaganda campaigns. Moreover, emigration to Palestine meant the utilization of the terms of the Haavara agreement, which meant the sale of German goods overseas, while the assets of those Jews waiting out the storm in neighboring countries were simply blocked in Germany, not being used for anything.

Even before the conclusion of the Haavara agreement, the Foreign Office in Berlin indicated its support for the emigration of German Jews to Palestine. In a note to the Prussian Interior Ministry early in April, 1933, the Foreign Office proposed granting multiple exit and reentry visas to German Zionist leaders so that their ties with and influence on foreign Zionists might be strengthened.[3] Haavara was to make Palestine a preferred destination of Jewish emigration in German Jewish policy prior to 1937. Referat Deutschland, the Foreign Office section responsible for Jewish affairs, noted in a report in September, 1933, that Palestine was and would remain the most

important and decisive destination of Jewish emigration from Germany.[4] In March, 1937, Wilhelm Döhle, Wolff's successor as consul-general in Jerusalem, indicated the importance the Foreign Office placed on Palestine as the preferred destination for Jewish emigrants between 1933 and 1937. He reviewed Palestine policy up to that point during the debate over Palestine policy in Germany in 1937. Not nearly as sympathetic to the Zionist option as Wolff had been, he described that policy during that period in the following manner: "All of our measures were based on the premise of promoting Jewish emigration from Germany, and the settlement of emigrating Jews in Palestine."[5]

The German delegation at the League of Nations continued to follow the same friendly attitude toward the British Mandate and Zionist efforts in Palestine until Germany withdrew from the League in October, 1933. Dr. Julius Ruppel, the German member of the Mandates Commission, was impressed with Zionist work in Palestine, and his reports to Berlin in the spring of 1933 may have been a contributing factor to the Foreign Office approach to Haavara.[6] During the League debate on Palestine in early October, 1933, German representative von Keller told the assembly that his government was making every effort to ensure the smooth emigration of Jews from Germany to Palestine.[7]

At least until early 1937, all agencies in the German Foreign Office in any way responsible for Palestine and the Middle East supported Zionist emigration from Germany to Palestine. Besides the support of Neurath and Bülow mentioned above, the three successive heads of the Orient-Abteilung, Schmidt-Rolke (1933–1934), Pilger (1934–1937) and Hentig (1937–1940), were in varying degrees favorably disposed toward Zionist activities.[8] Pilger, while not a particularly avid supporter of Zionism, was nevertheless cooperative and lent his full support to Foreign Office policies.[9] In the summer of 1934, Pilger joined in the efforts of Consul-General Wolff in Jerusalem to secure a loan of £pal 100,000 from the Wassermann and Warburg banks in Germany for the Jewish settlement of Nathanya in Palestine.[10] The money was to be used to purchase materials and machines from German firms for streets, houses and factories and was negotiated outside of the Haavara agreement. Dr. Werner-Otto von Hentig was a very reliable supporter of the Zionist option after 1937, and his position is considered below. The support of Consul-General Wolff for Zionism involved much more than the attempts of others, Germans and Jews, who hoped to make the best of a permanent rift between National Socialist Germany and world Jewry; Wolff had

hopes of reconciling the two and viewed the Zionist movement as the key to such a reconciliation. In 1934, he tried to secure a high-level Foreign Office visit to Palestine in order to establish a working relationship with the Jewish National Home.[11]

The Orient-Abteilung of the Foreign Office concerned itself with the political and economic aspects of the Palestine question in German foreign policy. It dealt with the anti-German boycott, the promotion of German trade with Palestine and the Middle East and the political impact of Zionist emigration from Germany to Palestine on relations with England and the Arab world. The stake of Referat-D in the Palestine issue was the extent to which Zionist efforts in Germany and Palestine might promote Jewish emigration and thus provide a solution to the Jewish question in Germany. Its task was to provide a bridge between domestic and foreign policy, specifically, between the ideological demands of National Socialist Jewish policy in Germany and the foreign policy goals of the Hitler regime. Moreover, it acted as apologist in the Foreign Office for the anti-Semitic policies of the regime, while trying to ensure that the foreign policy of the Reich be so formulated as to serve the interests of domestic Jewish policy at all times.[12] With the aim of complete dissimilation of the Jewish community in Germany and its eventual removal from the country, as well as the political and economic aims of German foreign policy in Palestine, there existed a certain harmony prior to 1937 in the domestic and foreign aspects of Jewish policy. This is amply demonstrated in a Foreign Office circular drawn up by Vicco von Bülow-Schwante of Referat-D in February, 1934, and issued to German consular missions abroad.[13] After summarizing the domestic measures against the Jewish community in Germany up to that point, the report went on to emphasize the logic of a pro-Zionist approach:

> On the other hand, there is that part of Jewry that rejects the possibility of an assimilation of Jews into the host nation, and therefore promotes the emigration and in-gathering of Jews scattered all over the world in their own political community. This group, in the first instance Zionism, comes closest to the goals of German Jewish policy. The emigration of German Jews will be actively promoted from now on by the National Socialist government. In particular, certain amounts of money will be made available for transfer to Jews prepared to emigrate. For this purpose, official German authorities are cooperating fully *sine ira et studio* with Jewish organizations, especially in the promotion of emigration to Palestine.[14]

Throughout 1934 and 1935, the Foreign Office continued to work with the Ministry of the Interior and the Zionistische Verein-igung für Deutschland to ensure the effective functioning of the Zion-ist movement in Germany in its efforts to organize the slow process of emigration from Germany to Palestine. The ZVfD was encouraged by the Foreign Office, the Interior Ministry and the Gestapo to send delegates to the Eighteenth Zionist Congress in Prague in August–September, 1933, and to the Nineteenth Congress in Lucerne two years later.[15] In both cases, the motive was to use German Zionists in an effort to dampen the recurring anti-German boycott and propa-ganda tendencies abroad. At both congresses, resolutions that were militantly anti-German, calling for new boycott measures and, at Lucerne, for an end to the Haavara agreement, were rejected.[16] In a report on the Lucerne proceedings to the Foreign Office in Berlin in August, 1935, the German Zionist delegates who had attended the congress described their tactics: "In these efforts we were supported by a large number of other Zionists who, like us, are of the opinion that Zionism must concern itself exclusively with the building of the National Home in Palestine, and cannot afford to take political positions toward individual states."[17]

The Zionist option followed by the Foreign Office found support in the Ministry of Justice and in the Ministry of the Interior, the lat-ter being the agency responsible for the actual process of emigration through its Reichstelle für das Auswanderungswesen (Office of Emi-gration). Dr. Hans Frank, the Bavarian minister of justice, indicated his support for the Zionist option as a solution to the Jewish ques-tion in Germany in a speech at the Reichsparteitag at Nürnberg in September, 1933.[18] Dr. Bernhard Lösener, director of the Judenreferat (Department of Jewish Affairs) in the Interior Ministry, was an avid supporter of the Zionist option. In an article published in the *Reichs-verwaltungsblatt* on November 23, 1935, Lösener reasoned:

If the Jews already had their own state in which the greater part of their people were settled, then the Jewish question could be considered completely resolved today, also for the Jews themselves. The least amount of opposition to the under-lying ideas of the Nürnberg Laws has been raised by Zionists, because they know at once that these laws represent the only correct solution for the Jewish people as well. For each nation must have its own state as the outward form of appearance of its particular nationhood.[19]

## The Role of the SS

In Bülow-Schwante's circular of February 28, 1934, emphasis was placed on the apparent community of interests between the National Socialist Jewish policy and the Zionist movement, or at least what was perceived at that time by many government and Party officials to be a community of interests. Bülow-Schwante noted the Zionist willingness to promote the dissimilation of German Jews and their eventual removal from Germany to Palestine. Implicit in his observations was the intention to encourage the Zionist ideal among German Jews so that the traditionally liberal/assimilationist Jewish community in Germany would eventually accept a new definition of its national and cultural identity. In September, 1935, Bülow-Schwante again pointed to the advantages of encouraging the Zionists in Germany: "On the basis of German Jewish policy and its foreign policy implications, there exists no reason to paralyze Zionist tendencies in Germany because Zionism does not contradict the National Socialist goal of gradually eliminating the Jews from Germany."[20]

Zionist and other Jewish organizations were regulated and controlled by the police apparatus, which fell under Himmler's SS.[21] It must be remembered that the SS did not begin to assume control over Jewish policy in general, and emigration policy in particular, until after 1938. With the decline of the SA in 1934, however, the SS had become the chief instrument in the execution and enforcement of the Jewish policy of the Hitler regime. While SA tactics had included boycotts and pogrom-style violence against the Jewish community, the SS sought a solution to the Jewish question through various forms of controlled emigration from Germany.[22] Of course, this was the policy pursued by the Foreign Office and other government agencies throughout the 1930s.[23]

As the racial elite of the Nazi system and the organization most concerned with *völkisch* purity, it was natural that the SS should play the key role in the practical execution of Jewish policy. Moreover, as the legitimate police authority, and the chief instrument of force outside of the army, the SS was the natural executioner of Jewish policy between 1933 and 1945. Its police power gave it a natural advantage over Party rivals such as the SA, Goebbels, Rosenberg and others in the struggle for control over Jewish policy during the 1930s.

The first indication of active SS participation in Jewish policy was a secret position paper prepared in June, 1934, warning that the German public might begin to feel that the Jewish question in Ger-

many had been solved with the April 1 anti-Jewish boycott and subsequent anti-Jewish legislation of the previous year.[24] It also pointed out the potential dangers of the international anti-German boycott. It recommended the promotion of mass Jewish emigration and warned of the difficulty of pursuading the strongly assimilationist Jews of Germany to leave. The paper also proposed a positive effort by the government and Party to encourage Zionist efforts in Germany designed to instill a sense of Jewish consciousness and identity in German Jews and to promote emigration to Palestine. Jewish schools, athletic groups, institutions and culture—in short, all Jewish organizations and activities promoting Jewish self-awareness— were to be encouraged. These efforts, along with the *Umschulungslager*, occupational retraining centers established by the Zionists throughout Germany for Jewish emigrants going to Palestine, were to be favorably treated by the SS. The report concluded that, even if Palestine should prove to be too small to absorb all of Germany's Jews, the rest might be settled in French-controlled Syria.[25]

Subsequent police practice under SS direction left little doubt that the goal was a speedy and efficient emigration of Jews from Germany. This was demonstrated in the preferential treatment directly and indirectly accorded to Jewish organizations promoting Jewish emigration, as opposed to the treatment accorded to liberal/assimilationist groups.[26] In January, 1935, the Bavarian political police ordered preferential treatment for all Zionist-affiliated organizations because of their efforts to facilitate Jewish emigration from Germany to Palestine.[27] The difference in treatment is most evident in the police regulation of Jewish meetings and activities after 1934. On February 10, 1935, Heydrich ordered the prohibition of speeches and activities that counseled Jews to remain in Germany.[28] Throughout 1935, the Sicherheitsdienst (Security Service, SD) of the SS was in the business of attending and regulating the content of Jewish gatherings and meetings. It censored speeches and banned anything that advocated a continued Jewish presence in Germany; on the other hand, it encouraged the propaganda activities of the Zionists.[29] A general ban on all meetings and speeches of Jewish organizations in Germany was issued by the Gestapo on May 31, 1935, although local Jewish cultural and sports activities, as well as the activities of the Zionist organizations, were exempt.[30]

There was some cooperation between the SS and the Revisionist Zionists, or *Staatszionisten*, during those years.[31] The question of uniforms for Jewish youth organizations, in itself a matter of little consequence, is indicative of the appeal that Zionism held for the SS.

This is evident in the reasoning behind an April, 1935, decision by the police authorities to permit members of the Betar, the militant Revisionist youth organization, to wear uniforms at their meetings, exempting them from the December 12, 1934, police regulation that prohibited members of Jewish youth organizations from wearing uniforms or uniformlike dress (*uniformähnliche Kleidungsstücke*).[32] This decision was based on the conviction that the Revisionist Zionist movement had proven itself to be vigorously pursuing Jewish emigration from Germany to Palestine, as well as on the hope that uniforms might attract more Jewish youths to its ranks. An ambiguous relationship between the Gestapo and the *Staatszionisten* lasted until 1938, when the movement was banned.[33] Its strategy had been based on an absolute acceptance, for practical as well as ideological reasons, of the reality that there was no place for Jews in the new Germany. In an interview with a reporter from the Goebbels newspaper *Der Angriff*, Georg Kareski of the *Staatszionisten* expressed his approval of the Nürnberg racial laws of September, 1935:

> For many years I have considered a clear separation of the cultural affairs of two peoples living together in one society as necessary for peaceful coexistence and have for a long time supported such a separation, which is based on respect for the alien culture. The Nürnberg Laws of 15 September, 1935, apart from their constitutional provisions, seem to me to lie entirely in the direction of just such a mutual respect for the separateness of each people. The interruption of the process of dissolution in many Jewish communities, which had been promoted through mixed marriages, is from a Jewish point of view entirely welcome. For the establishment of a Jewish national existence in Palestine, these factors, religion and family, have a decisive significance.[34]

Finally, in an article in the SS newspaper *Das Schwarze Korps* in May, 1935, Reinhard Heydrich again outlined the position of the SS regarding the Zionists and their efforts to prepare German Jews for a new life in Palestine.[35] He divided the Jewish community in Germany into two groups, the Zionists and the assimilationists.[36] He noted that the Zionists adhered to a strict racial position and that, through emigration to Palestine, they were in the process of building up their own Jewish homeland, while the assimilationist organizations were simply trying to deny their own race. Another article appeared in the September 26 issue, in which the following position was reiterated:

In the context of its *Weltanschauung,* National Socialism has no intention of attacking the Jewish people in any way. On the contrary, the recognition of Jewry as a racial community based on blood, and not as a religious one, leads the German government to guarantee the racial separateness of this community without any limitations. The government finds itself in complete agreement with the great spiritual movement within Jewry itself, the so-called Zionism, with its recognition of the solidarity of Jewry throughout the world and the rejection of all assimilationist ideas. On this basis, Germany undertakes measures that will surely play a significant role in the future in the handling of the Jewish problem around the world.[37]

In the middle of May, 1935, the Gestapo decided to dissolve liberal/assimilationist organizations such as the Centralverein and the Verband nationaldeutscher Juden (League of German Jews). This move was in keeping with the Nürnberg laws of September, 1935, according to which all German Jews were formally placed beyond the pale of German citizenship.[38] With the eventual dissolution of the liberal/assimilationist groups later that year, Zionist groups were the only ones of a political nature that were allowed to continue functioning.

By 1935, the Hitler regime had opted for the emigration solution, and Palestine had become the central factor. The pogrom approach of the SA had been shelved in 1934 and 1935 and would remain so until the events of November, 1938. Hitler's directive in August, 1935, prohibiting all individual acts against Jews and Jewish organizations, can be seen both as an indication of the pursuit of the emigration option and as Naˉˈ propaganda preparations for the 1936 Olympics; it might also be viewed as an attempt to enforce a more unified approach in the execution of Jewish policy.[39] At a ministerial conference on December 17, 1935, the representative of the Reichskanzlei announced that Hitler had decided to encourage Jewish emigration and "to open possibilities for them that will encourage voluntary emigration."[40] It was resolved that this might be accomplished through the abetment of the German Zionist movement. Dr. Hans Friedenthal, former chairman of the ZVfD, summarized the support of SS agencies for the Zionist cause in an interview with Dr. Kurt Jacob Ball-Kaduri in March, 1957: "The Gestapo did everything in those days to promote emigration, particularly to Palestine. We often received their help when we required anything from other authorities regarding preparations for emigration. This position remained constant and uniform the entire time, until the year 1938."[41]

### The *Umschulungslager*

The occupational retraining of German Jews going to Palestine was taken up seriously by German Zionists almost immediately after Hitler's appointment as chancellor in 1933. By 1936, an extensive system of retraining centers, run by the Hechaluz and sponsored by various Zionist groups and relief agencies, was functioning throughout Germany.[42] The regime and the Zionist organization felt that retraining programs would greatly facilitate the resettlement of German Jews in Palestine. SS encouragement of Zionist retraining programs, already mentioned in its position paper of June, 1934, was reiterated by the Bavarian Political Police on January 28, 1935: "The activities of Zionist-oriented Jewish youth organizations, which carry out the retraining of Jews as farmers and craftsmen before their emigration to Palestine, are compatible with the policies of the National Socialist leadership."[43] The Palestinian economy needed agricultural workers and artisans; the social, economic and occupational level of most German Jews meant that they were probably the immigrants least prepared for a new life in Palestine. Thus, these rigorous retraining programs were certain to receive the approval of the police authorities. They were designed primarily for Jewish youth who had not yet gone into business or the professions, in order to teach them the necessary agricultural and occupational skills in demand in Palestine.

Referat-D and the Ministry of the Interior expressed their support for the retraining activities of the Zionists in the summer of 1933, provided they took place within the borders of Germany and thus remained under German control. Retraining facilities in Germany were not sufficiently developed in 1933 to handle the sudden increase in demand, as relatively few German Jews contemplated leaving Germany for Palestine before 1933. As a result, the ZVfD sought permission to send young German Zionists to retraining sites in Denmark, Poland and Czechoslovakia to prepare for Palestine. Both the Foreign Office and the Ministry of the Interior rejected the request, mainly out of fear that the trainees would be exposed to the intense anti-German propaganda campaigns being waged by the Jewish communities and their non-Jewish supporters in those countries. In a note to the Interior Ministry on this subject in August, 1933, Bülow-Schwante observed that, while Jewish emigration to Palestine was to be pursued by all possible means, particularly through the retraining of emigrating Jews, the retraining activities had to be carried out within Germany so that some control could be maintained.[44]

The idea of retraining German Jews was encouraged by German authorities with a view toward facilitating Jewish resettlement in countries other than Palestine as well. Business people, academics and other professionals were not in short supply in the developed countries of the west, which, with the exception of Palestine, held a virtual monopoly on Jewish immigration from Germany during the 1930s. This was emphasized in a note from the Interior Ministry to the Ministry of Agriculture on June 13, 1934.[45] The Interior Ministry lamented the lack of manual or agricultural skills of most German Jews; it saw this as an obstacle to the smooth and speedy emigration of Jews from Germany and praised the retraining efforts of the *Umschulungslager* as conducive to German and Jewish interests alike.

Other government ministries were also involved in the overall support and encouragement afforded Zionist retraining efforts. After initial opposition to the agricultural retraining of Jews, based on fears that retrained Jews would end up staying in Germany and thus aggravate an already depressed agricultural labor market, the Ministry of Agriculture eventually accepted the idea with the encouragement of the Interior Ministry and came to support the expansion of the program throughout 1934 and 1935.[46] In a note to the Interior Ministry in September, 1935, the Ministry of Labor expressed its unqualified support for the *Umschulung* concept and referred favorably to the support already given to the retraining program by Hitler and the Gestapo.[47] Observing that the retraining of young Jews was a useful way of facilitating Jewish emigration, the note concluded that it was not primarily a labor matter but rather one that involved the resolution of the Jewish question in Germany through the promotion of Jewish emigration.

Zionist retraining efforts also enjoyed the encouragement of the British Embassy in Berlin. A British Embassy memorandum of April 3, 1936, asserted that the *Umschulungslager* run by the Hechaluz enabled the Jewish Agency to select suitable candidates for admission to Palestine, better prepared for absorption into the economic life of the country.[48] British encouragement of the retraining process could only have been viewed favorably by the German government, given its singular enthusiasm for emigration as the solution to the Jewish question.

Throughout 1935 and 1936, German police authorities permitted the Jewish Agency to send instructors from Palestine to Germany to help prepare Jewish emigrants for resettlement in Palestine. Many of the instructors were teachers of the Hebrew language, as well as people specially trained to prepare adolescents and children

for their new country. They were usually granted visas for one year; the Gestapo in Germany and the German Consulate-General in Jerusalem appear to have been most accommodating in bringing Jewish Agency instructors to Germany.[49] Although Heydrich did at times prohibit the use of Hebrew at Zionist meetings while Gestapo agents were in attendance, he encouraged its use at most functions in the conviction that this would facilitate Jewish emigration.[50]

The retraining process was also undertaken outside of the *Umschulungslager*, in the daily lives of German Jews during the 1930s. Zionists were encouraged to take their message to the Jewish community, to collect money, to show films on Palestine and generally to educate German Jews about Palestine. There was considerable pressure to teach Jews in Germany to cease identifying themselves as Germans and to awaken a new Jewish national identity in them.[51] While gradually removing Jewish children from state schools, the regime encouraged and even subsidized Jewish schools, continuing to pay Jewish teachers' pensions until 1939. There was little if any interference in the way in which the Jewish school system was run.[52] Perhaps the most symbolic gesture in the entire process of reeducation was embodied in the Nürnberg laws of 1935. While officially prohibiting the display of the German flag by Jews, the laws did permit them to display the blue and white Jewish national flag, later to become the flag of the state of Israel.[53]

## Abteilung II/112 and Palestine

There can be little doubt that the above-mentioned efforts by Party and government agencies to promote the Zionist cause in Germany were slowly having the desired effect. The liberal/assimilationist organizations were discredited and finally dissolved, and, although a substantial number of Jews tried to hold on and accept a drastically altered status in Germany, these tended to be among the older generation, who saw little sense in leaving.[54] On the other hand, the Zionist movement grew rapidly, especially among the young, and soon became the dominant force among German Jewry during the 1930s.[55] It is not my intention to suggest here that government and Party cooperation with and encouragement for the Zionist cause was indicative of a real concern or sympathy for Zionist work in Palestine and its eventual success.[56] Neither the possibility of its success nor that of its failure seems to have been considered by government or Party officials prior to the debate generated by the Peel Partition Plan in 1937. Until then, there seems to have been an almost blind utilization of Zionist ideology and the movement for the promotion of

purely German domestic and economic ends, with little or no concern for the effect that policy was having on the situation in Palestine itself.

It cannot be said that responsible officials in Berlin were totally unconcerned about Zionist efforts outside of Germany, particularly in Palestine itself. The SD began to take an active interest in Zionist affairs abroad after 1934. SS-Untersturmführer von Mildenstein of Abteilung II/112–3 was sent to observe the Nineteenth Zionist Congress in Lucerne in the summer of 1935, attached to the German Jewish delegation. SS-Hauptscharführer Eichmann, also of Abteilung II/112–3, was sent to observe the Twentieth Congress in 1937.[57] Both von Mildenstein and Eichmann felt they had accumulated valuable information on international Zionism that would be useful in the formulation of policies toward the Zionist movement in Germany. The anti-boycott success of the German delegation and its allies at the Lucerne Congress strengthened the relatively positive attitude of cooperation with Zionism on the part of the SD.

In his memoirs, Joachim von Ribbentrop complained of growing SD activity overseas and the resulting conflicts between himself and Himmler.[58] These activities had begun before Ribbentrop became foreign minister and included a network of informers and confidants, Germans as well as host country nationals. Their task was to collect information on the host countries and German officials in those countries and forward it to SD headquarters in Berlin without being subject to Foreign Office knowledge or control.

SD activities in Palestine began to pick up after 1935. The results were of little consequence, a fact that befits the amateur attempts of II/112–3 and II/B–4 to play the role of intelligence-gathering agencies in addition to their domestic police functions. The SD utilized correspondents of the German overseas news service, the Deutsches Nachrichtenbüro (DNB) as agents. This necessitated a certain amount of cooperation with the Ministry of Propaganda, to which the DNB was responsible. The DNB correspondent in Jerusalem, Dr. Franz Reichert, began working closely with Consul-General Wolff in 1934. Wolff asserted that Reichert was a firm supporter of a pro-Zionist policy and the Haavara agreement.[59] Throughout 1936, however, Reichert was engaged in a feud with Wolff's successor, Wilhelm Döhle, and the Orient-Abteilung in the Foreign Office in Berlin, over whether Reichert's reports to the DNB in Berlin, which went via Foreign Office post, were to be given special confidential treatment.[60] Döhle and the Foreign Office were willing to give Reichert's reports the same confidential treatment as their own reports and correspondence, but this apparently did not satisfy Reichert. He in-

sisted that his reports be free of Foreign Office scrutiny, most likely because he wanted to conceal his ties to the SD and Gestapo—the information he was relaying back to them as well as their attempts at diplomacy and intelligence gathering outside the usual channels.[61]

According to a II/112 situation report of October, 1937, Reichert's activities included "reporting on the problems of political Zionism and associated questions of policy in the Middle East."[62] He had several others working under him, including the DNB representative in Cairo (Herr Gentz), and Feivel Polkes of the underground Jewish intelligence service in Palestine, the Hagana.[63] Reichert used Polkes as a source of information for both Jewish and Arab plans in Palestine and considered him an extremely well-informed contact on all matters relating to Jewish and Arab affairs.[64] Reichert's enthusiasm over his Hagana contact led him to arrange a meeting between Polkes and SD and Gestapo officials in Berlin, which took place between February 26 and March 2, 1937.[65]

The meetings with Polkes in Berlin were conducted by Eichmann of II/112–3, and the SD assumed the costs of Polkes's stay in the German capital. From the beginning, Polkes made his political aims and motivations clear; he was working for massive Jewish immigration into Palestine and the creation of a strong Jewish majority and state. Furthermore, he asserted that his anti-British, anti-Arab and anti-Communist inclinations were representative of the Hagana as a whole. He revealed that he had contacts with the French, British and Italian intelligence services and was providing all of them with information in return for any support they might render the Zionist struggle. The II/112 memorandum of June 17, 1937, further described Polkes's offer to bring Germany into this network: "He also declared himself ready to gather information for Germany that did not conflict with his own political ends. Among other things, he would vigorously support German foreign policy interests in the Middle East and use his influence to secure sources of oil for the German Reich that would not touch upon Britain's spheres of influence if German foreign currency regulations for Jews emigrating to Palestine would be relaxed."

The SD was interested in Polkes's proposition, not to achieve special advantages for Germany in the Middle East or to acquire oil concessions, but rather to obtain information on alleged Jewish plans to assassinate German officials, including Hitler.[66] It was also trying to get more information on the murder of Wilhelm Gustloff, the Nazi Gauleiter in Switzerland, by a Jewish youth in February, 1936, as well as an attempted assassination of the Sudetan German leader Konrad Henlein. According to II/112, there were numerous assassina-

tion threats and plans against Hitler by Jewish groups around the world, and it was believed that the contact with Polkes would provide valuable intelligence for the German police authorities.[67] Therefore, Eichmann was assigned the task of developing the Polkes contact; he accepted an invitation from Polkes to visit Jewish settlements in Palestine later that year.[68]

The June 17 memorandum further summarized what II/112 was prepared to do for Polkes in return:

> Pressure will be exerted on the Reichsvertretung der Juden in Deutschland to oblige Jews who emigrate from Germany to go exclusively to Palestine, and not to other countries. A measure such as this is certainly in the German interest, and will be undertaken by the Gestapo. With this, Polkes's plans to build a Jewish majority in Palestine would at the same time be promoted. . . . Besides this, cash payments can be made to Polkes for his news gathering activities.

Of course, the suggestion to force Jews to emigrate exclusively to Palestine was one that II/112 would not be able to implement. The object of emigration policy was to move Jews as speedily as possible out of the country, and this depended in large measure on many receiver countries taking in as many German Jews as possible. Eliminating all but one would be counterproductive, especially in light of Palestine's limited size and absorptive capacity. Moreover, German authorities had little control over the ultimate destination of most emigrants once they left Germany. At the same time, Palestine was already becoming less attractive as a destination as a result of the Arab revolt of 1936 and the consequent restrictions on Jewish immigration imposed by British authorities. Finally, serious discontent began to surface in Party and government agencies late in 1936 and early in 1937 over the entire Palestine question, particularly over Germany's relationship to it. The possibility of the creation of an independent Jewish state began to raise serious doubts about past emigration policies that had encouraged Jews to go to Palestine. Even the SD was among those voicing concern by early 1937 over the possible creation of a Jewish state, should the Royal Commission so decide.[69]

An interesting episode involving the Hagana and Germany during the 1930s emerges from the documents on the Polkes visit to Berlin in 1937. In his conversations with Eichmann, Polkes referred to Mauser pistols that the Hagana had earlier received from Germany, observing that they had rendered valuable service to the Hagana during the recent unrest in Palestine.[70] In a study of Hagana in-

telligence activities, E. Dekel, a former Hagana officer, revealed that, between 1933 and 1935, some 300 barrels of cement were shipped from a fictitious exporter in Belgium to a fictitious importer in Jaffa, in reality the Hagana.[71] According to Dekel, about half the barrels contained, in addition to cement, 100-lb. containers filled with Mauser pistols and ammunition. He did not indicate the exact source of the pistols, although it would seem that they originated in Germany, as indicated in the Polkes-Eichmann conversations in Berlin early in 1937. The source within Germany remains a mystery. The Mauser-Jagdwaffen GmbH has informed me that, although most of their records were destroyed during the war, the firm did provide the Ministry of the Interior with large quantities of model C96, which appeared in 1932.[72] It is known from Dekel's study that Hagana agents were actively seeking arms and ammunition all over Europe during the 1930s and from the SS records on Polkes that Hagana agents were active in Germany at that time.[73] While it cannot be determined at this point exactly who provided the pistols to the Hagana, it is certain that someone in Germany did and that the police authorities were aware of it.

The efforts of II/112 of the SD to involve itself in the Middle East by establishing its own intelligence network there, the Polkes visit to Berlin in early 1937 and the subsequent Middle East trip by Eichmann were of very little consequence in the end. The SD and Gestapo remained throughout little more than instruments of the domestic police apparatus, executing Jewish policy inside Germany as formulated by the various government agencies and authorities. As the Polkes and Reichert contacts seem to indicate, II/112 was more interested in obtaining information on assassinations and alleged conspiracies in Germany and Europe, as well as a degree of surveillance on German representatives abroad, than in securing an accurate picture of the state of affairs in Palestine.

### Other Interested Agencies

Mention should be made of two other agencies that were to some degree involved in the formulation of Jewish policy during the 1930s and in the National Socialist approach to Zionism and the Palestine question in particular. Neither the Aussenpolitisches Amt (Foreign Policy Office, APA) of the NSDAP under Rosenberg nor the Propaganda Ministry under Goebbels was instrumental in the formulation of policy toward the Zionists before 1937. Both seem to have gone along with the pro-Zionist line pursued by the other agencies dis-

cussed thus far; both were to become more vocal in the whole Palestine question after 1937.

The attitude of the Propaganda Ministry toward Zionism before 1936–1937 is evident in articles that appeared in *Der Angriff* during the early years of the Hitler regime. On September 29, 1934, an article by Schwarz van Berk, the editor-in-chief of the paper, appeared, arguing that "Jewry in Germany is not assimilable. . . . the Jew is for all time excluded from the German *Schicksalsbahn* [destiny]. He might for example look for a new homeland in Palestine. We have always supported that. . . . Jews living among themselves—we have not had anything against that."[74] Another article in *Der Angriff* on October 9 of the same year called for a Jewish return to Palestine and the creation of a binational state in all of Palestine, including Transjordan.[75]

Alfred Rosenberg's Aussenpolitisches Amt in the NSDAP never amounted to much more than an insignificant Party department, "which justified its mean existence by accumulating vast newspaper-clipping files, sponsoring occasional beer parties for visiting dignitaries, indulging in fanciful projects from time to time, and inflating its insignificant undertakings in lavish reports prepared for the Chancellor."[76] Its occasional ventures into the field of foreign affairs were complete failures, due to the continuing role of the Foreign Office and Hitler's basic reliance on the traditional foreign policy apparatus, at least until 1938.[77] The insignificance of the APA throughout the 1930s and Hitler's opting for the Foreign Office, and eventually von Ribbentrop, are also indicative of the extent of Rosenberg's drop in the National Socialist hierarchy since the early days of the movement.

Rosenberg's early ideological opposition to Zionism has already been outlined above. It was based on the theory of a Jewish world conspiracy, with Zionism as one of its instruments. On the other hand, Rosenberg had indicated that Zionism, if not exactly what its proponents said it was, might nevertheless be utilized for the short-term practical aim of removing Jews from Germany. Before 1937, he had little to say about policy toward Zionism or Palestine, perhaps because he had said it all in his many published works. In an interview with M. Raymond Cartier of *Echo de Paris* on May 3, 1935, Rosenberg again outlined his dual approach toward Zionism: "The Zionist movement has the advantage that it emphasizes *Judentum* [Jewry], and views all assimilationist efforts as futile. In general, however, Jewry has remained unchanged, for it does not really intend solely or entirely to return to Palestine."[78] True to his earlier theo-

ries of a Jewish world conspiracy through the twin instruments of Bolshevism and Zionism, he argued in an article in the *Völkischer Beobachter* in 1934 that the Zionists had joined forces with all those who oppose the new Germany, particularly the Communists.[79]

Zionism and Palestine played key roles in the Jewish policy of the Hitler regime from 1933 to 1937. The Zionist movement was used as an instrument of domestic Jewish policy to promote the dissimilation and emigration of German Jews; it also became a vehicle for the promotion of German exports to Palestine and the Middle East. There appears to have been something approaching unanimity among the many responsible Party and government agencies with regard to Zionism and Palestine. However, the events of 1936 and 1937—namely, the Arab revolt and the subsequent partition plan proposed by the Royal Commission—appear to have destroyed the consensus. In the end, they did not really alter German policy. Before considering the debate in Germany over Palestine in 1937 and 1938, it is necessary to examine the role of Great Britain and of Arab nationalism in German policy calculations through 1937 and their relationship to the Zionist movement in the strategic and ideological considerations of the Hitler regime.

# 5. The Role of England in Hitler's Foreign Policy Plans

## Theories on Hitler's *Englandpolitik*

There are two schools of thought on the role of England in Hitler's foreign policy calculations before and after 1933. Both schools proceed on the assumption that Hitler's attitudes and policy toward England remained consistent from about 1924 until 1945 and that England was the key element in his geopolitical strategy. Yet fundamental differences exist between the two groups in terms of the complexity of Hitler's motivations and strategy, as well as the final role to be played by England in his long-term planning. The differences in interpretation hinge on whether *Lebensraum* in eastern Europe and the domination of the European continent was Hitler's ultimate goal or merely the first step toward a subsequent *Weltpolitik* in which Germany would use its European base to dominate the world. The former option involved conflict with Russia, but not with Britain; the latter involved the possibility of an eventual conflict with Britain or an alliance between Britain and Germany against the United States.

The first school limits Hitler's geopolitical goals to the winning of *Lebensraum* in the east and the domination of the European continent and explains Hitler's strategy within the context of alliances with Great Britain and Italy to achieve these ends.[1] According to this theory, Hitler would have settled for a partition of the world with Great Britain, Italy and Japan, with Britain maintaining its overseas empire and Germany exercising control over the European continent from the North Sea to the Urals. Italian aims in the Mediterranean and Africa were to be supported so long as they did not conflict with British imperial interests and could be satisfied largely at the expense of France.

The second school views Hitler's foreign policy aims and strategy as a more complex and comprehensive phenomenon.[2] Hitler's

geopolitical ambitions were global, not limited to the European con-
tinent; ideologically, the racial doctrines of National Socialism, spe-
cifically its anti-Semitism, were to be applied on a worldwide basis.
England's role in these plans was to evolve in two stages: the first was
to be essentially that prescribed by the first school, namely, support
for or at least acquiescence in German domination of Europe; the
second stage would involve either an eventual conflict with Britain
and America for world supremacy or an Anglo-German alliance
against the United States, with the British Empire subordinate to
the new German superpower in Europe.

National Socialist foreign policy can be viewed as a synthesis of
traditional conservative goals, which include some measure of Ger-
man supremacy in Europe, and revolutionary-ideological ends,
whereby Europe and perhaps the rest of the world would be domi-
nated by a Germanic master race under the leadership of a Greater
Germany.[3] Initially, peaceful relations with the rest of Europe were
needed so that the position of Hitler and the NSDAP might be con-
solidated. To this end, it was essential to promote the concept of a
National Socialist *Volksgemeinschaft* based on Nazi racial prin-
ciples and a rearmament program to enable the *Volk* to achieve its
ends in Europe.[4] Moreover, British acquiescence in—if not support
for—this mission, at least through 1937, was considered essential in
the face of certain French and Russian resistance.

The differences between the two schools regarding Hitler's *En-
glandpolitik* have little direct bearing on this study, since both recog-
nize the quest for an English alliance prior to 1939. Hitler's foreign
policy calculations during this period depended to a large degree on
the position of Great Britain within the framework of his geopoliti-
cal plans. His *Englandpolitik* went through some distinct phases be-
tween 1933 and 1939; throughout, an underlying desire for an al-
liance or understanding with Britain was maintained. These phases
ranged from an active bid for an Anglo-German alliance from 1933
to 1937 to the slow realization between 1935 and 1937 that active
British support was neither likely nor necessary for the realization of
his plans in Europe and finally to the contingency plans after late
1937 that German goals might have to be achieved even in the face of
British opposition. Throughout these stages, Hitler continued to
hope for an Anglo-German understanding and refrained from any
policy aimed at undermining the security of the British Empire or at
provoking its hostility. The attitudes and policy of the Hitler regime
toward Britain and the British Empire around the world were crucial
factors in its approach to the Palestine problem and to the Middle
East in general.

## The Formulation of Hitler's *Englandpolitik* to 1933

It would appear that when Hitler became chancellor on January 30, 1933, he already possessed what Axel Kuhn describes as a "fest umrissenes aussenpolitisches Programm" (clearly outlined foreign policy program).[5] In numerous speeches after 1920, as well as in *Mein Kampf* and his *Secret Book*, Hitler developed a comprehensive foreign policy that was considerably more ambitious than the relatively limited goals outlined in the Party Program of February, 1920. The 25 Points were utilized in the public speeches of various Party officials, who tended to concentrate their propaganda on domestic concerns and those foreign policy questions involving a revision of the Versailles settlement.[6] Within the Party, however, there was no dearth of intellectual activity in the formulation of a truly National Socialist foreign policy for the future.

As in other areas of political life, the NSDAP demonstrated a high degree of anarchy in the formulation of its foreign policy program during the Weimar years.[7] Klaus Hildebrand has isolated three distinct trends in the evolution of National Socialist foreign policy during the 1920s.[8] The "Wilhelmine Imperialists" represented the right wing of the Party; they were former officers, members of the upper classes, Pan-Germans and former members of the Navy League and the colonial societies. Led by men such as Ritter von Epp and Hermann Göring, this group hoped to restore the old Reich boundaries and to recover Germany's overseas colonies, by war if necessary. The "Revolutionary Socialists," led by the Strasser brothers, preferred German consolidation in central Europe and, at least in the early years, opposed colonial expansion. Some even tried to preach German solidarity with the colonial peoples of the world in their struggles against the western colonial powers. Finally, the "Agrarian Radicals," led by Walter Darré and Alfred Rosenberg, were committed to the racial-ideological approach of *Blut und Boden* (Blood and Soil), which rejected overseas colonies and called for a vast continental empire in central and eastern Europe at Russia's expense in alliance with Great Britain.

Hitler did not belong to any of these groups. In the end, he was able to exploit their differences and mutual hostilities, which precluded the formation of any anti-Hitler combinations. Elements of both the first and third trends are visible in the foreign policy line developed by Hitler during the 1920s, the third becoming particularly evident in *Mein Kampf* and in the *Secret Book*. Prior to 1922, Hitler's foreign policy conformed for the most part to the ideas of the Wilhelmine Imperialists. In speeches and newspaper articles, Hit-

ler's arguments were essentially revisionist, calling for the restoration of the prewar boundaries and former colonies and the unity of all ethnic Germans in one Reich and contending that Britain and France remained Germany's enemies.[9] The concept of *Lebensraum* in the east was not yet a part of Hitler's geopolitical calculations; when he did talk of the east during those years, he was referring to former German territory lost as a result of Versailles. England and France were viewed as Germany's hereditary enemies, denying Germany its unity and economic stability.[10] At times, Hitler even lamented the kaiser's choice of Austria-Hungary over Russia as an ally during the war and hinted that Bolshevik-Jewish control over Russia at that time was the only obstacle to Russian-German friendship.[11] In those days, Hitler considered Britain to be hopelessly under the control of world Jewry.[12]

It is difficult to pinpoint exactly when Hitler's attitudes toward England and Russia changed. It appears that he began to consider the benefits of a future Anglo-German alliance before he developed his schemes for *Lebensraum* in the east.[13] In 1932, Hitler claimed to have favored the English alliance for approximately twelve years, which would put its inception back to 1920 or 1921.[14] Kurt Luedecke asserted that he had discussed the English option with Hitler as early as 1921.[15] There was also the influence of Alfred Rosenberg on Hitler during the early 1920s and the success of the Bolsheviks in the Russian civil war by 1921. Rosenberg's foreign policy principles were based on the premises that world Jewry was responsible for the Bolshevik revolution in Russia and that Bolshevik Russia was the irreconcilable enemy of Germany. Furthermore, he believed that Germany's future lay in expansion to the east, not in overseas colonies, and that, to achieve these ends, Germany's alliance needs had to be fulfilled first and foremost by Great Britain.[16]

The reparations crisis of 1922, and the subsequent Ruhr crisis of 1923, acted as a catalyst in the transformation of Hitler's attitude toward England and its role in his alliance plans.[17] London's refusal to support the contention of the Reparations Commission in early 1923 that Germany was in arrears in reparations deliveries, as well as British criticism of the Ruhr occupation, made a profound impression on Hitler. Hostility toward France appears to have been the chief motive for Hitler's initial inclination for both a British and an Italian alliance, and not the ideological impulses of *Lebensraum* in the east, the struggle against "Jewish Bolshevism" or the idea of ideological solidarity with Italian Fascism.[18] Ideological considerations, including the role of England in Hitler's mythical Germanic master race, gained importance in Hitler's later calculations. In the

early years, however, he stressed the inherent Franco-British and Franco-Italian rivalries, the exploitation of which held many potential benefits for a revisionist and expansionist Germany.[19]

With the publication of *Mein Kampf* in July, 1925, Hitler's geopolitical plans for the future had reached maturity, and the National Socialist movement possessed a comprehensive foreign policy program that was pursued relentlessly between 1933 and 1945. Taking advantage of Anglo-French and Italian-French colonial rivalries, Germany would seek an alliance with Britain and Italy based on a common distrust and hostility toward France.[20] In doing this, Germany would renounce, for the time being, the *Weltpolitik* of Wilhelmine Germany, and with it the quest for naval power and an overseas colonial empire.[21] Hitler further demonstrated his acceptance of the *Blut und Boden* principles of the Darré-Rosenberg group and the premise that German expansion should be pursued primarily in eastern Europe, at Russian expense, and not overseas.[22] He went on to reason that Britain would come to accept German domination of Europe; he argued that Britain would not oppose German hegemony in Europe as it had opposed French hegemony in the past because Germany would remain a continental power, while French power in Europe had simply augmented France's position as a world power.[23] He hoped to convince England that German power would be confined to Europe and that Germany would not compete on the level of *Weltpolitik* as France had traditionally done. He would seek the elimination of French power in Europe, the destruction of Bolshevik Russia and the establishment of German hegemony over Europe, to be achieved through active cooperation with Great Britain.[24]

There is evidence that Hitler's ultimate aim was not the domination of Europe, but that he viewed it as a first stage toward a renewal of *Weltpolitik*. In both *Mein Kampf* and his *Secret Book*, he alluded to a second stage that would begin after a long interval of consolidation in Europe. Germany would eventually receive an overseas colonial empire at the expense of France and Belgium; this could involve a struggle either against England or in alliance with it against the potential enemy of both, the United States:

> All the kinship connections, however, could not prevent a certain feeling of envious concern in England for the growth of the American Union in all fields of international economic and power politics. A new mistress of the world seemed to be growing out of the former colonial country, the child of the great mother. It is understandable if England today re-examines her former alliances in anxious disquiet and if British statecraft

stares with dread toward a time when it will no longer be said: "England overseas," but "the seas for the Union."[25]

On this point Hitler differed with the Darré-Rosenberg line, which did not accept the possibility of war with England or the necessity of a large colonial empire overseas.

### The Quest for Alliance, 1933–1937

At the cabinet meeting called by Hitler on April 7, 1933, to review German foreign policy, it was agreed that good relations with Great Britain and Italy were essential, that any sort of understanding with France was impossible and that war was to be avoided at least until Germany was strong enough to sustain it.[26] These decisions provided the basis of German policy aims between 1933 and 1939; their success or failure depended in large measure on the outcome of his *Englandpolitik*.

Initially, Hitler planned to limit the growth of the German navy in his overall rearmament program in order to avoid the sort of friction that characterized Anglo-German relations prior to World War I. In his memoirs, Admiral Erich Raeder described a meeting he had with Hitler in February, 1933, during which Hitler asserted that the German navy was to be rebuilt for purely continental European tasks so that war with England, Italy and Japan might never occur.[27] Raeder noted that Hitler intended from the beginning to pursue some sort of naval agreement with Britain that would fix the relative strengths of both navies, ensuring Britain about a three-to-one advantage. Raeder also characterized Hitler's naval policy toward England as indicative of the Führer's intended *Kontinentalpolitik*, and a rejection of *Weltpolitik*, at least for the time being.[28] This early policy resulted in the Anglo-German Naval Pact of June 18, 1935, which Hitler considered a crowning achievement in his efforts to secure the cooperation and support of Great Britain.[29]

Colonial policy was not such an easy matter because of Germany's ever-precarious economic position and chronic shortage of raw materials. Hitler had asserted in *Mein Kampf* that Germany's destiny lay in eastern Europe and that an aggressive overseas colonial policy such as that pursued before the war was not in Germany's political or economic interest.[30] It is also true that, during the first two years of his regime, Hitler either ignored the question of colonial revision, as demonstrated in his many talks with British ambassadors Rumbold and Phipps, or simply expressed German disinterest in the matter. In an interview granted to Sir John Foster Fraser of the

*Daily Telegraph* on May 2, 1933, Hitler is reported to have argued: "I have given up the idea of German expansion beyond the seas. We do not want to enter into competition with England in naval strength. Our fate is not bound up with coasts or with dominions, but with the east of our frontier."[31] Hitler's strategy to win over Britain to his idea of an Anglo-German alliance was to offer German guarantees for the security of the British Empire.[32]

Hitler was by no means willing to give up the hope of at least some revision in the colonial question. He first began to urge revision in Germany's favor in the spring of 1935. In March, British Foreign Secretary Sir John Simon, accompanied by Anthony Eden, met with Hitler in Berlin to discuss Anglo-German relations.[33] Hitler argued that with 68 million inhabitants, Germany was crowded into a mere 460,000 square kilometers and thus had insufficient economic living space. He went on to suggest that this critical situation would have to be remedied if there were to be true peace in Europe, and that Britain would have to help achieve a solution. While he did not mention specific alterations in the map of Europe, or in the colonial status quo, his statements implied changes in both areas. He concluded by suggesting that Britain should recognize the community of interests between Germany and England and that a special relationship based on mutual cooperation, defense and security be developed immediately.

Several theories attempt to explain Hitler's tactical change on the colonial question in 1935 and 1936 and the beginning of his rather moderate campaign to win colonial concessions from London. This should certainly not be viewed as a move away from the idea of an Anglo-German alliance. In the first place, it is doubtful that Hitler's renunciation of colonies in *Mein Kampf* was meant to be permanent. It is also reasonable to assume that, for economic reasons, Hitler was interested in the return of some former German colonies as cheap sources of desperately needed raw materials. Schacht had always been an ardent supporter of colonial revision. He pressured Hitler to pursue a moderate, peaceful colonial policy in the hope that England would return at least some of Germany's former colonies. In this way, he hoped partially to relieve Germany's chronic shortage of raw materials and at the same time to dissuade Hitler from pursuing his plans for expansion in the east.[34] Others argue that after two years of unanswered overtures to England, Hitler began to use the colonial question in 1935 and 1936 as a purely tactical weapon to pressure Britain into a more responsive and cooperative attitude toward his European plans.[35]

The theme of colonial revision became a popular one in Hitler's

speeches in 1936 and 1937. In his famous "peace speech" of March 7, 1936, after the occupation of the Rhineland, Hitler demanded the return of the former German colonies.[36] At the Reichsparteitag in Nürnberg in September of that year, he again called for the return of German colonies, citing economic necessity and the need for food and raw material sources.[37] At the same time, Hitler continued to press for an Anglo-German alliance. This is evident in his instructions to Ritter von Epp, chief of the Kolonialpolitisches Amt (Colonial Office) of the NSDAP, on November 25, 1935, in which Hitler ordered removal from circulation of a pamphlet entitled "Koloniale Vorkämpfer Heraus" (Colonial Champions Come Forth), which advocated war if necessary to win back German colonies.[38] Moreover, he emphasized the delicacy of relations with England and cautioned von Epp to adapt the general propaganda for German colonial aims to the foreign policy lines of his regime.

Hitler's appointment of Ribbentrop as German ambassador to Great Britain in 1936 was part of a further attempt to reach an understanding with the British government.[39] As Hitler's personal foreign affairs adviser, Ribbentrop had been a staunch advocate of an Anglo-German connection. He had negotiated the Anglo-German naval agreement in 1935 and is supposed to have developed many contacts in England in his capacity as chief of Dienststelle Ribbentrop, another foreign affairs agency of the NSDAP. According to Ribbentrop, he was instructed by Hitler to do everything in his power to secure an Anglo-German alliance.[40] He claimed, "The Führer told me that he would be ready to put twelve divisions at the disposal of England for the purpose of maintaining the integrity of its Empire, wherever this should be necessary."[41]

Rosenberg's Aussenpolitisches Amt, the Party's other foreign affairs agency, was also committed to the idea of an Anglo-German alliance.[42] The *Blut und Boden* ideological current of the 1920s postulated that Germany's only enemy was Jewish-Bolshevik Russia. With the exception of a colony or two as sources of raw materials, Rosenberg favored an alliance with England for racial and strategic reasons and maintained that *Weltpolitik* was not in Germany's interest. According to Rosenberg, Germany's destiny lay in eastern Europe, and its aims in this area would best be secured through English support.

Another indication of the importance Hitler attached to an English alliance is the comparative worth to him of the English and Italian connections. In both *Mein Kampf* and his *Secret Book*, Hitler considered Italy and England natural allies of Germany. He asserted that neither had points of conflict with Germany and that both were, like Germany, natural enemies of France. He appears to have thought

that Britain and Italy were also natural allies without areas of conflicting interests; this error was to become painfully evident to him after the 1935 Ethiopian crisis. Nevertheless, he reasoned that the Mediterranean was Italy's natural sphere of influence, maintaining that Italian-French rivalry in the area was beneficial to Germany, while Anglo-Italian rivalry was to be avoided.[43] Hitler would support Italian ambitions in the Mediterranean and Africa, even when they conflicted with French interests, but not to the point of conflict with the imperial interests of Great Britain.[44]

Hitler's efforts between 1933 and 1936 to reach an understanding with England were not matched by similar efforts toward Italy. In fact, German-Italian relations during the first three years of Hitler's regime were not always friendly, as a result of the Austrian question and commercial rivalry in southeastern Europe.[45] Nevertheless, Hitler's long-range geopolitical plans envisioned alliances with both, and the conflicts that arose during the 1930s between Germany's would-be allies confronted Hitler with the possibility of having to choose between the two.

There is evidence that, in such a situation, Hitler would have opted for England, had the British government been more amenable to his alliance plans. Germany's move toward primary reliance on an Italian alliance, beginning with the Ethiopian crisis in late 1935 and the Rome-Berlin Axis in 1936, was pursued with some reluctance in spite of British indifference to Hitler's previous alliance overtures and British appeasement during the Ethiopian and Spanish conflicts.[46] The Ethiopian crisis of October, 1935, sheds light on the relative importance of Italy and England in Hitler's alliance strategy. According to Fritz Wiedemann, then Hitler's adjutant, the Führer predicted Italian failure and defeat if England should resist Italian actions in eastern Africa.[47] Wiedemann maintained that, given the choice between Mussolini and the British, Hitler told him that he would opt for the latter, in spite of ideological affinities to the former. Ribbentrop also alluded to Hitler's preferences for England as an ally over Italy.[48] But almost three years of British indifference to his alliance overtures and London's weak reaction to Italian aggression in Ethiopia created a dilemma of strategic and ideological proportions in Hitler's attitudes toward Britain. Albert Speer described Hitler's troubled reaction to the events of the fall of 1935 by quoting him as follows: "I really don't know what I should do. It is a terribly difficult decision. I would by far prefer to join the English. But how often in history the English have proved perfidious. If I go with them, then everything is over for good between Italy and us. Afterward the English will drop me, and we'll sit between two stools."[49]

Speer also confirmed that England's refusal to take a strong stand against the Italian challenge in an area of the world deemed vital to the security of the British Empire prompted Hitler to begin a gradual reassessment of his alliance strategy and to proceed with the Rome-Berlin Axis and a closer relationship with Italy.[50] This is not to say that Hitler had decided to drop the English option in favor of support for Italy in the event of an Anglo-Italian war. The goal of an understanding, if not an alliance, with Great Britain remained a major concern in Hitler's foreign policy calculations through the rest of the decade. This is evident in a Foreign Office memorandum of State Secretary von Weizsäcker in December, 1937:

> Under no circumstances should the connection between Berlin and London be permitted to break entirely. We will have to adapt ourselves in all probability for the next several years to cool relations with England. But time will eventually produce conditions conducive to an improvement in German-English relations. Therefore the Rome-Berlin Axis is at this time useful and tactically appropriate. However, it will be of no use in the long run if it has a negative impact on German-English relations. . . . The Foreign Office will pursue every opportunity to promote German-English relations.[51]

What changed for Hitler during the years 1935 – 1937 was not the desirability of an alliance with England, but the likelihood of such an alliance materializing. Hitler began to adjust his plans accordingly and prepared for a future course of action not with England, and still not against it, but without a preliminary Anglo-German alliance. For purposes of this study, the significance of this policy shift lies in Hitler's continued avoidance of an aggressively hostile position against England through 1937 and thereafter. While he would pursue his aims in Europe without prior British support, Hitler continued to hope for an Anglo-German understanding, as he told Neurath in May, 1937: "I shall try once, and if that is not successful, I shall try it again; and should I again fail, I shall try a third time. I am most determined in this."[52]

### The Tactical Change: Without England, 1935–1937

The basis for Hitler's strategy changes regarding England between 1935 and 1937 lay chiefly in his growing realization that England would not lend its support to his plans for European hegemony.[53] His dreams of an Anglo-German alliance after 1924 are indicative of a

general National Socialist ignorance of the outside world and a particular set of misconceptions about England, its government and people. It is doubtful that Hitler ever recognized the fundamental irreconcilability of the National Socialist and English political philosophies and systems and their conflicting foreign policy interests, strategies and goals. Hitler was interested in German continental hegemony, while Britain was willing to accept only minor revisions in Germany's favor in central Europe, including Austria and the Sudetenland—and this only in the name of national self-determination and German unity. Hitler wanted to achieve his ends through bilateral Anglo-German and German-Italian agreements, preferably in the form of active alliances, while Britain insisted upon working within the framework of multilateral agreements and collective security.[54] The Anglo-German Naval Pact was not the success Hitler thought it would be. It proved to be a shallow accomplishment, for it was not followed by the expected British support for his plans to redraw the map of central and eastern Europe.

From the beginning of Hitler's regime, there cannot have been much doubt in government and Party circles regarding British distrust, disapproval and, in many cases, hostility for the new German regime and its domestic policies in particular. The German ambassador in London, Hoesch, filed a lengthy report in August, 1933, on the state of Anglo-German relations and the causes of Britain's generally negative stance toward the Hitler regime.[55] The two factors cited as causing the most anti-German feeling in England were the anti-Jewish measures of the government and the general political repression meted out to the political and "racial" opponents of the regime. Hoesch concluded that there was no reason at that time to expect a friendly attitude toward Germany from the various English political parties and groups. The British aversion to the new regime in Germany had also manifested itself during Alfred Rosenberg's visit to London in May, 1933. The visit was a fiasco that had to be cut short because high government officials refused to see Rosenberg. Hoesch's report on the Rosenberg trip provides a good description of British attitudes:

> Rosenberg's visit has not brought about an improvement in the atmosphere here; rather, it has further intensified the negative attitude of England against the new Germany. It has nothing to do with Rosenberg himself, who in my judgment has represented the position of the new Germany with as much moderation as conviction. . . . rather it is indicative of the fact that. . . . English criticism saw in Rosenberg's presence the in-

carnation of the new Germany in England itself, which caused a storm of opposition to erupt.[56]

By the fall of 1934, the German position in England had deteriorated further. In a report to the Foreign Office in Berlin on September 12, 1934, the German Embassy in London noted that the events in Germany of June 30, the Austrian question and the murder of Dollfuss, German rearmament and the failure of the disarmament conference and the Jewish question and political repression in Germany had all become critical impediments to any improvement in Anglo-German relations.[57] But Hitler was unwilling to give up the very things that stood in the way of closer ties to England, goals that were considered essential to the National Socialist revolution. Besides the oft-repeated guarantees for the security and defense of the British Empire, guarantees that were of little practical value to the British, the only other move that Hitler was prepared to make in order to win British sympathies was to prohibit any ties to the two British Fascist movements.[58] The German rearmament program was essential to Hitler's foreign policy objectives; he could not do away with the authoritarian nature and terror tactics of his government, nor was he prepared to make the Jewish question in Germany a subject for discussion between Germany and Britain or any other foreign power.[59]

Despite the importance Hitler attached to the English alliance throughout the 1930s, he was prepared almost from the beginning to achieve his goals in Europe without, or even against, Britain, should circumstances so dictate. In talks with his generals on February 28, 1934, Hitler outlined his plans for *Lebensraum* in the east.[60] After stressing the desirability of an English alliance, Hitler ordered his generals to prepare for any eventuality, including English opposition to German moves, and to be able to counter British refusal with "quick decisive blows to the west, and then to the east." The impact of the Ethiopian crisis on Hitler's alliance calculations has been mentioned. There is general agreement that British acquiescence to Italian moves in 1935 was an important factor in Hitler's decision to march into the Rhineland in March, 1936.[61] If England sat idly by while its imperial interests in eastern Africa were directly threatened, Hitler assumed it would not counter a German move into the Rhineland, where no British interests were at stake. Moreover, British failure to act decisively in the face of Italian and German intervention in the Spanish civil war, together with Britain's sympathetic attitude toward the Loyalists, convinced Hitler that the alliance with Britain would not materialize for ideological reasons and that it did not matter in the end, since the western powers had demonstrated

their unwillingness to oppose Axis moves.[62] Hence, British passivity was viewed as an acceptable alternative to an active Anglo-German alliance.

Ribbentrop's failure to secure the coveted British alliance during his term as ambassador to Britain worked in the same direction. In late 1936, Ribbentrop reported to Hitler that he had been unable to win over the British government to some form of Anglo-German understanding.[63] Hildebrand characterizes the Ribbentrop mission between 1936 and 1938 as "die endgültige Klärung gegenüber Grossbritannien" (the final clarification regarding Great Britain).[64] It was a period during which Hitler made his final effort to secure an alliance with England, chiefly through Ribbentrop in London, and planned for the attainment of German goals in the event of an English refusal.

Hitler's "Denkschrift zum Vierjahresplan" (Memorandum on the Four-Year Plan) of August, 1936, was another indication of his frustration with Great Britain and his intention to proceed without the British alliance.[65] After reaffirming the need for *Lebensraum* and the necessity of war against Bolshevism, Hitler decreed that the army and the economy had to be ready for war within four years. Without mentioning England, he stressed the need for a German-Italian-Japanese alliance and that only Japan and Italy could be relied upon as future allies. Nevertheless, he said nothing about a future conflict with England, still something to be avoided at that point.

Hitler continued to make alliance overtures to England until the summer of 1937. Two notable examples are his offers to Lloyd George in Berlin on September 4, 1936, and to Lord Lothian in Berlin in May, 1937.[66] In both instances Hitler proposed an alliance based on spheres of interest, with Britain supporting German hegemony over Europe and Germany guaranteeing the British Empire. As in the past, Britain could not seriously consider sanctioning a German conquest of Europe. It appears that by the summer of 1937, in view of Britain's unchanging attitudes and persistent rejections of his overtures of friendship and strategic cooperation, Hitler concluded it was no longer worth the effort to continue actively pursuing an Anglo-German alliance.[67]

The last half of 1937 was characterized by a new determination on Hitler's part to achieve his objective without British support and, if necessary, even against British resistance. Hitler's gradual change in tactics reached the turning point about the same time that the more conciliatory government of Neville Chamberlain took office in London in May, 1937. On May 28, the new British government invited Neurath to come to London to discuss Spain and other European problems. The German government initially accepted the invi-

tation, and discussions were set for June 23 in London. Unexpect-
edly, Hitler canceled the Neurath trip at the last minute, using the
excuse that the German cruiser *Leipzig* had been torpedoed in Span-
ish waters by an unidentified submarine. The real reasons for the
cancellation appear to have been twofold: Hitler's general distrust
and frustration over past British refusal to cooperate and Italy's fears
of the possibility of an Anglo-German deal on Spain at Italy's ex-
pense.[68] The cancellation of Neurath's mission in the summer of
1937 was the first time Hitler refused to utilize an opportunity to
improve Anglo-German relations. It also appears that, with Britain
consistently refusing to join Germany in an alliance, Hitler felt he
could no longer afford to alienate his potential ally Mussolini, who
had demonstrated his growing support for and dependence upon his
ties to Germany by 1937.

The fruition of Hitler's tactical change to a course without En-
gland became apparent at the now famous meeting at the Reichskanz-
lei on November 5, 1937, attended by Hitler, his adjutant Colonel
Hossbach, General Blomberg and General Fritsch, Admiral Raeder,
Field Marshal Göring and Foreign Minister Neurath.[69] Hitler said
nothing new at the meeting when he stated that he would seek Ger-
man *Lebensraum* in the east by war; he had said as much in his ad-
dress to the Reichswehr generals on February 3, 1933, and again on
February 28, 1934. However, he implied that he would proceed with
his plans in central Europe without the English alliance he had pre-
viously thought would be a prerequisite. For the first time, he put
England in the same category with France, labeling both as hated
enemies, trying to deny Germany its rightful place in the sun. He
argued that England would be more cooperative in colonial questions
when confronted with a strong, well-armed Germany, asserting that
the British Empire had demonstrated its weakness in the face of Ital-
ian moves in Africa and Japanese power in Asia and predicting its
eventual demise. He concluded that Britain and France had neither
the will nor the capacity to intervene against German moves in Eu-
rope. Nevertheless, Hossbach's notes recorded no inclination on
Hitler's part to go to war against England or otherwise to undermine
Britain's imperial interests. His lengthy description of Britain's weak-
nesses seems designed to dampen his advisers' fears of Anglo-French
resistance to his immediate plans for central Europe. Hitler had
come to believe that he could achieve his ends in Europe without
England and then win it over with a *fait accompli*.[70]

Hitler's conversations with Lord Halifax at Berchtesgaden on
November 19, 1937, reveal both the continuing gap between German
and English strategy and ends and Hitler's new tactics toward En-

gland.[71] Halifax talked throughout of peaceful changes in central Europe through multilateral agreements and a system of collective security for eastern Europe. The Chamberlain government was more willing than previous British governments to accept changes in Austria, Czechoslovakia and perhaps Danzig. This was, of course, not nearly enough to satisfy the long-range goals of Hitler's foreign policy. Halifax's willingness to sanction peaceful revision in Austria and Czechoslovakia was not what Hitler ultimately had in mind regarding Germany's *Lebensraum* in Europe. Nor was Halifax forthcoming in the colonial question, promising only to seek creation of a German colony or two somewhere in Asia or Africa.[72] Finally, one senses a feeling of resentment and frustration on Hitler's part in his talks with Halifax. Hitler dwelt on his past offers to Britain of friendship and cooperation and on having been generally ostracized by Britain and the western powers since 1933. Halifax himself observed after his meeting with Hitler that the Führer presented his case with a sense of confidence in Germany's strength and independence and that it became clear to him that Hitler would no longer run after England.[73]

Hitler's new tactical approach toward England did not mean that his overall *Englandpolitik* had undergone a fundamental alteration. In spite of a gradual two-year transformation, the concept of Anglo-German collaboration remained desirable in Hitler's foreign policy calculations, even beyond 1939.[74] He had resolved to achieve his goals in Europe, while a weak, passive England watched helplessly from the outside. Once German hegemony was established on the continent, Hitler would possess the power to force the British Empire into a German-dominated alliance. There is no evidence that Hitler intended to attack or undermine the interests of the British Empire. None of his objectives during the 1930s, including the demands for colonial revision in Africa, were to be achieved at the expense of British imperial interests. Hossbach's memorandum and the summary of Hitler's conversations with Halifax indicate that Hitler was willing to accept colonial compensation elsewhere in Africa if Britain should be unable to return the former colonies in eastern and southwestern Africa. Even in the summer of 1940, when Hitler had reached the pinnacle of success and England the depths of despair, Hitler maintained his basic support for the position of the British Empire. In June, 1940, Hitler told Mussolini in Munich that the British Empire had to be preserved as an important factor in the world balance of power.[75] In a discussion on July 13, 1940, Hitler asserted: "If we defeat England, the British Empire will collapse. But Germany has nothing to gain from that. We would achieve with German blood

something from which only Japan, America and others would derive benefits."[76]

## The Racial Factor

Some attention must be paid to the racial motivations underlying Hitler's attitudes and policies toward England. Clearly, ideology and power politics were inseparable elements in the motivation and goals of National Socialist foreign policy. This is especially evident in Hitler's approach to England. The strategic advantages of an active British alliance or simple British acquiescence notwithstanding, Hitler's strong desire for Anglo-German collaboration was also based on his racial *Weltanschauung*. It involved not merely the drive toward German domination of Europe, but an implicit faith in the perpetual domination of the world by white Europeans. As Britain had succeeded in conquering much of the world, Hitler considered political and ideological support for the British Empire to be natural and in the German interest. The Anglo-Saxons were, after all, part of the Germanic master race, and the British Empire could be seen as living proof of Germanic superiority and the confirmation of Nazi racial doctrine. Hitler's offers during the 1933–1937 period to commit Germany to the defense of the British Empire were not based merely on a *quid pro quo* approach in order to receive British support for his plans; they can also be viewed as a positive gesture of racial solidarity, fully in keeping with the National Socialist racial *Weltanschauung*.

Hitler's early admiration and respect for the power and size of the British Empire is well documented. In a speech at the Hofbräuhaus in Munich on April 17, 1920, Hitler attributed Britain's success overseas to, among other things, the racial superiority of the British over their colonial subjects and to the British policy of racially segregating themselves from those subjects.[77] He observed that "the Englishman has always understood the necessity of being lord and not brother." He often referred to British domination of India with unconcealed enthusiasm, expressing amazement that a small country like Great Britain was able to rule over India and a far-flung empire through sheer force.[78] In *Mein Kampf*, he referred to the strength and determination of British rule in India and to the utterly unthinkable notion that a colonial people could ever throw off British control:

> And if anybody flatters himself that England will let India go without risking her last drop of blood, that is simply a bad sign of the absolute failure to learn from the World War and the

complete misunderstanding and ignorance of Anglo-Saxon determination. It is, furthermore, a proof of the German's total lack of any notion of the whole method of British penetration and administration of this empire. England will lose India only if it either falls victim to racial degeneration within its own administrative machinery, or if it is compelled to by the sword of a powerful enemy. Indian rebels will, however, never achieve this. We Germans have learned well enough how hard it is to force England. Entirely aside from the fact that, as a German, I would, despite everything, still far rather see India under English rule than under some other rule.[79]

He also described the futility of Egyptian efforts to achieve independence from England and concluded with the following racial justification for the existence of the British Empire and German support for it: "It is simply an impossibility for a coalition of cripples to storm a powerful state determined, if need be, to risk the last drop of blood for its existence. As a folkish man, who estimates the value of humanity on racial bases, I may not, simply because of my knowledge of their racial inferiority, link my own nation's fate with that of these so-called 'oppressed nations.'"[80] Alfred Rosenberg was also concerned with the question of European racial solidarity in the face of what he called growing African and Asian independence movements and the need for joint German, British, French and Italian resistance to them.[81] Moreover, Ribbentrop persistently stressed the theme of Anglo-German racial ties as the cornerstone for the alliance he was seeking during his term as ambassador to England.[82] Finally, Hitler made a public speech before a Nazi student rally in Munich in January, 1936, in which he made the following call for continued white domination of the world: ". . . and when we consider this peculiar historical picture today, then we can only comprehend it if we are determined to employ the eternal *Organisationsdrang* [organizational drive] of the white race, that is, this natural conviction that this white race has been ordained to govern, to lead and to rule the rest of the world."[83]

Hitler's *Englandpolitik* during the 1930s was the single most important factor that influenced the attitudes and policy of his regime toward the Arab world in general and Arab aspirations in Palestine in particular. For reasons of both power politics and racial ideology, Hitler was not prepared to support the Arab cause in Palestine. To do so would have alienated England and undermined his efforts to secure an Anglo-German alliance; at the same time, National Socialist racial principles would have been violated by supporting an

inferior race against European domination. Palestine was of crucial strategic importance to the British Empire and of little significance in Hitler's geopolitical calculations; any meddling there would obviously have damaged the already fragile relations between Britain and Germany. For Hitler, it was unthinkable that the peoples of what we today call the Third World could ever throw off the yoke of colonial rule and achieve independence, and this attitude was naturally applied to the Arabs in Palestine as well.

# 6. The Rejection of an Arab Connection, 1933–1937

## The Arab Response in Palestine to the Hitler Regime

After more than a decade of frustration and increasing hostility toward the British Mandate and an expanding Zionist presence, many Arabs in Palestine and elsewhere in the Middle East greeted the new regime in Germany with enthusiasm.[1] Unlike Britain, France and Italy, Germany had not become an object of suspicion and distrust in the Arab world during the post–World War I period. Many Arabs were inclined to identify themselves with some of the elements of National Socialism; they perceived Germany no longer as a neutral, disinterested outsider but as a potential source of active support against western imperialism and Zionism. The nationalist fervor of the Nazis and their determination to eliminate the inequities of the postwar settlement held considerable appeal for some Arab leaders who considered the Mandate system and the Balfour Declaration part of the injustice of that settlement. There was also considerable enthusiasm for the anti-Jewish program of the Hitler regime as a result of the conflict in Palestine since the end of the war. Most Arabs never realized that the Nazis would consider them racially inferior as well and that Germany had no intention of undermining British authority in the Middle East. Moreover, there was little recognition that the new Germany they admired so much was directly responsible for the dramatic increase in Jewish immigration to Palestine after 1933.

Palestinian Arab leaders lost little time in making known their positive assessment of events in Germany in 1933.[2] The views of the Grand Mufti of Jerusalem, Haj Amin el-Husseini, were conveyed to Berlin by Consul-General Wolff in a telegram on March 31, 1933.[3] The Mufti informed Wolff that Muslims in Palestine and elsewhere were enthusiastic about the new regime in Germany and looked forward to the spread of Fascism throughout the region. Wolff also re-

layed the Mufti's support for the aims of Nazi Jewish policy, particularly the anti-Jewish boycott in Germany, and a pledge of similar efforts against the Jews throughout the Islamic world. Wolff again met with the Mufti and other sheiks from Palestine one month later at Nebi Musa in the desert mountains near the Dead Sea. After proclaiming their admiration for the new Germany, the Mufti and the assembled sheiks expressed their approval of anti-Jewish policies in Germany, asking only that German Jews not be sent to Palestine.[4] Thus, there seems to have been some awareness among Arabs in Palestine that Germany might in fact be a source of their problems, as Wolff reported again in October, 1933.[5] Nevertheless, Wolff concluded in his annual report for the year 1933 that the Arabs were too politically naive to recognize and fully accept the link between German Jewish policy and their problems in Palestine.[6] He concluded that Hitler and the new Germany were accorded a high degree of public enthusiasm and support.

Reports reaching the Foreign Office and other government agencies in Berlin indicate a similar enthusiasm for the National Socialist regime elsewhere in the Arab world. The German Consulate in Beirut and the German Embassy in Baghdad received letters from Syrian and Iraqi citizens expressing their admiration for Hitler and their support for the new Germany, as well as proposals for closer ties between Germany and the Arab world.[7] The Propaganda Ministry also received reports from its sources in the Middle East on the extent of pro-German feeling. One report, of unknown authorship, outlined Germany's favorable position and the positive propaganda potential throughout the Middle East:

> I have been able to discern with happiness in all the countries of the Middle East that, with the exception of the Jews, all the people are following events in the new Germany with much sympathy and enthusiasm. Especially among the youth, national Fascist units are being established against England and France as the oppressors. Everywhere people wish for a man and leader such as our great Adolf Hitler. German newspapers are read with keen excitement, and there is a demand for more propaganda material and newspapers in French and English, as only a few speak German. Good propaganda in these countries can be useful to Germany.[8]

Among German diplomats in the Middle East, there appears to have been a consensus that Arab enthusiasm for National Socialist Germany was devoid of any real understanding of the substance of

National Socialism, the goals of the movement and the significance of Adolf Hitler. Timotheus Wurst, the German consul in Jaffa, effectively summarized this prevailing attitude in 1935, observing that the Arab attitude was conditioned primarily by the anti-Jewish policies of the Hitler regime and to some degree by the disciplined, militaristic and intensely nationalistic posture of the NSDAP.[9] He further noted that many Arabs hoped to pursue the aims of Arab nationalism in Palestine and elsewhere by creating a movement based on the National Socialist model and experience.

## The Rejection of Arab Overtures to 1936

Expressions of enthusiasm and friendship for the new Germany were quickly followed by efforts to secure some measure of German support for the Arab cause in Palestine and throughout the Middle East. Prior to the Arab revolt of 1936, these efforts were usually intended to generate assistance in two areas—namely, German diplomatic support against the British and French Mandates—and in the creation of Arab National Socialist parties in the Middle East. In a few instances, financial and military assistance was also requested before 1936. In Jerusalem, the pro-Zionist German Consul-General Wolff was the constant and disapproving target of such initiatives, as was his successor after 1935, Wilhelm Döhle.

Wolff's avid support for Zionist aims in Palestine was reinforced by a contemptuous view of the Arabs as a people and the aims of Arab nationalism in Palestine. This is evident in his rejection of Arab requests for money and arms for use against the French in Syria in the summer of 1933. In reporting the request to Berlin, Wolff observed: "In such situations, I always remember a conversation between the Lawrence of world war fame and the recently murdered Dr. Arlossoroff, which the latter described to me, and in which Lawrence had talked about the Arabs in the following way: I don't know how one can take the Arabs seriously at all, I know them well. It is not worth the effort."[10] Wolff's meetings with the Amir Abdullah of Transjordan are indicative of his personal dislike of both the Arabs and their cause, as well as the policy of restraint being followed by the German government regarding Palestine. The situation in Palestine since the unrest of 1928–1929 had been tense and volatile, and German consular officials were doing everything to avoid entanglement in the Arab-Jewish conflict. Prior to his departure for London in early June, 1934, Abdullah requested a meeting with Wolff, which the latter politely declined for fear that it would arouse British suspicions.[11] Wolff did meet with some of Abdullah's subordinates shortly

thereafter. After singing the usual praises for the new Germany, the Arab officials pressed Wolff for German diplomatic support for the political objectives of the Arab movement in Palestine.[12] Wolff described his polite but firm rejection of these overtures:

> In the face of such requests, I always declare that, in its present economic and political situation, Germany cannot consider material support—by this I mean support with money or materials such as weapons, etc.—but that the Arab question, the strengthening of the Arab people, its economic development are of considerable interest to us, that Germany has great sympathy and moral support for the Arabs and their interests and that hopefully the day is near when the freedom that Germany seeks for itself will also be achieved by the Arabs.

In the same report, Wolff outlined his personal misgivings over any form of support for the Arab cause in Palestine and simply dismissed the Arabs as weak, vain, corruptible and incapable of sustained political and military action.

Wolff's personal opinions were also a reflection of official views in the German government. On a number of occasions, both the German Foreign Office and the Reichskanzlei addressed themselves in a similar way to Arab overtures for German assistance. An example of official German indifference to Arab nationalism occurred during the visit to Berlin of Amir Shakib Arslan in November, 1934. Arslan lived in Geneva and was the editor of the newspaper *La Nation Arabe*, which was published there. He was a fierce Arab nationalist and one of the few spokesmen in Europe for the Arab cause.[13] As a Syrian, he was especially hostile toward France and sought to exploit Franco-German and Franco-Italian friction in order to win both Germany and Italy for the Arab cause.

Arslan went to Berlin hoping to see Hitler, but was unable to get past Prüfer of the Orient-Abteilung. During his talks with Prüfer, Arslan suggested that Germany, in its inevitable struggle with France, would eventually have to align itself with the Arab world.[14] He said that Syria, Morocco, Algeria and Tunisia, countries under French control, would be Germany's natural allies. Prüfer warned Arslan that his suggestions were dangerous and that the kind of collaboration he was proposing could involve Germany in a war for which it was neither inclined nor prepared. In his memorandum on the Arslan visit, which was circulated in the Foreign Office on November 7, 1934, Prüfer made the following conclusions on German-Arab relations:

In an emergency, Germany could support the Arabs with nei-
ther money nor weapons. . . . The conflict with France, which
the Amir fears for us, could be precipitated by the existence of
a German-Arab cooperative agreement. . . . The experience of
the war has shown that in spite of our alliance with the leading
Islamic power and in spite of an intensive propaganda effort in
the Mohammedan countries, we were not able to kindle the so-
called "holy war" among the Mohammedans, especially among
the Arabs. Therefore, I don't believe that it would serve any
practical purpose to act on the suggestion of the Amir.[15]

Prüfer's memorandum was approved by Foreign Minister von Neu-
rath, who agreed with Prüfer's suggestion that Arslan be denied an
audience with high government officials and with Hitler. The Reichs-
kanzlei in turn concurred with the opinions of Neurath and Prüfer
that Arslan should be denied access to Hitler.[16]

The Arab national movement contained a variety of currents
with a corresponding variety of ends. Much of the initiative during
the 1930s was provided by Syrians and Palestinians. Since Egypt and
Iraq had achieved nominal independence from England in 1922 and
1930, respectively, and Saudi Arabia had retained its independence
after the war, Syria and Palestine (including Transjordan) remained
the only territories still under Mandate authority. The Syrian and
Palestinian movements against continued French and British rule
under the Mandate system were part of a larger Pan-Arab national-
ism that grew in intensity during the interwar period.[17] While Pan-
Arab nationalists to this day have been unable to agree on the sub-
stance and conditions of Arab unity, the movement during the 1920s
and 1930s was fueled by the continued domination of the area by
Britain and France, as well as by Zionist activity in Palestine. When
Anglo-French power was irrevocably shattered during World War II,
and the former masters of the Middle East began to retreat, an impor-
tant stimulus for Arab unity disappeared with them and Arab lead-
ers increasingly fell back on the national boundaries drawn by their
colonial masters.

A Pan-Arab Committee was established in Baghdad in the spring
of 1933. Almost two years later, a group of Syrian and Palestinian
representatives of the Committee approached Fritz Grobba, the Ger-
man ambassador to Iraq, and proposed mutual cooperation between
Germany and the Pan-Arab movement.[18] They proposed cooperative
efforts in propaganda, diplomatic support and "bei späteren etwa er-
forderlichen Aktionen durch aktive Unterstützung" (in later possi-
bly necessary activities through active support). Grobba expressed

the usual German sympathy for Arab efforts to achieve unity and independence, but rejected any form of direct German support for or participation in the Arab movement. Furthermore, he was instructed by the Foreign Office on the 12th of February 12, 1935, to avoid any connection with the Baghdad group and its representatives, as Germany wanted nothing to do with these efforts.[19]

Similar advice was proffered by the German Consulate in Beirut that same year. Syrian nationalists had been making overtures to Consul Seiler since 1933 for German support. In a report to Berlin in April, 1935, Seiler warned that the political situation in Syria was ripe for a new round of violence and rebellion against French rule and that French authorities in Syria had become suspicious and fearful of German intentions.[20] Popular enthusiasm for Germany had probably led French authorities to suspect German intervention when there was none. Seiler's advice was the same as Grobba's; he urged the Foreign Office to follow a policy that would avoid all contact, and preclude even the suspicion of contact, with Pan-Islamic nationalists in Syria and elsewhere.

After 1933, there were attempts in the Arab world to establish political parties based on Fascist or National Socialist principles and organization. Both Grobba and Wolff were approached in 1933 by individuals with plans to create National Socialist parties in Iraq and Palestine, respectively. The Palestine correspondent of the newspaper *Al-Ahram*, Joseph Francis, represented a group of Palestinian Arabs who were interested in establishing such a party. Francis wrote to Wolff in April, 1933, requesting the help of the Consulate-General in this endeavor.[21] In Baghdad, a similar overture was made to Fritz Grobba by Abdul Ghaffur el-Bedri, publisher of the newspaper *Istiqlal*, and a group of his supporters.[22] Wolff's strong opposition to any sort of German encouragement or support for an Arab Nazi party in Palestine was conveyed in a note to the Foreign Office in Berlin in June, 1933, in which he argued:

> Because the strengthening of the prestige and the international position of the Reich . . . is understandably the first task of its official representatives abroad, it would seem to be dangerous if I were to incur even the suspicion of meddling in the internal affairs of my Amtsbezirk [jurisdiction] as a result of promoting a party with purely internal, Palestinian tendencies. The confidence of the Mandate government in me, which is essential for my work to be effective, could be gravely endangered as a result of even the smallest indiscretion, since it would be viewed as

promoting the activist, nationalist Arab tendencies that are, in
the final analysis, directed against that government and its po-
litical tasks.[23]

In Berlin, the Foreign Office concurred with Wolff's opposition to
Arab efforts to involve Germany in the creation of an Arab National
Socialist party in Palestine. An unsigned memorandum, originating
in the Orient-Abteilung in early July, provided the rationale behind
the instructions issued to Wolff on the matter later that month.

> The objections that Herr Wolff has raised against the promo-
> tion of an Arab National Socialist movement by official Ger-
> man representatives are fully supported here. Given the no-
> torious political unreliability of the Arabs, one must surely
> assume that, as a result of Arab indiscretion, such ties would
> soon become known not only in Palestine and the Near East,
> but also in London and Paris. Since the end of the war, our
> efforts in the eastern countries have had the objective of
> German economic and cultural expansion through political
> neutrality. A change in this policy through meddling in the in-
> ternal political affairs of these countries by our official repre-
> sentatives would likely result not only in economic setbacks,
> but, because of the preeminent strategic positions of Britain
> and France in the east, would also have adverse consequences
> for Germany's policy in Europe.[24]

Wolff was instructed to discourage contact between pro-Nazi Arabs
and the various Ortsgruppen (local branches) of the NSDAP in Pales-
tine, to which many Palästinadeutsche were beginning to flock.[25] He
was told to prevent any contacts between Francis and the Consulate-
General, as well as between Francis and the local NSDAP organiza-
tion of the German Christian communities, for the reasons outlined
in the above memorandum of the Orient-Abteilung.

Moreover, Arab membership in the existing NSDAP organiza-
tion for Germans in Palestine was further precluded by a decree is-
sued by Ernst Bohle of the Auslandsorganisation (Overseas Organi-
zation) of the NSDAP in June, 1934.[26] According to this decree, Party
membership abroad was to be denied to foreigners and reserved ex-
clusively for German citizens so that "any appearance of meddling in
the internal affairs of foreign countries can be scrupulously avoided."
Thus, the activities of the NSDAP in Palestine were restricted to the
German Christian communities alone, and every effort was made to

avoid contact with politically motivated Arabs in order to retain the goodwill of the British administration toward German consular representatives and toward the German Christian communities.

## The NSDAP and the Palästinadeutsche

Beginning in 1933, the National Socialist regime pursued a policy of *Gleichschaltung* (coordination) of German citizens living abroad. It was appropriate that the Nazis should show a greater interest in the Auslandsdeutsche (overseas Germans) and their ties to the fatherland than had been the case before 1933. The concept of a German racial community transcended existing state boundaries, and an implicit faith in the common destiny of that community necessitated its ideological education. The racial foundations of National Socialism made the Auslandsdeutsche an integral part of the new Germany. At the same time, the totalitarian nature of the Nazi political system demanded their political mobilization under the leadership of the NSDAP.

The cabinet meeting on foreign policy of April 7, 1933, is the first indication of the intentions of the new regime with regard to the Auslandsdeutsche. The following policy was adopted at that meeting: "The cultivation and preservation of *Deutschtum* [German nationality] abroad must in the first instance be promoted, even through the use of considerable means. We must pursue a harmonious *Anschluss* [union] of the German minorities abroad to the national movement in Germany."[27] A little over a year later, Hitler spoke to a group of German citizens from abroad in Kiel on the importance and obligations of the Auslandsdeutsche to the new Germany. He concluded: "I hope that the *Auslandsdeutschtum* [German nationality overseas] will attach itself ever more firmly to the new Reich. For Germany to be able to continue its economic rise, which will benefit all people, each overseas German must perform his duty. Germany's equality among the nations must be accomplished overseas as well."[28] In the same year, Ernst Bohle of the Auslandsorganisation warned that the National Socialist movement was summoning all Germans abroad to support the new Germany.[29] He warned that those who considered themselves German could not ignore this responsibility, urged overseas Germans to join their local cells of the NSDAP and argued that to be German one had to be a National Socialist.[30]

The NSDAP-Reichsleitung (NSDAP Directorate) in Munich strictly prohibited involvement by overseas Party cells in the domestic affairs of their host countries. Regulations were enacted that

governed the conduct of the individual Party member abroad and specifically banned the public display of swastikas and the wearing of uniforms outside of closed meetings. On March 30, 1933, the NSDAP-Reichsleitung instructed the Abteilung für Deutsche im Ausland (Department for Germans Overseas) that the most important guideline for every Party member was to refrain from action that might create difficulties or complications for Germany abroad.[31] In a circular to all overseas branches of the NSDAP on October 3, Bohle asserted that National Socialism was not an exportable commodity.[32] After warning of the dangers of political involvement in the internal affairs of host countries, he noted that the Auslandsabteilung (Overseas Section) was not interested in influencing foreigners in the direction of National Socialism and threatened punishment to any Party member who violated these guidelines. Finally, Rudolf Hess reiterated this policy in April, 1935, as noted in a memorandum circulated by Dr. Conrad Roediger of the Kultur-Abteilung (Cultural Section) in the Foreign Office.[33] Meddling in the domestic affairs of foreign countries was punishable under German law. An AO memorandum of October 5, 1937, outlined the specific laws in Germany that prohibited such activities, as well as the possibility of punishment for noncompliance with these laws.[34]

A complete history of the German Christian communities in Palestine after 1918 has yet to be written. Their relations with the Jewish and Arab communities and with the British Mandate authorities, as well as their response to National Socialism in Germany, have been treated for the most part in a cursory manner.[35] However, an examination of these relations, and the particularly difficult position of the German communities in Palestine after 1933, provides valuable insight into the policy of the Hitler regime toward Palestine and the Middle East during the 1930s.

The Palästinadeutsche encountered political realities at the end of World War I quite different from those that had prevailed before the war. They had to rebuild their communities in a postwar society torn by the bitter hostility and violence generated by the conflicting aims of Jewish and Arab nationalism. Moreover, they had to adjust to the watchful authority of a suspicious British administration. In order to survive, the German communities had to pursue the almost impossible task of maintaining strict neutrality between Arabs and Jews, as well as loyalty to and support for the British Mandate.

The ability of these communities to survive in this delicate and dangerous situation was dealt a severe blow by the National Socialist assumption of power in Germany in 1933. Of the approximately 1,800 non-Jewish Germans still living as permanent residents in Pal-

estine in 1933, most were members of the Temple Society, while the remainder were affiliated with various Protestant and Catholic religious and welfare institutions.[36] As Germans, they incurred the hostility of the Jewish community in Palestine because of the anti-Semitism of the Hitler regime and its anti-Jewish measures after 1933. The Arabs were inclined to view them as potential allies in a common struggle against Zionism and the British Mandate, while some British officials suspected a real or potential Nazi Fifth Column among the German residents of Palestine.

Among the Palästinadeutsche, the reaction to events in Germany in late 1932 and early 1933 was on the whole favorable. According to Dr. Richard Hoffmann of the Temple Society of Australia, the national awakening in Germany generated by the National Socialist movement had considerable impact on the German communities in Palestine.[37] He noted that ties to the Weimar Republic were virtually nonexistent and that there was little regret over its demise. He also stressed that while almost every Palestinian German had some doubts about specific elements of National Socialist policy, there was overall satisfaction with the course of events in Germany. It is also apparent that the situation in Germany tended to politicize the Palästinadeutsche as never before. An article in the Temple Society newspaper, *Die Warte des Tempels*, pointed to this reality at the end of 1933 and reflected a positive assessment of the Hitler regime that prevailed among Palestinian Germans: "Under these circumstances it is understandable that a considerable politicization among our people has occurred. . . . This is certainly not to be regretted, but on the contrary is very welcome, and no discerning non-German will be able to reproach us that as Germans we are proud of the great national effort of Hitler that has eliminated the unfortunate Party and class disorder and has protected our fatherland in the final hour from Communism, and that we recognize the ideas of National Socialism as completely correct."[38] This view of the new order in Germany would appear to be an extension of the prevailing attitudes and public opinion in Germany during the early years of the Hitler regime.

Skepticism and sincere misgivings about National Socialism and the policies of the Hitler regime were also to be found among the Palestinian Germans.[39] Some rejected National Socialism altogether, while many leaders of the Temple Society settlements, village mayors, pastors, councillors, bank and factory directors, shipping merchants and importers were fearful of political polarization within the German communities and of antagonizing the Jewish community and the British administration in Palestine.[40] In the same De-

cember 15, 1933, edition, *Die Warte des Tempels* called attention to the potential dangers created by the National Socialist movement for the peace and security of the German communities in Palestine. The newspaper warned its readers that they were in a non-German country, living in the midst of a non-German majority, and that they could not afford the kind of political activity advocated by the more militant Nazis: "We must never forget that we live in a non-German country in the midst of non-German people, and that our task here in Palestine can never be a political one. It would also be wrong if those among us who more or less accept the ideas of National Socialism should come to scorn those who still have reservations. There can be no doubt whatever that all of us are and always have been good, patriotic Germans."

The racial tenets of National Socialism were the most controversial issue that confronted the German Christian communities in Palestine during the 1930s. The Templers were a religious community, and most of the remaining Catholics and Lutherans in Palestine were involved in church-related work such as religious orders, schools, orphanages and hospitals. The racial philosophy and policies of the Hitler regime generated severe ethical conflicts with the strong spirit of Christianity that motivated most Palästinadeutsche. Moreover, there was the immediate problem of increasing suspicion and hostility among Jews in Palestine toward the German communities, as the latter were identified with the racism of the new Germany.

An article entitled "Volk und Rasse," which appeared in *Die Warte des Tempels* in August 1935, addressed this particular problem.[41] The article referred to the traditional inclination of the Temple Society to preserve its exclusively German national character, thus asserting that the Society and its traditions were in keeping with the racial foundations of National Socialism: "The unconditional maintenance in Palestine of the purity of our German national character, on which we have placed the highest value since the founding of our colonies and of which today we are rightly proud, demonstrates clearly that we have in practice approached the question of race completely along National Socialist lines." However, the article also points to the serious ethical and moral dilemma for many Templers posed by Nazi racial policy and its obvious conflict with Christian principles: "However, there still emerge all sorts of misgivings about National Socialist theory among some Palestinian Germans, particularly misgivings of a religious nature. One cannot reconcile the superiority of one race with one's belief in God the Father of all men." The article concluded that the Temple Society could never ac-

cept the Social Darwinist notion of racial superiority and claimed that its desire to retain the German character of the Society and its settlements was not based on such a concept.

Whatever anti-Semitic tendencies there were among the Palästinadeutsche were neutralized by moral conflicts and perhaps even more so by the reality of an exposed position in Palestine. Their distance from Germany and their minority status in an increasingly Jewish environment made the anti-Semitic propaganda of the Hitler regime seem particularly dangerous and out of place in Palestine.[42] Nazi racial doctrine and policy had little to do, therefore, with the attraction of many Germans in Palestine to the NSDAP. There had always been a strong inclination toward the old loyalties and traditions of imperial Germany before World War I; it is within this context that the NSDAP was able to become an important force among the Palestinian Germans during the 1930s.

A cell of the NSDAP was first established in Palestine in 1932 with 6 members, although membership dropped to 5 by the time Hitler took office.[43] By mid-1937, membership increased to just under 300, consisting of local branches Sarona/Jaffa with 108 members, Haifa with 90 members and Jerusalem with 66 members, with 25 members in Wilhelma and 19 in Betlehem/Waldheim.[44] The process of *Gleichschaltung* was pursued actively by the NSDAP headquarters in Germany and the NSDAP leadership in Palestine, thus strengthening the links between Germany and the Party organization in Palestine. An ambitious information campaign was undertaken by the Auslandsorganisation and the NSDAP organization in Palestine, which included courses, propaganda literature and organized excursions to Germany for conferences and rallies. The radio linkup was improved, and German news service bulletins were prominently displayed.[45] Some communal libraries were purged, and stocked with Nazi literature, while the AO in Berlin slowly gained control over all teachers in German overseas schools by requiring the oath of loyalty to Hitler in 1935 and pressing them into the Nationalsozialistisches Lehrerbund (National Socialist Teachers' Alliance) by early 1938.[46] The Hitler Youth established camps and enlisted most German children in Palestine.[47] The German Labor Front opened branches in Palestine in 1936, and the Party in Palestine enjoyed the full cooperation and support of the new consul-general, Wilhelm Döhle, who, unlike his predecessor, was an avid National Socialist.[48]

Several factors made the efforts of the Party in Palestine somewhat easier. Besides the nationalistic and patriotic appeal of the National Socialist movement, there were specific factors peculiar to the Palästinadeutsche that aided the Nazi *Gleichschaltung* in Palestine.

The country consisted of autonomous religious, cultural and ethnic communities, each isolated from the others and living according to its own customs, traditions and laws. Palestine was not a nation state, with a common loyalty and identity. There was little likelihood of a common Palestinian national consciousness developing, because of the exclusiveness and irreconcilability of Arab and Jewish nationalism. In Turkish times, all of the groups in Palestine had been submerged under the weight of Ottoman rule; to some extent, all were considered Ottoman subjects. After the war, both Jewish and Arab nationalism exploded under the more liberal rule of the British Mandate. The Ottoman identity, tenuous as it was, disappeared and was not replaced by any other common loyalty. After the war, one was Jewish, Arab or German and nothing else. The only common denominator was the authority of the British Mandate, which was by definition temporary. The Jewish and Arab communities were locked in a struggle, each attempting to impose its own national consciousness on the entire country. The Palästinadeutsche were a comparatively small and isolated group, and their weakness and vulnerability amidst the violence of the Arab-Jewish struggle made them dependent on the protection and goodwill of the British authorities.

The NSDAP in Palestine was able to take advantage of these feelings of isolation, weakness and vulnerability in its efforts to enlist the German communities in Palestine for the new Germany. The Party offered the psychological comfort of being able to identify with a young, dynamic movement and a strong fatherland. While the small Catholic community, composed mainly of members of religious orders, was not susceptible to this kind of appeal, the Lutheran laity and the Templers were. The Temple Society did not possess a strong, organized church and clergy to provide them with an intellectual and spiritual leadership capable of neutralizing the Nazi appeal.[49] Thus, the cultural and social isolation of the German communities in Palestine made many Palestinian Germans receptive to the political, social and cultural identity offered by the NSDAP. At the same time, it generated a fear of the social ostracism that usually occurred when an individual openly worked against the Nazis.[50]

A majority of Templers favored active participation in the local Party organization in order to secure some degree of control over Party policy in Palestine and to be in a position to neutralize policies that they deemed disadvantageous and dangerous.[51] Dr. Hoffmann also claimed that the Templers wanted to avoid forfeiting Party leadership to the Lutherans, with whom they had never enjoyed a satisfactory relationship.[52] In any case, the Temple Society raised no objections to Party membership for individual Templers, although it

refused to enter the Party as a whole. According to Dr. Hoffmann, the Temple Society's position on the question of membership in the NSDAP was as follows: "It is not the task of a religious community to bind its members to a political party, for that is a purely secular question which is subject to the conscience of the individual member. The Temple Society would neither enter the Party nor prevent its members from doing so. If a member believed it was right to enter, then the Temple Society would not exclude him from its community because of that."[53]

In Palestine, the NSDAP pursued a policy that was in keeping with the foreign policy objectives of the Hitler regime, the only realistic policy under the circumstances. The survival of the German communities in Palestine depended primarily on the protection and goodwill of British authorities, which was available only on condition of strict nonintervention in the internal affairs of Palestine and restriction of all Nazi activities to the German communities. This was accepted by the Foreign Office and the Party in Germany, as well as on the local Party level in Palestine throughout the 1930s. Moreover, Hitler's hopes for an understanding with England precluded any involvement in the Arab-Jewish conflict. Support for one side would have exposed the small, isolated German communities to retaliation from the other side, as well as from the British administration.

The Party organization in Palestine tried to maintain a low profile for itself and the entire German Christian population. Party members were forbidden to wear or otherwise display swastikas in order to avoid provoking the Jewish community or British authorities, while all incoming German tourists were placed under the same restrictions.[54] In 1937, Arab demonstrators displayed hundreds of German flags and pictures of Hitler at a festival. Consul-General Döhle expressed his angry disapproval in a note to the Foreign Office in Berlin, remarking that the demonstration was indicative of the intensity of Arab hostility toward the Jews and the British and that such manifestations of enthusiasm for Germany were harmful to German interests in Palestine.[55] He also described his repeated pledges to British authorities that Germans had nothing to do with the demonstration, that it had been a purely Arab affair and that Germans in Palestine had not provided the Arab demonstrators with German flags or pictures of Hitler. The Propaganda Ministry had refrained from sending anti-Jewish propaganda materials to the German communities in Palestine, fearing that such material, if discovered, might incite Jews against the vulnerable German settlements.[56]

The remnants of the files of the NSDAP/Landesgruppe-Palästina indicate that the local Party organization concerned itself mainly

with the Nazification of Germans in Palestine and with the promotion of German trade. There exists a great deal of correspondence between Cornelius Schwarz, the Landeskreisleiter (regional leader) in Palestine, and the Aussenhandelsamt der Auslandsorganisation (Foreign Trade Office of the Overseas Organization) of the NSDAP on trade matters between Germany and Palestine.[57] The records also indicate that the local Party organization usually had an empty treasury because its income, mainly from membership dues, was sent to AO headquarters in Germany.[58]

British authorities were satisfied that the activities of the NSDAP in Palestine were being conducted exclusively within the German communities and that the Palestinian Germans were not engaged in subversive activities. This is evident in a House of Commons debate on the subject in June, 1934. The German ambassador in London, Hoesch, followed the debate and reported to Berlin that the British government was satisfied with the loyalty of Germans in Palestine, and that rumors of Nazi assistance to the Arabs were unfounded.[59] A Palestine police report of June, 1936, concluded that German propaganda interest in Palestine was negligible and observed that the object of the Nazis in Palestine was to Nazify German settlers, not Arabs.[60] The same report stated, "It is understood that members are forbidden to interfere in local politics, to wear uniforms, or to display badges, and, although lectures may be attended by other than Germans, non-Germans have not so far been admitted as members." The refusal of the NSDAP in Palestine to involve itself in domestic politics and British satisfaction with this policy are referred to in a letter from the local branch leader for Haifa, Friedrich Wagner, to Cornelius Schwarz in January, 1937.[61] Wagner observed that when the Arab revolt broke out the year before, British authorities in Palestine had communicated to German consular officials their satisfaction that the German communities, particularly the NSDAP, had not been involved.

### The Arab Revolt of 1936

In 1936, a number of apparently unconnected Arab attacks on Jews, followed in some cases by Jewish reprisals, culminated in a serious riot in Jaffa on April 19.[62] These disorders were followed by the proclamation of an Arab general strike by the Higher Committee and by the Arab National Committees that were set up in the principal towns. The Higher Committee, consisting of ten men under the presidency of the Mufti, was established after the outbreak of violence, and it assumed control over the National Committees, the or-

ganization of the general strike and the general direction of the Arab cause.[63] The Higher Committee announced that the strike would continue until the British administration agreed to suspend Jewish immigration as a sign of its intention to implement the demands submitted by the Arab delegation in November, 1935.[64]

Armed Arab bands began to form throughout the country. At first, they were under the control of the local National Committees, but later they became virtually independent units. Initially, they concentrated on mining and barricading roads, cutting telegraph wires, derailing trains and cutting the oil pipeline running across northern Palestine to Haifa. The attention of neighboring Arab states was drawn into the conflict, as so-called Committees for the Defense of Palestine were established in Damascus, Baghdad, Beirut and Amman. Volunteers from Syria and Iraq arrived to join the Arab revolt, and Palestine soon became the focus and symbol of Arab nationalism and its struggle against Anglo-French imperialism and Zionism.

For most observers, the immediate cause of the revolt was the dramatic increase in Jewish immigration to Palestine as a result of events in Germany.[65] In 1930, 4,944 Jews immigrated to Palestine, followed by 4,075 in 1931. In 1932, the figure rose to 9,553, after which it increased dramatically to 30,327 in 1933, 42,356 in 1934, and 61,458 in 1935.[66] This put the National Home beyond the point of no return and brought the Arab community to the realization that drastic action was necessary in order to compel the Mandatory power to limit or prevent further Jewish immigration.[67] The Jewish population in Palestine, which had numbered only about 55,000 in 1919, had increased to 160,000 by 1929, and to almost 400,000 by 1937.[68] Moreover, the increase in Jewish immigration meant an increase in Jewish land purchases that, according to the Arab leadership, threatened to undermine the economic basis of Palestinian Arab existence. In short, the Arabs of Palestine viewed their position as being gradually reduced to that of an impotent minority and felt that they were slowly becoming foreigners in their own land under the sway of an alien people whose intellectual, political and financial resources were superior to their own.[69]

Events in other parts of the Arab world added to the difficulty of maintaining a Palestinian peace. Britain and France made several attempts during the 1920s and 1930s to placate Arab nationalism and its frustrated goal of independence. Britain granted nominal forms of independence to Egypt in 1922 and again in 1936, as well as to Transjordan in 1928 and Iraq in 1930, while France granted limited self-government to Syria in 1932 and to the new Lebanese Republic in

1936. In each of these countries, Britain and France retained control over defense and foreign affairs. By 1936, the Arabs of Palestine found themselves in the humiliating position of being the only Arab community without any vestige of self-rule, except in municipal affairs.[70]

In Germany the Arab revolt was greeted with almost total indifference. The press tended to be mildly critical of past British policy, although probably no more so than many British newspapers and certainly without any intention of lending moral support to the Arab cause. Reports from the British Embassy in Berlin during the spring and summer of 1936 indicate that the German press refrained from taking an anti-British, pro-Arab position. In a note to the British Foreign Office on May 27, British Ambassador Phipps described the coverage of the revolt by *Der Angriff*, the *Berliner Tageblatt*, the *Börsen Zeitung* and the *Deutsche Diplomatisch-Politische Korrespondenz*.[71] He noted that the press in Germany attempted to contrast the disorders in other parts of the world, including Palestine, with the peace and stability prevailing in Germany. He observed that many newspapers in Germany blamed the Soviet Union for abetting the revolt and, at the same time, called on Britain to do everything to reconcile Jews and Arabs. An article by Alfred Rosenberg appeared in the *Völkischer Beobachter* in June, 1936, in which he criticized the hitherto one-sided support that Great Britain had been giving to the Zionists and the neglect of legitimate Arab demands.[72] Rosenberg argued that Britain could be more sensitive to Arab wishes and still remain loyal to the spirit of the Balfour Declaration, which, he argued, was supposed to be the basis of a Jewish national homeland in Palestine and not the pretext for transforming Palestine into an exclusively Jewish state. Rosenberg's arguments reflected the overall German policy on the Palestine question during the 1930s; a Jewish minority in a British-governed and Arab-dominated Palestine was the status quo that the Hitler regime sought to maintain.

There does not appear to have been much discussion or debate in German government circles over the Arab revolt and general strike. The attempts of Arab leaders to secure German weapons for the Palestinian insurgents and Germany's refusal to grant such assistance, as well as the strict neutrality of the Palästinadeutsche in the conflict, indicate that Germany maintained a policy of noninvolvement in Palestinian affairs. Fritz Grobba, the German ambassador in Iraq, received requests from Arab sources during the early months of the revolt in 1936 for weapons and other supplies for Arab insurgents in Palestine. One such plea for assistance came in December, 1936, from Fauzi Kaoukji, a former officer in the Iraqi army who commanded Arab units in Palestine during the revolt.[73] Kaoukji requested

large amounts of German weapons, to be purchased on credit and eventually paid for by the Mufti's Higher Committee and by wealthy Arab businessmen. Grobba dealt with this request as he had dealt with previous Arab requests for German arms assistance. After expressing Germany's sympathy for Arab self-determination in Palestine, he stated that Germany wished to maintain friendly relations with Great Britain and that material assistance to the Arab rebellion in Palestine would have a negative impact on Anglo-German relations.

Early in January, 1937, Grobba was visited by members of the Mufti's Higher Committee who hoped to secure German arms and money for future efforts in Palestine.[74] Although the Peel Commission had not yet finished its deliberations in Palestine, and its recommendations were not published until six months later, there was anticipation in the Middle East and in Europe that the Commission would recommend the creation of an independent Jewish state in at least part of Mandatory Palestine. This was evident in the way in which the representatives of the Higher Committee presented their appeal to Grobba. They repeatedly emphasized that an independent Jewish state in Palestine would not be in Germany's interest, as it would be Germany's natural enemy, while an independent Arab state in all of Palestine would be Germany's natural ally. After observing that Germany was the only Great Power in which the Arab world could place its trust, they requested financial and arms assistance. Grobba replied that Germany, while sympathizing with the Arab position in Palestine, wished above all to have good relations with Great Britain and therefore could not actively support the Arab revolt against British authority.[75] In Berlin, the Foreign Office concurred with the position Grobba had been taking throughout the months of violence in Palestine. In its telegram to Grobba on January 5, 1937, the Orient-Abteilung conveyed the following instructions:

> Moreover, your point of view, which you have already expressed to Fauzi Kaoukji, is endorsed here entirely. We cannot become involved in the current conflict. Any form of official German support cannot, therefore, be approved. Should the matter be brought to you again, we ask you to take the same position, in the same careful manner, as in the past, but with the usual expressions of sympathy for their cause.[76]

It is difficult to trace the origin of the weapons used by Arab insurgents in Palestine during the first phase of the revolt in 1936 and during the subsequent unrest and violence in 1937, 1938 and 1939.

The most likely and immediate sources of weapons and financial assistance were neighboring Arab states. According to H. P. Rice, the deputy inspector-general in Palestine in 1936, large sums of money had been collected in Egypt, Lebanon and Syria by the Mufti's Central Relief Committee for the Arab cause in Palestine.[77] In August, 1936, Consul-General Döhle reported to Berlin that weapons and ammunition were coming into Palestine from neighboring Transjordan, in spite of Amir Abdullah's efforts to mediate between the rebels and British authorities.[78] In October, Grobba reported from Baghdad that, according to his information, the Palestinian rebels were well armed with Belgian and English weapons.[79] He noted that the weapons had originally been procured by an Anglo-Belgian consortium for the Ethiopian government in its war against Italy, but that one ship had been diverted to Saudi Arabia after the Italian victory and that the Saudi government had transferred the weapons to Palestine via Transjordan.

Britain suspected Italian and Soviet assistance to the Arabs. According to a German Embassy report from London in June, 1936, there had been a prolonged debate on Palestine in the House of Commons on June 16, during which the government had alluded to suspected Italian and Soviet assistance to the Arabs in Palestine.[80] Döhle was also convinced that many of the weapons used by Palestinian Arabs were Russian in origin, although he did not indicate exactly what led him to this conclusion.[81] In early 1937, he again reported to Berlin on his suspicions about Russian assistance to the Arabs of Palestine and forwarded a report from an unnamed agent to support his contention.[82] The report referred to the Mufti and his organization and provided the following unsubstantiated information:

> The elite units of the said Arab terror organization are moving more and more under Russian influence. With Russian help, the Arab guerrillas have come to possess good, modern weapons by now. . . . After the recent visit of a Soviet Russian trade representative in Jaffa, the possibilities of Russian weapons deliveries for the Arabs via the southern Palestine coast have been discussed. In view of the intense supervision of Greek ships, which played a role in weapons smuggling during the recent unrest, agreements were concluded for the use of Egyptian sailboats.

It seems certain that Italy provided at least financial assistance to the Palestinian Arabs during and after the outbreak of the 1936 revolt. According to a British Colonial Office report, in July, 1936,

the British government had reason to suspect that Italian consular authorities in Palestine and elsewhere in the Middle East were providing money and arms to the Arab rebels in Palestine.[83] These suspicions were expressed by the British chargé d'affairs in Rome during discussions with Ciano in September, 1936.[84] Ciano denied these allegations. Grobba also suspected Italian activity in Palestine and mentioned the subject during his conversations with Fauzi Kaoukji in Baghdad in December, 1936.[85] Although Fauzi denied receiving Italian help, he did admit that such assistance had been offered to him, but said he had refused to take it because of traditional Arab distrust of Italy.

In 1934, Mussolini began a campaign to improve the image of Italy in the Arab world in preparation for his forthcoming adventure in Ethiopia. Previous repressive policies in Libya were scrapped, and a new public works program, which included the building of schools and hospitals, was initiated. Mussolini was interested in winning Arab sympathy for Italy at the expense of Britain and France. His chief concern was to neutralize Arab ties to England, Italy's chief rival in the eastern Mediterranean and eastern Africa. The Palestinian turmoil provided him with an opportunity to do this and to tie England down while he waged war against Ethiopia. In 1934, the Italian radio station at Bari in southern Italy began broadcasting daily Arabic-language programs with a decidedly anti-British propaganda line. This was intensified during the revolt in 1936, and the propaganda war in the Mediterranean became one of the major points of friction in Anglo-Italian relations during the late 1930s.[86] Relations were cultivated with Shakib Arslan, the Syrian nationalist in Geneva referred to above. There is also evidence that the Mufti did receive money from Italy throughout the late 1930s. In September, 1940, Ciano told the German ambassador in Rome that he had maintained relations with the Mufti for years and had provided the Mufti with substantial financial aid from one of his secret funds.[87] In April, 1939, Ciano told Göring that Italian money had been paying for arms that were being smuggled into Palestine from Syria.[88]

This study is not an attempt to establish definitively the scope of alleged Italian and Russian involvement in the Palestinian revolt. However, it can be demonstrated with reasonable certainty that Germany was not involved in the Palestine conflict in 1936 and 1937. There is evidence of limited financial aid to the Mufti from Canaris's Abwehr (Counterintelligence) briefly in late 1938 and in 1939, a matter discussed below. For this chapter, it is sufficient to demonstrate that Germany refused to provide money and weapons to the Arab rebels in Palestine in 1936 and 1937.

It would be useful here to consider German policy on arms exports during the 1930s. German law prohibited the export of arms until the end of 1935. According to the Gesetz über Kriegsgerät (Law on War Material) of July 27, 1927, import and export of weapons was forbidden.[89] The Gesetz über Aus- und Einfuhr von Kriegsgerät (Law on Export and Import of War Material) of November 6, 1935, legalized and regulated the export of German arms.[90] Paragraphs 1 and 2 of the law delegated responsibility for the export of arms in the following way:

§1: The export and import of war materials (weapons, munitions and other equipment) is allowable only with special permission, which the Reichskommissar für Aus- und Einfuhrbewilligung [Commissioner for Export and Import Allowance], in agreement with the Reichskriegsminister [Minister of War], grants.

§2: The Reichskommissar für Aus- und Einfuhrbewilligung will publish in the *Deutscher Reichsanzeiger* and the *Preussischer Staatsanzeiger* a list of war materials that only with his permission will be made available for export and import.

Paragraph 3 contained a provision for the punishment of anyone attempting to sell weapons abroad, outside of established channels. Thus, the new law ruled out private deals in the world arms trade and specified that all arms transactions had to go through the appropriate agencies of the government.[91]

According to the statistics of the Handelspolitische Abteilung (Commercial Policy Department) of the German Foreign Office, Germany exported relatively few weapons to Arab countries in the Middle East between 1936 and 1939.[92] The statistics also show that Palestine received a small quantity of rifle and machine-gun ammunition in 1936 and 1937. In keeping with the noninvolvement policy of 1936 and 1937, it is unlikely that the ammunition was contraband intended for the Arab insurgents. Yemen was the only Arab country to receive a sizable amount of small arms and ammunition from Germany in 1936 and 1937, and it is possible that some of this material eventually ended up in Palestine.[93] These statistics, and the overall German arms trade in the Middle East from 1937 to 1939, are discussed in greater detail below. It is sufficient to note here that Germany refrained from providing financial or military assistance to the Arab revolt in 1936 and 1937; this was in keeping with its policy of noninvolvement in the Palestinian conflict, general aloofness

from the Arab cause and continuing desire to avoid antagonizing Great Britain.[94]

Finally, it is necessary to examine briefly the position of the Palästinadeutsche during the violence of 1936. As observed above, the German communities in Palestine were caught in the middle of Arab-Jewish hostilities, and they were vulnerable to pressures from both sides. The dilemma was described in an article in *Die Warte des Tempels* in June, 1936:

> In a sense, the Germans in Palestine find themselves at the moment in an especially difficult position. Although they are in no way involved in the political conflicts of the British, Arabs and Jews, they are nevertheless carefully scrutinized by all sides for their behavior and their sympathies and antipathies. The course of events during the last several years has generated a very lively sympathy among Palestinian Arabs for German National Socialism, which repeatedly manifests itself during the current unrest, so that cars with passengers who are recognized as Germans, even in the most remote regions and communities, remain unmolested and, beyond that, are cause for joyful demonstrations with cries such as "long live Germany," "long live Adolf Hitler," etc., which understandably if also completely incorrectly serves as evidence for the Jewish side for the "correctness" of the widespread but completely senseless opinion that Germany has its hand in the Palestinian game. On the other hand, there is the fact that in the current unrest, German disregard of the anti-Jewish boycott efforts of the Arabs by selling vegetables and eggs to Jews is considered wrong by the Arabs and a form of partisanship in favor of the Jews. In the face of such conceptions, it appears necessary again to establish that the position of the Germans in Palestine can only be one of complete neutrality toward all political questions in the country, in the future as it has been in the past.[95]

The personal sympathies of most Palästinadeutsche were no doubt on the side of the Arabs.[96] They shared with their Arab neighbors the fear that continued Jewish immigration ultimately threatened their existence in Palestine. A Jewish-dominated Palestine would pose considerable problems for a German minority, at least as long as National Socialism prevailed in Germany. The forced emigration of Jews from Germany might be countered by a similar removal of Germans from a future Jewish Palestine. However, German con-

sular authorities and NSDAP officials in Palestine were in complete agreement that the strict neutrality of the German communities in Palestine was essential. In a note to Berlin on July 7, 1936, Döhle referred to an understanding he had reached with Cornelius Schwarz, the NSDAP-Landeskreisleiter in Palestine, to this effect.[97] In the same report, Döhle told of repeated Arab attempts to secure money and weapons through the German Consulate-General, overtures he politely rejected. He concluded with further assurances that all Germans in Palestine would continue to avoid Arab gestures of friendship in order not to arouse British suspicions.

The article in *Die Warte des Tempels* alluded to the problems that neutrality created for the Palästinadeutsche. While relations with the Jewish community since 1933 had deteriorated significantly because of events in Germany, neutrality also led to friction in Arab-German relations. At times, the Arabs tried to pressure the Templers into making financial contributions or providing German land for bases of operations or for hiding weapons and wounded insurgents. In many cases, the German settlers found it difficult to refuse. The agricultural produce of the German settlements, in some areas already subjected to a general Jewish boycott, could have been boycotted by the Arabs, thus damaging the livelihood of the Templer settlements further. The dependence of German farmers on Arab labor made them vulnerable to Arab pressure through strikes. In May, 1936, members of the Arab Strike Committee of Nazareth visited the nearby Templer colony of Betlehem and asked for contributions to the Arab strike fund. The Templers refused, explaining that they were neutral in the conflict. In retaliation, the Arab workers on the Templer farms in Betlehem went on strike. The situation became tense, and relations between the German colonists at Betlehem and their Arab neighbors deteriorated. The local NSDAP leaders went to the district police to request police protection for the colony after a German settler was attacked by an Arab worker with a knife. A compromise was reached when the Templers agreed to donate £pal 60 to an Arab charity, which enabled them to maintain their official policy of neutrality.[98]

Similar difficulties arose for the Temple settlement of Sarona near Jaffa, where colonists were also forced to seek police protection.[99] Consul-General Döhle supported the pleas for increased police protection for the German colonies for security reasons as well as to demonstrate to the British administration that the Palästinadeutsche were trying to be neutral in the conflict. Nevertheless, he regretted that special police protection tended to identify the German communities even more closely with the British administra-

tion and thus intensify Arab suspicions of German collaboration with the British and the Zionists.[100] The German dilemma was to prove to British authorities that they were not actively supporting the Arab rebellion and to the Arabs that they were not in league with the Zionists and the British. In the midst of this situation, the economic well-being of the German settlements was deteriorating as a result of pressures, strikes and boycotts from one side or the other.[101]

The recommendations of the Peel Commission in July, 1937, set off a debate within government and Party circles in Berlin over past attitudes and policies toward the Palestine question. The possibility of an independent Jewish state generated a full-scale reevaluation of the previous support for the Zionist option as part of the regime's Jewish policy. At the same time, the intensity of the Arab revolt in Palestine since 1936, coupled with the general unrest and discontent throughout the Arab world, led to a reassessment of the policy of indifference toward the Arab national movement in Palestine and elsewhere in the Middle East. Some feared that Germany was needlessly incurring the enmity of the entire Arab world for its indifference to the aims of Arab nationalism, reluctance to oppose Anglo-French domination in the Middle East and tacit support and abetment of Zionist immigration into Palestine.

# 7. The Peel Partition Plan and the Question of a Jewish State

## The Peel Commission Report of July, 1937

The Royal Commission arrived in Palestine on November 11, 1936, and finished its work there on January 17, 1937.[1] It had been appointed on August 7, 1936, and charged with the following tasks:

> To ascertain the underlying causes of the disturbances which broke out in Palestine in the middle of April; to inquire into the manner in which the Mandate for Palestine is being implemented in relation to the obligations of the Mandatory toward the Arabs and the Jews respectively; and to ascertain whether, upon a proper construction of the terms of the Mandate, either the Arabs or the Jews have any legitimate grievances upon account of the way in which the Mandate has been or is being implemented; and if the Commission is satisfied that any such grievances are well-founded, to make recommendations for their removal and for the prevention of their recurrence.[2]

In Palestine, the Commission heard sixty witnesses at thirty public sessions and fifty-three witnesses at forty private sessions.[3] No Arab witnesses testified before the Commission until after the Mufti's Higher Committee ended its boycott of the Commission on January 6, 1937. Upon its return to London in late January, the Commission held further sessions, at which persons holding official positions or high offices of state appeared as witnesses. On July 7, 1937, the findings and recommendations of the Commission were published in London.

Since the Arabs had rejected the postwar status quo in Palestine and had rebelled in 1936, the Peel Commission was more interested in the evidence given by the Arab side. The Commission summarized the Arab position as follows: "They deny the validity of the

Balfour Declaration. They have never admitted the right of the Powers to entrust a Mandate to Great Britain. They hold that the authority exercised by the Mandatory is inconsistent with the Covenant of the League of Nations and with the principle of self-determination embodied in that Covenant."[4] The Arab witnesses maintained that the rights and position of Arabs in Palestine had been prejudiced by the fall in their numerical proportions from about 90% in 1922 to about 70% in 1936. They argued that their aspirations to self-rule and national independence had been frustrated by the Mandate system and that implementation of the Balfour Declaration threatened their national existence through the massive immigration of an alien people. The Commission report concluded that the two basic postwar facts of life in Palestine, namely, the British Mandate and the Balfour Declaration, were the underlying causes of the Arab revolt in 1936 and of the previous disturbances of 1920, 1921, 1929 and 1933. The desire of the Arabs of Palestine for national independence and their hatred and fear of the creation of a Jewish National Home were incompatible with those two postwar realities.[5]

While Arab grievances stemmed from the Mandate system in which the Balfour Declaration was embodied, Jewish grievances were based on a conviction that the Mandate system was not being faithfully carried out and that British authorities were obstructing the establishment of the National Home.[6] It was charged that British officials displayed pro-Arab proclivities and that the administration tolerated subversive activities, especially those of the Mufti of Jerusalem. Furthermore, British authorities were criticized for not making more land available to Jewish development, for not facilitating Jewish immigration, for not opening up Transjordan for Jewish settlement and for generally failing to ensure public security.

The Commission report concluded that the irreconcilability of Arab and Jewish nationalism, and of Arab nationalism and continued British rule, necessitated a drastic revision of the postwar settlement in Palestine. This conclusion was based in part on the realization that the wartime promises to Arabs and Jews had been contradictory and that neither the Jewish nor the Arab community was prepared to accept minority status in an independent Palestine. The report opined:

> Nor do we suggest that the obligations Britain undertook towards the Arabs and the Jews some twenty years ago have lost in moral or legal weight through what has happened since.
> The trouble is that they have proved irreconcilable; and, as far ahead as we can see, they must continue to conflict. To put it

in one sentence, we cannot—in Palestine as it now is—both concede the Arab claim to self-government and secure the establishment of the Jewish National Home. Manifestly the problem cannot be solved by giving the Arabs or the Jews all they want. The answer to the question "Which of them in the end will govern Palestine?" must surely be "Neither." We do not think that any fairminded statesman would suppose, now that the hope of harmony between the races has proved untenable, that Britain ought either to hand over to Arab rule 400,000 Jews; or that, if the Jews should become majority, a million or so of Arabs should be handed over to their rule. But, while neither race can justly rule all Palestine, we see no reason why, if it were practicable, each race should not rule part of it.[7]

The Commission report recommended the termination of the British Mandate over Palestine on the basis of a plan of partition. A new British Mandate was to be established over the area surrounding Jerusalem and Bethlehem, with access to the sea provided by a corridor to Jaffa. Small enclaves around the cities of Haifa, Safad, Nazareth, Acre and Tiberias in the north and along the Gulf of Aqaba in the south would be included in the new Mandate. An independent Jewish state was to be created where most Jewish settlements existed. It was to include the fertile coastal plain and most of Galilee in the north. The rest of the country was to be united with Transjordan to form a large, independent Arab state. Treaties of alliance, similar to the Anglo-Iraqi and the Franco-Syrian examples, were to be negotiated between Britain and the Arab and Jewish states.

The partition scheme generated little support among the interested parties.[8] The Arabs in Palestine and the neighboring Arab states rejected the plan almost immediately, although Amir Abdullah and some of the followers of the Nashashibi party in Palestine were willing at one point to accept the plan.[9] The Zionist Congress, meeting at Zürich in August, 1937, approved the principle of partition, but rejected as inadequate the borders proposed in the Commission report. In London, Parliament showed little enthusiasm for partition, and government support for the plan was weak and temporary. Both Houses of Parliament debated on July 20 and 21 and, after much opposition, agreed to put the plan before the Mandates Commission of the League of Nations. The League began its deliberations over the partition plan on July 30 and adopted it on August 18. Moreover, opposition to partition was prevalent within the British administration in Palestine.

The Arab revolt broke out once again almost immediately after

the publication of the Peel report in July. In December, the British government made public a statement to the high commissioner in Palestine that they did not consider themselves bound to a policy of partition.[10] A technical commission under Sir John Woodhead was appointed by London in late February, 1938, and dispatched to Palestine a month later. Its task was to work out the details of a practical partition scheme that would be acceptable to all parties concerned. In its report of October, 1938, the Woodhead Commission was unable to recommend a workable partition plan. One month later, Britain officially dropped the idea of partition.[11] In reality, partition as a solution to the Palestine conflict had for all practical purposes been scrapped by the end of 1937, only to be revived again ten years later by the United Nations.

## The German Foreign Office and the Question of a Jewish State

As the Peel Commission conducted its investigations in Palestine in late 1936 and early 1937, German policy was still geared to the promotion of Jewish emigration, with Palestine as a preferred destination. This policy is evident in discussions on the Jewish question that took place at the Ministry of the Interior on September 29, 1936.[12] The meeting was attended by representatives of the Interior Ministry, the Ministry of Economics, and the office of the Stellvertreter des Führers (Deputy of the Führer). Sommer, head of the office of the Stellvertreter des Führers, opened the discussions with a statement reiterating the goal of National Socialist policy of removing all Jews from Germany. State Secretary Dr. Stuckart of the Interior Ministry agreed with Sommer's statement and noted that *restlose Auswanderung* (total emigration) was the goal his Ministry was pursuing and that all efforts in the area of Jewish policy had to be directed toward this end. The representatives of the Ministry of Economics argued that, to achieve these ends, the economic livelihood of Germany's Jews had to be maintained so that they would be eligible for admission to other countries. All of the representatives at the meeting expressed support for the efforts of the Zionist *Umschulungslager* to retrain and prepare German Jews for emigration.

The discussions turned to the question of destination countries for German Jewish emigrants. Stuckart suggested that it was necessary to determine which receiver countries were best in terms of overall German interests. He touched upon a question of policy that was to be central to the Palestine debate in Germany in 1937. It would have to be determined whether Germany's interests were best served by the dispersion of German Jews throughout the world or

whether they should be concentrated as much as possible in one or several areas. There was little that Germany could do to direct the flow of Jewish emigrants to any particular part of the world. As Stuckart noted, Palestine was the only destination over which Germany possessed some degree of control, due primarily to the Haavara agreement. He summarized previous emigration policy and the importance of Palestine in that policy:

> It must be made clear in which direction the stream of Jewish emigration should be steered. In this context, it must be remembered that German Jews generally will be more advanced than the inhabitants of destination countries; this is particularly so in the South American countries. Therefore, we cannot exclude the possibility that the Jews, once in those countries, will soon rise to positions of influence and establish there an economic class hostile toward Germany. For this reason, the past emigration of Jews in the first instance to Palestine has been promoted.

Dr. Blome of the office of the Stellvertreter des Führers observed that Jewish emigration was of paramount importance and that, for this reason, emigration policy should not be wholly dependent upon Palestine as a destination. All of the representatives at the meeting agreed that emigration had to be promoted by all means available and concluded that this could be most effectively done without regard to the *Zielland* (destination country) of the emigrants. Thus, the removal of Jews from Germany was of greater importance than their eventual destination. Germany would take advantage of immigration possibilities for German Jews wherever they existed. This also meant that *Zerstreuung* (dispersion) rather than *Konzentration* (concentration) would be the result of this strategy in Jewish emigration policy.

During the deliberations of the Peel Commission, there was much speculation in Europe and the Middle East about the future of Palestine in light of the conflicting claims and goals of Arab and Jewish nationalism. There was little doubt that significant changes were in the offing due to the breakdown of order in 1936 and the apparent improbability of arriving at a solution based on the status quo. Although the recommendations of the Peel Commission were not made public until July, 1937, there appeared to be a consensus by January that a future settlement might include an independent Jewish state in at least part of Mandatory Palestine. The German Foreign Office was aware of this possibility as early as January 9, when Walther

Hinrichs of Referat Deutschland sent a memorandum to the office of the state secretary, warning him that a recommendation for an independent Jewish state might emerge from the deliberations of the Peel Commission.[13] Hinrichs noted that the political solidarity, and therefore influence, of world Jewry had grown considerably in the recent past, which, coupled with the course of the recent World Jewish Congress and the deliberations of the British Royal Commission, demonstrated that the idea of a Jewish state was being promoted with great energy and that its realization was being carefully prepared. He went on to criticize past indifference in the Foreign Office to the possibility of an independent Jewish state in Palestine and concluded by suggesting that government and Party agencies be made aware of the strategic and ideological dangers posed by an independent Jewish state, which he summarized as follows: "In this connection it must be observed that a Jewish state in Palestine would strengthen Jewish influence throughout the world to unpredictable heights. Just as Moscow is the center for the Comintern, Jerusalem would become the center of a Jewish world organization that could work through diplomatic channels, as Moscow does." He concluded that previous policies of encouraging Jewish emigration to Palestine, in particular the Haavara agreement, should be reexamined in light of the new realities in Palestine and that the government of Great Britain should be informed of German misgivings about a possible Jewish state in Palestine.

Implicit in Hinrichs's remarks was the established ideological doctrine of a Jewish world conspiracy and the resulting National Socialist aversion to Zionism and the idea of an independent Jewish state. According to Nazi logic, international conspiracies are directed from political power bases; a Zionist state in Palestine was seen as such a base for the alleged Jewish conspiracy, just as Moscow was the center for international Bolshevism and the Vatican for political Catholicism. On the other hand, purely strategic considerations necessitated German opposition to an independent Jewish state. The official anti-Semitism of the National Socialist regime and the racial foundations of the new Germany would automatically make an independent Jewish state a natural enemy in international politics. Bülow-Schwante of Referat Deutschland argued that an independent Jewish state would be admitted to the League of Nations and would attach itself to the coalition of states hostile to the new Germany.[14]

On January 16, the Ministry of the Interior informed the Foreign Office that it intended to promote Jewish emigration by all possible means, but without specifically favoring Palestine as had been done

in the past.[15] This had been agreed upon at the meeting at the Ministry of the Interior on September 29, 1936, in the hope that the annual rate of emigration would be increased. There is no indication that the Interior Ministry was in any way influenced by the deliberations of the Peel Commission or by speculation over a possible Jewish state in Palestine. Nor was there any inclination to reduce Jewish emigration to Palestine. The chief concern of the Ministry of the Interior as the chief authority in emigration matters was to secure the fastest, most efficient emigration of Jews from Germany through the utilization of as many receiver countries as possible.

This policy was approved by the Foreign Office, where concern over the outcome of the Peel Commission deliberations was growing. Bülow-Schwante reacted favorably to the Interior Ministry note of January 16, while warning at the same time against too large a transfer of Jews to Palestine: "The Foreign Office also considers it necessary to promote the emigration of Jews from Germany, but not exclusively to Palestine. Therefore, the decisive consideration must be that it is not in the German interest to contribute to the growth of Jewish influence in Palestine, through the promotion of the emigration of highly civilized Jews from Germany, to a level that would necessarily accelerate the establishment of a Jewish national state or 'National Home' under a British Protectorate in Palestine."[16] Bülow-Schwante further argued that the dispersion of German Jews throughout the world, and not their concentration in Palestine, should become an essential part of German foreign policy. He reasoned that Germany must do everything possible to prevent the creation of an independent Jewish state in Palestine, one that would possess the diplomatic means to damage German interests in the world. Thus, while the Ministry of the Interior viewed emigration policy as an element of domestic Jewish policy, the Foreign Office was naturally concerned about the consequences of Jewish emigration on German foreign policy.

The Orient-Abteilung (Pol. VII) in the Foreign Office shared Referat-D's opposition to the creation of an independent Jewish state in Palestine, albeit with some reservations. First, Pol. VII distinguished between a Jewish National Home under British control, which had been accepted by Germany in the past, and an independent Jewish state as advocated in international Zionist circles and proposed by the Peel Commission in July, 1937. Referring to Bülow-Schwante's January 21 note to the Interior Ministry, Pol. VII took a position on January 22 that made the distinction clear.[17] This position defended previous policies based on an acceptance of the provisions of the Balfour Declaration, namely, the establishment of a Jewish National

Home in Palestine under British administration, while at the same time rejecting as dangerous to German interests the possibility of changing the status quo by creating an independent Jewish state. Second, Pol. VII concluded that the alarm expressed by Referat-D was premature and that it was unlikely that the British government would accept the establishment of a Jewish state in the face of Arab opposition in Palestine and throughout the Middle East. While recognizing the danger that large-scale Jewish immigration into Palestine might contribute to the establishment of a Jewish state in the future, Pol. VII rejected Bülow-Schwante's suggestion that Germany conduct an active diplomatic and propaganda campaign against Zionist efforts to create a Jewish state, arguing that this would only provide Jewish propaganda with still more ammunition and thus contribute to the goal of a Jewish state. Finally, Pol. VII recommended a reexamination of overall Jewish policy in Germany only if the much talked about Jewish state should materialize.

In Jerusalem, Consul-General Döhle was as uncertain as Pol. VII about the outcome of the Peel Commission deliberations and its future recommendations. He did not yet share Referat-D's alarm that a Jewish state would be included in the recommendations of the Peel Commission. His reluctance to predict what might happen is evident in his note to the Foreign Office in Berlin on January 25, in which he seemed to lean toward the retention of the status quo as Britain's only realistic option.[18] By the end of March, however, he had become increasingly concerned about the situation in Palestine and the possibility of a Jewish state emerging from the recommendations of the Royal Commission. On March 22, Döhle sent to Berlin a comprehensive report on Palestine, including his assessment of past German policy, the current situation, the possible recommendations of the Peel Commission and their potential effect on German interests and policy.[19] He began by summarizing German policy up to that point: "In all of our previous measures, the primary consideration was the promotion of Jewish emigration from Germany and the settlement of the emigrating Jews in Palestine." Döhle also criticized the Haavara agreement for placing Germany's trade with Palestine in Jewish hands and lamented the fact that German exports to Palestine through Haavara did not earn their full value in foreign currency that the German economy desperately needed. Moreover, Haavara and the policy of openly encouraging Zionist emigration from Germany to Palestine were viewed as rousing Arab opinion against Germany. He noted that Germany had done precious little to cultivate the strong sympathy in the Arab world for the new Ger-

many, and German support for Zionist efforts would in the end turn the Arabs into enemies of Germany.

Döhle also mentioned the negative impact of increased Jewish immigration to Palestine and the possibility of a Jewish state on the security and well-being of the Palästinadeutsche. He noted that a Jewish state would deny both Arabs and Germans a normal life in Palestine. Reiterating that Germans would be held responsible by the Arab community for a Jewish state, and thus become targets for Arab hostility, he also pointed to the dangerous reality that most of the German settlements were in areas with large Jewish populations and would eventually be included in any territory that might be reserved for the Jewish state that could emerge from the Peel Commission recommendations. He concluded that a Jewish state would probably mean an end to the existence of some or all of the German colonies and institutions in Palestine. He also pointed to the dangers of political and economic competition that an independent Jewish state would pose for Germany in the world and questioned whether the domestic goal of rapid Jewish emigration from Germany was worth the sacrifice of important foreign policy interests: "Thus, in our policy toward Palestine until now, we have consciously sacrificed all of the elements, which in other countries are essential for the protection of German interests, in favor of the attempt to implement a policy of promoting Jewish emigration from Germany and the settlement of the emigrating Jews in Palestine."

Nevertheless, Döhle was still not entirely convinced that Britain would risk another Arab rebellion and further alienation of the Arab world by supporting a recommendation to establish a Jewish state in Palestine. His uncertainty remained evident in his admission that either an Arab solution or a compromise solution that retained the status quo with some restrictions on Jewish immigration would have a negative impact on Jewish emigration from Germany. Moreover, he shared the opinion of Pol. VII that Referat-D's suggestion to press Britain to limit Jewish immigration into Palestine and to prevent the establishment of a Jewish state was undesirable and unnecessary. He recommended a reassessment of Germany's priorities in the Jewish question so that legitimate foreign policy interests would no longer be sacrificed to the process of Jewish emigration to Palestine. Döhle did not recommend an end to Jewish emigration from Germany to Palestine. He was merely suggesting the same line agreed upon at the Interior Ministry on September 29, 1936, and endorsed by Pol. VII and Referat-D, that less emphasis be placed on Palestine as a preferred destination for emigrating Jews and that Ger-

man Jews be dispersed throughout the world. This would reduce the flow of German Jews to Palestine, while making the likelihood of a Jewish state in Palestine more remote.

Döhle also suggested a change of attitude toward the Arabs of Palestine, short of direct material assistance. He argued that the existing Arab sympathy for the new Germany and its Führer should be cultivated not through active involvement in Arab politics, but through the strict avoidance of the appearance of supporting or in any way contributing to the development of the Jewish National Home. He insisted that active support for the Arabs was undesirable and unnecessary because of the dangerous implications it would pose for relations with England. He reasoned that an end to overt German encouragement of Zionist efforts in Palestine, such as significant changes in the Haavara system, would be enough to ensure continued Arab sympathy for Germany. At the same time, changes in Haavara would enable Germany better to protect German settlements and institutions in Palestine and would generally retard Jewish efforts to create a viable economic and political base in the country.

Referat-D wanted to pursue the question of German relations with the Arab movement in Palestine, beyond the moral support and reduced cooperation with Zionism proposed by Döhle and Pol. VII. In a note to Foreign Minister von Neurath in February, 1937, Emil Schumburg of Referat-D referred to repeated Arab attempts to secure diplomatic and material assistance from German consular representatives in the Middle East and called for a review of German policy toward the Arabs: "In the view of Referat-D the question of whether it is in the German interest to support in some way (money) the Arabs in order to create a counterweight to the growing Jewish influence in Palestine needs further clarification."[20] In a note to the Propaganda Ministry one month later, Referat-D praised Mussolini's efforts to woo the Arab world and described them as advantageous to the Rome-Berlin Axis.[21] Thus, Referat-D was more inclined to become actively involved on the Arab side in Palestine, and run the risk of damaging relations with Great Britain, than were the responsible sections in the Politische Abteilung. Both Pol. VII and Pol. VI (Southeast Europe, including Italy) penciled out all references to German support for close Italian-Arab collaboration in their copies of the note to the Propaganda Ministry.

Grobba's position on German-Arab relations has already been outlined above. He opposed the kind of direct support for the Arabs that Referat-D was considering at the time, and his position on the establishment of a Jewish state in Palestine was generally in agree-

ment with the views of Döhle, Pol. VII and Referat-D. He too opposed the creation of an independent Jewish state in all or part of Palestine. In April, 1937, during discussions in Baghdad with the British commander-in-chief in Palestine on the crisis in Palestine, Grobba suggested that England's only solution was to be found in the strict interpretation of the Balfour Declaration and the position that any implied Jewish state in the promise of a National Home for the Jews in Palestine could only be a symbolic entity, something similar to the Vatican in Rome, in which Tel Aviv and the surrounding area would be given to the Jews as the center of such a symbolic state.[22]

Two other departments in the Foreign Office were connected with emigration policy and Palestine. The Auslandsorganisation, incorporated into the Foreign Office by Hitler on January 30, 1937, and representing the interests of the Palästinadeutsche, adamantly opposed any increase in Zionist strength in Palestine and the establishment of a Jewish state.[23] It shared Döhle's fears for the future existence of German colonies and institutions if a Jewish state should be established in Palestine and considered the Haavara agreement nothing more than a tool for the building up of the National Home and the ultimate creation of a Jewish state.[24] At one point, the AO even suggested an end to Jewish emigration from Germany altogether so as to ensure that German interests abroad would not be compromised by hostile German Jews.[25]

On the other hand, the Handelspolitische Abteilung strongly supported Jewish emigration to and concentration in Palestine, as well as the continuation of the Haavara arrangement and its positive impact on German exports to Palestine and the Middle East. Deputy Director Carl Clodius outlined the position of his department in a note to Referat-D on June 11·

> As in the past, I am of the opinion that, from an economic standpoint, the emigration of Jews from Germany, insofar as it is taking place and must take place, to Palestine is much less dangerous than the fragmentation of that emigration to a whole series of countries. The economic damage that Jewish emigration to Palestine can cause Germany is relatively insignificant; all the more so since the purchase of German goods by Jewish circles in Palestine will cease at the very moment that the advantages provided by the Haavara agreement, or a similar vehicle, no longer exist.[26]

In the same note, Clodius used the same economic arguments in favor of concentration in Palestine that had been used four years ear-

lier to justify the Haavara accord. He argued that German Jews in countries other than Palestine would ardently support the economic boycott against Germany and would be most effective in doing this, as the majority of German Jews are involved in business and the economy. Thus, the Handelspolitische Abteilung and the Ministry of Economics, as the responsible economic authorities in the question of emigration policy, were less concerned about the strategic and ideological consequences of a Jewish state and desirous of maintaining the increasing flow of German exports to Palestine through Jewish emigration. They wished to continue previous policies without any changes.

By the end of April, 1937, Referat-D began calling for a unified policy on the question of a Jewish state in Palestine.[27] In late April, Ministry Director von Weizsäcker circulated guidelines on future Palestine policy among the responsible departments in the Foreign Office.[28] He began by reaffirming Germany's primary interest in promoting Jewish emigration. He added that it was necessary to avoid concentrating Jews in Palestine, as this would facilitate the creation of an independent Jewish state, to which all departments were opposed at that time. He shared the opinion of Referat-D that the Jews should be dispersed throughout the world in order to prevent the establishment of a power base for world Jewry. This would best be achieved by directing the flow of Jewish emigrants from Germany to destinations other than Palestine. Finally, he cautioned against taking any formal diplomatic initiatives with England on the issue.

In spite of rumors that the Peel Commission would recommend a Jewish state, uncertainty prevailed in Berlin over the outcome of the Commission's deliberations. Only Referat-D was inclined to believe that the Commission would recommend a Jewish state. On May 24, a meeting was held at the Foreign Office and attended by representatives of Referat-D, Pol. VII, the Handelspolitische Abteilung and the AO. It was decided that policy guidelines would be issued to the German Embassies in London, Rome and Baghdad and the German Consulate-General in Jerusalem.[29] The guidelines were to be based essentially on those of Weizsäcker, but to avoid the specifics of emigration policy, which would be resolved when the recommendations of the Peel Commission were made public. There was an awareness that the complex question of Jewish emigration policy would require a comprehensive reexamination with the participation of other interested ministries and agencies and decisions from the highest authorities, including Hitler himself. The Ministry of the Interior, which still controlled the emigration process, and the Ministry of Economics, which was involved in emigration proce-

dures through its role in the financial aspects of Jewish emigration and the Haavara system, would be important factors in future discussions. The SD, which at that time was beginning to clamor for a centralization of authority in Jewish policy as well as a greater role for itself in the formulation of that policy, would also have to be considered.[30]

On June 1, Foreign Minister von Neurath issued the following policy guidelines to the German Embassies in London and Baghdad and to the German Consulate-General in Jerusalem:

1. The establishment of a Jewish state or a Jewish-controlled *Staatsgebilde* [state organization] under British Mandate authority is not in the German interest, for a Palestine state could not absorb world Jewry, but would provide instead an additional, internationally recognized power base for international Jewry, rather like the Vatican state for political Catholicism or Moscow for the Comintern.
2. There exists a German interest in strengthening the Arabs as a counterweight against the constantly growing power of Jewry.
3. It cannot be assumed that a direct German intervention would substantially influence the development of the Palestine question. All the same, it is recommended that interested foreign governments not be completely left in the dark about our views.[31]

The guidelines contained supplementary instructions for each of the three consular missions. The Embassy in London was instructed to inform the British government that Germany's past support for Jewish emigration to Palestine was not intended to facilitate the creation of an independent Jewish state.[32] In Baghdad, Grobba was cautioned that a new attitude toward the Arab cause did not mean material assistance or specific commitments of other active support for the Arab cause in Palestine or elsewhere. Finally, Döhle was informed that the points brought up in his lengthy report of March 22 would serve as a basis for a comprehensive reexamination of emigration policies and the Haavara agreement in the near future.

An indication of the issues that were to be raised in the forthcoming policy review was provided by a Foreign Office circular distributed to all consular missions abroad on June 22, 1937.[33] The circular was prepared by Bülow-Schwante of Referat-D. It contained background information on the Palestine problem, the Peel Commission, Zionist aspirations and Arab resistance, relations with Brit-

ain and the attitudes and policies of France and Italy as interested Mediterranean powers. The circular noted that these factors had led the Foreign Office to begin a reassessment of previous German policy on Palestine:

> Until now, the primary goal of German Jewish policy was to promote the emigration of Jews from Germany by all possible means. To this end, even foreign currency sacrifices were made. Through the conclusion of a transfer agreement with Palestine (the so-called Haavara Treaty) it is possible for Jews emigrating to Palestine to use a portion of their assets in the form of German exports to Palestine to build a new existence there. This German position, dictated entirely by domestic considerations, which in practice promotes the consolidation of Jewry in Palestine, and thus facilitates the building of a Jewish state, could lead one to the conclusion that Germany favors the establishment of a Jewish state in Palestine.

According to the circular, the Jewish question, with its emphasis on the speedy removal of Jews from Germany, had always been treated as a purely domestic issue. It questioned the wisdom of placing the emphasis on the emigration of German Jews rather than their destination, or simply on the domestic rather than the foreign policy implications. Moreover, the circular warned that it was not enough to make Germany *judenrein*, for the Jewish question could not be considered solved when the last Jew left Germany:

> In reality there exists a greater interest in maintaining the dispersion of world Jewry. For the Jewish question will not be resolved for Germany when there are no longer any Jews in Germany. Rather, developments in recent years have shown us that internationally Jewry will inevitably be the *weltanschauliche* and political opponent of National Socialist Germany. The Jewish question is therefore at the same time one of the most important problems in German foreign policy. There exists, therefore, a considerable German interest in the developments in Palestine. For a Palestine state would not absorb Jewry, but would instead create for it—along the lines of the Vatican state—an additional internationally recognized power base, which could have disastrous consequences for German foreign policy.

Thus, the Foreign Office called for a reevaluation of Jewish policy in Germany with due consideration of its impact on the position of National Socialist Germany in a hostile world. It reflected realistic strategic considerations as well as the ideological foundations of National Socialism. The former included the recognition of pro-German sympathies in the Arab world and the potential benefits of cultivating that sympathy, the negative impact of overt German support for Zionist efforts on German-Arab relations and the dangers of an independent Jewish state joining the emerging coalition of states hostile to the new Germany, while the latter reflected the ideological premise of a Jewish world conspiracy. The Neurath guidelines of June 1 were included in the circular, as well as instructions to all consular missions to report on Zionist efforts to rally support around the world for a Jewish state in Palestine.

**The Rejection of Diplomatic Initiatives against the Partition Plan**

With the publication of the Peel Commission report on July 7, and its recommendation for an independent Jewish state in part of Palestine, the German government faced several domestic and foreign policy options in formulating a response. It had become clear even before July 7 that Germany would refuse to participate in any international discussions dealing with the partition plan, no doubt out of fear of making Jewish policy in Germany the subject of debate in any international conference on Palestine. This was certainly clear in the Neurath guidelines of June 1. On July 17, Grobba relayed from Baghdad a request from the Iraqi prime minister for a public statement against the Peel Commission recommendations from a high official in the German government.[34] Neurath made the following marginal comment on the Grobba note: "That is out of the question. We want to stay out of this discussion."

Nor was serious consideration given to influencing events in Palestine through active assistance to the Arab cause. On July 15, Döhle told the Mufti that too close an identity with the Arab position on partition on the part of Germany could have undesirable consequences for both Germany and the Arab cause.[35] On July 30, Neurath informed Grobba that Arab disunity on the partition question was another reason for Germany to keep its distance.[36] Both Weizsäcker and Hentig, the new director of Pol. VII, were opposed to the visit to Berlin by Musa al Alami, a Palestine Arab politician and lawyer with ties to the Mufti, in August, 1937.[37] The visit had been ar-

ranged by Döhle, and al Alami, who was visiting Germany anyway, was granted an interview with Hentig on August 26. Although there are no records of this meeting, one can reasonably assume that Hentig discouraged any efforts al Alami might have made to secure German participation in the Arab campaign against the partition scheme. An unsigned memorandum, probably by Hentig, was circulated in Pol. VII on August 7 and listed some of the options Germany might pursue in order to counter the efforts to establish a Jewish state.[38] These included cooperation with other European governments that might also oppose a Jewish state and financial and military support for the Arabs in Palestine and elsewhere in the Arab world, notably Iraq. However, the author warned against the latter course because of the damage it would cause to Anglo-German relations and because of what he described as "the notorious political unreliability of the Arabs." In a marginal note, Weizsäcker indicated his opposition to using the Arab cause as a weapon against the proposed Jewish state.[39] Finally, Referat-D also indicated its opposition at least to material assistance to the Arabs as a means of preventing the Jewish state. In a memorandum of August 7, Emil Schumburg observed that Germany could not afford the damage to its relations with Great Britain that such support would cause.[40] However, Schumburg did suggest joint German-Italian diplomatic support for Arab efforts against the partition plan. He reasoned that a joint initiative could be undertaken in such a way that British suspicions would not be aroused and even proposed joint Anglo-German-Italian discussions on the problem.

Germany did embark on a press campaign in the summer and autumn of 1937 against the partition plan and the proposed creation of a Jewish state in Palestine.[41] The German press had already adopted a more critical attitude toward Great Britain in 1937 as a result of Hitler's changing attitudes on Anglo-German relations.[42] Articles in the *Völkischer Beobachter* blamed the partition plan for renewed Arab unrest in the summer and autumn of 1937. Britain was criticized for allowing itself to be hurried into a policy that made the situation more volatile and the solution of the Palestine conflict more unlikely. The German press expressed much sympathy for Arab resistance to partition and asserted that the Arabs had an incontestable moral right to protect their country and its Arab character. In August, the German Consulate-General in Jerusalem reported that the German press campaign against partition had been enthusiastically greeted by the Mufti and Arab public opinion in Palestine.[43] On October 26, Neurath received British Ambassador Henderson,

who complained about the anti-British press campaign over Palestine then raging in Germany.[44]

Germany was not willing to pressure anti-Semitic governments in eastern Europe to change their unconditional support for Zionist emigration to Palestine. Poland and Rumania, the two countries in eastern Europe outside of the Soviet Union with the largest Jewish populations, had been ardent supporters of Zionist emigration to Palestine since the end of World War I. The Polish delegation at the League of Nations had consistently supported the Zionist cause throughout the 1920s and 1930s and had periodically applied pressure on Great Britain to allow more Jews into Palestine and to open up Transjordan for Jewish settlement.[45] Besides Palestine, the Polish government was interested in finding other parts of the world capable of taking in large numbers of Polish and other eastern European Jews, as it was obvious that Palestine was much too small to absorb more than a small percentage of eastern European Jewry.[46] While pressing for maximum Jewish immigration into Palestine, the Polish government also tried to obtain overseas colonies to serve as sources of raw materials and as destinations for Jewish emigrants from Poland.[47] In 1937, Poland entered into negotiations with France in an attempt to secure French approval for a plan to send thousands of Polish Jews to Madagascar.[48]

The partition plan of July, 1937, disappointed the Polish and Rumanian governments. On July 5, two days before the publication of the plan, the Deutsches Nachrichtenbüro reported that the Polish government, already aware of what the Peel report would contain, approved the establishment of a Jewish state in Palestine, but was critical of the relatively small area it would occupy.[49] The report also outlined the Polish view that Palestine was a major factor in the solution of the Polish Jewish question. It described the support of the government for a plan of the New Zionist organization (Revisionist) of Poland to send 150,000 Polish Jews annually to Palestine. Later that month, the German Embassy in Bucharest reported the disappointment of the Rumanian government with the small size of the proposed Jewish state.[50] Throughout the summer of 1937, the Polish government tried to pressure Rumania into joining its efforts to persuade Britain to enlarge the proposed Jewish state and to increase Jewish immigration into Palestine.[51]

There does not appear to have been a German effort to persuade Poland and Rumania to alter their support of mass Jewish emigration to Palestine and the creation of an independent Jewish state.[52] In July, the German Embassy in Bucharest outlined the German position on

the partition scheme to officials in the Rumanian Foreign Ministry and some right-wing politicians.[53] The German position was met with little enthusiasm, as evident in the July 28 Embassy report. In Jerusalem, the Mufti expressed Arab concern to German Vice-Consul Dittmann over Polish and Rumanian support for a Jewish state in Palestine and asked for German intervention with both countries to dissuade them from such support.[54] Dittmann promised to relay the information to Berlin, where Referat-D was already trying to organize a diplomatic *démarche* on the matter vis-à-vis Poland and Rumania. In a note to the Interior Ministry on August 17, Bülow-Schwante argued:

> It seems to me necessary to dissuade the Polish government, and especially the Rumanian government, whose foreign minister is currently a reporting member of the Mandates Commission of the League of Nations, from promoting the establishment of a Jewish state out of their single interest in further settlement possibilities for Jews in Palestine. In my view, it is even more in the German interest, in cooperation with the Polish and Rumanian governments, which, like the German government, have a special interest in the Jewish emigration problem, to steer Jewish emigration to countries other than Palestine so as at least not to promote the establishment of a Jewish state in Palestine.[55]

Two days later, Referat-D urged Pol. VII to seek Polish cooperation through the German Embassy in Warsaw in finding destinations other than Palestine to which Jewish emigrants could be directed.[56] Hentig's marginal notes on Schumburg's memorandum to Pol. VII indicate that Hentig opposed putting pressure on the Polish and Rumanian governments in the matter of Jewish emigration to Palestine. He noted that it would be impossible to dissuade those governments from their current policies and that Germany should remain independent on the issue.[57] On August 24, Referat-D again urged Pol. VII to seek Polish cooperation in the question of Jewish emigration to Palestine.[58] However, there does not appear to be any documentary evidence that Germany made any formal diplomatic moves to secure Polish and Rumanian policy changes.[59]

### Emigration Policy and the Haavara Debate

There was little that Germany could do to prevent the establishment of a Jewish state in Palestine. Initiatives that might have had some

impact on events in Palestine, such as participation in international discussions, diplomatic and material assistance to the Arab cause and diplomatic pressure on Poland and Rumania regarding their emigration policies, were not taken. Instead, emigration policy in Germany and the Haavara agreement became the focus of debate in government and Party circles through the second half of 1937 and early 1938. The extent to which Jewish emigration from Germany to Palestine and the transfer of Jewish assets via Haavara facilitated Zionist efforts to build an independent Jewish state was the immediate issue upon which the debate centered. It is doubtful that anyone in the German government believed that events in Palestine could be decisively influenced by changes in emigration policy or termination of the Haavara agreement. German Jews comprised only about 22% of the total Jewish immigration to Palestine between 1933 and 1937 and formed a much lower percentage of the total Jewish population of the country.[60] The success or failure of the National Home and Zionist aspirations for an independent state depended to a much greater degree upon the masses of Jewish immigrants arriving in Palestine from the ghettos of eastern Europe. Germany could not have a decisive impact on the level of Jewish immigration to Palestine, upon which the hopes for a Jewish state ultimately rested. Any decline in the number of immigrants from Germany would be offset by increases in the number from eastern Europe. Thus, an attempt to reduce or suspend Jewish emigration from Germany to Palestine could never be fatal to the ultimate Zionist aim of a Jewish state.

Yet the debate over emigration to Palestine and Haavara went on as if the success or failure of the Jewish state depended on its outcome. Jewish emigration from Germany remained the cardinal principle and chief goal of German Jewish policy at that time. This is evident from the meeting at the Interior Ministry in September, 1936, the Döhle report of March, 1937, the Weizsäcker guidelines of April, the Neurath guidelines of June 1 and the Foreign Office circular of June 22, 1937. To be resolved, however, was the question of whether Jewish emigration from Germany to Palestine and the transfer of Jewish assets via Haavara should be altered or terminated in view of the Peel Commission recommendations. There was general agreement among the interested sections and representatives of the German Foreign Office that previous emigration policies, specifically, the terms of the Haavara agreement, contributed to Zionist strength in Palestine and thereby facilitated Zionist efforts to establish a Jewish state; and with the exception of the Handelspolitische Abteilung, they viewed this with varying degrees of alarm. This position was summarized in a memorandum from the Auslandsorganisation to

Referat-D on June 5, to which both Referat-D and Pol. VII gave their approval:

> The Haavara treaty with the Zionist organizations subordi-
> nates the entire German export trade with Palestine to the
> transfer of capital of emigrating Jews, or those Jews intending
> to emigrate, from Germany to Palestine. It also ensures that
> the Aryan and non-Jewish customers who import German
> goods into Palestine are forced to support Jewish immigration.
> The Haavara transfer signifies in an economic sense an outflow
> of goods without any economic return, be it in the form of
> foreign currency or goods. Politically it means a valuable sup-
> port for the establishment of a Jewish national state with the
> help of German capital. . . . Therefore the Aussenhandelsamt
> [Foreign Trade Office] of the AO proposes, on the basis of past
> experience, a revision of the Haavara treaty that
>  1. results in the outflow of goods from Germany without any
>     return in the form of foreign currency or goods.
>  2. forces the non-Jewish element in Palestine to finance Jewish
>     immigration.
>  3. facilitates the establishment of a Jewish national state with
>     the help of German capital.[61]

There seemed to be a consensus that some alteration of the terms of the Haavara agreement might perhaps have a desirable impact on events in Palestine. Refusal to lend active support to the Arabs and reluctance to pressure eastern European governments into temporiz-ing their ardent support for Zionist efforts left Haavara and emigra-tion procedures in Germany as the only possible areas for action against the proposed Jewish state.

According to the AO memorandum of May 26, and the June 5 variation, the Auslandsorganisation had begun its campaign against the Haavara agreement two years before, only to have those efforts blocked by the Ministry of Economics and by Heinrich Wolff, the former German consul-general in Jerusalem. The May 26 version also referred to the long-standing criticism of Wolff's successor, Wilhelm Döhle. Döhle's criticism of Haavara had been expressed as early as January, 1936, in a note to the Foreign Office in Berlin, in which he warned that Haavara's monopoly over German trade with Palestine was contrary to German interests.[62] During the Arab revolt of 1936, Döhle became fearful that the existence of Haavara might turn Arab opinion against Germany. Not only was it an obvious ex-ample of German collaboration with Zionist immigration into Pales-

tine, but it made the purchase of German goods there dependent on Jewish businesses and the Haavara. Furthermore, it was felt that Haavara monopoly over German trade with Palestine might have an adverse effect on German imports into the country. German goods came in through the Jewish-controlled Haavara, and many of these goods were then sold to Arab buyers. However, an Arab boycott of Jewish businesses accompanied the revolt and general strike in 1936 and thus threatened to cut off German goods from the Arab market in the future.[63]

In September, 1936, the Arab Chamber of Commerce of Jerusalem made an appeal to the German Consulate-General for revision of the Haavara agreement.[64] The Chamber of Commerce pointed out that Haavara had worked satisfactorily for German exports to Palestine, inasmuch as Jews were able to sell German products to Arab consumers on a large scale. However, the letter went on to warn: "At present and for the future, we believe that the Jews will not be able to continue to sell to Arabs to the same extent, as it is strongly anticipated that the Arab consumers will refuse to buy anything from Jews irrespective of the origin of the commodities due to a boycott which has been put into effect since the beginning of the present disturbances." It was also suggested that Germany would do better to concentrate on trade with the Arab majority rather than with the Jewish minority. Yet the letter did not call for an end to Haavara, but proposed instead that direct trade links between German suppliers and Arab importers be established, independent of Haavara. In this way, cash from Arab buyers would go directly to Germany, bringing in much-needed foreign currency, and German exports to Palestine would be secure if the Jewish boycott against German goods should ever take root in Palestine. As for Haavara, the Chamber of Commerce noted, "The Arab Chamber of Commerce does not wish to undermine the policy adopted by, and the agreement entered into between the 'Haavara' and the German government."

The Arab arguments were the basis of Döhle's early calls for revision of Haavara. In November, 1936, he responded to the Arab Chamber of Commerce in the following way: "I know that the aims of the Arab Chamber of Commerce are tending to liberate the Arab market from Jewish mediation. I understand your purpose and I have consequently called the attention of the offices in Germany and the German merchants upon the matter."[65] Neither the Arab community nor Döhle demanded an end to Haavara in 1936. Even the lengthy critique of the Haavara system included in Döhle's report of March 22, 1937, recommended changes in, not the abolition of, the Haavara agreement.

Both Döhle and the AO were also motivated by the impact of Haavara on the Palästinadeutsche. The complaint of the German communities was essentially the same as that of the Arabs. Imported goods from Germany were purchased through Haavara Ltd. in Palestine. With the increasingly unfriendly relations between Jews and non-Jewish Germans in Palestine, including Jewish boycotts of the agricultural products of the Temple colonies, reliance upon the Haavara system for imported goods from Germany created an unfavorable situation for the Palästinadeutsche.[66] Döhle asked for special arrangements whereby Palestinian Germans could import goods from Germany at favorable prices without depending upon Haavara.

In March, 1936, negotiations were initiated by the Foreign Office, the Reichsbank and the Ministry of Economics with representatives of Haavara Ltd. The German side asked Haavara officials to use their influence to halt the Jewish boycott of the products of the Temple Society settlements and to ensure that German importers in Palestine would not be discriminated against by Haavara when they bought German goods.[67] The Haavara officials agreed to work for an end to the Jewish boycott of German agricultural products in Palestine and to ensure equal access to German imports for the Palästinadeutsche.

This did not satisfy the demands of Döhle and the AO for a revision of the Haavara system to include separate arrangements for Arab and German importers. The Haavara system on the German end had been under the control of the Ministry of Economics and its foreign currency section, the Reichsstelle für Devisenbewirtschaftung, and the Reichsbank since its inception in 1933, and the economic authorities in 1936 were not willing to alter the system to suit the demands of Döhle and the AO. The AO's frustration and disapproval over the government's refusal to make the desired changes is evident in its note to the Reichsstelle für Devisenbewirtschaftung on April 6, 1936.[68] Later that year, the Ministry of Economics reiterated its objection to major revisions in the Haavara system. In a note to the Foreign Office in November, the Reichsstelle für Devisenbewirtschaftung observed that the establishment of additional procedures for Arabs and Germans to import German goods into Palestine outside of Haavara would inevitably have a disturbing impact on the entire market for German goods.[69]

By the spring of 1937, the campaign against Haavara had been given new impetus by the Peel Commission and the growing concern and debate over a possible Jewish state in Palestine. Previous arguments concerning the Haavara monopoly over German trade with Palestine and its impact on Arab and German importers had not been able to generate enough opposition within the German gov-

ernment to have the Haavara agreement altered. However, the possibility of an independent Jewish state in Palestine, and Haavara's contributory role, did result in substantially more criticism of Haavara, especially in the Foreign Office. Döhle and the AO were joined by Referat-D and Pol. VII (under Pilger) in calling for a complete revision of the Haavara system.

As in the past, the Ministry of Economics was opposed to major changes in the Haavara system. The AO memoranda of May 26 and June 5 refer with regret to the continuing support for Haavara by the Ministry of Economics and the Handelspolitische Abteilung of the Foreign Office.[70] However, the Ministry of Economics had begun its own reassessment of Haavara amid the growing controversy in the spring of 1937 over the possibility of a Jewish state in Palestine. In late March, the Ministry sent Assessor Wilmanns, the adviser for Haavara in the Reichsstelle für Devisenbewirtschaftung, on a two-month trip to the Middle East, which included a lengthy stay in Palestine. In Palestine, Wilmanns held discussions with Döhle, Cornelius Schwarz of the NSDAP/Landesgruppe-Palästina, representatives of the Bank of the Tempelgesellschaft and other German businessmen, as well as with Arab businessmen and various Haavara and Zionist officials. He also visited Jewish settlements in an effort to ascertain the results of almost four years of Haavara. It is not known how Döhle reacted to the activities of Wilmanns in Palestine, although it is reasonable to assume that the consul-general was not pleased. Landeskreisleiter Schwarz was very critical of Wilmanns and his activities in Palestine. In a letter to Gauleiter Bohle of the AO in Berlin, Schwarz complained that Wilmanns was too supportive of Haavara, Zionism and Jews in general.[71] He further complained that Wilmanns had spent most of his time on Jewish settlements and had even accepted an invitation to dine with Jews in Tel Aviv on Hitler's birthday. He concluded that Wilmanns was unqualified to report on the situation in Palestine because he was so one-sidedly supportive of Germany's worst enemies and because his activities had severely damaged Germany's position in Palestine.

In early May, shortly after his return to Berlin, Wilmanns put together several reports on his stay in Palestine that are indicative of his and his Ministry's disagreement with Döhle, Referat-D, Pol. VII and the AO on the matter of Haavara.[72] In one report, entitled "Die handelspolitische Behandlung des arabischen Bevölkerungsteiles" (The Trade Policy Treatment of the Arab Population Segment), Wilmanns argued that the Haavara system was not damaging Arab attitudes toward Germany and Arab-German relations. He noted that the Arab boycott of Jewish businesses should not be taken seriously

because many Arabs were still buying from Jews. He also observed that many Arabs continued to sell land to Jewish interests, which indicated again how much business and how little Palestinian nationalism meant to them. Although he admitted that most Arab businessmen would prefer to do business with Germany outside of the Haavara system, he noted that they would in fact continue to do business through Haavara if they were assured fair prices and equal treatment. He concluded that Arab friendship for Germany remained strong and did not appear to be undermined by the obvious facilitation of Jewish immigration into Palestine by the Haavara agreement.

Wilmanns did arrange for the Tempelbank, the only non-Jewish institution participating in the Haavara system on the Palestine end, to deal with all Arab complaints against Haavara and to handle more Arab business transactions within the Haavara system. It was hoped that this would also enhance the role of the Tempelbank in the overall Haavara operation. He also rejected Döhle's March 22 assessment of the Haavara agreement and its impact on Arab-German relations and cautioned against acting on Döhle's hypotheses until the situation in Palestine was clarified by the publication of the Peel Commission recommendations.

The anti-Haavara forces suffered a setback in July when Werner-Otto von Hentig replaced Hans Pilger as head of Pol. VII in the Foreign Office. Under Pilger, Pol. VII had generally supported the arguments of Referat-D, Döhle and the AO with regard to emigration policy (the need to disperse German Jews throughout the world), Palestine and Haavara. Although Hentig's personal views on the establishment of an independent Jewish state in Palestine appear to have been uncertain, he did favor continued Jewish emigration from Germany to Palestine and the retention of Haavara as a means to that end. He supported a policy of concentrating Jews in Palestine, and their autonomy in a Palestinian state with an Arab majority, as Germany's response to the recommendations of the Peel Commission.[73] In an undated memorandum, most likely composed during the debate over Haavara in the autumn of 1937, Hentig reviewed the opposition of Referat-D and others to the agreement and their desire for major changes.[74] He observed that Hitler's overriding goal of rapid Jewish emigration from Germany would be compromised by fundamental changes in the Haavara system, which had in the past so successfully facilitated the emigration process. In further defending Haavara and the position of the Ministry of Economics, he argued that Haavara had cost Germany very little and that it had the potential for expansion, thus further facilitating rapid Jewish emigration from Germany. Hentig concluded by addressing himself to the ques-

tion of *Zersplitterung* vs. *Konzentration* as the basis of emigration policy, and the related question of a Jewish state in Palestine:

> In Palestine, the Jews live among themselves. There they face difficult political and economic problems. Even under the most favorable conditions, the territory allotted to the Jews by the partition plan can absorb only two million Jews. They find themselves in a small corner of the Mediterranean where they do not in any way cross paths with vital German interests. Militarily they are and will remain insignificant as far as we are concerned. For us, the concentration of Jews in Palestine, as my discussions with individual Jews have already indicated, is politically and economically more advantageous than the existence of many separate settlement areas in, let us say, Russia, Madagascar or Equador, or in others that are currently being discussed. Moreover, I am convinced that a Jewish state must become the center of a more responsible policy than the scattering of Jewish influence over the entire world and its governments. . . . For these reasons, I consider it politically correct to continue promoting emigration to Palestine as the best solution to the Jewish problem, albeit with whatever limits to Haavara deemed necessary.

The first ministerial conference on the Palestine question was held at the Foreign Office in Berlin on July 29, three weeks after the publication of the Peel Commission report.[75] Besides the interested departments within the Foreign Office, the meeting was attended by representatives of the office of the Stellvertreter des Führers, the Ministry of the Interior, the Ministry of Economics and the Reichsstelle für Devisenbewirtschaftung, the Reichsbankdirektorium and Rosenberg's Aussenpolitisches Amt. A notable absentee was Consul-General Döhle, who was unable to leave Jerusalem at that time. The Haavara issue was discussed within the context of three policy questions: Jewish emigration from Germany, the economic consequences of Haavara and Germany's Arab policy. During the deliberations three options in emigration policy were outlined: the emigration of Jews could be stopped entirely and German Jews held under the strict control of "innerdeutsche Stellen mit allen sich daraus ergebenden Einwirkungsmöglichkeiten" (internal German authorities with all of the possible resulting influences); emigration could be promoted with a view toward avoiding concentration in Palestine and dispersing German Jewry throughout the world; or Jewish emigration could be directed principally toward Palestine, with the

advantage that concentrating Jews in one area would enable the Reich more easily to neutralize the Jewish world conspiracy. At that time, nobody supported the first option, the one adopted in 1941 in preparation for the "final solution."

A representative from the Ministry of the Interior asserted that Hitler had carefully weighed the options in emigration policy and had decided in favor of the third, namely, continued emigration to and concentration in Palestine. The Interior Ministry concluded that any resolution of the Haavara issue that hindered further Jewish emigration in any way was, therefore, out of the question. Hitler's apparent approval of continued Jewish emigration from Germany to Palestine by no means settled the Haavara debate. Still at issue were the economic pros and cons of the Haavara system and the relationship of Arab and German importers in Palestine to that system. Neither of these questions was settled at the July 29 meeting, and their resolution was postponed for two months in order to give the participants in the debate an opportunity to purge the Haavara system of its negative aspects. As of July 29, the Haavara system was still in operation as before, with the general agreement that changes in the procedures for German and Arab importers in Palestine would be worked out within the system.[76]

The Haavara discussions resumed at the Foreign Office on September 21, and at the Ministry of Economics on September 22. The tenor of the discussions was somewhat different from those held on July 29. By September, there was no question that Jewish emigration from Germany to Palestine would continue, probably as a result of Hitler's directive that Jewish emigration continue by all possible means. Therefore, the priority of all-out Jewish emigration was to be the most important consideration in resolving the Haavara question, which is clearly evident in the September meetings.[77] There was some question about the accuracy of the Interior Ministry statement in July claiming that Hitler had decided in favor of concentrating German Jews in Palestine. At the September 21 meeting in the Foreign Office, a representative of the Ministry of the Interior attempted to clarify his Ministry's statement on Hitler's position on Jewish emigration to Palestine.[78] It was noted that Hitler's decision in July had been a general one in favor of continued Jewish emigration from Germany by all possible means and that he had said nothing specifically about directing the emigration process to Palestine. The Interior Ministry again stressed the position that any revision of the Haavara agreement, or reduction in the volume of its transactions, should not be allowed to have an adverse affect on the total Jewish emigration from Germany.

If Hitler did not single out Palestine as a preferred destination, neither did he exclude it as an important *Zielland* in the emigration process. This is apparent in the course of the September discussions on Haavara. Statements made by the traditional critics of Haavara reflected the impact of Hitler's July directive on emigration. Even Consul-General Döhle, one of the earliest and most persistent critics of Haavara, emphasized his wish to retain the system, albeit in revised form, as an instrument for promoting Jewish emigration from Germany in accordance with Hitler's instructions.[79]

The discussions continued on the following day at the Ministry of Economics. An interim solution to the problem of Arab and German importers in Palestine was reached whereby the Tempelbank, in accordance with Wilmanns's suggestions of May and June, would handle all transactions involving German and Arab importers in Palestine within the Haavara system.[80] The Ministry of Economics had again successfully prevented a major revision of the Haavara. Attempts by Döhle and the AO to take Palestinian Arab and German importers out of the Haavara system had been frustrated, at least for the time being. The Ministry of Economics did agree that some categories of German goods, which normally were not made available for export via Haavara, would become available to German importers in Palestine.[81] The critics and the supporters of Haavara appear to have reached a degree of consensus by the end of the deliberations, which is evident in an AO memorandum of September 23 describing the course of the September meetings.[82] The memorandum concluded: "Although the results of the meetings of the twenty first and twenty second of this month do not meet the wishes of the AO 100%, it also appears that the Ministry of Economics is no longer an obstacle to some legitimate changes in the Haavara accords. Moreover, Consul-General Döhle and Landesgruppenleiter Schwarz appear to be satisfied with the results of the negotiations."

The debate over Haavara was touched off again in October by the Ministry of the Interior. Its position on Haavara had been based solely upon the impact of Haavara and Jewish immigration to Palestine on the total volume of Jewish emigration from Germany. So long as Palestine and Haavara provided an effective outlet for Jewish emigrants, the Interior Ministry gave its support to Zionist efforts in Germany. At the conferences in July and September, the position of the Ministry had been that decisions on Haavara and Palestine would have to be made within the context of Hitler's July directive on emigration.

By the autumn of 1937, the Interior Ministry had begun to react to events in Palestine and their impact on the emigration process in

Germany. Total Jewish immigration into Palestine had fallen off considerably in 1936 and 1937 due to the violence of the Arab revolt and the general political uncertainty surrounding the Peel Commission. After the publication of the Commission's recommendations in July, 1937, the Arab revolt broke out again with renewed vigor; by mid-October, violence surpassing the level of the previous year raged throughout the country. This resulted in a substantial decrease in Jewish immigration to Palestine, and with it a decrease in the level of Jewish emigration from Germany to that country.[83] The argument so successfully utilized in the past by the Ministry of Economics and others that the Haavara system and Jewish emigration from Germany to Palestine were essential elements in the process of making Germany *judenrein* was being undermined by events in Palestine.

On October 7, the Interior Ministry invited representatives of the office of the Stellvertreter des Führers, the Foreign Office, the Ministry of Economics and the Sicherheitsdienst of the SS to a meeting later that month for further discussions on Haavara and overall emigration policies. The Interior Ministry outlined the following reasons for calling the meeting: "Developments in Palestine have led to the conclusion that the Haavara agreement can no longer fulfill its original task, namely, the promotion of Jewish emigration from Germany to Palestine, in desirable numbers from the standpoint of domestic Jewish policy. Therefore, I consider it necessary to raise the question of whether the agreement should be maintained in the future, and what other possibilities exist for promoting Jewish emigration from Germany."[84] The meeting was called for October 18. On October 14, the Interior Ministry asked the Ministry of Economics to postpone the implementation of the interim agreement on Haavara reached in September, since the Haavara agreement would once again be the subject of debate and its maintenance appeared to be no longer justified.[85] Thus, the anti-Haavara forces received a new ally. The Interior Ministry's criticism of the Haavara agreement was not based upon the difficulties of Arab and German importers in Palestine in the face of the Haavara monopoly, or the unavailability of certain categories of German goods to those importers, or the fact that exports to Palestine through Haavara did not earn their full value in much-needed foreign currency or Haavara's contributory role in the possible establishment of a Jewish state; rather, it concluded that the Haavara arrangement was no longer able to fulfill its intended task of effectively contributing to Jewish emigration from Germany. It appeared to the Ministry of the Interior that Palestine would no longer be able to absorb large numbers of Jews from Ger-

many because of the continuing unrest and the consequent restrictive immigration policies of the British Mandatory government.

During the October 18 meeting, the representative from the Reichsstelle für das Auswanderungswesen (Reich Office for Emigration Affairs) in the Ministry of the Interior noted with alarm the decline in overall Jewish emigration from Germany in 1937.[86] The reasons given for the decline were the growing reluctance of most countries to accept Jewish immigrants; the unrest in Palestine, which discouraged prospective Jewish immigrants; the increasing number of German goods that did not qualify for export through Haavara; and improved economic conditions in Germany that encouraged Jews to stay. The representative of the Reichsstelle für Devisenbewirtschaftung offered the usual defense of the Haavara system, which was countered with Interior Ministry arguments urging termination of the agreement. Bernhard Lösener of the Interior Ministry summarized his Ministry's position in the following way: "The exhaustive debate has led to the conclusion that, with the considerable decline in Jewish emigration to Palestine, the disadvantages of the agreement so far outweigh its advantages that, from the standpoint of domestic Jewish policy, there no longer exists an interest in the agreement, and it no longer seems justifiable to maintain it."[87] Lösener's views were accepted by the representatives of the office of the Stellvertreter des Führers and the Foreign Office, while the Ministry of Economics continued to insist that the Haavara system was still the cheapest way to promote Jewish emigration from Germany.

The Interior Ministry's proposal to terminate the Haavara accords was not an attempt to end Jewish emigration from Germany to Palestine. Lösener noted that Hitler's directive for all-out Jewish emigration, as well as the new realities in Palestine, had neutralized the effectiveness of Haavara, but that Palestine would continue to be an important destination for Jewish emigrants from Germany.[88] Moreover, there was complete agreement among the participants at the October 18 meeting that the *Umschulungslager* and other retraining programs for Jews emigrating to Palestine should continue to function.

The traditional opponents of Haavara were quick to add the reasoning of the Ministry of the Interior to their own in an effort to have the agreement ended. To the argument that the Haavara system should be abolished because it no longer effectively contributed to Jewish emigration from Germany was added the old argument that Haavara contributed to Jewish economic strength in Palestine, thus

facilitating Zionist efforts to build an independent Jewish state. The opponents of Haavara were able to stress both the undesirability of transferring Jewish capital to Palestine and the growing incapacity of Haavara to contribute to Jewish emigration from Germany. These arguments were summarized in an AO memorandum at the end of October, 1937, as the basis for another call for the termination of Haavara: "One thing is clear, the Haavara agreement is no longer capable of promoting the emigration of Jews to Palestine. Beyond that is the decision of the *Reichsaussenminister* [Foreign Minister] that the strengthening of Jewry in Palestine is for political reasons undesirable. It is therefore necessary that the Haavara agreement be terminated immediately."[89]

The Ministry of Economics continued its efforts to save the Haavara agreement in the waning months of 1937. In late October, the Ministry prepared counterarguments to those set forth by the Ministry of the Interior a few weeks before. On October 29, a memorandum on the Haavara question was sent to the Foreign Office, the office of the Stellvertreter des Führers, the Beauftragter für den Vierjahresplan (Plenipotentiary for the Four-Year Plan), the AO, the Reichsbank-Direktorium and the Ministry of the Interior warning against termination of the Haavara pact.[90] It was argued that an end to the Haavara system would result in a new Jewish boycott in Palestine and elsewhere. Moreover, the memorandum contained the usual assertion of the Ministry of Economics that an end to Haavara would have a negative impact on Hitler's plans for all-out Jewish emigration. The Ministry conceded that some revision was necessary, whereby less well-to-do emigrants might have greater opportunity to utilize the system and Arab and German importers in Palestine might be granted greater independence.

In early December, the Reichsstelle für Devisenbewirtschaftung proposed measures it hoped would shield Haavara from the problems of the emigration process.[91] It was suggested that retraining opportunities be made available to more prospective emigrants and that the economic status of Jews still in Germany be protected so that they would not become too poor to be eligible for immigration to other countries. It was also proposed that foreign currency brought into Germany by immigrating Auslandsdeutsche be sold to emigrating Jews for twice its value in Reichsmarks. Other suggestions for making more foreign currency available to Jewish emigrants were made. They involved for the most part a greater utilization of the assets of well-to-do Jews in order to provide poorer Jews with the financial means to emigrate. The December proposals also counted heav-

ily on a change in the political situation in Palestine that might reverse the decline in Jewish immigration to that country.

The Ministry of Economics was joined by Werner-Otto von Hentig in its efforts to save the Haavara agreement. Both could have argued that an independent Jewish state in Palestine, free from Arab resistance and British restrictions, would open the gates to greater numbers of Jewish immigrants and thereby have a positive impact on Jewish emigration from Germany. They realized, however, that this was contrary to German policy as outlined by the Foreign Office in June, 1937, and to National Socialist ideology. Basing their support of Haavara on the desirability of an independent Jewish state in Palestine would be counterproductive. Haavara could only be justified in terms of its capacity to promote Jewish emigration from Germany, while at the same time avoiding any significant contribution to the establishment of a Jewish state.

Hentig attempted to support Haavara by stressing the improbability of a Jewish state in Palestine, regardless of the level of Jewish immigration and the Haavara system. In an undated memorandum, composed in late 1937 or early 1938, he made the following observations:

> The fear of promoting the establishment of a sovereign Jewish state has led to the suggestion that Jewish emigration to Palestine be terminated. A half year after the appearance of the Peel Plan, the situation is such that in the British Cabinet, with the exception of Ormsby-Gore, there is no inclination to carry out the Peel Plan and its proposed partition of Palestine. In Jewish and Arab circles, resistance to the plan has become so strong that the chances for the establishment of the Jewish state in the foreseeable future must be viewed as very slim.[92]

Hentig further argued that even if the Peel recommendations were carried through, and there was the likelihood of a Jewish state in the near future, an end to Haavara or to Jewish emigration from Germany to Palestine would have little if any impact on developments there. He noted that any decline in the numbers of Jews from Germany would easily be offset by immigrants from eastern Europe who would probably be even more hostile toward Germany than German Jews. Hentig's observations on the unlikelihood of a Jewish state at that time were shared by Consul-General Döhle, the Handelspolitische Abteilung and the Politische Leitung in the Foreign Office. In December, 1937, and January, 1938, Carl Clodius of the Handels-

politische Abteilung, Otto von Bismarck and Ernst von Weizsäcker of the Politische Leitung and Consul-General Döhle in Jerusalem had all expressed their conviction that it was unlikely that Britain would implement the partition recommendation of the Peel Commission for the reasons already outlined by von Hentig.[93]

### Hitler's Intervention and the Continuation of Jewish Emigration to Palestine

By the end of 1937, the Haavara debate had still not been resolved. The fate of Haavara had been effectively separated from the question of Jewish emigration to Palestine since Hitler's July directive on Jewish emigration. In the subsequent discussions of September and October, it was understood that emigration to Palestine would continue as part of the general emigration process. After the October conference at the Ministry of the Interior, the Haavara system was judged more in terms of its growing incapacity to contribute to Jewish emigration from Germany than in terms of its role in strengthening the Zionist position in Palestine. Moreover, much of the debate over Haavara had concerned revision of the agreement rather than its termination. Throughout the debate during the summer and autumn of 1937, there was never any doubt that Jews would continue to emigrate from Germany to Palestine regardless of changes in or even termination of the Haavara agreement. Indicative of this is the permission granted to the Adriatica-Societa Anonima de Navigazione of Venice in late November to promote in Germany Jewish emigration to Palestine via Italian harbors.[94]

Hitler's role in the debate over emigration policy, Palestine and the Haavara agreement is difficult to assess, as is his role in all aspects of National Socialist Jewish policy. The debate over emigration to Palestine and Haavara in 1937 amply demonstrated his aloofness, as well as some of the confusion in policy making that resulted from the multiplicity of authorities and agencies dealing with the Jewish question. Yet no important aspect of Jewish policy is likely to have been adopted without Hitler's prior approval. He seems to have provided the general policy goals and to have intervened periodically in the debates among the many Party and government agencies over the best means of achieving those goals. In this way, the question of Jewish emigration to Palestine was resolved in 1937 and 1938.

The available evidence indicates that Hitler opted for continued Jewish emigration from Germany to Palestine, in spite of the partition plan and the possible creation of an independent Jewish state. Had Palestine been excluded from the emigration process in his July

directive, there would have been no need for further debate over Haavara and Jewish emigration to Palestine. Yet Hitler left the Haavara question open in July for further discussion, and it is clear from the tenor of the September and October discussions on Haavara that emigration to Palestine would continue regardless of the proposed Jewish state, if necessary without Haavara.

Sometime in January, 1938, Hitler again intervened in the ongoing debate over Haavara and Jewish emigration to Palestine. In contrast to his directive of July, 1937, Hitler made a specific commitment in January, 1938, to continued Jewish emigration to Palestine. In the Foreign Office, Carl Clodius of the Handelspolitische Abteilung referred to Hitler's decision in a summary of German policy contained in a lengthy memorandum to Referat Deutschland.[95] Clodius noted the general consensus among all interested agencies that revision of the Haavara agreement must not compromise Jewish emigration from Germany to Palestine, since Hitler's July directive on Jewish emigration could not be carried out if Palestine "in dieser Beziehung ausgeschaltet wird" (is excluded in this respect). He also observed that Germany's firm and unequivocal stand against an independent Jewish state in Palestine did not preclude continued Jewish emigration from Germany to Palestine, since the Peel recommendations had proven impossible to implement. Finally, Clodius referred to Hitler's decision that month that Jewish emigration to Palestine must continue unhindered.

Ernst von Weizsäcker made reference to Hitler's decision in a note to the Aussenpolitisches Amt of the NSDAP sometime in January, 1938.[96] He briefly reviewed the debates and discussions over Haavara and Jewish emigration to Palestine during the past year and noted that, according to a recent decision by Hitler, Jewish emigration to Palestine should continue as before. Moreover, a note from the Aussenhandelsamt of the AO to the director of the AO in the Foreign Office on February 1 verified Hitler's decision in the following way: ". . . in a recent decision, the Führer, after consultations with Reichsleiter Rosenberg, has decided that Jewish emigration from Germany should continue to be promoted with all possible means, and that it should be directed in the first instance to Palestine."[97]

Former Zionist officials have also verified Hitler's January, 1938, decision on Palestine. The late Dr. Ernst Marcus stated in his article that he was informed by von Hentig in early 1938 that Hitler had made an affirmative decision on Haavara and Jewish emigration to Palestine and that all obstacles to this emigration had been removed.[98] At the Eichmann trial in Jerusalem in 1961, the late Dr. Benno Cohen, the last chairman of the Zionistische Vereinigung für

Deutschland, testified that after differences of opinion on the German side regarding Haavara, a decision had come down from above that the program should go on and that German Jews should continue to emigrate to Palestine.[99] Reference to this decision is also made in Werner Feilchenfeld's study on the Haavara agreement.[100] Feilchenfeld also relates evidence of Hitler's continued support for Haavara and Jewish emigration to Palestine as late as July, 1939. In a report to Haavara Ltd. on his talks with von Hentig and others in the German Foreign Office from July 2 to 9, 1939, Feilchenfeld notes that von Hentig told him of a discussion with Hitler at the Obersalzberg some three weeks before, during which Hitler told von Hentig that he desired continued Jewish emigration to Palestine.[101] Further evidence can be obtained from two Gestapo memoranda of February and March, 1938, respectively, that allude to the "erwünschte weitere Abwanderung deutscher Juden nach Palästina" (desired further migration of German Jews to Palestine).[102]

Gestapo actions beginning in February, 1938, reflect Hitler's decision of the previous month. Dr. Hans Friedenthal of the Zionistische Vereinigung für Deutschland was empowered to negotiate directly with the British Embassy in Berlin and the Colonial Office in London in an effort to secure greater immigration opportunities for German Jews in Palestine.[103] In July, the Gestapo permitted representatives of the Vienna Palästinaamt (Palestine Office) and the Vienna Israelitische Kultusgemeinde (Israelite Religious Community) to go to London to seek an increase in immigration certificates for German Jews to enter Palestine.[104] Moreover, exceptions to the tight restrictions on Jews entering Germany continued to be made for Zionist officials on business in Germany.[105]

The diaries of retired general Gerhard Engel, one of Hitler's former adjutants, might provide further evidence on Hitler's attitude toward Jewish emigration from Germany to Palestine. According to Engel, Hitler mentioned in 1939, and again in 1941, a plan he had devised in 1937 to send Germany's remaining Jewish population to Palestine. Engel described the plan in the following manner:

> At the time it occurred to him to get rid of the 600,000 German Jews through a business transaction, and he took his plan to offer the British the half million Jews as laborers for Palestine very seriously. But the plan was not well received by the English or by other states. The British made it clear to him in a note that they already had their hands full with this problem and did not wish to add to the unrest.[106]

Engel has also informed me that, although Hitler was skeptical about Zionism and opposed the creation of a Jewish state in Palestine, he did not reject the Zionist option in German Jewish policy.[107] The former adjutant asserted that Hitler came to favor *Konzentration* over *Zerstreuung*, preferably in the more remote areas of the world so as to isolate and thus exclude German Jews from the world political mainstream. He claimed that Palestine and other parts of the British and French empires were increasingly viewed as likely areas in which German and later European Jews might be concentrated and thus removed from the political stage. In the same letter, Engel maintained that feelers were first put out to England at the 1936 Olympic games in Berlin, but that the British showed no interest.[108] He claimed further that the 1937 offer was made through British Ambassador Nevile Henderson in Berlin, and again through Hjalmar Schacht during a visit to London that year and that Schacht was Hitler's negotiator for this plan. England is said to have rejected this overture as well.

It is possible that Hitler himself was an inaccurate source and that Engel simply took down what Hitler had said in 1939 and 1941. We know that Hitler did concern himself with the question of Jewish emigration and Palestine in 1937 and 1938 and that he decided then in favor of continued Jewish emigration from Germany to Palestine. We also know that the basic thrust of German emigration policy from 1938 to 1940 was *Konzentration* of German and later European Jewry, whether in Palestine, Madagascar or elsewhere, a matter considered below. It may be, however, that the idea of offering German Jews to Britain as laborers for Palestine never went beyond the confines of Hitler's imagination and table talk, but that it is still indicative of his concerns and decisions at that time. He may simply have talked about desires and intentions as if they were facts.[109]

It is difficult to assess the reasons for Hitler's intervention in favor of continued Jewish emigration to Palestine. It does not appear likely that he was affected by factors specifically related to the conflict in Palestine itself or the arguments of those involved in the Palestine debate in Germany. He may have come to discount the likelihood of a Jewish state ever being established in Palestine in the face of Arab resistance and British reluctance. I have found no evidence that he was moved in this instance by the traditional anti-Semitic thesis that the Jews were racially, culturally and historically incapable of building their own state. On the other hand, he may have concluded that Jewish emigration from Germany to Palestine had little effect on the course of events there and that a Jewish state would emerge in Palestine regardless of Germany's Jewish and emi-

gration policies. It would perhaps be more fruitful to seek an explanation within the framework of Hitler's overall foreign policy initiatives and plans for war after late 1937, considered below.

The fate of Haavara was not settled by Hitler's decisions in early 1938. The events of late 1937 and early 1938 severed the connection between Jewish emigration to Palestine and the Haavara agreement in future German policy. The former would continue as before, while the continued existence of the latter remained uncertain and increasingly irrelevant. The debate over the Haavara system continued with waning interest and immediacy until the autumn of 1939, when the agreement lapsed as a result of the outbreak of war.[110] The orderly but slow and time-consuming Haavara process was becoming inappropriate to the changing needs and demands of Germany's domestic Jewish policy after 1938. Haavara was no longer able to fit in with the harsh economic conditions imposed on German Jews in 1938 and the mass deportation procedures adopted by the SS after 1938.

# 8. Continuation of the Zionist Option

## War Plans and Racial Policy

Hitler's initiatives in 1937 and early 1938 in the questions of Jewish emigration and Palestine can best be understood in terms of Uwe Dietrich Adam's phrase "Hitlers Verknüpfung von Kriegsplanung und Rassenpolitik" (Hitler's linking of war planning and race policy).[1] It does not appear that Hitler troubled himself to any extent with the theories and arguments of the interested government and Party agencies in the Palestine question from 1933 to 1937. There is no evidence that he expected an independent Jewish state to emerge as a result of the recommendations of the Peel Commission or that he believed German emigration policy affected the course of events in Palestine one way or the other. There can be little doubt, however, that his initiatives in all aspects of Jewish policy were prompted by the ideological requirements of a National Socialist *Weltanschauung* that made racial doctrine the ultimate basis of German foreign policy.[2] That foreign policy was geared toward an eventual war for the achievement of a new racial order in Europe. Its prerequisite was a new racial order in Germany that, by early 1938, had not yet been accomplished. The decision to continue pushing German Jews to Palestine was part of the broader efforts in 1938 and 1939 to complete the new racial order in Germany before the planned war for *Lebensraum*. These included the final elimination of Jewish participation in the German economy and the new forced emigration schemes of the SS. A Foreign Office circular entitled "Die Judenfrage als Faktor der Aussenpolitik im Jahre 1938" (The Jewish Question as a Factor of Foreign Policy in 1938), issued by Referat Deutschland on January 25, 1939, emphasized the connection between Germany's foreign policy initiatives and those undertaken in domestic Jewish policy in 1938:

It is certainly no accident that the year of destiny 1938 has brought the Jewish question nearer to its solution simultaneously with the realization of the Greater German idea. For Jewish policy was both the precondition and the consequence of the events of the year 1938. Perhaps more than the power-political opposition of the former enemy alliance of the world war, the pressure of Jewish influence and the undermining Jewish spirit in politics, the economy and culture has crippled the strength and the will of the German people to rise again. The cure for this sickness of the *Volkskörper* [body politic] was, therefore, one of the most important preconditions for the application of power that in 1938, against the will of the world, forced the union of the Greater German Reich.[3]

Hitler had expressed his intention to wage war on several occasions after 1933. Besides his above-mentioned speech before the Reichswehr generals on February 3, 1933, he addressed an assembly of Gauleiter and other Party officials in Munich in September, 1935, announcing his intention to wage war after a preparation period of four years.[4] His memorandum announcing the Four-Year Plan in August, 1936, outlined plans to make the economy and the army ready for war within four years.[5] He also reiterated his aims in central and eastern Europe, and his intention to achieve those aims by war, at the Reichskanzlei meeting on November 5, 1937.[6] Moreover, personnel changes in late 1937 and early 1938 may be presumed to have been designed to remove opposition to those plans from within the government and the military. Schacht went on leave of absence from the Ministry of Economics in September, 1937, and resigned on December 8 of that year.[7] In January and February, 1938, Hitler secured the removal of the minister of war and commander-in-chief of the armed forces, Field Marshal Werner von Blomberg, and of the commander-in-chief of the army, General Werner Baron von Fritsch.[8] Both men had expressed their reservations about Hitler's plans for war at the Reichskanzlei meeting of November 5, 1937, and at subsequent meetings with Hitler. After Blomberg's dismissal, Hitler took over the post of commander-in-chief of the armed forces. Finally, Freiherr von Neurath, who had also expressed his reservations about risking war with the west, was eased out of his post as foreign minister and replaced by the more amenable Ribbentrop.[9] Within the space of three months, Hitler had effectively neutralized the army, the Foreign Office and the Ministry of Economics as impediments to his plans for war and had brought them more firmly under the control of himself and the Party.

From the beginning of his political career, Hitler had stressed the unity of domestic and foreign policy questions and goals. In an article in the April, 1924, edition of *Deutschlands Erneuerung,* Hitler asserted that only "nach dem inneren Sieg" (after inner victory) would Germany be in a position to break "die eiserne Fessel seines äusseren Feindes" (the iron fetter of its external enemy).[10] The Jewish question was at once an issue of domestic and foreign policy for National Socialism; the theory of a Jewish world conspiracy depicted the individual Jew, regardless of nationality, as an agent of that conspiracy, working against Germany from within and from without, on the national and international levels. In his speech at the Hofbräuhaus on April 27, 1920, Hitler had described Germany's struggle against world Jewry as one fought on two fronts; he characterized the world war as waged by world Jewry against Germany and promised at the same time to continue Germany's counterstruggle against the Jews on the domestic front.[11] In his *Secret Book,* he described the racial foundations of National Socialist foreign policy objectives in central and eastern Europe, as well as the domestic prerequisites for the success of that foreign policy: "Even in the future the enlargement of the people's living space for the winning of bread will require staking the whole strength of the people. It is the task of domestic policy to prepare this commitment of the people's strength; the task of a foreign policy is to wield this strength in such a manner that the highest possible success seems assured."[12] On January 30, 1937, Hitler told the Reichstag that the necessary domestic prerequisites for Germany's future political and military objectives had been largely achieved.[13] He alluded to the removal of Jews from most aspects of German life as a new element of strength in the German people and asserted that the securing of the internal life of the German people must lead to securing their external relations. He concluded, "The internal order of the German people provided me with the necessary precondition for rebuilding the German armed forces, and from both of these realities emerges the possibility of breaking the shackles that we have borne as the deepest shame ever inflicted on a people." Finally, on March 29, 1938, in a speech at the Hanseatenhalle in Hamburg, Hitler attributed the success of the recent Austrian *Anschluss* to the domestic consolidation of the Nazi state.[14]

Hitler was wont to attribute the outbreak and course of World War I to the machinations of a world Jewry aiming for the destruction of Germany and the rest of Europe. The Jews of Germany were condemned as traitors who sabotaged Germany's war effort, fomented revolution in 1918–1919, established the hated republic and accepted the Versailles Treaty.[15] After 1933, Nazi propaganda depicted

the Jews of the world as international crusaders against the new Germany. Again, German Jews were alleged to be part of this conspiracy, seeking to undermine and destroy Germany from within. Anticipating the future in a speech at the Hofbräuhaus in Munich on February 24, 1938, Hitler alluded to imagined gains reaped from past wars by world Jewry and promised that the Jews of Germany would never again be in a position to support the conspiracy from within.[16]

By early 1938, the Jews of Germany had already been removed from the political, social and cultural life of the nation as a result of legislation between 1933 and 1935.[17] Yet, with some restrictions, Jewish participation in the German economy continued to be tolerated through 1937.[18] Furthermore, there were still some 350,000 Jews in Germany by the end of 1937, although more than 130,000 had emigrated by early 1938.[19] In short, the so-called Jewish question had not yet been resolved after five years of Nazi rule in Germany; this fact was evident to the Nazi leadership as it prepared for a war that would dramatically transform the scope of that question. The issues of Jewish participation in the economic life of the country and emigration policy were to be resolved as part of Germany's domestic preparation for war. This fact was emphasized in two articles in the SS newspaper *Das Schwarze Korps* in November, 1938, by which time the SS had assumed a leading role in the formulation of Jewish emigration policy.[20] The articles implied that a continued Jewish presence in Germany was incompatible with German security in the event of war. They noted that the new Germany was determined to undertake a total solution of the Jewish question in Germany through elimination of Jews from the economy and their complete removal from Germany. It was asserted that Germany finally possessed the military strength to bring the Jewish question to its total solution. In a few prophetic sentences, the newspaper warned that if war should break out before the last Jew left Germany, the fate of those remaining would be *Vernichtung* (annihilation). The destiny of Germany's Jews was tied to Nazi plans for war.

### The Economic *Ausschaltung*

Until 1938, Jewish emigration had been almost exclusively under the control of the old nationalist-conservative bureaucrats of the Foreign Office, the Ministry of the Interior and the Ministry of Economics.[21] Some modicum of legality and restraint characterized the implementation of German emigration policy during those years.[22] Hitler's preparations for war included the elimination of the traditional conservative leadership and its replacement with reliable Na-

tional Socialists.[23] In Jewish policy, this meant Schacht's replacement by Göring in economic affairs and the centralization of authority in Jewish emigration under the SS. As early as September, 1935, Hitler had openly hinted at future changes in the conduct of Jewish policy, according to which the Party would assume full control. At the Nürnberg Party rally, Hitler observed that the struggle against the internal enemies of the nation would never be allowed to falter as a result of the incapacity of the state bureaucracy to lead it.[24] He concluded: "What the state is not in a position to resolve will be resolved by the movement. For the state too is merely one of the organizational forms of national life, driven and controlled, however, by the direct expression of the national will to life, the Party, the National Socialist movement."

Helmut Genschel characterizes the period 1933–1937 as one of "schleichende Judenverfolgung" (insidious persecution of the Jews) in economic affairs, and the period from 1938 until the war as the "offene Ausschaltung aus der Wirtschaft" (open elimination from the economy).[25] It has been observed above that Hitler, however reluctantly, had realized before 1938 that a frontal attack on Jewish participation in the economy threatened German economic recovery and therefore the security and plans of the National Socialist regime. Some Aryanization of Jewish businesses had occurred between 1933 and 1937, although much of it involved voluntary sales by Jews wishing to emigrate.[26] Anti-Jewish legislation during those years was directed against Jewish professionals and civil servants rather than those engaged in economic activities. By late 1937, less than 25% of Jewish business had been Aryanized, and by April 1, 1938, there still existed some 40,000 Jewish enterprises in the *Altreich* (Old Reich), many of them active in rearmament and in the import-export trade.[27]

The elimination of the Jews from the economic life of Germany had always been a major goal of the National Socialist movement. It was implied in the 25 Point Program of the NSDAP, published in February, 1920.[28] The seventh point recognized the duty of the state to promote the industry and livelihood only of citizens of the state; since point 4 excluded the Jews from the category of citizens, their role in the economy would be expendable. In his speech at the Hofbräuhaus in Munich on August 13, 1920, Hitler talked about the necessity of eliminating the Jews from economic activity.[29] Although expediency dictated a continuing role for Jews in the German economy during the first five years of the Nazi regime, that role was to be temporary, in view of the pressures for complete physical removal of the Jews from Germany in the late 1930s.

The promulgation of the Four-Year Plan in 1936 was the first in-

dication that changes in the economic status of German Jewry were in the offing. The plan, coupled with the rearmament program already under way and the reintroduction of conscription, provided the first signs of economic expansion since the beginning of the Hitler regime; moreover, it resulted in the gradual elimination of some of the problems that had prevented a direct attack on the Jewish position in the economy.[30] An expansionist economy would be able to absorb disruptions that would result from the removal of German Jews from economic activity; furthermore, the autarkical measures adopted in 1935 and 1936 resulted in a decline in German trade with the west and a slight lessening of overall dependence on foreign trade.[31] In short, by 1937, the regime felt more secure politically and economically on both the domestic and international levels. Moreover, the decline in German trade with the west, as well as the relative success of the Haavara system, had generally neutralized the dangers of the worldwide Jewish boycott of German goods.[32]

In his memorandum of August, 1936, outlining the tasks of the Four-Year Plan, Hitler proposed that a law be enacted that would make the Jews of Germany responsible "for all damages that, through individual acts of criminality, are perpetrated on the German economy and thus on the German people."[33] This proposal reflected the extent to which war plans and Jewish policy were related in Hitler's mind, for the plan was designed to prepare Germany economically and militarily for war. The step-by-step measures against the Jews in the economic sphere in 1938, the billion-mark levy imposed after the *Kristallnacht* (Night of the Broken Glass), and the continuing process of economic expropriation in 1939 were the fruits of Hitler's proposal.

This study does not analyze the various anti-Jewish economic measures enacted by the National Socialist regime in 1938 and 1939.[34] With Schacht's demise in the fall of 1937, the way was cleared for the final assault on German Jewry's last stake in German society. Besides satisfying Nazi fantasies of internal security and the unity of the racial community, the expropriation of Jewish assets provided the regime with an added source of income with which to pay for the preparations for war. Hitler might also have hoped that further pressure would induce the remaining Jews in Germany to emigrate. Major Engel's diary contains the following entry for August 13, 1938, about alleged observations made by Hitler at the time:

> The Führer spoke today before a small circle about the
> Nürnberg Laws and their results. When he thinks about these
> laws in retrospect, they seem to have in fact been too humane.

The Jews were deprived of certain rights, and were removed from the *Staatsleben* [life of the state]; but there still remains their activity and work in the free economy, and that is of course exactly what is most suitable for the Jew. . . . He will now have to consider, as a result of additional laws leading to the further restriction of Jewish life in Germany, that the mass of the Jewish population in Germany simply will not want to remain. That would be the best way to get rid of them.[35]

## The SS and the Centralization of Emigration Policy

That the SS had relatively little influence on the formulation of Jewish policy through 1937 is particularly evident in the debate over Haavara and Palestine during that year. Neither the SD nor the Gestapo played any significant role. The meeting between Eichmann and Feivel Polkes in Berlin in February, 1937, and Eichmann's trip to the Middle East later that year apparently were not connected with the policy debate over Palestine.

The peripheral position of the SS was certainly not self-imposed. By early 1937, disenchantment was growing within the SD and Gestapo over the chaotic manner of policy formulation and over the multiplicity of competing and conflicting authorities and policies in Jewish affairs. In January, 1937, a comprehensive report on the Jewish question in Germany was compiled by Department II/112 of the SD.[36] The report emphasized that rapid Jewish emigration from Germany should be the keynote of all efforts in the Jewish question and that past efforts to this end had not been very effective. The causes of the recent decline in Jewish emigration from Germany were listed as general complacency about the Jewish question on the part of government authorities, continued Jewish participation in the economy, growing difficulties in emigration to Palestine and elsewhere due to political unrest, quota restrictions and the loss of capital in the emigration process. The report recommended the elimination of Jews from the economy, a significant increase in political and legal pressure on Jews to leave Germany and the establishment of radically new procedures to further Jewish emigration from Germany.

The report concentrated on the emigration process and the problems of promoting a more rapid departure of Jews from Germany. Contrary to the positions of Referat-D in the Foreign Office, the Ministry of the Interior, the AO and others, II/112 argued that emigration policy should aim for *Konzentration* rather than *Zersplitterung* of German Jewry abroad.[37] "Jewish emigration from the territory of the Reich is so urgent that an absolute *Zielstrebigkeit*

[resoluteness] should not be overlooked in the process. In particular, it must be realized that Jewish emigration should be concentrated, that is, it must be directed only toward particular countries in order to avoid in a number of countries the creation of a hostile element that will constantly stir up the populace of these countries against Germany." The report went on to recommend the utilization of three South American countries and the continued utilization of Palestine as areas in which Jews from Germany should be concentrated. Moreover, the report was critical of the attempts of the AO and others to turn Germany toward a greater support for the Arab national movement in Palestine: "Encouraging an anti-Jewish attitude among Arabs in Palestine by members of the AO of the NSDAP is to be avoided. The stirring up of Arabs against Jewish immigrants is harmful to the Reich in the end, because unrest will severely curtail emigration activity, which was especially evident during the unrest of 1936."

Finally, the report recommended technical changes and improvements in the formulation and conduct of Jewish policy in order to hasten the removal of Jews from Germany. It called for the complete centralization of the emigration process under one agency—namely, the SS—whose task it would be to run the entire domestic operation of the emigration process. This would include selecting suitable areas to which the stream of Jewish emigration would be directed, conducting negotiations with diplomatic representatives of countries willing to accept Jews, finding new methods for the transfer of Jewish capital and, above all, carrying out the solution of the entire problem in the National Socialist sense. Department II/112 was proposing the transfer of control over Jewish emigration from the responsible government ministries to the SS, something that was to occur in 1938 and 1939. The advocacy of *Konzentration*, continued emigration to Palestine and utilization of the assets of well-to-do Jews to cover the emigration costs of the poor were to become cornerstones of SS emigration policy during those years.

Department II/112 continued its campaign in the spring of 1937 to strengthen its role in the formulation and conduct of overall Jewish policy, particularly in matters of emigration. On April 7, SS-Hauptscharführer Dieter Wisliceny of II/112 circulated a memorandum calling for SD participation in all matters relating to Jewish emigration.[38] He argued that II/112 should be included in the deliberations of the Ministry of Economics and other government ministries concerning emigration policy, including the question of Zionist emigration to Palestine. On April 21, another Wisliceny memorandum was circulated in II/112 that stressed the importance of Zionist emigration to Palestine in the overall solution of the Jewish ques-

tion, as well as the key role the SD should play in that process.[39] Although his view that the solution of the Jewish question in Germany depended primarily on Zionist emigration to Palestine was not shared by many in the SD or elsewhere, his observations reflect consistent SS espousal of rapid emigration to specific areas of concentration, which included Palestine, as well as the efforts of the SS to assume ultimate control over Jewish policy in Germany.

The *Anschluss* of Austria in March, 1938, finally afforded the SD an opportunity to put its recommendations to work. On March 16, Adolf Eichmann was assigned to Vienna with the task of heading a branch office of II/112.[40] The persistent complaining of Eichmann, Wisliceny and others in II/112 must have found a receptive audience in Himmler and Heydrich. It is also significant that Eichmann had been in charge of II/112–3, the section responsible for Zionism and emigration, prior to his assignment to Vienna. He was given free rein to organize and carry out the emigration of Jews from Austria according to his own recommendations of the previous year. In short, the SS assumed immediate and total control over emigration policy in Austria at a time when the various government and Party agencies were still competing for control in the *Altreich*.

All other aspects of Jewish policy in Austria were subordinated to the aim of rapid Jewish emigration. In accordance with the 1937 recommendations of Eichmann and Wisliceny, a Zentralstelle für jüdische Auswanderung (Central Office for Jewish Emigration) was opened in Vienna.[41] The emigration process in Germany had been characterized by factors that limited the number of emigrants each year; these were for the most part eliminated in Austria. What would have taken weeks or months of running from one agency to another was accomplished in one day by Eichmann's Zentralstelle. The involuntary nature of Eichmann's emigration system made the term "deportation" more appropriate.[42] In spite of pogroms, disenfranchisement and expropriation, emigration had remained technically voluntary in the *Altreich* through 1938. In Austria, on the other hand, Jews were slowly concentrated in Vienna, interned in concentration camps and eventually forced through the Zentralstelle, where they were stripped of their assets and received in a matter of hours the stamps, papers, visas and passports necessary for leaving the country.[43] Unlike the situation in the *Altreich*, where Jews still retained much control over their assets until 1938 as long as they remained in Germany, the Eichmann system simply confiscated most of what the emigrants possessed; the standing principle of II/112 that the rich must pay for the emigration of the poor so that all would be able to leave was applied assiduously.[44] Finally, whereas

the departure of the emigrant from the *Altreich* had usually depended upon the possession of an immigration visa to another country, the Austrian emigrant was often expelled without a valid visa or with papers that the SD authorities knew to be illegal.[45]

The SD was also brought into the formulation and conduct of Jewish policy in the *Altreich* in early 1938. Hitler's initiative in 1937 and early 1938 had given top priority to emigration in Jewish policy, and there is evidence that the SD had managed to secure an important role in the emigration process by that time. In its mid-year report in July, 1938, II/112 was able to note with satisfaction that it had been brought into the economic preparation of Jewish emigration, which had previously been subject to the competing claims and influence of numerous government agencies.[46] According to Bernhard Lösener of the Ministry of the Interior, a process had begun in which his ministry was increasingly eliminated from the formulation and implementation of policy.[47] Unlike its experience in Austria, the SD faced stiff competition from other Party agencies in Germany for control over Jewish policy in 1938.[48] The personnel changes in the Economics Ministry and the Foreign Office in late 1937 and early 1938 had removed the moderating influence of Schacht and Neurath in Jewish policy. Göring accumulated considerable power and authority in Jewish affairs after his victory over Schacht, while Ribbentrop's position was anything but moderate. Göring's power in economic affairs and his leading role in the drive to remove the Jews from the economy made him the dominant authority in the Jewish question by late 1938. Goebbels too sought a leading role, and, along with the SA and Julius Streicher, favored pogrom-style violence against Germany's remaining Jewish population.[49] The SS, bolstered by its position in Austria and the "success" of its emigration procedures there, was urging a similar formula for the *Altreich*.[50]

The events surrounding the *Kristallnacht* in November, 1938, did result in greater centralization of Jewish policy and a dominant role in the emigration process for the SS. There is general agreement that Göring, Himmler and Heydrich had opposed the unbridled violence of November 9, 1938.[51] Göring was in the process of expropriating Jewish assets as a way of raising more capital to pay the enormous costs of military preparations. The destruction of Jewish property represented a loss of potential income. The SS, which had always opposed the pogrom approach, feared that the violence and destruction would have a negative impact on the emigration process. Himmler, Heydrich and others appealed to Hitler to have the destruction halted and sought in vain to have Goebbels removed from his position.[52] In a meeting with Hitler and Goebbels on November 10, Göring was

able to have the violence stopped.[53] He also emerged from the meeting with supreme authority in Jewish affairs and orders to carry out the complete removal of Jews from the economy.

Göring's authority manifested itself in the remaining weeks of 1938 and early 1939. He was authorized by Hitler to call a meeting of all interested agencies and officials on November 12 to plan the final elimination of the Jews from the economy and, above all, to promote the all-out emigration of Jews from Germany under the authority of the SS.[54] Among those present were Goebbels, Heydrich, Interior Minister Frick, Economics Minister Funk, a representative of the German insurance companies and an observer from the Foreign Ministry. At the meeting, Göring denounced the violence and destruction of the *Kristallnacht* on the grounds that it only harmed the German economy in the end. The levy of 1 billion marks imposed on the German Jewish community is indicative of Göring's desperate need for added revenue in view of what he was to call six days later "die kritische Lage der Reichsfinanzen" (the critical situation of Reich finances).[55] Besides the ideological connection between war and Jewish policy, there was for Göring the practical necessity of finding additional means with which to pay for a future war. It was resolved at the November 12 meeting that the total elimination of the Jews from the economic life of the country would be pursued with greater intensity and that these efforts would be geared toward the rapid emigration of Jews from Greater Germany. Although it was clear that Jewish policy was to be centralized under Göring's authority, continued rivalries among government and Party agencies in late 1938 forced Göring to circulate the following reminder on December 14:

In order to assure the necessary unity in the handling of the Jewish question, which strongly affects the entire economic situation, I request that all decrees and other important instructions that pertain to the Jewish question be directed to me before their release, and that they receive my approval. I request that you instruct all departments and authorities in your *Dienstbereich* [service area] that every independent action in the Jewish question is to cease.[56]

At the November 12 meeting, Göring also empowered the SD to organize Jewish emigration according to its own plans and procedures. On November 15, the SD, conscious of its newly acquired authority in emigration matters, informed the Foreign Office of its intention to set up a Reichszentrale für jüdische Auswanderung (Reich Central Office for Jewish Emigration) in Berlin, along the lines of its

earlier counterpart in Vienna.[57] SS-Oberführer Rudolf Likus was told by close associates of Göring that Göring and Himmler were in complete agreement on the future conduct of Jewish policy.[58] In its year-end report for 1938, II/112 was able to note with satisfaction the centralization process that had taken place during the second half of the year and the department's new authority in the emigration process.[59] In the same report, II/112 indicated its intention to exert its authority in all aspects of emigration policy, including those related to German foreign policy, such as the question of suitable countries or regions of the world to which Jewish emigrants should be directed, a central issue in the Palestine debate of 1937.

On January 24, 1939, in a note to the minister of the interior, Göring reported his appointment of Reinhard Heydrich of the SD to organize Jewish emigration from Germany according to the procedures established by Eichmann in Vienna.[60] Göring authorized the creation in the Interior Ministry of a Reichszentrale für jüdische Auswanderung, to be directed by Heydrich as head of the SD. He noted that Jewish emigration from Germany was to be promoted by all possible means and that the entire process would henceforth be directed by this new centralized authority. Göring also reiterated his position as the chief authority after Hitler in the Jewish question.

Heydrich wasted little time in organizing the Reichszentrale in Berlin and in asserting the dominant role of the SD in emigration matters. In a note of February 11, 1939, to various government ministries, Heydrich outlined the organization of the Reichszentrale and left little doubt of his intention to put the SD in full control.[61] After almost a year in Vienna, Eichmann was brought to Berlin in February and placed under Heinrich Müller, then head of the Gestapo, who was put in charge of the Reichszentrale. The Zentralstelle in Vienna as well as the one set up later in Prague became branches of the Berlin operation.[62] Thus, the SS achieved full control of the emigration process, responsible only to Göring and ultimately to Hitler.[63] The various government ministries were subordinated to the overall authority of Göring and to the authority of Heydrich in all domestic and international aspects of Jewish emigration. Therefore, the Palestine debate was officially over. Göring's January 24 note to the Interior Ministry gave Heydrich the authority to determine which parts of the world were the most suitable destinations for Jewish emigrants. The SS had consistently favored Jewish emigration to Palestine and would continue to do so with its enhanced authority in emigration policy.

## The Limits of the Legal Immigration System

While efforts to increase Jewish emigration were under way in Germany and Austria in 1938, immigration opportunities to other countries for German and Austrian Jews were gradually declining. The number of entry visas available was never sufficient for those who wanted to leave Germany, and some available visas were for countries where settlement was hazardous for many middle-aged, middle-class urban Jews.[64] Entry into Palestine had also become tightly controlled. Not only did Britain limit the number of immigration certificates, but the Zionist movement itself set up rigid standards for prospective immigrants prior to 1938. It sought young people in good health, with some training for agricultural work or manual trades; moreover, persons with capital were preferred immigrants at a time when the needs and interests of Palestine took preference over the problem of rescuing Jews from Nazi persecution.[65] The unrest and violence in Palestine from 1936 to 1938 had resulted in further British restrictions on Jewish immigration, while the countries of the western world demonstrated their reluctance after 1937 to raise immigration quotas in order to meet the growing Jewish refugee crisis.[66]

By the summer of 1938, Eichmann's emigration operation in Vienna was beginning to have an adverse effect on an already acute international refugee problem. A High Commission for Refugees from Germany had been created by the League of Nations in 1935, but had proved ineffective.[67] In July, 1938, on the initiative of President Roosevelt, an international conference designed to find solutions to the Jewish refugee problem was convened at Evian, France.[68] Thirty-two nations from Europe, North and South America and the British Dominions, as well as representatives of Jewish relief agencies and other organizations, assembled in an effort to find new homes for the growing flood of refugees from central as well as eastern Europe. The conference lasted for a week and established a permanent committee that tried in vain through the rest of 1938 and early 1939 to reach an agreement with the German government on Jewish emigration. The efforts of the committee failed because of the contradictions in the policies of the Evian nations and Germany. While calling on the German government to cooperate in the speedy and orderly emigration of German Jews and the transfer of at least some Jewish assets, most of the Evian countries either refused to increase their immigration quotas or actually sought further restrictions on Jewish immigration. Not even the United States was prepared to increase its annual German immigration quota signifi-

cantly.[69] On the German side, both Göring and Schacht demonstrated some interest in cooperating with the Evian committee, in spite of the fierce opposition of Goebbels and Ribbentrop. In the end, however, Germany was prepared neither to permit the removal of significant amounts of Jewish capital to other countries nor to admit foreigners into the conduct of domestic Jewish policy. Ribbentrop's reasoning, which became the basis of the German position, was outlined by Weizsäcker in a note to the German Embassy in London in July, 1938.[70] According to Weizsäcker, Ribbentrop considered the Jewish question in Germany to be a domestic German problem that could not be subject to foreign intervention and opposed the transfer of Jewish capital from Germany or any form of cooperation with the Evian conference.

Germany could not cooperate in an international solution to the Jewish question that was motivated by sympathy for the plight of the Jews in central Europe. The Foreign Office circular to all German consular missions of January 25, 1939, rejected the notion that Jewish assets might be removed from Germany and condemned the hypocrisy of the Evian countries for their reluctance to admit more Jewish immigrants.[71] The circular went on to advocate the *Zersplitterung* of German Jews overseas, dismissing SS arguments that this would create new elements in many countries that would incite the populace of those countries against Germany and thus keeping alive the debate between the proponents of *Konzentration* and those of *Zersplitterung* in emigration policy. The circular concluded that Germany was not opposed to international solutions of the Jewish problem, but favored participation in an international effort based on premises radically different from those of the Evian conference. It asserted that any international effort should not be based on a "false sympathy for the 'persecuted Jewish religious minority,' but on the premise dictated by the recognition of all people of the danger that Jewry poses for the *völkischen Bestand* [racial stock] of nations."

Cooperation with the Evian nations might have given the Hitler regime some influence in determining the destinations of Jewish emigrants from Germany. Although most of the Evian nations were reluctant to admit greater numbers of Jewish refugees, it was still a reasonable assumption at the time that large numbers of German Jews would have ended up in the countries of western and northern Europe and North America. However, this was not compatible with the aims of SS emigration policy, which advocated the concentration of German Jews in a few isolated areas, mainly in Palestine and South America, and opposed the scattering of German Jews throughout the western world, where, it was felt, they would be in a position

to damage German interests. In June, 1938, SD headquarters in Berlin
ordered Eichmann in Vienna henceforth to prevent the emigration of
Jews from Austria to other countries in Europe.[72]

A difference in emphasis rather than in actual policy in the ques-
tion of Jewish emigration from Germany to Palestine existed between
the SD and the Foreign Office in 1938 and 1939. During those years,
the views of Referat-D on the question of emigration and Palestine
appear to have prevailed over those of the Orient-Abteilung (Pol. VII)
within the Foreign Office, no doubt due to Neurath's replacement by
Ribbentrop as Reichsaussenminister. The Foreign Office continued
to stress the dangers of a Jewish state, even after Britain had dropped
the partition plan and had substantially reduced Jewish immigration
to Palestine.[73] On the other hand, much of its opposition to the con-
tinued reliance on Palestine as an outlet for Jewish emigration from
Germany was based on the limited capacity of the country to absorb
the masses of European Jewry in the future. The Foreign Office cir-
cular of January 25, 1939, noted Palestine's limited absorptive capac-
ity while viewing the Jewish question no longer as a purely German
phenomenon, but rather in terms of its European dimensions, in
which millions of Jews would be driven from Europe and a new Eu-
ropean racial order established.

The Foreign Office never advocated the suspension of Jewish emi-
gration to Palestine, while the SD had also been mindful throughout
of the dangers an independent Jewish state would pose for Germany
and had accepted the arguments upon which the Foreign Office and
others had based their views. In a position paper circulated in II/112
by Herbert Hagen in early 1939, it was clearly stated that Germany
could never accept a decision by Britain to satisfy Jewish ambitions
for an independent state in Palestine.[74] Yet the SD tended to stress
Palestine's role as a favorable dumping ground for Jews from central
Europe and was clearly less alarmed than the Foreign Office over the
possibility of a Jewish state ever being established in Palestine. In
September, 1938, II/112 took the position that Germany would
strongly oppose any British decision to partition Palestine and per-
mit the establishment of an independent Jewish state, but that Pales-
tine would continue to serve as a useful outlet for Jewish emigration
from Germany so long as England did not pursue that policy option.[75]

## The Promotion of Illegal Immigration to Palestine

Britain's restrictive immigration policy rather than the spectre of a
Jewish state was the major obstacle to the Palestine policy of the SD
as it assumed control over Jewish emigration in Germany. This re-

sulted in SD/Gestapo participation in the organization and operation of illegal immigration of Jewish refugees into Palestine in 1938 and 1939.[76] At Göring's conference on November 12, 1938, Heydrich admitted SD complicity in illegal immigration schemes originating in Austria.[77] On February 11, 1939, at the first meeting of the directing committee of the newly formed Reichszentrale für die jüdische Auswanderung in Berlin, Heydrich indicated his wish to continue utilizing the illegal transport of Jews from central Europe to Palestine: "SS-Gruppenführer Heydrich brought up the question of the illegal emigration of Jews to Palestine. He pointed out that he was essentially opposed to all illegal emigration. However, in the case of Palestine, the situation was such that, at that time, illegal transports were proceeding from many other European countries that themselves were only *Durchgangsländer* [transit countries], and that under these circumstances this opportunity could be made use of by Germany as well, albeit without official participation."[78] The Foreign Office lent its support to the SD for the promotion of the illegal immigration of Jews to Palestine.

Immediately after the *Kristallnacht* in November, 1938, all Jewish political organizations, including the Zionistische Vereinigung für Deutschland and the Centralverein were dissolved, and all Jewish newspapers with the exception of the nonpolitical *Jüdisches Nachrichtenblatt* were forbidden to publish.[79] The violence of that evening had also resulted in the destruction of the Palästinaamt on Meineckestrasse in Berlin. After the violence had passed, and Göring and the SS were in firm control of Jewish policy, Zionist functions resumed throughout Germany, albeit under the altered circumstances dictated by the new emigration procedures of the SD. Ahron Walter Lindenstraus, a former employee at the Palästinaamt in Berlin, testified at the Eichmann trial that the SS helped to restore the working operation of the Amt immediately after the *Kristallnacht* pogrom.[80] He further testified that the SS helped the Palästinaamt recover immigration certificates that had already been granted by British authorities for a group of German Jews to go to Palestine. In Berlin and Vienna, the SS ordered the release from jail of all Jews arrested during the *Kristallnacht* who were in any way connected with the Palästinaamt.[81]

In 1937, a group of Jewish labor leaders and Hagana officials in Palestine set up the Mossad le Aliyah Bet (Committee for Illegal Immigration); later that year, the Mossad established a base in Paris from which to direct the illegal immigration of Jews into Palestine.[82] Three agents in Paris, Yehuda Ragin, Ze'ev Shind and Zvi Yehieli, formed the nucleus of the Mossad operation, which soon had agents

spread throughout Europe and the Middle East and was able to transport well over 100,000 Jews illegally to the shores and frontiers of Palestine between 1938 and 1948. Mossad agents were assigned to Berlin and Vienna in 1938, with instructions to establish a working relationship with the SD and the Gestapo in organizing the clandestine immigration to Palestine.[83] Their tasks included coordinating transports in Germany and Austria, selecting and organizing those Jews wishing to leave via the illegal route and cooperating with Nazi authorities, without whom there would be no emigration. Mossad agents operated independently from the official Zionist organization and the Jewish Agency for Palestine prior to the *Kristallnacht* in November, 1938, because both had opposed illegal immigration into Palestine before that time.[84] In his account of the illegal immigration to Palestine, Ehud Avriel, a former Mossad agent in Vienna, characterized the attitude of German authorities in Vienna as follows: "In prewar Germany, these operations were neither illegal nor secret: the Gestapo office directly across the street from our town knew exactly where we were and what we were doing; the illegality began only at the shores of Palestine with the British blockade."[85]

The SD and the Gestapo were receptive to the Mossad's initiatives for cooperation. After November, 1938, Mossad agents in Berlin, Vienna and later Prague dominated the Palestine offices in each of those cities. They were provided with farms and other facilities to set up vocational training camps for prospective immigrants.[86] Mossad agents in Vienna worked through Wolfgang Karthaus, a high-ranking Austrian Nazi who was sympathetic to the Jewish plight, to secure the cooperation of Gauleiter Josef Bürckel and Gestapo agents Lange and Kuchmann.[87] Through them, Yugoslav transit visas were obtained, enabling Austrian Jews to make their way to Palestine via Mossad ships that took on illegal immigrants in Yugoslav ports. Eichmann soon brought the Mossad operation under his control and urged the movement of greater numbers of illegal emigrants out of Austria.[88] Jews were also smuggled down the Danube, through Black Sea ports in Rumania and Bulgaria and through Greece to Palestine.[89] In 1939, the SD put pressure on Mossad agents in Berlin and Prague to move large numbers of Jews out of the Reich, with Heydrich demanding that 400 Jews per week be prepared and sent off from Berlin alone.[90] In the summer of 1939, Mossad agent Pino Ginzburg concluded an agreement in Berlin with the Gestapo to move 10,000 Jews by ship from the ports of Emden and Hamburg to Palestine. The outbreak of war in September forced the abandonment of the operation.

Although Nazi authorities tried to conceal their complicity in

the illegal transport of Jews to Palestine, both the British and the American governments were aware of SS and Gestapo involvement in 1938 and 1939. As early as the summer of 1938, the American Consulate in Vienna reported to Washington that its information confirmed the collaboration of German authorities in the illegal movement of Jews from central Europe to Palestine.[91] Britain's awareness was evident in reports from the British Consulate in Vienna in the summer and autumn of 1938 and in debates in the House of Commons in London in July, 1939.[92]

It would be difficult to determine exactly how many "illegals" were brought out of central Europe to Palestine in 1938, 1939 and 1940. The estimates that are available cover the total illegal immigration into Palestine, which included large numbers of eastern European Jews not yet under Nazi control. The governments of Poland and Rumania were also enthusiastic about any schemes, legal or otherwise, that would foster Jewish emigration from their countries.[93] It must be assumed that the proportion of "illegals" from Greater Germany in the total illegal immigration was not insignificant. The American Consulate in Jerusalem reported in August, 1938, that Jewish authorities in Palestine were themselves not certain as to how many Jews were entering the country illegally at that time.[94] The Consulate did report that the consensus of Jewish opinion was that some 500 "illegals" were entering the country each month, and that the assistant commissioner for migration, N. I. Mindel, estimated that over 25,000 illegal immigrants were resident in Palestine by August, 1938. British estimates also varied. Malcolm MacDonald, the secretary of state for colonies, claimed that some 4,000 illegal immigrants had entered Palestine during the first six months of 1939.[95] The British Foreign Office and Colonial Office estimated that over 11,000 illegal immigrants successfully entered Palestine during the six months from April to September, 1939.[96] Jon and David Kimche assert that more than 1,000 illegals per month were entering Palestine by the end of 1938.[97]

German authorities continued to pursue both legal and illegal emigration of Jews from Greater Germany to Palestine in 1938 and 1939. In 1938, the Gestapo approved a request by Jewish leaders in Germany to petition foreign embassies for more immigration visas for Jewish emigrants.[98] At the Eichmann trial, Dr. David Paul Meretz, a former Zionist official in Germany, testified that the Gestapo approved a request to permit a delegation of German Zionists to attend the forthcoming Twenty-First Zionist Congress at Geneva in September, 1939.[99] Meretz stated that the delegation intended to seek more legal immigration certificates, as well as to explore ways

to stimulate illegal immigration into Palestine. Moreover, in the spring of 1938, the SD and the Ministry of Economics agreed that, for the time being, the Haavara system would continue to function and that funds provided by Jewish relief agencies abroad for emigration purposes would be placed in full at the disposal of the emigrants.[100]

In the Foreign Office, support for SS emigration policy was usually forthcoming. Referat Deutschland continued to express its misgivings about concentrating too many Jews in Palestine and about the future possibility of a Jewish state.[101] On the other hand, most in the Foreign Office recognized that there was little likelihood of a Jewish state ever being established in Palestine. From Jerusalem, Consul-General Döhle reported that Britain had given up the idea of partition and that a Jewish state was unlikely as a result.[102] In Pol. VII, Werner-Otto von Hentig argued that, as a result of Britain's failure to implement the partition plan, there was no real danger of a Jewish state in Palestine and that Jewish emigration to Palestine could proceed.[103] From London, German Ambassador Dirksen reported that Britain had not only given up on partition and an independent Jewish state, but was also moving toward an Arab solution to the problem.[104]

The new forced emigration procedures adopted in 1938 and 1939 did result in a significant rise in the number of Jews forced out of Greater Germany in 1939. In the four-month period from February 1 to May 31, 1939, 34,000 Jews were forced out of the *Altreich* and another 34,300 out of Austria.[105] Emigration to Palestine was up considerably as well. The figures on legal immigration to Palestine show a dramatic increase in the number of German Jews entering Palestine in 1938 and 1939. These figures would certainly be higher if illegals were included.

### Toward the Final Solution

The emigration procedures established by the SD in 1938 and 1939 were continued during the first two years of the war, albeit with diminishing success.[106] Immigration possibilities to other countries, already severely restricted in 1938 and 1939, were limited even more by the adverse conditions of war. Moreover, Germany's conquests in 1939 and 1940 brought millions of Jews under Nazi control, making it impossible to remove such large numbers of Jews from Europe, even with the methods perfected by Eichmann in Vienna in 1938. Still, in 1939 and 1940, the SS continued to promote Jewish emigration to Palestine, using both legal and illegal channels. Retraining

programs for Jews in Germany seeking to emigrate to Palestine continued to receive the support of the SS, the Foreign Office and the Ministry of the Interior. Throughout 1940 and much of 1941, German authorities in eastern Europe did nothing to prevent the steady if chaotic flow of Jewish refugees to Palestine and in some cases encouraged it.[107] At his trial in Jerusalem in 1961, Adolf Eichmann testified, "Until receipt of the orders stopping emigration, I did not have any instructions to stop emigration to Palestine, even during the first years of the war."[108]

Schumburg's circular of January 25, 1939, observed that the Jewish problem would not be solved for Germany merely by the departure of the last Jew from German soil. Besides fearing the possible establishment of a Jewish state in Palestine, Referat Deutschland rejected Palestine as a key element in the solution of the Jewish question because of its size. In 1938, Schumburg and others had already begun to view the Jewish question in its European rather than its German dimensions as plans for war materialized. It was no longer a matter of simply removing half a million Jews from Germany; for National Socialism, the Jewish question was ultimately a European one, in view of its plans for a new order in Europe, and involved the disposal of some 10 or 11 million Jews from the North Sea to the Urals. As Schumburg observed in his January 25 circular, Palestine would never be able to absorb more than a fraction of that number.[109] It is also significant that in his speech to the Reichstag five days later, Hitler also alluded to the European dimensions of the Jewish question within the context of a new racial order in Europe.[110]

The initial German conquest of much of Poland and about a million and a half Polish Jews in September, 1939, radically transformed the scope of Nazi Jewish policy. Moreover, changes in the terms of the Nazi-Soviet Pact later that month were to bring more Polish territory and an enormous increase in the number of Polish Jews under German control. Since 1938, SS emigration policy had been designed to concentrate Jews from Greater Germany in Palestine, South America and other non-European areas; however, Palestine's size and limited absorptive capacity, as well as the fluctuating willingness of South American and other governments to accept Jewish immigrants, necessitated new and more suitable points of concentration for the millions of Jews soon to be driven from Europe. Therefore, between 1938 and 1940, the Hitler regime considered Madagascar and other similarly remote areas of the world much larger alternatives to Palestine, capable of absorbing the millions of Jews destined to be forced from Europe.[111]

It has already been noted that Poland had sought an agreement

with France in 1936 and 1937 whereby much of Poland's Jewish population would be sent to Madagascar. In April, 1938, the British Colonial Office asked the British Foreign Office to approach France about immigration possibilities for European Jews in Madagascar.[112] Like Poland, but for different reasons, Britain was seeking alternatives to Palestine for Jewish refugees. In the Colonial Office, William Ormsby-Gore wrote:

> Could you ask him [M. Bonnet] if France could do anything to permit Jewish refugees to settle in Madagascar, especially from Austria? To please the Foreign Office I have agreed to drastic cutting down of the number I personally would like to see allowed to go to Palestine—but if the Foreign Office object to Jewish refugees going to Palestine in order to try and placate the Arabs, at least we ought in view of the Balfour Declaration to use any influence we can to find them havens of refuge from religious and racial persecution elsewhere. Madagascar is large, healthy, undeveloped and sparsely populated.

In late 1938, France agreed to consider Jewish settlement on the island of Madagascar provided Britain and the United States made similar efforts with some of their own territories.[113] Prime Minister Chamberlain proposed Jewish settlement in Tanganyika in eastern Africa and British Guyana on the northern coast of South America.[114]

Germany took a keen interest in Poland's initiatives on Madagascar. Like Britain and Poland, Nazi authorities were concerned about alternative outlets for mass Jewish emigration due to the restrictions on Jewish immigration to Palestine. In January, 1938, the Polish foreign minister received a sympathetic hearing from German Foreign Minister von Neurath on Polish efforts to secure Jewish emigration to Madagascar.[115] Julius Streicher was an early advocate of mass Jewish emigration to Madagascar. Editorials in *Der Stürmer* in January and May, 1938, claimed that the newspaper had proposed such a solution to the Jewish question several years earlier and that Poland's recent initiatives warranted favorable consideration.[116] The SS newspaper *Das Schwarze Korps* carried an article in February, 1938, that criticized the western democracies for not making parts of their empires available for Jewish immigration.[117] The article also criticized France for not acting more quickly on the Polish initiatives on Madagascar and concluded that only forceful resettlement of Jews outside of Europe would solve the Jewish question. Felix Kersten, Himmler's personal physician, claimed that Himmler had suggested to Hitler in 1934 that Jewish emigration from Germany to Madagascar be promoted.[118] At his trial, Adolf Eichmann testified

that he "played with the idea of Madagascar" shortly after his arrival in Vienna in early 1938.[119] In March, 1938, II/112 began serious consideration of Madagascar as a possible alternative to Palestine in the future solution of the Jewish question. On March 5, Herbert Hagen requested Eichmann's section (II/112–3) to begin assembling information on Madagascar and its potential as a solution to the Jewish question and referred to previous Franco-Polish negotiations as a positive step.[120]

In early 1939, Alfred Rosenberg wrote and spoke on several occasions in favor of the Madagascar option. He, too, stressed the European dimensions of the Jewish question and the need for a strong, united, German-led front of anti-Semitic states to drive the Jews from Europe. He supported the concentration of European Jewry on Madagascar or in Guyana, dismissing Palestine as too small to play an effective role in the solution of the Jewish question. He asserted that Germany could never tolerate an independent Jewish state in Palestine or elsewhere and envisaged an arrangement for Madagascar or Guyana that would create a reservation (*Reservat*) in which the Jews of Europe would be concentrated, with the western democracies retaining control.[121] At Göring's conference on November 12, 1938, the topic of Madagascar was brought up briefly. According to Ernst Woermann of the Foreign Office, Göring reacted favorably to the Madagascar option during the discussions and claimed that Hitler was also favorably inclined.[122] Hitler had already expressed his support for an understanding among the anti-Semitic regimes of Germany, Poland, Hungary and Rumania aimed at securing the removal of millions of Jews from Europe to Madagascar. The former Polish ambassador to Germany, Josef Lipski, sent the following note to Foreign Minister Beck in Warsaw after a meeting with Hitler at the Obersalzberg on September 20, 1938: "He has in his mind an idea for settling the Jewish problem by way of emigration to the colonies [Madagascar] in accordance with an understanding with Poland, Hungary and possibly also Rumania (at which point I told him that if he finds such a solution we will erect him a beautiful monument in Warsaw)."[123]

While there was considerable talk in Germany about Madagascar in 1938 and 1939, there were no formal plans or diplomatic preparations for the deportation of Jews to that island or to Guyana or other similarly remote parts of the world until after the German conquest of much of Europe in 1940 and 1941. The detailed proposals of Referat Deutschland in the Foreign Office and those of the SS in 1940, when the German conquest of France and Britain's anticipated surrender made the Madagascar scheme appear feasible, are consid-

ered elsewhere.[124] It is important to note here that Palestine was still considered a desirable destination for Jewish emigrants by German authorities between the outbreak of the war in 1939 and the evolution of the final solution in 1941. Correspondence between the SS and the Foreign Office in 1939 and 1940 indicates that existing patterns of emigration were to continue for Jews still in Greater Germany, while new proposals for concentrating masses of Jews in eastern Poland (the so-called Lublin Reservation) and Madagascar were to be considered as possible solutions to the overall Jewish question in Europe.[125] There appears to be some continuity in Nazi emigration policy between 1933 and 1940, from Palestine and South America to the Lublin Reservation and Madagascar. That policy generally sought to concentrate Europe's Jewish population in remote areas outside of Europe, preferably in reservations under the strict supervision and control of a European power. Whereas Palestine would serve as a reservation for German Jews under British authority after 1933, Madagascar would become a much larger reservation for a much larger undertaking under French or German control.

# 9. Germany, Palestine and the Middle East, 1938–1939

## Shifting Patterns in Hitler's *Englandpolitik*

The successful implementation of Hitler's timetable for war in 1938 and 1939 depended on Britain's attitude toward the isolated wars he planned to wage against Germany's eastern neighbors. His efforts to secure an Anglo-German understanding between 1933 and 1937, based upon mutually recognized spheres of domination, had failed to rouse the interest of the British government. After 1935, it had become increasingly apparent to Hitler that Great Britain would continue to oppose German domination of Europe. On the other hand, the war in Ethiopia and the occupation of the Rhineland had led Hitler to conclude that Britain would not go to war for the sake of central and eastern Europe. What Josef Henke describes as Hitler's *ohne England Kurs* (course without England) after 1937 was based on the assumption that Britain would neither support German expansion beyond the incorporation of Austrian and Sudeten Germans into the Reich nor go to war against Germany in defense of Hitler's future victims in eastern Europe.

The Austrian *Anschluss* was not really a test of the efficacy of Hitler's *ohne England Kurs* because Britain had come to accept the peaceful union of Germany and Austria by 1938.[1] As noted above, Lord Halifax had expressed the willingness of the British government to endorse necessary changes in Austria and the Sudetenland in the name of national self-determination during his visit to Berlin in November, 1937. Thus, it appears certain that Hitler expected little opposition from Britain to the annexation of Austria in March, 1938.[2] Ribbentrop was in London in early March, 1938, and reported to Hitler on several occasions that Britain would not go to war over Austria, even if the *Anschluss* had to be accomplished by force.[3] The *ohne England Kurs* would not be tested until Germany threatened some action on the European continent in conflict with British in-

terests against which the British government was prepared to act with force.

The crisis over Czechoslovakia in 1938 exposed the flaws in the *ohne England Kurs*, with British pressure forcing Hitler temporarily to accept an international solution that fell short of his intended goal. At the now famous Reichskanzlei meeting of November 5, 1937, the aim of German policy was clearly defined as the complete destruction of Czechoslovakia, not merely the union of the Sudeten Germans with the Reich.[4] The Sudeten German question was merely a pretext for a war against Czechoslovakia as a necessary step in the systematic expansion of German *Lebensraum* in central and eastern Europe.[5] Hitler's directive of May 30, 1938, to the commanders of the army, the navy and the air force ordered immediate preparations for the invasion of Czechoslovakia and the destruction of the Czechoslovak state.[6]

Britain was prepared to cooperate in a solution to the Sudeten German problem that would have satisfied German demands for the national self-determination of the Sudetendeutsche.[7] However, the British government also made clear its opposition to a German invasion of Czechoslovakia as the means of resolving the problem. On May 11, 1938, British Ambassador Henderson delivered a note to Foreign Minister von Ribbentrop that made a clear distinction between Britain's position on peaceful change in the status of the Sudeten Germans and its position in the event of a German invasion of Czechoslovakia.[8] Henderson warned that a conflict between Germany and Czechoslovakia could develop into a larger European war in which Britain could not remain disinterested. During the May crisis of 1938, the British government again indicated that it could not stand idly by in the event of a German invasion of Czechoslovakia.[9]

Whether Britain would have gone to war over Czechoslovakia in May or September, 1938, is beyond the scope of this study. It is important here to gauge Hitler's reaction to British threats of intervention during the crisis and his actions in view of the possibility of war with Great Britain in 1938. The *ohne England Kurs* assumed that, in spite of objections and protests, Britain would not intervene in the process of German expansion in central and eastern Europe. If Berlin concluded that the attainment of its objectives in 1938 was impossible without a full-scale war in the west, then the *ohne England Kurs* would prove itself a failure. Certainly, the quest for an Anglo-German alliance from 1933 to 1937 and the *ohne England Kurs* thereafter precluded war with England.

British threats in the May crisis forced Hitler to consider the possibility of war with the west before the complete conquest of

*Lebensraum* in the east.[10] In late May, he ordered measures to be taken to strengthen Germany's western defenses and instructed the German armed forces to prepare for a possible conflict with the west. These measures, coupled with his visit to Italy in early May, might have been an attempt to discourage England from risking war over Czechoslovakia rather than a definite resolve to achieve his ends regardless of the cost. In April, Hitler had stated at the Obersalzberg that the anticipated move against Czechoslovakia should commence only when Italy was firmly allied to Germany and that the resulting pressure on Britain and France would dissuade them from intervening.[11] However, he was unable to get a commitment from Mussolini in 1938 to enter a war that might result from Germany's campaign for *Lebensraum* in central and eastern Europe.[12] It is also clear that the German military feared a war against the west in 1938 and therefore opposed the planned invasion of Czechoslovakia. On June 18, Hitler's General Staff submitted to him a revised draft of the May 30 directive for *Fall Grün* (Operation Green) that would make military action against Czechoslovakia conditional on absolute assurances that the western powers would not intervene.[13]

It is not known what immediate effect if any this initiative from the military had on Hitler's calculations during the summer of 1938. It would appear from the events of the summer and autumn of that year that Hitler was dissuaded from risking war with England to accomplish the destruction of Czechoslovakia. He made further attempts in the summer of 1938 to convince Britain and France that each of the Great Powers had its separate spheres of influence and power and that each should be free to act within its own sphere without interference.[14] The concept of Great Power spheres of influence precluded negotiations over Czechoslovakia or any other question considered part of the German sphere, just as it would preclude international action on problems within the British and French imperial spheres. Hitler was interested neither in British mediation in the Sudeten crisis nor in an international solution to the problem.[15]

Any doubts that the British government might have had regarding Hitler's true intentions in Czechoslovakia disappeared during the Hitler-Chamberlain talks at Bad Godesberg in late September. Hitler demanded not only incorporation of the Sudetenland into the Reich, but also immediate evacuation of Czech troops and entry of German troops into the areas to be ceded. All of this was to occur before the terms of the transfer could be worked out.[16] Having already agreed to the cession of the Sudetenland, the Czech government would also be forced to yield the country's carefully prepared defenses before the organization of a new posture. The immediate

entry of the German army into the Sudetenland would deprive a truncated Czech state of every safeguard for its national existence. Chamberlain could not agree to Hitler's new conditions for a settlement and accused the German side at Bad Godesberg of deliberately moving toward war.[17]

By the last week in September, the crisis over Czechoslovakia had reached the breaking point. The government in Prague had accepted all of the German demands with the exception of the immediate entry of German troops into the Sudetenland. Britain and France, having urged the Czech government to accept the cession of territory, refused to urge compliance with the German military occupation of the Sudetenland. On the German side, *Fall Grün* was to commence on October 1 on the basis of Prague's refusal to accept Hitler's latest demand. The original plans and orders for *Fall Grün* of April and May, 1938, had stipulated that unacceptable demands be made on the Czech government to provide a pretext for military action.

It appears that sufficient doubt had developed in Hitler's mind about British intentions to compel him to cancel *Fall Grün*, to tolerate foreign intervention at Munich in a matter within the German sphere and to accept a settlement that fell short of his aim. He was confronted with a choice that he had always hoped to avoid, namely, between the destruction of Germany's eastern neighbors and peace with Great Britain. His *ohne England Kurs* had failed at least temporarily, because the two components of that policy appeared to be incompatible in 1938. One had to be sacrificed for the other; peace with England was maintained for the time being at the expense of the destruction of Czechoslovakia.

On September 26, Hitler met with Sir Horace Wilson, a close adviser to Chamberlain, in Berlin. Wilson warned Hitler that Britain would stand by France in any Franco-German war arising from the Sudeten crisis.[18] In a report to Berlin on September 28, the German Embassy in London concluded that England would intervene if Germany marched on Prague.[19] On the same day, the British fleet was mobilized in a further effort to dissuade Hitler from launching an attack on Czechoslovakia.[20]

There were other factors that must have restrained Hitler and increased his own sense of isolation. The most important of these was Italy's reluctance to encourage any action that might lead to a general European war. The Italian attitude was apparent in Mussolini's appeal for further negotiations on the Czech problem and his suggestion for a four-power conference to resolve the issue.[21] The Hungarian government was reluctant to risk a general European war

in spite of its ambitions for Czechoslovakian territory.[22] Finally, the negative reaction of the citizens of Berlin to a late September show of German military strength along the Wilhelmstrasse might also have been a restraint.[23] Clearly the threat of British intervention was the crucial factor that prompted Hitler's sudden retreat from war. He would not have needed the active participation of Italy and Hungary or the support of the German populace to wage war against an isolated Czechoslovakia.

Hitler appears to have regretted his decision not to invade Czechoslovakia almost immediately after the Munich conference.[24] He resented western intervention in central Europe and a settlement that deprived him of his war of conquest over Czechoslovakia. Moreover, Munich delayed his timetable for the conquest of *Lebensraum* in eastern Europe. During the months following Munich, he came to the realization that the agreement merely gave England the extra time it was seeking to complete its rearmament and preparations for a future war.[25] He concluded that Britain had been bluffing in September and would not have gone to war against Germany over the issue of Czech survival. His anger was fed by the uncomfortable thought that his decision to meet with the western powers at Munich was neither necessary nor strategically sound.

In speeches delivered at Saarbrücken on October 9, at Weimar on November 6 and at Munich on November 8, Hitler declared that Germany would no longer tolerate British intervention in Germany's European sphere.[26] He further asserted that the protection and realization of Germany's legitimate rights would no longer be sacrificed through negotiations with outside powers and that Germany would not shy away from war to realize its aims in the future. In a speech before the members of the German press in Munich on November 10, he expressed his concern about German public opinion and the peace euphoria that followed the Munich conference.[27]

He called on the press to prepare the public for war and admitted that it had been necessary in the past to pursue German foreign policy aims within the framework of repeated assurances of Germany's peaceful intentions. He further admitted that his promises of German satisfaction after the solution of the Austrian and Sudeten questions were part of the previous *peace propaganda*. He asserted that nothing could be further from the truth than the assumption that Germany was, after the Munich episode, a saturated power; rather, he concluded that Germany stood at the beginning of monumental developments that confronted the nation with important new foreign policy tasks.

By the end of 1938, Hitler was prepared to pursue his aims in

central and eastern Europe, even if it meant war with Great Britain.[28] The events of 1938 had brought him to the realization that war against the west might be necessary before Germany achieved continental hegemony. This meant that the previous timetable, based on the attainment of continental dominance before any conflict with England, would have to be altered. Hitler had to begin planning a possible western campaign as a contingency, forced upon him by Great Britain, to precede the eventual assault on the Soviet Union.[29] At the Reichskanzlei conference of November 5, 1937, Hitler had not dismissed the possibility of conflict with the west over Austria and Czechoslovakia. During the May crisis of 1938, he had again been forced to consider the possibility of war with the west as a preliminary step in his conquest of eastern Europe.

Although he had not lost his long-standing desire to come to terms with England on the basis of spheres of influence, by early 1939, Hitler was prepared to force such an arrangement on England through war. He did not have in mind the destruction of the British Empire, but wanted instead to remove British power from the European continent.[30] In this way, he hoped to force Britain into accepting the kind of Anglo-German partnership he had favored since *Mein Kampf.*

On November 26, 1938, a position paper was prepared by the Oberkommando der Wehrmacht (High Command of the Armed Forces, OKW), on Hitler's orders, to serve as the basis for forthcoming military discussions with Italy.[31] It envisioned a potential war between the Axis and Great Britain and France in which England would be expelled from the continent and ultimately forced to acquiesce in Germany's conquest of *Lebensraum*. There does not seem to have been any intention to wage all-out war on Britain and its empire. Hitler's strategy was to crush France, something he planned in *Mein Kampf*, and thus deny Britain a foothold on the continent. Germany could then turn its attention to the east for the onslaught against the Soviet Union.

On May 23, 1939, Hitler met with his military commanders at the Reichskanzlei.[32] What was said at the meeting provides a clear picture of Hitler's strategy and goals regarding England in the months ahead. The conquest of living space in the east was emphasized as Germany's major geopolitical aim. It was decided that Poland would be invaded at the first favorable opportunity and that the likelihood of fulfilling this task without provoking a war with the west was minimal. At this meeting, the first reference was made to the possibility of a temporary change in relations with the Soviet Union during a *Zwischenstufe* (intermediate stage) of conflict with the west.[33]

Finally, while the discussions produced plans for the defeat and occupation of the Netherlands, Belgium and France, there were no similar plans for Great Britain and the British Empire. Air and naval attacks against Britain would be carried out from airfields and ports along the channel and North Sea until England accepted German hegemony over the European continent.

The events of the summer of 1939 demonstrate Hitler's continuing preference for an understanding with England. The only change in Hitler's *Englandpolitik* after Munich was that he was prepared to go to war rather than give up or postpone any element of his plans for *Lebensraum*. This did not mean that his hopes for Anglo-German cooperation had disappeared. His failure to secure the voluntary nonintervention of the western powers had forced him to reach a temporary accommodation with the Soviet Union and to proceed according to the guidelines established at the May 23 Reichskanzlei meeting. He still wanted to avoid war with England in spite of the developing Soviet option. He made this clear in a conversation with Carl Burckhart, the League of Nations commissioner for Danzig, on August 11.[34] During last minute talks with British Ambassador Henderson on August 24 and 25, in an effort to avoid Anglo-German hostilities over Poland, Hitler reviewed his past attempts to reach an understanding with England and lamented Britain's failure to reciprocate.[35] He further told Henderson that Germany intended to solve the problems of Danzig and the Corridor, boasted of Germany's accommodation with the Soviet Union and warned that Germany no longer faced the disadvantage of a two-front war.[36] Finally, he reiterated his long-standing desire for an Anglo-German understanding based on mutual guarantees and support.

The crisis days of August and the threat of war with Great Britain did not dissuade Hitler, as had been the case a year earlier. He was prepared to proceed with his so-called *Zwischenstufe*, protected by his pact with Stalin.[37] When he thought he had accomplished this by the summer of 1940, Hitler hoped at long last to be able to achieve the elusive accommodation with England that would permit him to turn on the USSR and complete the drive for living space in eastern Europe.[38]

### German Propaganda and Italian Middle East Policy

Hitler's efforts to pressure England into acquiescing in his plans for expansion in central and eastern Europe in 1938 and 1939 were augmented by an intense anti-British propaganda campaign.[39] The aim of the campaign was twofold: to impress upon the British govern-

ment Germany's determination to achieve its aims in Europe by war if necessary and to distract the British from Europe by periodically attacking the conduct of British imperial policy. Much of the ammunition for this campaign was provided by the always volatile situation in the Middle East, particularly in Palestine following the publication of the recommendations of the Peel Commission.[40] Early in 1938, moreover, Germany began broadcasting in Arabic to the Middle East from a transmitter at Zeesen.[41] The broadcasts stressed Arab-German friendship and were critical of British and French policy in the Middle East. Palestine was a particularly convenient source for anti-British propaganda, although the attacks on British policy that appeared in the German press and on German radio never called for the elimination of British power in the eastern Mediterranean. Vague references to the legitimate national aspirations of the Arab people were not an advocacy of an end to British power and influence in the Middle East. By late 1938, the British Foreign Office was satisfied that German propaganda against Britain regarding Palestine and the Middle East was intended to maintain and increase the pressures on Britain in the Levant and thus turn it away from the issues at stake in Europe.[42]

On several occasions, Hitler took advantage of the unrest in Palestine in an attempt to embarrass the British government and to press his notion of mutually agreed upon spheres of interest. In his Reichstag speech of February 20, 1938, he attacked the British Parliament and the British press for their persistent criticism of political and racial persecution in Germany.[43] He referred to the harsh sentences given to Arab rebels by British military courts in Palestine and argued:

> I advise the members of the English House of Commons to concern themselves with the judgments of British military courts in Jerusalem, and not with the judgments of German courts of justice. . . . I would never allow members of the German Reichstag to concern themselves with matters of English justice. The interests of the British world empire are surely very great, and they are also recognized as such by us. But the German Reichstag and I as representative of the Reichstag, and not a delegation of English letter writers, decide what is in the best interest of the German people and empire.

On September 12, 1938, at the closing session of the Nürnberg Party congress, Hitler compared the Sudeten Germans with the Arabs of Palestine and warned:

My task, and the task of us all, my fellow Germans, is to en-
sure that *hier nicht aus Recht Unrecht wird* [here wrong does
not come from right]. For it concerns fellow-Germans. I am in
no way willing to allow a second Palestine to emerge here in
the heart of Germany through the cleverness of other states-
men. The poor Arabs are defenseless and perhaps forgotten.
The Germans in Czechoslovakia are neither defenseless nor are
they forgotten.[44]

In his October 9 speech at Saarbrücken, Hitler again demanded Brit-
ish acceptance of German freedom of action in central Europe in re-
turn for German support for Great Britain in Palestine and elsewhere
in the British Empire.[45] He continued in the same vein on November
8 at the Bürgerbräukeller in Munich:

The English Parliamentarians are surely very much at home in
the British world empire, but they are not in central Europe.
Here they lack any knowledge of the circumstances, events
and relationships. They must not take this assessment as an
insult, for we do not know our way around so well in India, or
in Egypt or even in Palestine. I would consider it correct if
these gentlemen would concentrate the enormous knowledge
they possess and their unfailing wisdom at this moment on—
let us say—Palestine. They could do wonderful things there.
For what is happening there smells a lot like force, and very
little like democracy. But I am only presenting that as an ex-
ample, and in no way as criticism, for I am only the represen-
tative of my German people, and not the advocate of others.
Therein lies the difference between myself and Mr. Churchill
and Mr. Eden, who pose as advocates of the whole world.[46]

Finally, in a speech at Wilhelmshaven on April 1, 1939, Hitler again
pursued the same line of argument to counter British protests over
Germany's incorporation of Bohemia and Moravia into the Reich:
"When a British statesman demands today that every problem within
the German sphere of interest must first be discussed with England,
then I could demand equally that every British problem first be dis-
cussed with us. Certainly these Englishmen would respond to me:
the Germans have no business in Palestine! We don't want anything
to do with Palestine. Just as we Germans have no business in Pales-
tine, so, too, England has no business in our German living space."[47]
    Just as the German propaganda campaign against England was
not an attempt to undermine Britain's position in Palestine or

throughout the Middle East, Germany's relationship with Italy during the prewar years was in no way intended to alter the status quo in the eastern Mediterranean. It has been observed above that, throughout the 1920s and early 1930s, Hitler had expressed his disinterest in the entire Mediterranean area and had recognized it as Italy's natural sphere of interest and expansion. The evidence also indicates that he neither favored an Anglo-Italian conflict in the Mediterranean nor supported any existing or potential Italian claims against British territory in the Middle East during the years before World War II.

On several occasions during the late 1930s, Germany reiterated its disinterest in the Mediterranean and its support for a strong Italian position in the area.[48] On a visit to Italy in September, 1936, Hans Frank told Mussolini that Hitler regarded the Mediterranean as an Italian sea in which Italy had the right to exercise a dominant role.[49] During Mussolini's visit to Germany in September, 1937, it was agreed that Germany would continue to support Italian interests in the Mediterranean, while Italy would recognize Germany's dominant role in Austria.[50] It was also agreed that each would endeavor to seek advantages for the other in any improvement in relations with Great Britain. In March, 1939, German Ambassador von Mackensen told Ciano that Hitler's policy was still to regard the Mediterranean as an Italian sea and that Germany had no territorial ambitions in the area.[51] On March 25, Ribbentrop circulated a memorandum to various government ministries and Party agencies that concluded that German policy in the Mediterranean would reflect Italian needs and ambitions.[52] By November, 1938, Consul-General Döhle was able to report from Jerusalem that Germany was faithfully observing the unwritten agreement of the Rome-Berlin Axis, according to which German support for It-lian policies in the Mediterranean and Middle East would be forthcoming.[53]

Italian disappointment with the peace settlement of 1919, which had considerably strengthened British and French domination of the Mediterranean area, fueled the revisionist sentiment of Fascist Italy after 1922. Mussolini's concept of the entire Mediterranean Sea as *mare nostrum* emerged as a rather general, ill-defined aim eventually to replace Britain and France as the dominant force in the Mediterranean and in the Red Sea.[54] However, Italy posited no specific claims against Britain in the Middle East, with the exception of a desire to share in the control and operation of the Suez Canal. While anxious to protect and promote its own prestige and influence in Palestine, Italy did not seek to replace Britain as the Mandate power. In the 1920s, Mussolini came to accept the British need for a link with India through Palestine and Transjordan and did not dis-

pute British control of those territories; on the other hand, Italy did on occasion express an interest in succeeding France as the Mandatory for Syria.[55] Syria, Albania, Tunis, Corsica and Nice were the major aims of Italian revisionism in the Mediterranean area during the interwar years, while Anglo-Italian friction stemmed from competition in the area of Ethiopia, Somalia and the Red Sea, as well as the British presence on Malta.[56]

Mussolini was mildly supportive of the aims of the Zionist movement and the idea of a Jewish National Home in Palestine during the 1920s and the early 1930s.[57] He, too, was once of the opinion that Great Power influence in Palestine and the Middle East was best promoted through the support of Zionism, although both Britain and Italy came to the realization by the late 1930s that support for the Arab side might be more fruitful. Until 1935, Mussolini pursued a cooperative policy toward Britain and France, hoping that he would receive their support for the planned conquest of Ethiopia. His stand on Austria in 1934 and participation in the so-called Stresa Front against Germany are indicative of this policy.[58] The Ethiopian war in 1935, followed by the Spanish civil war in 1936, forced Mussolini to conclude that his aims could only be achieved in the face of Anglo-French opposition. As a result, Italy began an intense anti-English campaign in the Middle East and a program of financial support for Arab insurgents in Palestine. Italy's efforts to woo Arab opinion after 1936 were designed more to put pressure on Britain to accept the Italian conquest of Ethiopia and some measure of equality in eastern Africa and the Red Sea than seriously to undermine British power in the Levant.

Hitler had always wished to avoid an Anglo-Italian conflict in the Mediterranean and Africa because of his desire to make both England and Italy allies of Germany. It is demonstrated below that Hitler saw a great deal of value in utilizing Britain's overseas troubles to pressure it into a more compliant attitude toward Germany's plans for central and eastern Europe. Both Hitler and Mussolini could benefit from Britain's difficulties in Palestine after 1937. They sought not to destroy Britain's position in Palestine, but rather to increase the pressure on Britain to acquiesce in Italian expansion in Africa and German expansion in Europe. In November, 1937, British Ambassador Henderson sent the following assessment from Berlin of the value of Italian policy in the Mediterranean to German aims in Europe:

> If an Anglo-German understanding proves impossible of accomplishment, it is likely that the German government will

seek in the first place to realize its aims not by an act of aggression against Great Britain, but by a policy of pressure in other parts of the world. The ties with Italy and Japan will afford Germany a good opportunity for exploiting her own nuisance value and it may be expected that the German government will more or less actively assist Italy in causing us trouble in the whole of the Mediterranean basin.[59]

One can appreciate the limited scope of German efforts to exacerbate Britain's difficulties in the Middle East through an understanding of the German position on Anglo-Italian relations. While Italian efforts to encourage anti-British feeling in the Arab world were to Germany's advantage, Hitler also encouraged measures that would prevent an Anglo-Italian conflict in the Mediterranean and Red Sea areas. He approved of the Anglo-Italian "Gentlemen's Agreement" of January, 1937, according to which Britain and Italy were supposed to take steps to end their propaganda war in the Middle East.[60] Although this agreement failed to generate an improvement in Anglo-Italian relations, it was a step toward the more comprehensive Anglo-Italian understanding of early 1938. In the summer and autumn of 1937, Britain had tried to enlist Italian support for the Peel Partition Plan in the face of Arab and Jewish resistance and to reach an agreement whereby Italy would cease supporting anti-British forces in Palestine, both Arab and Jewish.[61] Germany's strong opposition to the idea of partition and an independent Jewish state notwithstanding, the Foreign Office in Berlin instructed its Embassy in Rome on August 23, 1937, to refrain from any attempt to influence Italian policy or the Italian negotiating position with England.[62] The August 23 telegram did instruct the German Embassy in Rome to make known to the Italian government Germany's views on the situation in Palestine and to attempt to find out what Italy's position on Palestine and the partition plan would be in future negotiations with England.

An Anglo-Italian accord was signed on April 16, 1938, according to which both sides agreed to preserve the status quo in the eastern Mediterranean and the Red Sea.[63] In return for British acceptance of the Italian conquest of Ethiopia and a preponderant role in Yemen, Italy agreed to end its anti-British propaganda in the Middle East and to respect the status quo in Palestine and in the rest of the Middle East. The German Foreign Office was enthusiastic about the agreement, especially since the question of partition and a Jewish state had become dead issues. In a telegram to the German Embassy in Prague on April 19, Weizsäcker observed that the elimination of An-

glo-Italian friction was advantageous for Germany.[64] An unsigned memorandum dated April 27, found in Weizsäcker's files, concluded that, from the standpoint of German interests and policy, the Anglo-Italian agreement was a definite strategic advantage.[65] It referred to the dangers for Germany posed by any conflict between Great Britain and Italy and to the precedent of this bilateral agreement on spheres of interest, precisely the approach taken by Germany as the basis of its relationship with Great Britain.

There is no evidence that Hitler favored a conflict in the Mediterranean between his Italian ally and either Britain or France before August, 1939. It appears that he wanted to avoid any difficulties in the Mediterranean that might involve material support for Italy and thus detract from Germany's objectives in Europe. Henke rightly observes that during the political and military discussions between Germany and Italy in the spring of 1939, Germany concerned itself with a possible war against Britain and France in Europe only and ignored the matter of Italian ambitions in the Mediterranean basin.[66] Moreover, Weizsäcker claimed that the German government was pleased with Italy's position in the spring and summer of 1939 that it would not be ready for war for several years.[67] In March, 1939, Hitler told Italian Ambassador Attolico that the Axis would need from eighteen months to two years to prepare for war against Britain and France.[68] He reiterated his general support for Italy but said nothing about Italian ambitions in the Mediterranean. It is likely that Hitler wanted to prevent any unilateral action by Italy against France or Britain, especially while Germany was engaged in its campaign against Poland.[69] Italy's repeated warnings that it could not contemplate war until 1942–1943 at the earliest were accepted by Göring during his talks with Mussolini in Rome on April 15 and 16 and by Ribbentrop during his talks with Ciano in Milan on May 6 and 7.[70] It seems clear that Germany and Italy agreed on the necessity of avoiding a conflict between Italy and the western democracies, at least until such time as Germany was ready for its onslaught against the west.

### Germany and the Arab World, 1938–1939

It has been concluded above that German attitudes toward Arab nationalism through 1937 were conditioned by the strategic and racial considerations of Hitler's *Englandpolitik*. Before the summer of 1937, the German government refrained from giving any encouragement or moral support to the Arab national movement in Palestine or elsewhere in the Middle East, in spite of the efforts of Döhle in

Jerusalem, Grobba in Baghdad, the AO in Berlin and a few others to promote a more sympathetic response from Germany. Hitler's hopes for an understanding with Britain precluded even the mildest form of moral support for an Arab nationalism aimed at loosening Britain's grip on its share of the Levant. The German position was altered somewhat in June, 1937, in view of the forthcoming recommendations of the Peel Commission. Neurath's circular of June 1 proposed a more sympathetic attitude toward the Arabs of Palestine as a means of combating the partition plan and the recommendation for an independent Jewish state in Palestine. However, it has been demonstrated that the German government had no intention of becoming involved in the matter and that there was overall agreement in Berlin that the new approach to the Arabs would certainly not involve material assistance or anything beyond the brief anti-partition propaganda campaign in the German press in the summer and autumn of 1937. The German effort was an attack on partition and the creation of a Jewish state, not an endorsement of Arab independence and an end to the Anglo-French Mandates in the Levant.

Germany continued to reject Arab requests for material assistance for the Arab revolt in Palestine during the months immediately following publication of the Peel report. This policy continued through the first half of 1938; with the growing realization that the partition scheme would not be implemented, there was less reason to risk alienating Britain through active support of the Arab cause in Palestine. At that point, Hitler's *ohne England Kurs* did not necessarily require increased British preoccupation with its own imperial problems. Thus, Germany saw no need to contribute to Britain's difficulties in Palestine and in the Middle East as a whole. On October 8, 1937, Hentig informed the German Consulate in Beirut that Germany would not provide weapons or munitions to the Arab cause in Palestine.[71] On November 9, Grobba told Sheik Yussuf Yassin al-Hud, Ibn-Saud's private secretary, that Germany desired friendly relations with Great Britain and was therefore unable to provide the Palestinian Arabs with the support they wished.[72] On January 7, 1938, Grobba reported that he had rejected a request for weapons from a group conspiring against King Ibn-Saud, claiming that it was not Germany's policy to become involved in purely Arab matters.[73] By the end of March, 1938, Lord Perth, the British ambassador in Rome, reported his conviction that Germany was not interested in anything other than commercial activity in the eastern Mediterranean, either alone or in conjunction with Italy.[74] Moreover, Perth observed that the Italian government did not want German involvement in the Mediterranean area at that time.

Part of Germany's commercial activity in the Middle East during the late 1930s involved the sale of weapons to nominally independent countries as Germany began exporting weapons again in 1936. A consortium of German corporations was formed to cooperate with the government in the sale of German weapons abroad. This consortium, known as the Reichsgruppe Industrie: Ausfuhrgemeinschaft für Kriegsgerät (Reich Industrial Group: Export Cooperative for War Material), consisted of some of Germany's leading arms manufacturers;[75] moreover, it reflected the government's desire to increase Germany's exports and thereby earn much-needed foreign exchange through the sale of German arms to overseas buyers.[76] In most cases, Germany demanded full payment in foreign currency or raw materials; only in rare instances did it grant long-term credit arrangements.[77] One result of this policy was that most German weapons exports went primarily to European and South American countries, while sale to the Middle East and South Asia made up a very small proportion of total weapons exports.[78]

Opportunities for exporting arms to areas outside of Europe and South America were considerably restricted by the conditions of colonial rule in Africa, the Middle East and South Asia. The absence of fully independent governments and the almost total political, economic and military domination of those areas by Britain, France and others precluded free access to existing and potential arms markets. This was certainly true in the Middle East, where, with the exception of Palestine, states had achieved varying degrees of independence from Britain and France. Although Saudi Arabia, Iran and Afghanistan were not directly under British colonial rule, their freedom of action was limited by British power and influence. This was especially so in the case of Saudi Arabia. Egypt, Iraq and Transjordan, in spite of nominal independence, were still subject to a continuing British military presence and overwhelming political, economic and military dominance by Great Britain. Syria and Lebanon were perhaps even more closely tied to France. Moreover, if these countries had the need, desire and complete freedom to purchase large amounts of arms from Germany, they still lacked the financial means to do so. During the 1930s, the Middle East was still one of the smaller oil-producing areas of the world; both the price and the demand for Middle East oil were comparatively low, and those countries that did produce significant amounts of oil did not have the kind of purchasing power they have today.

Afghanistan and Iran were the only two countries in the area in which Germany actively sought to strengthen its political influence during the 1930s. There is a temptation to attribute this to racial fac-

tors, with both countries populated by peoples who distinguish themselves as Aryans from their Semitic Arab neighbors to the west. Another reason might be that there was less likelihood of running into British opposition, because direct British power and influence were somewhat weaker than in the Arab world. In October, 1936, Hitler ordered the promotion of close economic ties between Germany and both Iran and Afghanistan, and Germany's political and economic position in those two countries was considerably enhanced between 1936 and 1939.[79] Alfred Rosenberg's Aussenpolitisches Amt in the NSDAP was an important proponent of German penetration of Afghanistan.[80] While the Foreign Office favored economic penetration, it was reluctant to support the APA wish to train and equip the Afghan army.[81] By 1939, Germany had become the chief supplier of imports into Afghanistan. Moreover, it did undertake to train and equip the Afghan army and police and achieved a position of considerable prestige and influence in both Afghanistan and Iran by 1939.[82] There does not appear to have been any British opposition to German activities in either Afghanistan or Iran. One might speculate in the absence of further evidence that Britain was more fearful of a Russian than a German threat in South Asia. Afghanistan and Iran, both of which shared long borders with the Soviet Union, were natural bridges for Soviet expansion toward India.

Germany also demonstrated an interest in Iraq as a market for weapons exports in 1936 and 1937. Unlike Iran and Afghanistan, however, Iraq had been a British Mandate until 1932 and was a vital link in Britain's overland communications with India. The terms of Iraqi independence provided for the retention of a strong British military presence in the country, as well as in the entire Persian Gulf. The Anglo-Iraqi treaty of June 30, 1930, was designed to regulate the relations between the two countries by terminating the Mandate, providing for Iraqi independence and admission into the League of Nations, and by establishing a close military alliance between them.[83] Provisions were worked out whereby British military installations in Iraq would continue to function and Britain would play a crucial role in the defense of the country. Included in the agreement was the understanding that Iraq would purchase its military necessities from Britain and look elsewhere only when Britain was unable to provide the desired equipment.

On October 29, 1936, a *coup d'état* was staged in Baghdad by Bakr Sidqi, the chief of the Iraqi General Staff, and Hikmat Sulayman, who became prime minister.[84] The new regime wished to lessen Iraq's political and military dependence on Britain and sought closer ties with Germany.[85] Since Britain, due to its own rearmament needs,

was unable to supply some of the weapons Iraq had been seeking, the new Iraqi government turned to Grobba for assistance. At the end of 1936, a German General Staff officer, Colonel R. Heins, posing as a geologist, came to Baghdad to assess the Iraqi requests.[86] In March, 1937, Grobba reported that the new Iraqi government had received permission from the British government to look elsewhere to satisfy some of its weapons requirements.[87] The Iraqi government was interested in artillery, antiaircraft pieces, machine guns, trucks, fighter aircraft and bombs.[88] Problems arose, however, over the British requirement that all weapons purchased from other countries, with the exception of antiaircraft batteries and antitank weapons, be of the same caliber as those in the British arsenal. On April 3, the Reichskriegsministerium (Reich Ministry of War) notified the Foreign Office in Berlin that most of the weapons requested by Iraq could not be delivered because of the cost and production problems involved in changing the standard German calibers and because of Germany's own rearmament needs.[89]

The German Ministry of Economics was especially keen on exporting arms to Iraq as a means of earning foreign currency, while the Foreign Office was less than enthusiastic about the matter for fear of complicating relations with England.[90] Grobba did not want to pursue a weapons deal with Iraq if it resulted in a confrontation with England, as indicated in his telegram from Baghdad to the Foreign Office in Berlin on May 12, 1937.[91] By late June, Grobba reported that Britain was beginning to have reservations about the possible sale of German arms to Iraq.[92] He noted that the intense negotiations undertaken by Krupp and Rheinmetall with Iraqi authorities for the delivery of relatively modest amounts of German weapons to Iraq was causing concern among British officials there. According to Grobba, British reservations were based on Iraq's role in the Palestine conflict and Iraqi purchases of Italian arms in spite of British objections.[93] Iraq had become the most outspoken critic of the Peel Partition Plan in Palestine and vowed to use its resources to prevent its implementation. Nevertheless, Grobba did advise Berlin to proceed with the plan to sell weapons to Iraq in spite of British reservations, because he was convinced that Britain would acquiesce in the end, just as it had when the Iraqi government purchased Italian arms.

The consortium of German firms formed in 1937 under the leadership of Rheinmetall-Borsig to negotiate with the Iraqi government was able to sign its first weapons deal with Baghdad on December 9, 1937. It amounted to a good deal less than what Iraq had previously requested and apparently did not encounter British objections. The Iraqi army was to receive eighteen 2cm antiaircraft pieces with am-

munition for the total price of £Strlg 92,082.[94] Representatives of
Rheinmetall-Borsig had visited London in October in an effort to se-
cure British approval for this transaction, as well as future German
sales in the Middle East.[95] The representatives told British officials
that German authorities, especially in the Reichskriegsministe-
rium, preferred to work with Britain rather than against it in the
matter of German arms sales in the Middle East. While British au-
thorities did express their reservations about German arms sales to
Iraq, they agreed to permit the Iraqi purchase of some German weap-
ons that Britain itself was unable to supply.

Only two other major arms transactions were concluded be-
tween Germany and Iraq before the war. In September, 1938, the
Iraqi government purchased eighteen 2cm machine guns with am-
munition, and in April, 1939, eighteen 2cm antiaircraft pieces with
ammunition.[96] Germany had, therefore, considerably less success in
Iraq than in Afghanistan and Iran.

Even after the summer of 1938, when events in Europe provided
Hitler with a pretext for contributing to Britain's difficulties in the
Middle East, Germany made only sporadic, halfhearted attempts to
utilize Arab discontent and unrest to its advantage. There is ample
evidence that Hitler did attempt to take advantage of the unrest in
Palestine to distract Britain from the crisis over Czechoslovakia and
thus discourage British intervention. Hitler held a secret conference
in mid-July, 1938, attended by Göring, Keitel, Goebbels, Himmler
and others, during which he ordered the timing of the planned attack
on Czechoslovakia to coincide with any period of heightened con-
flict in Palestine.[97] The evidence also indicates that, by the summer
of 1938, Germany was prepared to abet the conflict in Palestine to
this end. For the first time, Germany embarked upon a policy of lim-
ited intervention in Palestine, not to undermine and eliminate the
British position in Palestine or to promote the cause of Arab inde-
pendence, but simply to contribute to pressures that might dissuade
Britain from intervening in central Europe.[98] In the absence of evi-
dence, it would seem likely that consideration was also given to the
impact of continued Jewish emigration to Palestine on the violence
raging in the country and consequently on the difficulty of Britain's
position.

The vehicles for the new German effort in Palestine were Admi-
ral Canaris's Abwehr (Counterintelligence Service) and Ambassador
Grobba in Baghdad. In his diaries, former Abwehr officer Helmuth
Groscurth made the following entry for August 29, 1938: "Discussion
with Ambassador Grobba from Baghdad. Arab movement should
be activated immediately."[99] Canaris had met the Mufti earlier in

1938 when traveling incognito to Beirut.[100] An Abwehr report of early 1939 also mentioned the financial aid that had been provided to the Mufti and his operations in Beirut.[101] Fritz Grobba was used on at least one occasion to deliver money to the Mufti. According to Grobba, he once met Musa al Alami, who had fled Palestine for exile in Syria, in Damascus and turned over to him £Strlg 800, which, Grobba said, "was entrusted to me in Berlin for this purpose."[102] The Abwehr also attempted to have small quantities of German weapons delivered to Arab insurgents in Palestine via Saudi Arabia and Iraq in 1938, albeit unsuccessfully. According to von Hentig, arrangements had been made by the Abwehr, the assistant foreign minister of Saudi Arabia and the Iraqi prime minister to smuggle German weapons into Palestine via Saudi Arabia and the Persian Gulf, but the whole scheme had to be canceled because Fuad Hamza, the assistant foreign minister of Saudi Arabia, was also working for the British.[103] It does appear, however, that the Abwehr had earlier provided Fuad Hamza with money for the Arab cause in Palestine. In a note to Ernst Woermann in May, 1939, Fritz Grobba referred to money that Germany had sent to the Arab movement in Palestine via Saudi Arabia: "On behalf of King Ibn-Saud, I was asked confidentially by his adviser, Sheik Yussuf Yassin, about our relations with Fuad Hamza, and further, if we had given him money for the Palestinian matter, and, when I answered that we had, I was given to understand that we should discuss matters regarding Palestine only with people whom the Grand Mufti designates as his agents."[104]

In 1938 and early 1939, Britain suspected but was never quite certain that some German money was going to the Mufti for the Arab movement in Palestine.[105] The United States was convinced by October of 1938 that German money was involved in the Arab unrest in Palestine that continued without interruption throughout 1938 and the first half of 1939.[106] During 1938, rumors were rampant that German money and arms were flowing into Palestine, although British authorities were satisfied that Germany was not sending weapons into the country.[107] Nor is there any documentary evidence that the German Foreign Office approved of the Abwehr's financial support for the Mufti and the Arab cause in Palestine. Although the documents contain no comments on the matter, favorable or otherwise, from Ribbentrop, Weizsäcker, Woermann, Hentig and others, it is not likely that there was much support for the endeavor in the Foreign Office. It is known that Hentig, Weizsäcker and Woermann were generally opposed to a major German involvement in the Middle East, while Ribbentrop appears to have been completely uncon-

cerned about the region. Grobba was the prime mover in Iraq and joined with the APA in 1938 in urging closer ties between Germany and Saudi Arabia. In the case of Saudi Arabia, the responsible authorities in the Foreign Office were again cool to the idea of deeper political and economic involvement.

In 1937, Ibn-Saud had sent his personal physician, Dr. Medhat Sheik el-Ardh, to Berlin to sound out German government, Party and business circles about supplying weapons to Saudi Arabia.[108] Ibn-Saud's initiative occurred at about the time that the APA began to take an interest in the Middle East. Later in the year, Sheik Yussuf Yassin al-Hud, Ibn-Saud's personal secretary, approached representatives of the German firm Otto Wolff in Baghdad and requested 15,000 German rifles and long-term credits with which to pay for the weapons.[109] Neither of these initiatives met with success, although they did encourage the APA about future prospects for Germany in Saudi Arabia. In March, 1938, al-Hud was sent to Berlin by Ibn-Saud at the instigation of the APA and Grobba for the purpose of negotiating closer political and economic ties with Germany.[110] The visit included another Saudi request for German military assistance, including 25,000 rifles with ammunition. The APA supported the Saudi request and was enthusiastic about the prospect of increasing German influence on the Arabian peninsula, as outlined in a memorandum on July 23, 1938.[111] The same memorandum complained of strong opposition from the responsible ministries to closer political and economic ties with Saudi Arabia. Both the Ministry of Economics and the Economics section (W–III) in the Foreign Office were opposed to any deals with Saudi Arabia, whether for weapons or other goods, because of Saudi inability to pay with cash.[112] Hentig and Woermann in the Foreign Office opposed weapons transactions with Saudi Arabia for economic and political reasons. In a note to the APA in the autumn of 1938, Hentig outlined his reasons for opposing arms sales to Saudi Arabia.[113] He argued that even the Saudis acknowledged that they could never act against Great Britain and under certain circumstances would be forced to side with the British. Therefore, he concluded that the political preconditions for German military assistance to Saudi Arabia were completely lacking. The weapons deal was successfully blocked by Hentig and the economic authorities. The only accomplishment of the APA and Grobba was establishment of diplomatic relations between the two countries, with Grobba being accredited to Saudi Arabia in addition to his post in Baghdad.

Grobba did not entirely disagree with Hentig's reasons for op-

posing the sale of arms to Saudi Arabia. Grobba told Luigi Sillitti, the Italian ambassador to Saudi Arabia, that in the event of war, Ibn-Saud would side with Great Britain, because only Britain had the power to ensure the delivery of foodstuffs upon which Saudi Arabia depended.[114] Nevertheless, he did favor meeting some of the Saudi requests for German arms and developing German-Saudi economic relations. In a note to Woermann on February 18, 1939, Grobba recognized that not all of the Saudi requests could be met; however, he advocated some declaration by the German government supporting Arab independence in general, as well as the open provision of a few weapons to preserve Saudi goodwill toward Germany.[115]

According to Hentig, Ferrostaal A.G., the company with which al-Hud had negotiated for arms during his Berlin visit in 1938, was not very enthusiastic about selling weapons to Saudi Arabia for both political and economic reasons.[116] Nor was the OKW inclined to support the sale of arms to Saudi Arabia and the forging of closer political and military ties after the Abwehr's aborted attempt to smuggle weapons into Palestine via Saudi Arabia. The OKW considered the Saudi government unreliable and remained cool to the idea of providing weapons to Ibn-Saud as a result.[117] Finally, an unsigned memorandum of the APA's Amt für Vorderasien (Office for the Near East) of June, 1939, referred to Hentig's previous success in persuading Ribbentrop against arms deliveries to Saudi Arabia.[118]

Events in Europe and the Middle East in the late spring of 1939 led to a change in the German position on supplying weapons to Saudi Arabia. By the end of May, Grobba had succeeded in convincing Woermann and even Hentig that a German move in Saudi Arabia was desirable. The most important factor in this change was probably Hitler's acceptance by late May of the risk of war with England over Poland. This appears to have been the case in the thinking of the German Foreign Office as well. Early in May, Grobba renewed his appeal to Woermann to reconsider his position on military assistance to Saudi Arabia.[119] Grobba argued that Germany would soon be at war with England and that closer ties with Saudi Arabia were necessary to ensure a benevolent Saudi neutrality, a goal he considered to be in Germany's strategic interest. In his memorandum to Ribbentrop of May 22, Hentig outlined the reasons for his change of position on relations with Saudi Arabia.[120] While he did not mention the possibility of war in Europe, it is implied throughout his comments with a definite sense of urgency. Moreover, he outlined the political and economic changes in the Middle East in recent months that, in his opinion, made a move in Saudi Arabia desirable in view of the European situation:

For recent months have proven, 1. that Egypt has moved completely to the British side, 2. the resistance in Palestine is clearly subsiding, 3. Syria is not in a position to conduct an independent policy, 4. a threat from the flank via Turkey to British overland communications has been eliminated, 5. King Ibn-Saud had been regularly earning a good income in the past year from the oil fields on the Persian Gulf, and 6. there is a growing distrust of Italy in the Arab world. . . .

Thus, by the early summer of 1939, the German Foreign Office had concluded that most of the countries in the Middle East, including Turkey, would side with England either as allies or as friendly neutrals.[121] Moreover, the British white paper on Palestine of May, 1939, effectively neutralized the Arab rebellion; it officially rejected partition and the creation of an independent Jewish state, drastically reduced Jewish immigration and required Arab consent for future Jewish immigration.[122] Although the white paper did not meet the Arab demand for immediate independence, it did remove the most immediate source of anti-English feeling in the country. Arab unrest waned after the publication of the white paper, thus depriving Germany of a convenient point of British vulnerability in the Middle East. It appeared to Hentig that opportunities in the Middle East for distracting Britain were suddenly disappearing at a moment when they were needed most. At the same time, Saudi Arabia's small but growing oil revenues after 1938 eliminated the economic arguments against extending military and economic aid to Ibn-Saud's government.

In the middle of May, al-Hud returned to Berlin for another attempt at securing German weapons. He met with a much more receptive German Foreign Office and was not forced to waste his time with the APA as he had been forced to do a year earlier. On June 8, al-Hud was received by Ribbentrop, who gave his assent to al-Hud's request for a large quantity of German rifles and the construction of a munitions factory in Saudi Arabia.[123] On June 17, Hitler received al-Hud at the Berghof and gave his approval for the sale of 8,000 rifles with 8 million rounds of ammunition, the construction of a small munitions factory in Saudi Arabia and the sale of antiaircraft guns and tanks in the more distant future.[124] Italy had come to favor a greater German involvement in Saudi Arabia because of its own unpopularity on the Arabian peninsula and needed German support to offset the British advantage in the Red Sea.[125] Negotiations between al-Hud, the Foreign Office and the OKW on a weapons package and the terms of payment continued until an agreement was reached in

July.[126] The package, which included 4,000 rifles, ammunition, anti-aircraft guns and the munitions factory, was never delivered due to the outbreak of war in September.

Hentig's earlier fears about Saudi unreliability and susceptibility to British pressure had not disappeared entirely during the summer of 1939. There remained a sense of hopelessness throughout the German Foreign Office regarding the German position in the Middle East in the event of war. Hentig's memorandum of May 22 to Ribbentrop had described the disappearance of opportunities in Egypt, Palestine, Syria, Turkey and Iraq, with Saudi Arabia representing the last opportunity for exploiting British vulnerabilities in the Middle East. Yet the suspicions about Saudi Arabia seemed to linger despite al-Hud's meetings with Ribbentrop and Hitler in June, 1939. It is possible that the German government had no intention of delivering the arms and other assistance promised to al-Hud in June, hoping instead to use the threat of German involvement in Saudi Arabia to pressure Britain about Poland. On July 11, the OKW informed the Foreign Office in Berlin of the following instructions from Hitler: "On July 11, 1939, the Führer, through his adjutant, informed us that he disapproves of weapons deliveries to hostile countries, or to states whose position in a war would be doubtful. Weapons should be delivered where they can help us, or at least where they cannot harm us, for example, to South America, the Baltic states and Bulgaria."[127] The list of German arms exports to the Middle East for the spring and summer of 1939 reflects reluctance to send weapons to countries other than Iran and Afghanistan. While arms exports to these countries increased considerably, those to Arab states all but disappeared.[128]

In his memoirs, Fritz Grobba summarized Germany's overall Middle East policy during the 1930s as one of wasted opportunities.[129] He observed that Germany failed to take advantage of Arab hostility toward Britain and France and sympathy for Germany to promote German political and economic influence in the area and attributed this failure to several factors: Hitler's racism, which was directed against Arabs as well as Jews; his basic disinterest in the Middle East; his deference to British and Italian interests in the Mediterranean area; and a disinclination on his part to see British power eliminated from the Middle East. Grobba concluded that the Hitler regime was never willing to lend its support to the concept of Arab independence and national self-determination. Because of his racial *Weltanschauung* and geopolitical strategy, and the significance of first England and then Italy in that strategy, Hitler would never have committed Germany to the cause of Arab independence.

General Franz Halder, the chief of the General Staff of the German Army between 1938 and 1942, concurred with Grobba's observations in his foreword to a study of German involvement with Arab nationalist movements, prepared for the U.S. Army by two former German officers involved in the Middle East during World War II.[130] Referring to the years before and after 1939, Halder observed:

> German efforts to exploit the Arab nationalist movements against Britain lacked a solid foundation. Occupied by other problems more closely akin to his nature, Hitler expended too little interest on the political and psychological currents prevalent in the Arab world. . . . In the diplomatic, propaganda and military fields, Germany had neglected to prepare the ground for a serious threat to Britain in the area of that country's important land communication route between the Mediterranean Sea and the Indian Ocean. . . . No uniformly thought out plan was developed for the exploitation of the Arab nationalist movements.

Until the outbreak of World War II in September, 1939, Germany's overall policy toward the Middle East remained subordinate to the course of Hitler's relations with England and the question of German expansion in Europe. The belated and halfhearted involvement in Palestine in 1938 and 1939 was an attempt to influence events in Europe, not to change the status quo in Palestine. There seemed to be a realization that Axis power had its limits in the eastern Mediterranean.[131] Moreover, German Middle East policy, particularly with regard to Palestine, was also dependent on the needs of domestic Jewish policy, namely, rapid Jewish emigration from Germany. During his talks with al-Hud in Berlin in June, 1939, Hitler refused to act on al-Hud's criticism of German emigration policy.[132] In January, 1938, Döhle had reported from Jerusalem that Arab sympathy for Germany was declining as a result of Germany's continued promotion of Jewish emigration to Palestine.[133] He also coupled this point with the fact that persistent refusal to contribute diplomatically or materially to the Arab struggle against Britain and Zionism was undermining Arab friendship for Germany. Grobba warned of the same problem facing Germany in Iraq in late 1938.[134] Arab dissatisfaction with German emigration policy continued through the summer of 1939. In June and July, both Hentig of Pol. VII and Hinrichs of Referat-D described the growing hostility in the Arab world over the question of Germany's role in the process of illegal Jewish immigration to Palestine.[135] In March, 1939, Grobba also pointed

to Arab disappointment and frustration with Germany's deference to Italian ambitions throughout the Mediterranean, especially in Syria.[136] Thus, Jewish policy on the domestic front, coupled with the role of Britain and Italy in Hitler's geopolitical calculations, conditioned Germany's approach to Palestine and the Middle East. The Arab cause in Palestine, at best a convenient tool to influence events in Europe briefly in 1938 and 1939, remained apart from the interests of National Socialist Germany.

# 10. Conclusions

The Palestine policy of National Socialist Germany during the 1930s was firmly rooted in the ideological development of the National Socialist movement during its early years. Hitler's attitudes toward Zionism and world Jewry, Great Britain and, indirectly, the Arab world emerged from his speeches and writings during those years and remained consistent through the 1930s. Hitler accepted Alfred Rosenberg's premise that the Zionist movement was an arm of an international Jewish conspiracy. He believed that Zionism did not merely seek the creation of a refuge for persecuted Jews, but that it hoped instead to establish an independent power base from which to conduct the conspiracy against Germany and the rest of the Aryan world. All Jews, whether Zionist, non-Zionist or anti-Zionist, were viewed as part of this conspiracy. On the other hand, there emerged a willingness to use Zionism to reverse the assimilationist tendencies of the German Jewish community and to promote the rapid emigration of Jews from Germany. This is especially evident in Rosenberg and to a lesser extent in Hitler during the early years.

Hitler's admiration for the British Empire and his desire for an Anglo-German understanding were also evident during the early years of the movement and would remain so throughout the 1930s. It is clear that he pursued British support for German expansion in Europe and for at least a share in Europe's domination over the rest of the world. His racist *Weltanschauung* precluded any sympathy or support for the national liberation and self-determination of the peoples of Africa and Asia. He believed not only in the necessity and inevitability of German hegemony in Europe, but in the perpetual hegemony of white Europeans over the world as a whole as well. Scholars may debate the question of whether Hitler ultimately intended to replace the Anglo-French world empires with a German version or whether he intended to secure a share of that domination for Germany in partnership with Britain. It is certain that he did not

seek the destruction of British imperial power by the budding na-
tionalisms of Africa and Asia. To have encouraged Arab ambitions
for national self-determination in Palestine and throughout the
Middle East would have disrupted his plans for an Anglo-German
understanding on Europe and would have violated the racial tenets of
National Socialism.

The policies toward the Zionist movement pursued by govern-
ment and Party agencies in Germany between 1933 and 1937 have
been outlined in detail. While these policies do stem from the ear-
lier willingness of Hitler and Rosenberg to use Zionism as a means
of encouraging Jewish emigration from Germany, they were also the
result of economic realities that confronted the new regime in Ger-
many in 1933. Moreover, Zionism held a certain appeal for many
anti-Semites. Its *völkisch* concept of nationhood was at least related
to the traditional German equivalent, a nationalist alternative to the
nineteenth-century liberal ideal of a pluralistic society held by the
great majority of Jews in Germany. It offered to assist in efforts to
remove Jews from the political, social and cultural fabric of German
society and to encourage their departure from Germany.

Almost unanimous support for Zionist emigration to Palestine
was the rule between 1933 and 1937 in the agencies of the German
government and the Nazi party. The responsible authorities in the
German Foreign Office, including the German Consulate-General in
Jerusalem, the Orient-Abteilung, Referat Deutschland and the Han-
delspolitische Abteilung, lent their support and encouragement to
Zionist efforts. As the agency responsible for the implementation of
emigration policy and procedures, the Ministry of the Interior en-
couraged orderly Zionist emigration from Germany, while the Min-
istry of Economics and the Reichsbank were responsible for the
Haavara agreement and the economics of large-scale Jewish emigra-
tion from Germany to Palestine. Moreover, the responsible agencies
within the SS police establishment accorded the German Zionist
movement preferential treatment over the various non-Zionist and
anti-Zionist liberal/assimilationist organizations. Zionist occupa-
tional retraining centers (*Umschulungslager*) were encouraged, while
Zionist officials and teachers from Palestine and elsewhere were
usually granted entry visas by German authorities in order to facili-
tate the efforts of the German Zionist movement.

Economic factors also underlay German support for the Zionist
option. Besides the ideological imperatives of National Socialism
that considered all Jewish property in one way or another as stolen,
Germany's precarious economic position made it impossible for Jew-
ish emigrants to take even a modest portion of their assets abroad to

meet the usually strict immigration requirements of most destination countries. Hitler's early economic policies, inspired by Schacht, sought to find new markets for German manufactured goods and to redirect Germany's foreign trade away from its industrial competitors toward the less industrialized parts of Europe and the rest of the world, where German goods would meet less competition. The overall effort to promote German exports was threatened by the international boycott against German goods that resulted from the anti-Jewish legislation in Germany in 1933. Zionist emigration to Palestine provided a useful means to lessen the negative impact of these factors to some extent. The Haavara transfer agreement of 1933 partially resolved the problem of removing Jewish assets from Germany by enabling Jewish emigrants to transfer a small portion of those assets to Palestine in the form of German goods to be sold on the Palestine market. German exports to Palestine and to the rest of the Middle East were substantially increased as a result of Haavara. Although this amounted to very little in Germany's overall export trade, it did represent a contribution to Schacht's economic aims. Finally, Haavara helped to neutralize the international anti-German boycott. Already beset with a variety of problems in organization and coordination, the boycott leaders also had to contend with the adverse example of Palestine as the Jewish National Home importing large quantities of German goods.

Between 1933 and 1937, Palestine remained the preferred destination in Nazi emigration policy. This is not to say that the Zionist goal of a Jewish majority and state in Palestine was acceptable to the Hitler regime or that relations between Nazi officials and the German Zionist movement approached even a modicum of cordiality. The racial policies of the Hitler regime created a situation in which both German and Zionist authorities reluctantly recognized more advantage than disadvantage in a relatively high degree of cooperation. For the Hitler regime, the foundations for a Jewish National Home in Palestine, laid by the Balfour Declaration in 1917 and subsequent Anglo-Zionist efforts, were used as an instrument in its pursuit of a "racially healthy" *Volksgemeinschaft* in Germany. The realization in 1937 that those efforts might lead to the creation of an independent Jewish state in Palestine revived the old anti-Semitic bogey of an international Jewish conspiracy and generated considerable debate in German government and Party circles over Germany's past and future relationship to the Zionist movement.

German attitudes and policies toward the other two elements in the Palestine triangle, Britain and Arab nationalism, have also been considered in detail. The consensus among scholars is that Hitler

based his geopolitical strategy and hopes from the early 1920s until the late 1930s on some form of Anglo-German understanding, be it an alliance or simply passive British acquiescence to his aims in Europe. This study does not address itself to the debate over the existence or nonexistence of German plans for world domination after the attainment of continental hegemony. In either case, the needs and scope of Hitler's foreign policy during the 1930s would have been essentially the same. On the other hand, his attitudes and policy toward Arab nationalism and the Middle East were conditioned in large measure by his *Englandpolitik*.

Between 1933 and 1937, Hitler sought an accommodation whereby he would provide German guarantees for the security of the British Empire in return for British approval of German expansion in central and eastern Europe. Although he did demand the return of at least one of Germany's former colonies in Africa as a source for raw materials, he was prepared to renounce for the time being the *Weltpolitik* of the imperial era. Nor would he sanction any Italian imperial claims against the British Empire. Clearly, the English alliance was more important to him than the Italian before 1937. As his dream of an Anglo-German alliance failed to materialize, Hitler began to revise the tactics of his *Englandpolitik*. England's reaction to events in Ethiopia, Spain and the Rhineland in 1935 and 1936 convinced him that he could achieve his aims in central and eastern Europe without an English alliance, free of English intervention. He would continue to pursue the elusive understanding, but at the same time prepare to achieve his aims without it.

Germany's Arab policy was clearly influenced to a considerable extent by Hitler's *Englandpolitik* as a result of the importance of the English factor for his plans in Europe. It was also the result of the international dimensions of his racial *Weltanschauung*. Repeated Arab attempts throughout the 1930s to secure German diplomatic, financial and material assistance against the Zionists and the British in Palestine were rejected. The documents reveal a consensus in the German Foreign Office that friendly relations with Great Britain were essential and precluded the kind of assistance requested by Arab leaders. The NSDAP/Landesgruppe-Palästina confined its work to the German Christian communities that remained neutral in the Arab-Jewish conflict and loyal to the British administration. Relations with the other nominally independent Arab states were such that Germany refrained from actions that might have been construed by British authorities as detrimental to British security in the strategically vital Middle East. Arab frustration over the continuing British presence in Palestine and elsewhere generated little or no

sympathy from the German leadership before 1937. The strategic and ideological goals of National Socialist foreign policy necessitated aloofness from the Arab national movement. For Hitler, Britain held the key to the successful pursuit of German aims in Europe; overt support for Arab national self-determination would have worked against the attainment of those ends. Moreover, the racial philosophy of National Socialism precluded support for Arab efforts to achieve independence at the expense of British power in the Middle East.

By mid-1937, Germany's relationship to all three factors in the Palestine triangle had come under serious question in government and Party circles in Berlin. The Peel Partition Plan of July, 1937, and its recommendations for separate Arab and Jewish states in Palestine raised doubts about the wisdom of continued support of Zionist emigration to Palestine and past rejection of Arab overtures for assistance. Moreover, it appears from the conversations at the famous Reichskanzlei meeting in November, 1937, that Hitler was prepared seriously to consider war against England if necessary to achieve his aims in Europe.

There was nearly unanimous opposition within the government and Party leadership to the creation of an independent Jewish state in Palestine, regardless of individual political and ideological predilections. Adherence to the Jewish conspiracy theory was not necessary for a German case against an independent Jewish state. The anti-Semitic policies of the Hitler regime would make a Jewish state a natural enemy of the Reich and a dangerous addition to the growing coalition of nations hostile to the new Germany. This strategic reality blended well with the old conspiracy theories of the nineteenth century, and of Nazi ideologues, enabling them and the conservative civil servants in the Foreign Office to share a common aversion to the Peel Partition Plan of 1937. Foreign Minister von Neurath's circular of June 1, 1937, embodied this combination in its warning that Palestine could become a base for the alleged international Jewish conspiracy against Germany, much as the Vatican was for political Catholicism and Moscow for the Comintern.

The debate within the government and the Party over Palestine during the second half of 1937 was centered on German emigration policies, specifically, the question of destination countries for Jews emigrating from Germany. Even the most ardent critics of previous policy did not advocate an end to Jewish emigration from Germany to Palestine. Grobba, Döhle, Referat Deutschland and the Auslandsorganisation favored a greatly reduced role for Palestine in the process of Jewish emigration. Grobba and Döhle were alarmed at the negative impact that support for German Zionism was having on

Germany's prestige among the Arabs, while Referat-D and the AO supported those fears and added their own belief that an independent Jewish state would contribute to the international Jewish campaign to destroy the new Germany. They also proposed a major revision of the Haavara agreement that would lessen its contribution to the growing strength of the Zionist position in Palestine. They did not propose a complete end to Jewish emigration from Germany to Palestine, nor to the use of Haavara to promote it. They argued that emigration policy should seek to scatter German Jews around the world, rather than to concentrate them in Palestine, where they would certainly facilitate the creation of a Jewish state. These individuals and agencies also favored closer ties to the Arabs in Palestine and elsewhere, short of material assistance, fearing that German support for Zionist emigration to Palestine was needlessly costing Germany the natural sympathy of the Arab world. On the other hand, Pol. VII and the economic authorities in the Foreign Office and the Ministry of Economics favored continued use of Palestine as the primary destination for Jewish emigration from Germany. They argued that German Jews scattered abroad would actively contribute to anti-German sentiment and policies in their new countries, while concentrating them in Palestine would enable Germany to deal with them effectively as a unit. They strongly favored the retention of the Haavara system, although they were willing to make some changes in order to satisfy its critics.

The ministerial meeting on Palestine held on July 29, 1937, was under instructions from Hitler to effect the rapid emigration of Jews from Germany with all means available. He neither singled out Palestine as a preferred destination nor excluded it. At subsequent meetings on Palestine in September and October, there was no question that Palestine would continue to play an important role in the emigration process. The only question still subject to debate was the efficacy of Haavara and the matter of its alteration or outright abolition. Those meetings indicate that Palestine's usefulness as a *Zielland* had come to be questioned not so much out of fears of an independent Jewish state as out of the realization that Palestine's capacity to absorb increasing numbers of Jewish immigrants was increasingly limited due to violent unrest between Arabs and Jews and consequent British immigration restrictions. By the end of 1937, Hentig and others could argue, in support for the maintenance of previous policies, that Britain would never be able to implement the partition plan in the face of Arab opposition and that a Jewish state in Palestine was an unlikely prospect for the future. In January, 1938, Hitler again called for rapid mass Jewish emigration from Germany and

made specific reference to Palestine as a desirable destination in the emigration process.

The debate in 1937 had also raised the question of German attitudes toward the Arab national movement in Palestine. In the spring of 1937, Döhle had urged a more sympathetic response, short of material assistance, to the Arab overtures of friendship for Germany. Neurath's June 1 circular had also called for a more sympathetic position on Arab nationalism, although it did not recommend material assistance or even overt diplomatic support. In the end, the suggestions of Döhle, Neurath, Grobba and others changed nothing; Germany continued for the most part to ignore the Arab world and soon consigned the entire Mediterranean area to the Italian sphere of interest.

German reluctance to take full advantage of the volatile situation in Palestine and elsewhere in the Arab Middle East in order to pressure Britain on the issues of Austria, Czechoslovakia and Poland reflected Hitler's ongoing wish to avoid provoking England and thus ensure at least British acquiescence in German expansion. The exception to this occurred during the developing crisis over Czechoslovakia in 1938. The small amounts of money relayed from Canaris's Abwehr via Grobba to the Mufti in Beirut in the summer and autumn of 1938 represented a brief attempt to contribute to Britain's troubles in Palestine and thereby influence British policy in the crisis in central Europe. It is not certain that Hitler had authorized Canaris's effort, and one should not construe this example of German intervention in Palestine as an attempt to promote the success of the Arab cause in Palestine or otherwise to threaten Britain's position in the Middle East. Apart from this, there were no serious efforts to take advantage of Arab nationalism to further German interests or undermine British imperialism. The export of insignificant quantities of weapons to the Arab countries where British influence was dominant was done with the knowledge and consent of England. German arms were never provided to Arab insurgents in Palestine during the years of violence, although the Abwehr had planned to send arms to Palestinian insurgents via Saudi Arabia and Iraq. The shipments were never sent, and the fact that Germany made no other attempts to send arms to Palestine reflected the limits to the degree of difficulty the German government wished to create for Britain in Palestine. Nor did Germany encourage Italian aims in the eastern Mediterranean that might have conflicted with British interests. On the contrary, the German government approved of Anglo-Italian efforts in 1937 and 1938 to settle their problems peacefully. Thus, the Hitler regime continued to ignore the Arab factor in 1938 and 1939.

Germany and Italy had no interest in the achievement of true Arab independence, nor was there any interest on Germany's part in undermining or eliminating the British position in the Levant.

It is unlikely that Hitler's intervention in January, 1938, in favor of continued Jewish emigration to Palestine was motivated by factors specifically related to the arguments of those Party and government officials involved in the Palestine debate in Germany. It would seem that Hitler linked Jewish policy in general, and the changes in the organization and operation of German emigration policy in 1938 and 1939 in particular, to his timetable for war. He believed that a Reich completely free of Jewish influence and a Jewish presence was a prerequisite for embarking on his campaign for *Lebensraum* in Europe. By early 1938, Jewish participation in the German economy was still considerable, while past emigration procedures had not been able to remove even half of Germany's 1933 Jewish population. Measures were initiated in 1938 and 1939 to strip Germany's remaining Jewish population of its role in the economy, arbitrarily to confiscate what was left of Jewish assets and to centralize the emigration process under the SS. The new emigration procedures followed by the SS were designed to remove the maximum number of Jews from Greater Germany in the shortest period of time. The relative merits of the various destination countries appear to have been of little consequence to Hitler, although countries outside of Europe had always been the preferred destinations since 1933. The only aim of emigration measures after 1938 was to complete the removal of Jews from Germany as rapidly as possible; as long as Palestine was capable of absorbing Jewish refugees from Germany, all means, legal and illegal, were used to that end. Moreover, in spite of an overall reduction in the numbers of Jews entering Palestine in 1938 and 1939, there was a substantial increase in the number of Jews entering from Germany. Finally, the SD and the Gestapo, in control of the emigration process after 1938, cooperated with Zionist organizations in the effort to move illegal immigrants to Palestine past Britain's restrictive quotas and blockade.

German plans for war in 1938 and 1939 affected emigration policy in other ways as well. The Foreign Office circular of January 25, 1939, asserted that the Jewish question would not be solved for Germany when the last Jew left German soil. The implications of this view were evident in Hitler's speech to the Reichstag on January 30 of that year. He argued that the Jewish question was a European one and that peace would never come to Europe until it was resolved. Clearly, the Jewish question was a central factor in Germany's domestic preparations for war in 1938 and 1939 as well as in the plans

for the creation of a new European order under National Socialism. It assumed its natural new dimension in German strategy in 1938 and 1939 with the prospect of German conquests in the east.

Some opponents of Zionist emigration to Palestine had long argued that Palestine was not a suitable destination over the long term because of its size, political unrest and the immigration restrictions imposed by British authorities. These arguments had little bearing on the matter of Jewish emigration from Germany. However, the imminence of war in 1938 and 1939 and the Nazi leadership's increasing interest in the European dimensions of Germany's "Jewish problem" prompted serious consideration of radically new solutions. The old emigration procedures had been geared to the relatively small German Jewish community and would not be applicable to the millions of Jews living in Germany's new *Lebensraum* in eastern Europe, especially under the adverse conditions of war. Thus, the idea of shipping millions of European Jews to Madagascar became more popular among elements of the Nazi leadership, including Hitler himself. The ideas and plans that emerged between 1938 and 1941 in Germany envisioned a huge *Reservat* on Madagascar for the Jews of Europe, at first under European, then, after 1940, under German control. This was essentially the kind of solution that had been pursued for the German Jewish question through the promotion of Zionist emigration from Germany to Palestine between 1933 and 1940. Palestine had been viewed as one of several *Reservate* for German and other European Jews; an independent Jewish state in Palestine was no more likely or acceptable than it would have been on Madagascar. In both instances, the Jewish people were to remain under the control of a European power; in the case of Palestine, that control was exercised by Germany's potential ally, Great Britain.

Germany's Palestine policy between 1933 and 1940 was based on a fundamental acceptance of the post–World War I status quo in the Middle East. For different reasons, the Hitler regime continued in the footsteps of the various Weimar governments by identifying German interests with the postwar settlement in Palestine. That settlement embodied a growing Jewish presence and homeland in Palestine, as well as the establishment of British imperial power over Palestine and much of the Middle East. It also represented a denial of Arab claims to national self-determination and independence in Palestine and throughout the Middle East. Between 1933 and 1940, German policy encouraged and actively promoted Jewish emigration to Palestine, recognized and respected Britain's imperial interests throughout the Middle East and remained largely indifferent to the ideals and aims of Arab nationalism.

# Appendix 1.

## German Institutions in Palestine during the Interwar Years, Excluding the Settlements of the Temple Society

A. Deutsch-evangelische Institutionen:
1. Jerusalemstiftung (Berlin-Charlottenburg 2, Marckstrasse 2)
   —Erlöserkirche und Muristanhospiz/Jerusalem
   —Propstei und deutsch-evangelische Schule/Jerusalem
2. Jerusalemverein (Berlin-Halensee, Paulsbornerstrasse 86)
   —Kirche, Schule und Diakonissenstation/Bethlehem
   —Schulen in Beth-Djala und Beth-Sahur
3. Ölbergsverein (Potsdam, Augustastrasse 18/19)
   —Kaiserin Augusta-Viktoriastiftung auf dem Ölberg, Hospiz-gebäude
4. Diakonissen-Anstalt Kaiserswerth am Rhein
   —Deutsches Hospital/Jerusalem
   —Mädchenerziehungsanstalt Talitha-Kumi/Jerusalem
5. Balley Brandenburg des Johanniter Ordens (Berlin W5, Schöne-bergufer 19)
   —Johanniter-Ordens-Hospiz/Jerusalem
6. Verein für das Syrische Waisenhaus (Köln-Marienburg, Ulmen-allee 86)
   —Waisenhaus mit Schule und Werkstätten/Jerusalem
   —Zweigstation für Landwirtschaft in Bir-Salem bei Ramleh
   —Galiläisches Waisenhaus in Nazareth
7. Evangelische Karmelmission (Thiemendorf, Oberlausitz)
   —Hospiz auf dem Karmelberge/Haifa
   —Missionstation und Schule/Haifa
   —Schule in El-Bassa

---

SOURCE: PA: Büro des Reichsaussenministers, "Palästina," Übersicht über die deutschen Institutionen in Palästina, Stand vom 1937.

B. Deutsch-katholische Institutionen:
  1. Deutscher Verein vom Heiligen Lande (Köln, Steinfelder-Gasse 17)
     —Deutsche Benediktinerabtei/Jerusalem
     —St. Paulus Hospiz und Görresheim/Jerusalem
     —Schmidt's Girls School/Jerusalem
     —Hospiz in El-Kubebe (Emmaus)
     —Hospiz und Ausgrabungstätte in Tabgha/Genezarethsee
  2. Barmherzige Schwestern vom Hl. Carl Borromäus (General-mutterhaus in Trebnitz, Schlesien)
     —Provinzial-Mutterhaus mit Hospiz und St. Karlsschule/Jerusalem
     —Deutsches Hospital und Hospiz/Haifa
     —Hospiz auf dem Berge Karmel/Haifa
     —Schule/Haifa
     —Genesungsheim in El-Kubebe (Emmaus)

# Appendix 2.

## German Schools in Palestine during the Interwar Years with Sources of Support

1. Schule der deutschen evangelischen Gemeinde / Jerusalem: Deutsche evangelische Gemeinde, Jerusalem
2. Talitha Kumi / Jerusalem: Diakonissen Anstalt, Kaiserswerth
3. Katholische Mädchenschule des Vereins vom Heiligen Lande, genannt Schmidt's Girls School / Jerusalem: Deutscher Verein vom Heiligen Lande, Köln
4. St. Karls Schule / Jerusalem: Orientmission der barmherzigen Schwestern vom heiligen Karl Borromäus
5. Deutsche Realschule / Jaffa: Tempelgemeinde und Evangelische Gemeinde, Jaffa
6. Schule der Tempelgemeinde / Wilhelma: Tempelgemeinde, Wilhelma
7. Deutsche Schule / Haifa: Tempelgemeinde und Evangelische Gemeinde, Haifa
8. Armenschule der Karmelmission / Haifa: Evangelische Karmelmission, Haifa
9. St. Karls Schule / Haifa: Orientmission der barmherzigen Schwestern vom heiligen Karl Borromäus
10. Schule des Syrischen Waisenhauses / Jerusalem: Evangelischer Verein für das Syrische Waisenhaus, Köln
11. Lyceum Tempelstift / Jerusalem: Tempelgemeinde, Jerusalem
12. Schule der Tempelgemeinde / Sarona: Tempelgemeinde, Sarona
13. Evangelische Gemeindeschule / Waldheim: Bürgerliche Gemeinde, Waldheim
14. Deutsche Schule / Betlehem: Tempelgemeinde, Betlehem
15. Deutsche Schule / Nazareth: Elterngemeinschaft, Nazareth, Tiberias

---

SOURCE: ISA: Deutsches General-Konsulat / Jerusalem, 67 / 1358.

# Appendix 3.

## *Settlements of the Temple Society in Palestine*

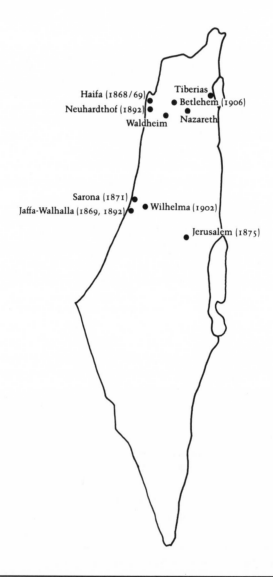

Haifa (1868/69)

Neuhardthof (1892)

Waldheim

Tiberias

Betlehem (1906)

Nazareth

Sarona (1871)

Jaffa-Walhalla (1869, 1892)

Wilhelma (1902)

Jerusalem (1875)

SOURCE: ISA: Deutsches General-Konsulat/Jerusalem, 67/1383. Nazareth and Tiberias were not Templer colonies, but a few Templer families did live in both cities.

# Appendix 4.

## *German Trade Balance with Palestine, 1924–1932*

| Year | Imports from Germany (in £pal) | Exports to Germany (in £pal) |
|------|--------------------------------|------------------------------|
| 1924 | 574,066 | 19,525 |
| 1925 | 954,329 | 20,708 |
| 1926 | 734,305 | 54,053 |
| 1927 | 557,617 | 90,009 |
| 1928 | 667,218 | 69,025 |
| 1929 | 743,656 | 117,356 |
| 1930 | 762,075 | 203,549 |
| 1931 | 638,185 | 201,730 |
| 1932 | 775,104 | 332,819 |

SOURCE: ISA: Deutsches General-Konsulat/Jerusalem, 67/1272.

# Appendix 5.

## Major German Imports into Palestine and Ranking Compared to Other Countries as of 1927

1. earthenware and porcelain (4th)
2. glassware, mirrors, glass for lamps (2nd)
3. cement (1st)
4. wrought iron (2nd)
5. bedsteads (2nd)
6. steel girders (1st)
7. kitchen utensils (2nd)
8. nails, screws, brackets (2nd)
9. iron plates (1st)
10. safes (4th)
11. iron pipes (2nd)
12. aluminum (1st)
13. brass products, copper plates (1st)
14. lead products (2nd)
15. pewter products (3rd)
16. watches (1st)
17. knives (2nd)
18. agricultural tools (2nd)
19. scientific equipment (2nd)
20. photographic equipment (1st)
21. agricultural machinery (1st)
22. machines of all kinds, electric machines, sewing machines, electrical equipment (1st)
23. cotton products (4th)
24. carpets and wool products (3rd)
25. wool covers (2nd)
26. artificial silk and rayon products (2nd)
27. linen (2nd)

SOURCE: PA: Pol.Abt.III—Wirtschaft, Palästina, Handel 11, Bd.1, DGK/Jerusalem an AA/Berlin, JN 541/27, 9. Mär.1927.

28. hats (2nd)
29. women's stockings (2nd)
30. carbonic acid (1st)
31. lubricating oil (5th)
32. soap (2nd)
33. leather (1st)
34. wrapping paper (2nd)
35. paper for printing (2nd)
36. roofing felt (1st)
37. silver-plated products (3rd)
38. jewelers' equipment (2nd)
39. gramophones (2nd)
40. perfume (2nd)

# Appendix 6.

## Officers of the Deutsches Pro-Palästina Komitee as of March, 1929

1. Ehrenausschuss:
   Preussischer Kultusminister Prof. Dr. Becker
   Preussischer Ministerpräsident Dr. h.c. Otto Braun
   Professor Dr. Albert Einstein
   Geh. Regierungsrat L. Kastl, Mitglied der Permanenten Mandats-
      kommission des Völkerbundes
   Generalkonsul Eugen Landau
   Reichstagspräsident Paul Löbe
   Staatssekretär in der Reichskanzlei Dr. Pünder
   Staatssekretär des Auswärtigen Amts Dr. von Schubert
   Direktor der Deutschen Bank Oscar Wassermann
   Staatssekretär des Preussischen Staatsministerium Dr. Weismann
2. Präsidium:
   Botschafter a.D. Graf Bernstorff, Vorsitzender
   Ministerialdirektor Dr. H. Badt
   Rabbiner Dr. Leo Baeck
   Prof. D. Dr. Dr. J. V. Bredt, M.d.R.
   Dr. R. Breitscheid, M.d.R.
   Kurt Blumenfeld, Vorsitzender der Zionistischen Vereinigung für
      Deutschland
   Regierungspräsident Dr. H. Haussmann
   Prof. Dr. O. Hoetzsch, M.d.R.
   Freiherr von Richthofen, Ministerialdirigent im Auswärtigen Amt
   Geh. Konsistorialrat Prof. D. Dr. Sellin
   Legationsrat Prof. Dr. M. Sobernheim
   Kommerzienrat Konsul Dr. W. Sobernheim

---

SOURCE: PA: Pol.Abt.III, Politik 2 a—Palästina, Bd. 1, "Tätigkeitsbericht des D.K.P.P. zur Förderung der jüdischen Palästinasiedlung für die Zeit vom 1.II.28–31.I.29."

Other Members Who Joined during the 1920s:

Eduard Bernstein, M.d.R.

Prof. Dr. Blanchenhorn

Geh. Regierungsrat Cleinow

Reichsminister a.D. Dr. Dernburg

Dr. A. Grabowsky

Prof. Dr. Jäckh

Thomas Mann

Reichskanzler a.D. Hermann Müller

Generalkonsul Prüfer

Oberregierungsrat Dr. Simons

# Appendix 7.

## Jewish Legal Immigration to Palestine, 1933–1940

| Year | Total Jewish Immigration | Jewish Immigration from Germany | | Jewish Immigration from Austria |
|------|------|------|------|------|
| | | Number | % of Total | |
| 1933 | 30,300 | 7,600 | 25 | |
| 1934 | 42,400 | 9,800 | 23 | |
| 1935 | 61,900 | 8,600 | 14 | |
| 1936 | 29,700 | 8,700 | 29 | |
| 1937 | 10,500 | 3,700 | 35 | |
| 1938 | 12,900 | 4,800 | 37 | 2,200 |
| 1939 | 16,400 | 8,500 | 52 | 1,700 |
| 1940 | 4,500 | 900 | 20 | 200 |

SOURCE: Feilchenfeld et al., *Haavara-Transfer*, p. 90.

# Appendix 8.

## *The Haavara Transfer, 1933–1939*

| Year | Total Amount Transferred in RM |
|------|-------------------------------|
| 1933 | 1,254,955.96 |
| 1934 | 8,895,038.75 |
| 1935 | 17,103,153.93 |
| 1936 | 19,958,645.50 |
| 1937 | 31,407,501.30 |
| 1938 | 18,853,913.63 |
| 1939 | 8,197,033.99 |

SOURCE: Feilchenfeld et al., *Haavara-Transfer*, p. 75. See also ISA: Deutsches General-Konsulat/Jerusalem, 67/1254, Trust & Transfer Haavara Ltd., Monatstransfer-Bericht per 28.II.39.

# Appendix 9.

## A List of Goods Transferred to Palestine through the Haavara Agreement

1. beer
2. tiles
3. marble works
4. empty bottles and jars
5. porcelain
6. sanitary ware
7. iron bars
8. iron girders
9. iron black sheets
10. nails
11. stoves
12. iron tubes, pipes and fittings thereof
13. wire and wire nettings
14. iron and steel manufactures
15. aluminum manufactures
16. brass and copper manufactures
17. tin bars
18. printer's types
19. blades for safety razors
20. cutlery
21. photographic apparatus
22. tools
23. dental, medical, optical and veterinary instruments and appliances
24. electric cable, wire and insulated pipes for electric cable and wire
25. electric glowlamps
26. electric accumulators, motors and generators
27. printing and bookbinding machinery
28. pumps
29. sewing machines
30. woodworking machinery
31. cotton piece goods
32. cotton manufactures
33. woolen tissues, velvets and embroidery
34. boots and shoes
35. braces, suspenders and belts
36. stockings
37. drugs, medicines and chemical manufactures
38. paints, colors and lacquers
39. paper and stationery
40. toys
41. toilet preparations
42. lamps
43. goldsmith's ware
44. tractors and motor cars

SOURCE: ISA: Deutsches General-Konsulat/Jerusalem, 67/1252.

# Appendix 10.

## *The Zionist and Affiliated Organizations under the Supervision of Section II/112−3 of the Sicherheitsdienst*

1. Zionistische-politische Organisationen:
   —Zionistische Vereinigung für Deutschland
   —Misrachi
   —Staatszionistische Vereinigung
   —Brith Hechajal
2. Umschulungsorganisationen:
   —Hechaluz
   —Haschomer Hazair
   —Werkleute
   —Makkabi-Hachscharah
   —Brith Chaluzim
   —Brith Haschomrim
3. Institutionen zum Palästina-Aufbau:
   —Palästinaamt der Jewish Agency
   —Keren Hajessod
   —Keren Kajemet Lejisroel
   —Keren Tora Wa Awoda
   —Keren Hamenorah
4. Jugend- und Sportorganisationen:
   —Habonim noar Chaluzim
   —Zeire Misrachi
   —Brith Hanoar schel Zeire Misrachi
   —Jüdisch-nationale Jugend "Herzlia"
   —Deutscher Makkabi-Kreis
   —Makkabi Hazair
5. Zionistische Frauenorganisationen
6. Zionistische Organisationen im Auslande:
   —Jüdische Weltkongress

---

SOURCE: BA: R/58−1242, Richtlinien für die Postauszeichnung, 11.Jun.1937.

—Komité des Délégations Juives
—American Joint Distribution Committee
—Amerikanischer jüdischer Kongress
—Zionistenkongress

Sowie sämtliche anderen jüdischen Organisationen im Ausland und deren Nachrichtendienste wie Haganah, Jüdische Telegraphenagentur, usw.

# Appendix 11.

## *Locations of the Zionist Retraining Centers in Germany*

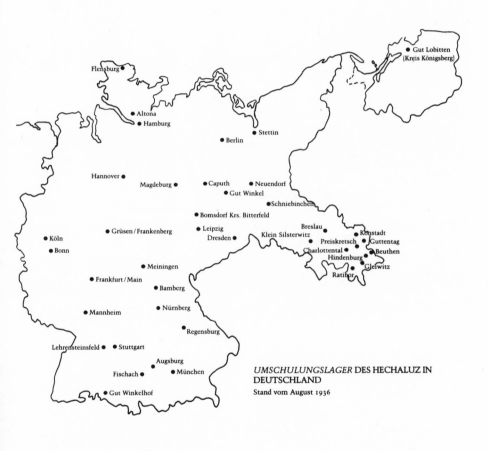

Flensburg ●

● Gut Lobitten
(Kreis Königsberg)

● Altona
● Hamburg

● Stettin

● Berlin

Hannover ●

Magdeburg ●       ● Caputh    ● Neuendorf
                  ● Gut Winkel
                     ●Schniebinchen
          ● Bomsdorf Krs. Bitterfeld

● Grüsen / Frankenberg    ● Leipzig         Breslau ●          ● Kunstadt
● Köln                    Dresden ●    Klein Silsterwitz    ● Preiskretsch  ● Guttentag
● Bonn                                        Charlottental ●      ●Beuthen
                                                  Hindenburg ●
            ● Meiningen                               Gleiwitz
  ● Frankfurt / Main                          Ratibor ●
            ● Bamberg

● Mannheim      ● Nürnberg

            ● Regensburg

Lehrensteinsfeld ●  ● Stuttgart

            Augsburg
  Fischach ●        ● München         *UMSCHULUNGSLAGER* DES HECHALUZ IN
                                      DEUTSCHLAND
      ● Gut Winkelhof                 Stand vom August 1936

SOURCE: NA: T-175/411, 2935451.

# Appendix 12.

## The Organization and Leadership of the NSDAP/Landesgruppe-Palästina

Stand von 1935:
1. Landesgruppenleiter: Cornelius Schwarz, Jaffa.
2. Kommissarischer Landesvertrauensmann: Sam Hoffmann, Sarona.
3. Landes-Film- und Funkwart: Matthias Haigis, Jerusalem.
4. Ortsgruppen bezw. Stützpunkte:
   —Jerusalem (Ortsgruppe): Ludwig Buchhalter.
   —Haifa (Ortsgruppe): Friedrich Wagner.
   —Sarona/Jaffa (Ortsgruppe): Sam Hoffmann.
   —Wilhelma (Stützpunkt): Alfred Hönig.
   —Betlehem (Stützpunkt): Hans Sus.

SOURCE: ISA: Deutsches General-Konsulat/Jerusalem, 67/1362.

# Appendix 13.

## German Weapons Exports to the Middle East, 1936–1939

1936 *Januar*
> Arabien: 13 Pistolen u. Revolver; 2 500 Pist. Revolv. Munition; 1 700 Gewehr, Karab. Munition.
> Jemen: 1 Gewehre, Karabiner.
> *März*
> Arabien: 4 000 Gewehr, Karab. MG Munition.
> Jemen: 1 Flugzeug.
> *April*
> Iran: 500 Maschinenpistolen.
> Palästina: 200 Gewehr-Karab. MG Munition.
> *Juli*
> Arabien: 1 Maschinenpistol.
> Jemen: 55 Maschinenpistolen; 2 500 Gewehre, Karabiner; 10 001 042 Gewehr-Karabiner MG Munition.
> Iran: 3 000 000 Pulver, Sprengladungen, Zündladungen.
> *September*
> Iran: 3 Maschinenpistolen; 8 000 000 Pulver, Sprengladungen, Zündladungen.
> Jemen: 2 000 Gewehre u. Karabiner; 7 006 000 Gewehr-Karabiner MG Munition.
> *Oktober*
> Arabien: 1 Gewehr-Karabiner.
> Irak: 40 Pistolenmunition; 30 Gewehr-Karabiner MG Munition.
> *Dezember*
> Irak: 40 Pistolenmunition; 60 Gewehr-Karabiner MG Munition.

SOURCE: PA: Geheim-Akten 1920–1936, II FK.33: Kriegsgerät Allgemeines, Geheimsachen, "Statistik über K. G. Ausfuhr"; and HaPol Abt.: Kriegsgerät (Geheim), Handel mit Kriegsgerät, Allgemeines, Bde. 1–4.

1937  *Januar*
       Irak: 1 Gewehre u. Karabiner.
       Jemen: 1 000 000 Gewehr-Karabiner Munition.
       *April*
       Palästina: 210 Gewehr-Karabiner MG Munition.
       *Mai*
       Britisch-Indien: 300 Gewehre, Karabiner.
       *Dezember*
       Arabien: 1 Gewehr-Karabiner.
       Britisch-Indien: 150 Gewehr-Karabiner.
       Irak: 18 2cm Maschinenkanonen u. Munition.
       Iran: 4 Einheitsbussolen—Richtkreise m. Zub.
       Jemen: 5 000 Gewehr-Karabiner MG Munition.
1938  *Januar*
       Arabien: 1 000 Gewehr-Patronen.
       Brit.-Indien: 5 000 Gewehr-Patronen.
       Jemen: 2 000 Gewehr-Karabiner MG Munition.
       *Februar*
       Ägypten: 1 Maschinenpistole.
       Brit.-Indien: 65 Gewehre u. Karabiner; 5 000 Gewehr-Kara-
          biner MG Munition.
       *März*
       Arabien: 1 Maschinenpistole; 500 Pistolen-Munition.
       *April*
       Arabien: 10 000 Kilo Pulver, Sprengladungen, Zünd-
          ladungen.
       Jemen: 20 000 Gewehr-Karabiner MG Munition.
       *Mai*
       Ägypten: 1 Maschinenpistole.
       Iran: 2 500 000 Gewehr-Karabiner MG Munition.
       *Juni*
       Brit.-Indien: 168 Gewehre u. Karabiner.
       Iran: 20 000 000 Gewehr-Karabiner Munition.
       *Juli*
       Iran: 9 500 000 Gewehr-Karabiner Munition.
       *August*
       Afghanistan: 36 81mm Minenwerfer; 10 800 F1Mx Minen-
          werfer Gesch.; 18 T Mess u. Zielgeräte.
       *September*
       Irak: 18 2cm Masch. Gewehre; 7 200 2cm Munition.
       Iran: 50 M.Karab. 7,9 (Stand. Gew.); 25 000 Gewehr-Karab.
          MG Munition; 16 B.Rh. Mess u. Zielgeräte.

*November*
Afghanistan: 10 848 Pulver, Sprengladungen,
　　　　　　Zündladungen; 66 000 Artillerie Geschose;
　　　　　　3 600 Minenwerfergesch.
Iran: 1 000 000 Pistolen Munition.
*Dezember*
Afghanistan: 36 Tankabwehrkanonen; 12 Fliegerabwehr-
　　　　　　kanonen.
Ägypten: 1 Maschinenpistole.

1939　*Januar*
Irak: 100 Patr. Lee Enfielt.
*Februar*
Afghanistan: Exerziermunition.
*März*
Ägypten: 1 Schnellfeuerpistole.
*April*
Ägypten: 1 Schnellfeuerpistole.
Irak: 18 2cm Maschinenkanonen u. Munition.
*Mai*
Afghanistan: 32 7,5cm Geschütze; 15 000 Flak-Munition;
　　　　　　25 Kisten Exerziermunition; 5 000 Artillerie
　　　　　　Munition.
Ägypten: 1 Maschinenpistole.
*Juni*
Afghanistan: 16 7,5cm Geb. Geschütze; 588 Beschirrg.
　　　　　　f. Tragtiersattel f. 24 7,5cm Gesch.
Ägypten: 1 Maschinenpistole.
*Juli*
Afghanistan: 12 7,5cm Geb. Geschütze; 490 Beschirrg.
　　　　　　f. Tragt. f. 24 7,5cm G.G.L/22 Satz.; 15 000
　　　　　　Sprengr. f. 7,5cm Geb. Gesch.
*August*
Afghanistan: 3 Schnellfeuerpistolen u. Munition; 5 000 Auf-
　　　　　　schlaggranaten 105mm.
Iran: 15 binok. Beobachtgs, Fernrohre; 60 000 Mauserge-
　　　　wehre, Kal. 7,92mm; 10 000 Karabiner Kal. 7,92mm;
　　　　40 Maschinengewehre Kal. 15mm; 35 Flugzeug- MG
　　　　m. Zubehör; 4 Flugzeug- MG iran. Modell m. Zubehör;
　　　　1 000 Inf. Patronen SS Kal. 7,92mm; 20 000 15mm
　　　　Flak Patronen; 7 920 15mm Durchschlag-Patronen;
　　　　9 000 15mm Flak-Patronen.

# Notes

## Abbreviations Used

### 1. Archival

BA: Bundesarchiv / Koblenz
CAHJP: Central Archives for the History of the Jewish People, Hebrew University / Jerusalem
CDJC: Centre de Documentation Juive Contemporaine / Paris
CZA: Central Zionist Archives / Jerusalem
IfZ: Institut für Zeitgeschichte / München
ISA: Israel State Archives / Jerusalem
LBI: Leo Baeck Institute / New York
NA: National Archives / Washington, D.C.
PA: Politisches Archiv des Auswärtigen Amts / Bonn
PRO: Public Record Office / London
SD-DF: State Department Decimal Files at the National Archives / Washington, D.C.
TG: Tempelgesellschaft für Deutschland / Stuttgart-Degerloch
YV: Yad Vashem / Jerusalem

### 2. Published Documents

ADAP: *Akten zur Deutschen Auswärtigen Politik 1918–1945*
DBFP: *Documents on British Foreign Policy, 1919–1939*
IMT: *International Military Tribunal*

### 3. Ministries, Agencies, Consular Missions

AA: Auswärtiges Amt
AO: Auslandsorganisation der NSDAP
APA: Aussenpolitisches Amt der NSDAP
DB: Deutsche Botschaft
DG: Deutsche Gesandtschaft
DGK: Deutsches General-Konsulat
Promi / RMVP: Reichsministerium für Volksaufklärung und Propaganda
RAM: Reichsaussenminister

RFM: Reichsfinanzministerium
RIM: Reichsministerium des Innern
RWM: Reichswirtschaftsministerium
St.S: Staatssekretär
USt.S: Unterstaatssekretär
ZVfD: Zionistische Vereinigung für Deutschland

## 1. Imperial and Weimar Precedents

1. Isaiah Friedman, *Germany, Turkey and Zionism, 1897–1918*, pp. 3–4.

2. The following works offer a comprehensive account of the political, ideological and spiritual cleavages within the world Jewish community among Zionists, non-Zionists and anti-Zionists; Adolf Böhm, *Die Zionistische Bewegung*, 2 vols.; Ben Halpern, *The Idea of a Jewish State*; Walter Laqueur, *History of Zionism*; Nahum Sokolov, *History of Zionism, 1600–1918*, 2 vols.; David Vital, *The Origins of Zionism*, and *Zionism: The Formative Years*.

For the specific question of German Jewry and Zionism, see the numerous appropriate essays in the following publications of the Leo Baeck Institute: Werner E. Mosse and Arnold Paucker, eds., *Juden im Wilhelminischen Deutschland 1890–1914*, *Deutsches Judentum in Krieg und Revolution 1916–1923*, and *Entscheidungsjahr 1932: Zur Judenfrage in der Endphase der Weimarer Republik*; *Yearbook of the Leo Baeck Institute*, vols. 1–30, 1956–1985. See also H. G. Adler, *Die Juden in Deutschland von der Aufklärung bis zum Nationalsozialismus*; Kurt Jacob Ball-Kaduri, *Das Leben der Juden in Deutschland*; Kurt Blumenfeld, *Erlebte Judenfrage: Ein Vierteljahrhundert deutscher Zionismus*; Richard Lichtheim, *Die Geschichte des deutschen Zionismus*, and *Rückkehr: Lebenserinnerungen aus der Frühzeit des deutschen Zionismus*; Donald Niewyk, *The Jews in Weimar Germany*; Arnold Paucker, *Der jüdische Abwehrkampf gegen Antisemitismus und Nationalsozialismus in der letzten Jahren der Weimarer Republik*; Stephen Poppel, *Zionism in Germany, 1897–1933: The Shaping of a Jewish Identity*; Jehuda Reinharz, *Fatherland or Promised Land: The Dilemma of the German Jew, 1893–1914*; Martin Rosenbluth, *Go Forth and Serve: Early Years and Public Life*; Ismar Schorsch, *Jewish Reactions to German Anti-Semitism, 1870–1914*.

3. Herzl's efforts and their outcome are examined in detail in Friedman, *Germany*, chaps. 4–5; Lichtheim, *Rückkehr*, p. 242; Saadia Weltmann, "Germany, Turkey and the Zionist Movement, 1914–1918," *Review of Politics* 23 (1961), 258; Egmont Zechlin, *Die deutsche Politik und die Juden im ersten Weltkrieg*, pp. 290–291.

4. Friedman, *Germany*, pp. 5–6, 65–68.

5. For an account of the kaiser's attitude toward Jews, see Lamar Cecil, "Wilhelm II. und die Juden," in *Juden im Wilhelminischen Deutschland 1890–1914*, ed. W. E. Mosse and Arnold Paucker, pp. 313–347.

6. Friedman, *Germany*, p. 5.

7. Neither Chancellor Hohenlohe nor State Secretary von Bülow was

sympathetic toward Zionism, Herzl's efforts to enlist the kaiser's support or the kaiser's approach to the sultan on Herzl's behalf (see Zechlin, *Die deutsche Politik*, pp. 292ff.).

8. For more on Germany's relationship with the Ottoman Empire before and during World War I, but excluding for the most part the Zionist question, see Gregor Schöllgen, *Imperialismus und Gleichgewicht: Deutschland, England und die orientalische Frage 1871–1914*; Ulrich Trumpener, *Germany and the Ottoman Empire, 1914–1918*. Additional treatment of all aspects of German-Zionist-Ottoman diplomacy before the war is provided by Alex Carmel, "Die deutsche Palästinapolitik, 1871–1914," *Jahrbuch des Instituts für Deutsche Geschichte* 4 (1975); Friedman, *Germany*; Klaus Herrmann, "Political Response to the Balfour Declaration in Imperial Germany: German Judaism," *Middle East Journal* 19 (1965); Weltmann, "Germany"; Zechlin, *Die deutsche Politik*, chaps. 17–22. Other sources include Ball-Kaduri, *Das Leben*, p. 173; Böhm, *Zionistische Bewegung*, vol. 1, p. 405; Lichtheim, *Rückkehr*, pp. 242–252; Rosenbluth, *Go Forth and Serve*, pp. 176ff.

9. Lichtheim, *Rückkehr*, pp. 242–278.

10. Leonard Stein, *The Balfour Declaration*, p. 539.

11. A good documentary account of Britain's wartime policy toward Zionism and the events leading to the Balfour Declaration can be found in Doreen Ingrams, ed., *Palestine Papers, 1917–1922: Seeds of Conflict*, pp. 7–18. See also Stein, *Balfour Declaration*, chaps. 20–21; Christopher Sykes, *Crossroads to Israel*, chap. 1.

12. Lichtheim, *Rückkehr*, pp. 366ff.

13. Stein, *Balfour Declaration*, pp. 533–535.

14. See Friedman, *Germany*, pp. 382ff.; Herrmann, "Political Response," pp. 313–314; Weltmann, *Germany*, pp. 262–269; Zechlin, *Die deutsche Politik*, pp. 413–419.

15. Ingrams, *Palestine Papers*, p. 19.

16. Ibid.

17. Ibid.

18. Zechlin, *Die deutsche Politik*, pp. 419–420.

19. See J. H. Graf von Bernstorff, *Memoirs of Count Bernstorff*, p. 172; Herrmann, "Political Response," pp. 313–318; Lichtheim, *Rückkehr*, p. 376; Stein, *Balfour Declaration*, p. 602; Weltmann, "Germany," pp. 262–269; Zechlin, *Die deutsche Politik*, pp. 420–426. The Ottoman government did not have much to lose, since most of Palestine had already fallen to the British under General Allenby. The Ottoman declaration of December 12 approved Jewish settlement in Palestine, which would, in theory, be returned to Ottoman sovereignty in any peace settlement.

20. *Jüdische Rundschau*, March 2, 1934.

21. Membership included Jews and gentiles, Conservatives, Liberals and Socialists, Philosemites and anti-Semites, as well as key government personalities, academicians and writers. Among them were Philipp Scheidemann, Gustav Noske and Max Cohen-Reuss of the Social Democratic party, Matthias Erzberger, leader of the Catholic Center party, and Count Kuno

von Westarp of the Conservatives. Others included Reichstag president Konstantin Fehrenbach and such scholars and publishers as Otto Auhagen, Georg Cleinow, Hans Delbrück, Adolf Grabowsky, Otto Hoetzsch, Ernst Jäckh, Karl Meinhoff, Max Weber and Werner Sombart.

22. Zechlin, *Die deutsche Politik*, p. 435.

23. Ibid., p. 434.

24. For a comprehensive account of the beginnings and development of the Temple Society and its settlement in Palestine during the nineteenth century, see Alex Carmel, *Die Siedlungen der württembergischen Templer in Palästina 1868–1918*. A dated but useful work is Hans Seibt, "Moderne Kolonisation in Palästina." See also Paul Sauer, *Beilharz-Chronik: Die Geschichte eines Schwarzwälder Bauern- und Handwerkergeschlechts vom 15. Jahrhundert bis Heute in Deutschland, Palästina und Australien*. For a complete list of German institutions and Temple settlements in Palestine during the interwar years, see appendices 1–3.

25. PA: Pol.Abt.III, Innere Verwaltung 14—Palästina, Aufzeichnung (author unknown), 23.Sept.1920; and Politik 16—Palästina, Jahresbericht über die Verhältnisse der deutsch-evangelischen Gemeinde zu Jerusalem 1922/1923, III o 3167/23, 10.Okt.1923.

26. The only detailed account of the policies of Weimar Germany toward the Palestine question is Francis R. Nicosia, "Weimar Germany and the Palestine Question," *Yearbook of the Leo Baeck Institute* 24 (1979).

27. PA: Pol.Abt.III, Politik 2—Palästina, Bd.1, Aufzeichnung von Schuberts, 2.Sept.1920.

28. PA: Gesandtschaft Bern, Palästina, 1922–1937, Aufzeichnung des AA über die Lage in Palästina, Nr. IIb 245, 8.Mai 1922.

29. See appendices 4–5.

30. See Nicosia, "Weimar," p. 326.

31. PA: Pol.Abt.III, Politik 5—Palästina, Bd.1, Aufzeichnung Sobernheims, III o 844, 8.Dez.1924.

Until 1936, Politische Abteilung III–2 (Orient) in the German Foreign Office was responsible for the Middle East and South Asia. Two offices within this department dealt directly with Palestine, one responsible for Egypt, the Sudan, Arabia, Palestine, Syria, Iraq and Abyssinia, and the other for Jewish Affairs under Sobernheim. The Jewish Affairs section was established early in 1918 as part of the last-minute efforts of the German government to counter the impact of the Balfour Declaration on Jewish opinion in Europe and to help secure continued Jewish goodwill for Germany. It was eliminated in 1933. Professor Sobernheim, a renowned Orientalist, did not officially belong to the German Zionist movement, although his Zionist sympathies are certainly clear; see Lichtheim, *Rückkehr*, p. 377; Paucker, *Der jüdische Abwehrkampf*, p. 282.

32. PA: Botschaft Ankara, Politik 3—Palästina, 1924–1938, "Bericht über meine Reise nach Palästina im März und April 1925," III o 1269.

33. For the complete text of the Palestine Mandate and of article 22 of the League of Nations Covenant, see J. C. Hurewitz, ed., *Diplomacy in the*

*Near and Middle East: A Documentary Record, 1914–1955,* vol. 2, pp. 61–62, 106–111.

34. See Niewyk, *The Jews,* chap. 6; Paucker, "Zur Problematik einer jüdischen Abwehrstrategie in der deutschen Gesellschaft," in *Juden im Wilhelminischen Deutschland 1890–1914,* ed. W. E. Mosse and Arnold Paucker, pp. 591ff.; Schorsch, *Jewish Reactions,* pp. 179ff.; Zechlin, *Die deutsche Politik,* p. 307.

35. See Blumenfeld, *Erlebte Judenfrage,* pp. 180–181; Paucker, *Der jüdische Abwehrkampf;* Reinharz, *Fatherland,* chap. 5.

36. See Nicosia, "Weimar," pp. 328–335; Josef Walk, "Das Deutsche Komitee Pro-Palästina, 1926–1933," *Bulletin des Leo Baeck Instituts* 15 (1976), 162–193.

37. Twelve members from the original Pro-Palästina Komitee became members of the new organization. They were Otto Auhagen, Georg Bernhard, Robert Breuer, Otto Eberhard, Adolf Grabowsky, Otto Hoetzsch, Ernst Jäckh, Karl Meinhof, Lothar Meyer, Werner Sombart, Ludwig Stein and Oskar von Truppel; see Walk, "Das Deutsche Komitee," p. 165, n. 12.

38. PA: Pol.Abt.III, Nachlass Sobernheim: Jüdische Angelegenheiten, Deutsches Komitee Pro-Palästina.

39. PA: Pol.Abt.III, Politik 2*a*—Palästina, Bd.1, Bernstorff an Mecklenburg, 3.Okt.1927. German Foreign Office support for Bernstorff's position had been communicated to the German Consulate General in Jerusalem in February of the same year; see PA: Pol.Abt.III, Politik 2*a*—Palästina, Bd.1, AA/Berlin an DGK/Jerusalem, III o 807, 22.Feb.1927.

40. See Nicosia, "Weimar," pp. 331ff.; Walk, "Das Deutsche Komitee," pp. 168–178.

41. See PA: Pol.Abt.III, Politik 2*a*—Palästina, Bd.1, Preussischer Kultusminister Becker an die Vereinigung für das liberale Judentum e.V., III o 676, 5.Jan.1927; Nachlass Sobernheim: Jüd. Angelegenheiten, Deutsches Komitee Pro-Palästina, Bd.1, Der St.S. in der Reichskanzlei an die Vereinigung für das liberale Judentum e.V., 30.Dez.1926; Politik 2*a*—Palästina, Bd.1, AA/Berlin an DGK/Jerusalem, III o 287, 27.Jan.1927. See also Nicosia, "Weimar," pp. 333–334; Hermann Pünder, *Von Preussen nach Europa: Lebenserinnerungen,* pp. 125–126, 138.

42. See PA: Pol.Abt.III, Jüd. Angelegenheiten: Jüd.Pol.1—Allg., Bd.6, Aufzeichnung des AA, IIIe 39, 29.Dez.1924; and Aufzeichnung Sobernheims, III o 1191, 3.Jun.1925.

During an earlier visit to Berlin in 1921, Chaim Weizmann had stressed the strong community of interests, especially in the economic sphere, between Germany and the Zionist movement. He placed orders for over RM 1 million worth of goods for Palestine and promised to use his influence in London to help remedy the economic difficulties in postwar Germany (see PA: Pol.Abt.III, Politik 1—Palästina, Bd.1, Aufzeichnung des AA, IIIe 65, 10.Jan.1922).

43. PA: Pol.Abt.III, Politik 6—Palästina, Bd.1, DB/London an AA/Berlin, K.Nr. 69, 1.Sept.1921.

44. See Francis R. Nicosia, "Arab Nationalism and National Socialist Germany, 1933–1939: Ideological and Strategic Incompatibility," *International Journal of Middle East Studies* 12 (1980), 352.
45. See also PA: Pol.Abt.III, Politik 2—Syrien, Bd.1, Aufzeichnung des AA, zu III T.1478 (no date); Geheim-Akten, 1920–1936, Politik 2—Syrien, DGK/Jerusalem an AA/Berlin, JN 145/27, 24.Jan.1927.
46. PA: Pol.Abt.III, Politik 5—Palästina, Bd.3, Aufzeichnung Ziemkes, A.O. 6577, 23.Dez.1929.
47. See Nicosia, "Weimar," pp. 342–344.
48. PA: Pol.Abt.III, Politik 3—Länder—England, Bd.2, Aufzeichnung des AA (author unknown), III o 6430, 30.Dez.1929.
49. PA: Pol.Abt.III, Politik 5—Palästina, Bd.3, Aufzeichnung Ziemkes zu III o 2110/30, 9.Mai 1930.
A commission under Sir Walter Shaw was sent to Palestine in 1929 to investigate the Wailing Wall riots of 1928 and the subsequent disturbances in 1929 (see Sykes, *Crossroads*, pp. 141ff.).

**2. Early National Socialist Attitudes toward Zionism**

1. See Robert Cecil, *The Myth of the Master Race: Alfred Rosenberg and Nazi Ideology*, p. 65; Martin Broszat, *Der Nationalsozialismus: Weltanschauung, Programm und Wirklichkeit*, p. 25; Eberhard Jäckel, *Hitlers Weltanschauung: Entwurf einer Herrschaft*, pp. 66–67; Ernst Nolte, "Eine frühe Quelle zu Hitlers Antisemitismus," *Historische Zeitschrift* 192 (1961), 584–606. On the tie between the German concept of nationality and racial anti-Semitism, see Karl Schleunes, *The Twisted Road to Auschwitz: Nazi Policy toward German Jews, 1933–1939*, chap. 1; Ernst Nolte, *Three Faces of Fascism*, trans. Leila Vennewitz, p. 480.
2. See Hannah Arendt, *The Origins of Totalitarianism*; Norman Cohn, *Warrant for Genocide: The Myth of the Jewish World Conspiracy and the "Protocols of the Elders of Zion"*; Jacob Katz, *From Prejudice to Destruction: Anti-Semitism, 1700–1933*; Paul Massing, *Rehearsal for Destruction: A Study of Political Anti-Semitism in Imperial Germany*; G. L. Mosse, *Toward the Final Solution: A History of European Racism*; Peter Pulzer, *The Rise of Political Anti-Semitism in Germany and Austria*; Eva Reichmann, *Die Flucht in den Hass: Die Ursachen der deutschen Judenkatastrophe*; Fritz Stern, *The Politics of Cultural Despair*; Shulamit Volkov, *The Rise of Popular Anti-Modernism in Germany: The Urban Master Artisans, 1873–1896*.
3. See Reginald Phelps, "Hitlers grundlegende Rede über den Antisemitismus," *Vierteljahrshefte für Zeitgeschichte* 16 (1968), 400–420. This was Hitler's first comprehensive speech on the Jewish question, delivered in Munich on August 13, 1920.
4. His boyhood friend, August Kubizek, observed that Hitler had been unable to find satisfactory outlets for his views and his political ambitions in pre–World War I Vienna (Kubizek, *Adolf Hitler, Mein Jugendfreund*, p. 297). Hitler himself wrote of his general dissatisfaction with Lueger and Schönerer in *Mein Kampf*, chap. 3.

5. For the best published documentation of Hitler's career from late 1918 through 1919, see Ernst Deuerlein, "Hitlers Eintritt in die Politik und die Reichswehr," *Vierteljahrshefte für Zeitgeschichte* 7 (1959), 179–185, 191–205. See also Werner Maser, *Die Frühgeschichte der NSDAP: Hitlers Weg bis 1924,* pp. 96–106, 180–181; and Cecil, *Myth,* pp. 29–34, 79–81. For more on the early movement to which Hitler attached himself, see Reginald Phelps, "Before Hitler Came: Thule Society and Germanen Orden," *Journal of Modern History* 35 (1963), 245–261, and "Hitler and the Deutsche Arbeiterpartei," *American Historical Review* 68 (1963), 974–986; Otto Strasser, *Hitler and I,* trans. Gwenda David and Eric Mosbacher, p. 68.

6. Deuerlein, "Hitlers Eintritt," Nr. 12, pp. 203–205. See also Uwe Dietrich Adam, *Judenpolitik im Dritten Reich,* p. 22.

7. See Mosse, *Final Solution,* pp. 122ff.

8. Robert Ergang, *Herder and the Foundations of German Nationalism,* pp. 243–244.

9. Moses Hess, *Rome and Jerusalem: A Study in Jewish Nationalism,* trans. Rabbi Maurice J. Bloom, pp. 9–10. Herzl attributed the basic principles of his Zionism to Hess. See Böhm, *Zionistische Bewegung,* vol. 1, p. 88; Leon Poliakov, *The History of Anti-Semitism: From Voltaire to Wagner,* trans. Miriam Kochan, vol. 3, p. 408.

10. Niewyk, *Jews in Weimar Germany,* p. 129.

11. Mosse, *Final Solution,* p. 122.

12. Ibid., pp. 123–124.

13. Ibid., p. 104.

14. Böhm, *Zionistische Bewegung,* vol. 1, pp. 62–70.

15. Theodor Herzl, *The Jewish State: An Attempt at a Modern Solution of the Jewish Question,* pp. 95ff.

16. Reinharz, *Fatherland,* pp. 109–110.

17. See Laqueur, *History of Zionism,* p. 20; Friedman, *Germany,* p. 6.

18. Dühring also warned that a Jewish state would provide international Jewry with another weapon in its conspiracy against the gentile world. His ideological hostility toward the concept of Zionism, on the one hand, and his apparent willingness to use it to remove Jews from Europe, on the other, was to be the same approach taken by Rosenberg and Hitler after World War I (see Eugen Dühring, *Die Judenfrage als Frage der Rassenschädlichkeit für Existenz, Sitte und Kultur der Völker,* 4th ed., pp. 127 ff.; Cecil, *Myth,* p. 72).

19. Adler, *Die Juden,* pp. 101–102; Friedman, *Germany,* p. 10.

20. Axel Kuhn, *Hitlers Aussenpolitisches Programm,* p. 17. See also Massing, *Rehearsal for Destruction,* p. 246. For more on the anti-Semitism of Heinrich Class and the Pan-German League, see Adam, *Judenpolitik,* pp. 20–21; Pulzer, *Political Anti-Semitism,* chap. 24.

21. Wilhelm Marr, *Der Sieg des Judenthums über das Germanenthum: Vom nicht confessionellen Standpunkt aus betrachtet,* 4th ed., pp. 14ff.

22. See Friedman, *Germany,* pp. 6, 10.

23. Ibid., p. 10.

24. Zechlin, *Die deutsche Politik*, pp. 434–435.

25. Niewyk, *Jews in Weimar Germany*, pp. 139–141.

26. See Houston Stewart Chamberlain, *Die Grundlagen des 19. Jahrhunderts*, 23rd ed., vol. 1, p. 387; Dühring, *Die Judenfrage*, p. 127.

27. Günter Schubert, *Anfänge nationalsozialistischer Aussenpolitik*, p. 13.

28. Gottfried Feder, *Hitler's Official Program and Its Fundamental Ideas*, pp. 38–45.

29. Schubert, *Anfänge*, p. 16.

30. Deuerlein, "Hitlers Eintritt," Nr. 19, p. 212.

31. BA: NS/26–51. Part of Hitler's speech at this meeting was published in the *Völkischer Beobachter*, 5.Jun.1920.

32. For an account of Rosenberg's early life in Estonia, see Cecil, *Myth*, chap. 1.

33. Phelps, "Before Hitler Came," pp. 245–261.

34. See Cecil, *Myth*, pp. 17–18, 20; Cohn, *Warrant for Genocide*, p. 194. Cecil relies on Rosenberg's early publications, cited below.

35. The following works attest to the significance of Rosenberg's contribution and his influence on Hitler during the early years: Cecil, *Myth*, pp. 29–30, 45, 79–81; Cohn, *Warrant for Genocide*, pp. 194ff.; Joachim Fest, *Hitler*, trans. Richard and Clara Winston, pp. 140–145; Ernst Hanfstaengl, *Hitler, The Missing Years*, p. 41; Konrad Heiden, *Der Fuehrer*, trans. Ralph Manheim, pp. 31–32, and *A History of National Socialism*, p. 84; Kurt Luedecke, *I Knew Hitler*, pp. 79, 84; Maser, *Die Frühgeschichte*, pp. 180–185; Nolte, "Eine frühe Quelle," pp. 587–588; Schubert, *Anfänge*, pp. 111ff., 126, 137; Strasser, *Hitler and I*, p. 66.

36. Chamberlain's influence on Rosenberg is evident in the latter's *Houston Stewart Chamberlain als Verkünder und Begründer einer deutschen Zukunft*. Chamberlain's *Weltherrschaftstheorie* [world dominion theory] fell far short of the concrete theories that Rosenberg, with the aid of the so-called "Protocols of the Elders of Zion," gave Hitler. Chamberlain never accepted the authenticity of the "Protocols," but saw rather a natural process of destruction that he believed had been taking place over a period of centuries, without the deliberate, secret scheming described in the "Protocols" (see Cecil, *Myth*, p. 79). It is difficult to determine whether Hitler had ever thoroughly read and digested Chamberlain's work. Konrad Heiden asserts that Rosenberg was Hitler's tutor for Chamberlain's theories, as Rosenberg always considered himself to be Chamberlain's disciple and successor (Heiden, *Der Fuehrer*, p. 246). It is possible that Hitler had been exposed to the conspiracy theory before 1919–1920 as a result of reading Theodor Fritsch, one of the more important and widely read anti-Semites in prewar Germany. Fritsch wrote of a Jewish conspiracy in his main work, *Handbuch der Judenfrage*. It was originally published in 1893 in Leipzig as the *Antisemitenkatechismus*. According to Luedecke, Nolte and Phelps, Hitler had read this work and was greatly influenced by Fritsch (see Luedecke, *I Knew Hitler*, pp. 40–41; Nolte, *Three Faces of Fascism*, p. 643, n. 3; Phelps, "Before Hitler Came," p. 247; Moshe Zimmermann, "Two Generations of Ger-

man Anti-Semitism: The Letters of Theodor Fritsch to Wilhelm Marr," *Yearbook of the Leo Baeck Institute* 23 [1978], 99).

37. The following early works by Rosenberg all deal with the alleged link between the Jewish world conspiracy and Bolshevism: *Die Spur des Juden im Wandel der Zeiten; Totengräber Russlands; Unmoral im Talmud; Pest in Russland! Der Bolschewismus, Seine Häupter, Handlanger und Opfer.* The same theme is stressed in his later works as well.

38. See Cohn, *Warrant for Genocide,* pp. 194–195; Heiden, *Der Fuehrer,* chap. 1; Schubert, *Anfänge,* p. 112; Alexander Stein, *Adolf Hitler, Schüler der Weisen von Zion,* p. 13.

39. Cecil, *Myth,* pp. 72–73; Cohn, *Warrant for Genocide,* pp. 25–40. The authenticity of the "Protocols" was disproved by a correspondent of the *Times,* Philip Graves, in 1920, and again in Switzerland during a court battle between Swiss Jewish organizations and local anti-Semites who were trying to spread the "Protocols" in Switzerland during the 1930s. The "Protocols" were a forgery, originally a satire on the ambitions of Napoleon III, published anonymously in 1867 (see Cohn, *Warrant for Genocide,* pp. 71ff.; Schubert, *Anfänge,* p. 24).

40. Cohn, *Warrant for Genocide,* pp. 126ff.

41. See *Die Spur; Der staatsfeindliche Zionismus; Die Protokolle der Weisen von Zion und die jüdische Weltpolitik.*

42. Rosenberg, *Der staatsfeindliche Zionismus,* p. 16.

43. Ibid., p. 25.

44. Ibid., p. 15. Rosenberg made the same argument in an article entitled "Der Zionismus," which appeared in the *Völkischer Beobachter,* 17.Feb.1921.

45. Rosenberg, *Der staatsfeindliche Zionismus,* pp. 58–60.

46. Ibid., pp. 62–63. See also his later work, *Der Weltverschwörerkongress zu Basel,* pp. 20–23, as well as *Protokolle,* p. 27.

47. See Leo Pinsker, *Autoemanzipation,* p. 29; Böhm, *Zionistische Bewegung,* vol. 1, pp. 100–102.

48. Rosenberg, *Die Spur,* p. 153. See also Rosenberg's article entitled "Antisemitismus" in the *Völkischer Beobachter,* 7.Aug.1921.

49. Rosenberg, *Der staatsfeindliche Zionismus,* p. 63; *Die Spur,* p. 105.

50. Rosenberg, *Der staatsfeindliche Zionismus,* p. 63.

51. The same line was followed by Rosenberg in his later, more ambitious *Der Mythus des 20. Jahrhunderts: Eine Wertung der seelisch-geistigen Gestaltenkämpfe unserer Zeit,* pp. 463–465.

52. There appears to have been a reluctance on Hitler's part to address himself publicly to the Jewish question between 1925 and 1933. The likely reasons for this include a ban on speaking imposed on him for a time by some of the states, a general lack of voter appeal in anti-Semitism and the greater appeal of other issues such as the revision of the hated Versailles Treaty. See also Sarah Gordon, *Hitler, Germans and the "Jewish Question",* chaps. 2, 6–9.

53. BA: NS/26–51.

54. Schubert, *Anfänge,* pp. 27–30.

55. BA: NS/26–53. This is also printed in Phelps, "Hitlers grundlegende Rede," pp. 400–420.

56. Ibid.

57. Ibid.

58. Ibid.

59. The work by Adolf Wahrmund, which according to Phelps was the source of Hitler's concept of the Jews as a nomadic people, is *Das Gesetz des Nomadentums und die heutige Judenschaft.*

60. Phelps, "Hitlers grundlegende Rede," pp. 405–406. See also Jäckel, *Hitlers Weltanschauung,* pp. 63–64.

61. Hitler, *Mein Kampf,* pp. 447–448, and *The Secret Book,* trans. Salvator Attanasio, p. 212.

62. Reginald Phelps, "Hitler als Parteiredner im Jahre 1920," *Vierteljahrshefte für Zeitgeschichte* 11 (1963), 305. Several anonymous articles appeared in the *Völkischer Beobachter* during those years that were also supportive of Zionist efforts to remove Jews from Germany to Palestine (see *Völkischer Beobachter,* 31.Mär.1920, and 27.Jun.1920). Even Julius Streicher, in a speech before the Bavarian Diet on April 20, 1926, argued that German Jews should go to Palestine rather than stay in Germany (see BA: NS/26–508).

## 3. The Development of the Haavara Transfer Agreement

1. Hans-Jürgen Schröder, *Deutschland und die Vereinigten Staaten 1933–1939: Wirtschaft und Politik in der Entwicklung des deutsch-amerikanischen Gegensatzes,* p. 35. See also Dieter Petzina, "Hauptprobleme der deutschen Wirtschaftspolitik 1932–1933," *Vierteljahrshefte für Zeitgeschichte* 15 (1967), 18–55.

2. BA: R/43–II: 540, Niederschrift über eine Sitzung des Ausschusses der Reichsregierung für Arbeitsbeschaffung am 9.Feb.1933.

3. Ibid. See also Schröder, *Deutschland,* p. 37.

4. Wolfram Fischer, *Deutsche Wirtschaftspolitik 1918–1945,* p. 54. See also Schröder, *Deutschland,* p. 48; Kuhn, *Programm,* p. 267.

5. Hitler, *Mein Kampf,* pp. 304–305.

6. Fischer, *Wirtschaftspolitik,* p. 54.

7. K. D. Bracher, W. Sauer, G. Schulz, *Die Nationalsozialistische Machtergreifung: Studien zur Errichtung des totalitären Herrschaftssystems in Deutschland 1933–1934,* pp. 478ff.

8. Ibid.

9. Dieter Petzina, *Autarkiepolitik im Dritten Reich: Der Nationalsozialistische Vierjahresplan,* p. 15. For a more detailed account of Nazi foreign trade policies, see Dörte Doering, "Deutsche Aussenwirtschaftspolitik 1933–1935: Die Gleichschaltung der Aussenwirtschaft in der Frühphase des Nationalsozialistischen Regimes."

10. Petzina, *Autarkiepolitik,* p. 15.

11. Ibid., p. 34. Raw material imports were given priority over food imports. Germany was less dependent on imported food, while raw materials

were needed to keep industry going, workers employed and rearmament plans on schedule.

12. Schröder, *Deutschland*, p. 33.

13. Max Domarus, *Hitler: Reden und Proklamationen, 1932–1945*, vol. 1/1, p. 234.

14. Schröder, *Deutschland*, p. 33.

15. ISA: 67/1272, AA/Berlin an sämtliche diplomatische Vertretungen, W.4462, 19.Jul.1933.

16. PA: HaPol Abt.—Handakten Wiehl, Vierjahresplan, Bd.1, Runderlass des Reichsaussenministers vom 19.Dez.1937.

17. Hjalmar Schacht, *My First Seventy-Six Years*, trans. Diana Pyke, pp. 327–334. See also Petzina, *Autarkiepolitik*, p. 18; Fischer, *Wirtschaftspolitik*, pp. 72–73.

18. René Erbe, *Die Nationalsozialistische Wirtschaftspolitik 1933–1939 im Lichte der modernen Theorie*, p. 76. See also Schacht, *My First Seventy-Six Years*, p. 314; Fischer, *Wirtschaftspolitik*, pp. 72–73.

19. PRO: FO371/21659–C14812, précis of a lecture given by Dr. Schacht on November 29, 1938, to the Economic Council of the German Academy. See also Fischer, *Wirtschaftspolitik*, pp. 73–74. In the years 1935, 1936 and 1937, Germany registered trade surpluses, which included monthly surpluses in thirty-two out of thirty-six months (see BA: R/2–225).

20. Petzina, *Autarkiepolitik*, p. 19.

21. Ibid., pp. 30–31. See also Schröder, *Deutschland*, p. 44.

22. BA: R43/II–991a. The concept of autarky, as embodied in the Four-Year Plan, was not at all an attempt to withdraw from world trade. The plan attempted to reduce dependence on imported raw materials, but did not deny the old axiom that Germany had to export to live. The continued promotion of German exports remained part and parcel of economic policy after 1936 (see PA: HaPol Abt.—Handakten Wiehl, Vierjahresplan, Bd.1, Göring an das Reichswirtschaftsministerium, AA, u.a. vom 5.Mai 1937; Petzina, *Autarkiepolitik*, pp. 19–20; Schröder, *Deutschland*, p. 47). In a speech in January, 1939, Hitler again called for new efforts to increase exports (see Domarus, *Hitler*, vol. 2/1, p. 1053).

23. BA: R43/II–329, Vermerk über den Stand und die Aussichten der deutschen Warenausfuhr vom 24.Mai 1933.

24. BA: R43/II–1339, Ministerbesprechung am 7.April 1933 über die aussenpolitische Lage. For a complete and controversial account of the international anti-German boycott movement and its impact on the German economy, German Jewish policy and the Haavara, see Edwin Black, *The Transfer Agreement: The Untold Story of the Secret Pact between the Third Reich and Jewish Palestine*. Black's assertions in the subtitle that the Haavara agreement was "secret" and that it was a hitherto "untold story" are simply not accurate. Nor can I agree that the Haavara was a decisive factor in the early survival of the Nazi regime.

25. Helmut Genschel, *Die Verdrängung der Juden aus der Wirtschaft im Dritten Reich*, pp. 76–77.

26. ISA: 67/1272, AA/Berlin an sämtliche diplomatische Vertretungen, W.4462, 19.Jul.1933.

27. See Adam, *Judenpolitik*, pp. 85–90; Genschel, *Die Verdrängung*, pp. 43ff.

28. Adam, *Judenpolitik*, pp. 87–89.

29. Schacht was reappointed director of the Reichsbank in March, 1933, after a three-year absence. He was made minister of economics as well in July, 1934. Schacht claimed that Hitler never interfered in his policies before the 1936 autarky plans. He also claimed that Hitler told him in 1934 that the Jewish position in the economy would be left untouched, something that Schacht insisted upon during his term of office. After Schacht's departure as economics minister in December, 1937, his apparent moderating influence on Hitler faded; in 1938, the Jews were eventually eliminated from all economic activity (Schacht, *My First Seventy-Six Years*, pp. 319–320; see also Adam, *Judenpolitik*, pp. 88–89, 122ff.; Genschel, *Die Verdrängung*, p. 111).

30. There are many instances of Schacht's concern about the impact of anti-Jewish measures on the economy. At a meeting held in the Economics Ministry on August 20, 1935, called to discuss the effects of Jewish policy on the economy, Schacht, as well as Frick of the Ministry of the Interior and Bülow of the Foreign Office, recognized the necessity of avoiding the radical tendencies of certain Party agencies in the Jewish question. In terms of Jewish participation in the economy, it was agreed that the Jews should be made subject to special laws, especially in the economic sphere, which would essentially maintain their freedom of activity in the economy (see PA: Pol. Abt.III—Jüd. Angelegenheiten, Jüd.Pol.1: Allg., Bd.13, Aufzeichnung über die Chefbesprechung in RWM am 20.Aug.1935 betr. die Rückwirkungen der deutschen Judenpolitik auf die Wirtschaftslage, 83–21, 21/8).

31. Werner Feilchenfeld, Dolf Michaelis and Ludwig Pinner, *Haavara-Transfer nach Palästina und Einwanderung Deutscher Juden 1933–1939*, p. 19. See also Dietrich Aigner, *Das Ringen um England: Das deutsch-britische Verhältnis: Die öffentliche Meinung, Tragödie zweier Völker*, pp. 179–180, 214–226, for an account of the boycott movement in England and English public opinion regarding Germany.

32. See Genschel, *Die Verdrängung*, pp. 78ff.; Hans-Adolf Jacobsen, *Nationalsozialistische Aussenpolitik 1933–1938*, p. 157.

33. PA: Inland II A/B, 83–29, Bericht eines Vertrauensmannes der deutschen Gesandtschaft in Brüssel, 83–63, 5/1, Januar, 1934. This report was forwarded to Berlin in Inland II A/B, 83–63, Bd.1, DG/Brüssel an AA/Berlin, 83–63 5/1, 5.Jan.1934.

34. Feilchenfeld et al., *Haavara-Transfer*, p. 19. See also Aigner, *Das Ringen*, p. 221.

35. Klaus Herrmann, *Das Dritte Reich und die Deutsch-Jüdischen Organisationen 1933–1934*, p. 63; Rosenbluth, *Go Forth and Serve*, pp. 250–254.

36. Herrmann, *Das Dritte Reich*, p. 63; Rosenbluth, *Go Forth and*

*Serve*, pp. 250–254. Whatever effectiveness they might have had in London was cancelled by the public announcement in Germany on March 28 of a general boycott against Jewish businesses, to be held on April 1.

37. BA: R/43–II: 600, Reichsvertretung der deutschen Juden an Lord Melchett/London, 12.Jul.1933. The Zionist newspaper in Germany, *Jüdische Rundschau*, printed appeals against the anti-German boycott as early as March (*Jüdische Rundschau*, 31.Mär.1933).

38. PA: Referat-D, Po5 NE adh2 allg., Bd.1, Nr.486, 30.Mär.1933.

39. PA: Referat-D, Po5 NE adh2 allg., Bd.1, Aufzeichnung des Referat Deutschlands vom 19.Mai 1933.

40. PA: Referat-D, Po5 NE adh1, Nr.1, Bde.1,2 (entire file).

41. PA: Referat-D, Po5 NE adh2 allg., Bd.1, Aufzeichnung des Referat Deutschlands vom 19.Mai 1933.

42. PA: Referat-D, Po5 NE adh2 allg., Bd.1, Aufzeichnung von Neuraths, 31.Mär.1933. It is unlikely that the boycott could have been canceled at the last minute.

43. Feilchenfeld et al., *Haavara-Transfer*, pp. 28–29. See also Luedecke, *I Knew Hitler*, p. 594; David Yisraeli, "The Third Reich and the Transfer Agreement," *Journal of Contemporary History* 6 (1972), 131. *Haavara* is Hebrew for transfer.

44. According to Rudolf Rahn, a German diplomat with much experience in the Middle East during those years, the main ingredient in German *Orientpolitik* during the 1930s was economic, chiefly the export trade (see his *Ruheloses Leben: Aufzeichnungen und Erinnerungen*, p. 120).

45. BA: R/7–VI: 222/2, Reichswirtschaftsministerium Nr.35 vom 5.Apr.1938.

46. PA: HaPol Abt.—Handakten Clodius, Ägypten, DG/Kairo an AA/Berlin, 703, 7.Okt.1933.

47. PA: Sonderreferat—W, Rohstoffe und Waren: Petroleum, Bde.6,7. Both the USSR and Rumania were eager to sell more oil to Germany in return for German goods and technology. This was ideal for Germany, because it could pay for oil with exported goods. Another source was the United States, where overproduction made oil inexpensive.

48. PA: Pol.Abt.III—Wirtschaft, Saudisch Arabien, Wirtschaft 6: DG/Bagdad an AA/Berlin, Nr.754, 15.Jun.1933.

49. Fritz Grobba, *Männer und Mächte im Orient: 25 Jahre Diplomatischer Tätigkeit im Orient*, pp. 94–95.

50. See appendix 7.

51. PA: Pol.Abt.III—Wirtschaft, Palästina, Wirtschaft 21: Weltwirtschaftskonferenz, "Palästina und die Weltwirtschaftskonferenz," in *Industrie und Handel* 131 (10.Jun.1933).

52. Ibid. See also *Jüdische Rundschau*, 25.Jul.1933.

53. PA: Pol.Abt.III, Politik 2—Palästina, Bd.1, DGK/Jerusalem an AA/Berlin, Nr.Polit. 4033, 28.Mär.1933.

54. PA: Pol.Abt.III, Politik 2—Palästina, Bd.1 (entire file).

55. Ibid. In a letter to me on April 17, 1974, Dr. Werner Feilchenfeld,

one of the architects of the Haavara transfer agreement, wrote that a substantial part of the Jewish population in Palestine remained hostile to the idea of a transfer agreement with Germany and continued the boycott.

56. PA: Pol.Abt.III, Politik 2—Palästina, Bd.2, DGK/Jerusalem an AA/Berlin, Nr.Polit. 40/33, 17.Mai 1933, and Nr.Polit. 48/33, 23.Mai 1933. For an analysis of the boycott policies of the Revisionists internationally, see PA: Inland II A/B, 83–63, Bd.3, Geheimes Staatspolizeiamt an AA/Berlin, II 1B2–61426/J.162/35, 6.Feb.1935.

57. Ernst Marcus, "The German Foreign Office and the Palestine Question in the Period 1933–1939," *Yad Vashem Studies* 2 (1958), 182; Yisraeli, "Transfer Agreement," pp. 129–132. Not all of the business people and industrialists in Palestine favored the transfer agreement. Some Jewish industrialists were opposed because of the competition German imports would impose on their embryonic industries in Palestine (see Werner-Otto von Hentig, "Palästina," in *Jahrbuch der Hochschule für Politik* [1940], p. 110).

58. Yisraeli, "Transfer Agreement," p. 132. Both the German Foreign Office and the Interior Ministry urged German Zionists to attend the Congress in Prague so as to exercise an anti-boycott influence on the rest of the Congress. Although a complete German delegation did not attend, a few representatives led by Dr. Martin Rosenbluth did, and they were successful in their fight against the boycott resolutions (see PA: Referat-D, Po5 NE adh6 Nr.4, Bd.1, ZVfD an AA/Berlin, 30.Aug.1933).

59. PA: Pol.Abt.III, Politik 2—Palästina, Bd.1, DGK/Jerusalem an AA/Berlin, Nr.Polit. 25/33, 24.Apr.1933.

60. Wolff's hostility to the racial doctrine of National Socialism has been verified by Marcus, "German Foreign Office," p. 83, and Ball-Kaduri, *Das Leben*, p. 175. There was some dissatisfaction with Wolff among the more ardent anti-Semites of the NSDAP/Landesgruppe-Palästina because of his strong sympathy for the Zionists and because his wife was Jewish. He was described by one Party member in Palestine as "ein bekanntlich sehr warmer Freund der Juden" (a well-known very warm friend of the Jews) (see PA: Inland II A/B, 83–20, Bd.3/II, W. Ruff, NSDAP/Palästina an AA/Berlin, 5.Okt.1935). The fact that Wolff's wife was Jewish was contrary to the spirit of the Gesetz zur Wiederherstellung des Berufsbeamtentums (Law on the Restoration of a Professional Civil Service) of April 7, 1933, and the amendment of June 30 requiring wives of civil servants to be Aryan (see Adam, *Judenpolitik*, pp. 63–64).

It was also contrary to the spirit of the guidelines issued jointly by the Foreign Office and the Auslandsorganisation der NSDAP on February 7, 1934, governing the entry of Foreign Service officers into the NSDAP and the AO requirement that all German diplomats show proof of the Aryan descent of their wives (see ISA: 67/954, Runderlass des AA, 120–11, 29/1, "Vereinbarung zwischen dem AA und der AO der NSDAP über den Eintritt von Angehörigen des auswärtigen Dienstes in die NSDAP," 7.Feb.1934, and Runderlass des AA, 120–11, 23/2, 7.Mär.1934).

Wolff applied for membership in the NSDAP in March, 1934, and took the oath of loyalty to Adolf Hitler, required by the Foreign Office as of Au-

gust 25, in September of that year (ISA: 67/954, DGK/Jerusalem an die AO der NSDAP, 1/34, 6.Mär.1934, and DGK/Jerusalem an AA/Berlin, Nr. Beamtenang. 17/34, 10.Sept.1934).

61. PA: Pol.Abt.III, Politik 2—Palästina, Bd.1, DGK/Jerusalem an AA/Berlin, Nr.Polit. 25/33, 24.Apr.1933.

62. PA: Sonderreferat—W, Finanzwesen 16, Bd.1, DGK/Jerusalem an AA/Berlin, Expf.1/33, 25.Apr.1933.

63. See Pol.Abt.III, Politik 2–Palästina, Bd.2, DGK/Jerusalem an AA/Berlin, Nr.Polit. 40/33, 17.Mai 1933.

64. PA: Sonderreferat—W, Finanzwesen 16, Bd.2, Statement by Mr. Sam Cohen to the Jewish Telegraphic Agency Bulletin, 27.Sept.1933.

65. CZA: Z4/3567–VIII, Auszug aus einem Rundschreiben der Zionistischen Vereinigung für Deutschland vom 20.Apr.1933. See also Ball-Kaduri, *Das Leben*, p. 92; Sykes, *Crossroads*, pp. 135–137.

66. PA: Pol.Abt.III—Wirtschaft, Palästina, Allgemeines 3, DGK/Jerusalem an AA/Berlin, Nr.Polit. 3/34, 15.Jan.1934.

67. PA: Inland II A/B, 83–21, Bd.1, Äusserung der Zionistischen Vereinigung für Deutschland zur Stellung der Juden im neuen deutschen Staat, 21.Jun.1933.

68. See Lichtheim, *Geschichte*, pp. 252–253.

69. Mark Wischnitzer, "Jewish Emigration from Germany, 1933–1938," *Jewish Social Studies* 2 (1940), 25.

70. Ibid.

71. Hermann Graml, "Die Auswanderung der Juden aus Deutschland zwischen 1933 und 1939," in *Gutachten des Instituts für Zeitgeschichte*, vol. 1, pp. 79–80.

72. Until 1936, emigrants to destinations other than Palestine could take out only RM 200, and this was reduced to RM 10 thereafter. Most of what was not taken by the government as *Reichsfluchtsteuer* (emigration tax) was deposited in a blocked account and lost to the emigrant forever. Between 1933 and 1940, the German government collected some RM 900 million as *Reichsfluchtsteuer* (see Arthur Prinz, "The Role of the Gestapo in Obstructing and Promoting Jewish Emigration," *Yad Vashem Studies* 2 [1958], 207; Genschel, *Die Verdrängung*, p. 258; Raul Hilberg, *The Destruction of the European Jews*, pp. 90–91; Schleunes, *Road to Auschwitz*, pp. 195–196).

73. See PA: Sonderreferat—W, Finanzwesen 16, Bd.1, DGK/Jerusalem an AA/Berlin, Nr.Expf. 3/33, 15.Apr.1933, and DGK/Jerusalem an AA/Berlin, Nr.Expf. 4/33, 24.Apr.1933.

74. PA: Sonderreferat—W, Finanzwesen 16, Bd.1, DGK/Jerusalem an Herrn VLR Prüfer, AA/Berlin, Nr.Expf. 19/33, 27.Apr.1933.

75. PA: Sonderreferat—W, Finanzwesen 16, Bd.1, Schnellbrief an das Reichswirtschaftsministerium vom 24.Apr.1933.

76. See Ball-Kaduri, *Das Leben*, p. 156; Marcus, "German Foreign Office," p. 182. Dr. Ernst Marcus was the liaison between the German Foreign Office and the Berlin office of the Haavara Ltd., known as the Palästina-Treuhandstelle, or Paltreu.

77. Letter from Dr. Werner Feilchenfeld to me, April 17, 1974.

78. PA: Sonderreferat—W, Finanzwesen 16, Bd.1, Reichswirtschafts-ministerium an AA/Berlin, Nr.Dev.I 31328.33, 22.Jul.1933.

79. Feilchenfeld letter, April 17, 1974.

80. PA: Sonderreferat—W, Finanzwesen 16, Bd.1, Der Reichswirt-schaftsminister an die Firma Hanotaiah Ltd. in Palästina, Dev.I 20111/33, 19.Mai 1933.

81. ADAP: C, I/2, Nr.369. One Palestinian £ was equal to one £ Ster-ling, or RM 12.50. The immigration regulations for Palestine, established by British authorities, categorized immigrants according to their capital worth and profession. Many German Jews fell into category A/1, or those dispos-ing of at least £pal 1,000. Immigrants in this category had to bring with them a minimum of £pal 1,000 to be admitted, and there were no quotas for this category. Most others from Germany fell into category A/2, profes-sionals with at least £pal 500. Many of these were admitted in A/1 because of the surplus of physicians, lawyers, academics and other professionals in Palestine and because of unlimited immigration in category A/1 (see Feilchenfeld et al., *Haavara-Transfer*, pp. 38–40).

82. PA: Sonderreferat—W, Finanzwesen 16, Bd.1, Reichswirtschafts-ministerium an AA/Berlin, Nr.Dev. 31328.33, 22.Jul.1933.

83. ADAP: C, I/2, Nr.399. See also Feilchenfeld et al., *Haavara-Trans-fer*, pp. 24–26.

84. ADAP: C, I/2, Nr.399.

85. The letter of August 10 can be found in ADAP: C, I/2, Nr.399. For the others, see PA: Sonderreferat—W, Finanzwesen 16, Bd.2, S. Hoofien/Anglo-Palestine Bank an den Herrn Reichswirtschaftsminister, Betr.Dev.I 36005/33, 22.Aug.1933, and der Reichswirtschaftsminister an Herrn S. Hoofien/Anglo-Palestine Bank Ltd., 25.Aug.1933.

86. PA: Sonderreferat—W, Finanzwesen 16, Bd.2, Runderlass der RWM, 54/33, 28.Aug.1933.

87. About one-half of all Jewish immigrants from Germany through 1936 were classified as "capitalists" (category A/1) by British immigration authorities in Palestine. According to Zionist figures, German-Jewish immi-grants in this class were able to transfer an average total of £pal 2,000, or RM 25,000, per family (see CZA: L/22–38/2, memorandum of March 11, 1936).

88. See appendix 8.

89. PA: Sonderreferat—W, Finanzwesen 16, Bd.1, AA/Berlin an DGK/Jerusalem, 31.Aug.1933.

90. PA: Sonderreferat—W, Finanzwesen 16, Bd.4, DGK/Beirut an AA/Berlin, I/N2660, 10.Sept.1934, DG/Bagdad an AA/Berlin, Nr.2687, 8.Nov.1934, Paltreu/Berlin an die Reichsbank, 29.Nov.1938, and Reichsstelle für Devisenbewirtschaftung an Paltreu/Berlin, Dev.A277 14/34, 1.Aug.1934. See also ISA: 67/1246, DG/Kairo an DGK/Jerusalem, 17.Jan.1935, AA/Berlin an DGK/Jerusalem, III o 516, 7.Feb.1935, and Haavara Ltd./Tel Aviv an DGK/Jerusalem, 24.Mär.1935.

91. Haavara officials concluded a similar agreement with Czechoslo-

vakia in 1934, and one with Poland in March, 1937. See ISA: 67/1242, DB/Warschau an AA/Berlin, HV53011.36, 17.Nov.1936; PA: Inland II A/B, 83–21A, Bd.1a, Aufzeichnung der Reichsstelle für das Auswanderungswesen, G.Z.A. 1002/8.7.37, 13.Jul.1937.

92. See Lichtheim, *Geschichte*, p. 264.

93. ISA: 67/1242, Einfuhr nach Lieferantenländer, 1. Halbjahr 1937 im Vergleich zum 1. Halbjahr 1936, aus "Nachrichten für Aussenhandel," Nr. 232, 9.Okt.1937. For a list of the kinds of goods transferred from Germany to Palestine through Haavara, see appendix 9.

## 4. The Zionist Connection, 1933–1937

1. Ball-Kaduri, *Das Leben*, pp. 174ff.; Marcus, "German Foreign Office," p. 190.

2. SD-DF: 862.4016/627, Messersmith/Berlin to State Dept./Washington, No. 1222, April 7, 1933.

3. PA: Pol.Abt.III, Politik 2—Palästina, Bd.1, AA/Berlin an das Preussische Ministerium des Innern, III o 119, 5.Apr.1933.

4. PA: Referat-D, Po5 NE adh7, Bd.1, Bericht über die Lage der jüdischen Flüchtlinge aus Deutschland in den verschiedenen Ländern, Sept. 1933. In March, 1933, Sonderreferat Deutschland was established in the Foreign Office and placed under the authority of the state secretary. Its duties were to include "Beobachtung für die Aussenpolitik wichtiger innerpolitischer Vorgänge in Deutschland; Beobachtung der Einwirkung des Auslandes auf innerpolitische Verhältnisse in Deutschland; Unterstützung des Staatssekretärs bei seinen Kontakten mit den Inlandsstellen; die Judenfrage usw." (observation of important domestic events in Germany for foreign policy; observation of the influence of foreign countries on the domestic situation in Germany; support of the secretary of state in his contacts with the interior departments; the Jewish question, etc.). Referat-D was meant to be the Party's foot in the door of the Foreign Office, particularly with its involvement in the foreign policy aspects of the Jewish question. Palestine contained elements of both domestic Jewish policy and foreign policy questions such as the creation of a Jewish state, Arab nationalism and relations with Great Britain. Since Referat-D and the Orient-Abteilung (Abteilung III before 1936, and Abteilung VII thereafter) were both responsible for Palestine, there were often policy conflicts between the Party ideologues of the former and the more conservative diplomats of the latter. These are considered below. Referat-D was placed under the supervision of Vicco von Bülow-Schwante, a relative of the well-known von Bülow family, and Emil Schumburg. Ardent Party members, they were questioned by American officials after the war but were not tried as war criminals (see NA: Pre-Trial Interrogations of Vicco von Bülow-Schwante, Interrogation No. 2122, October 8, 1947, and of Emil Schumburg, Interrogation No. 4226, July 21 and October 21, 1947). For more on the establishment and operation of Referat-D, see ADAP: C, III/2, Anhang II; Christopher Browning, *The Final Solution and the German Foreign Office*, pp. 11–22; Eliahu Ben Elissar, *La Diplo-*

*matie du IIIe Reich et les Juifs 1933–1939*, p. 134; Jacobsen, *National-sozialistische Aussenpolitik*, pp. 22–23; Paul Seabury, *The Wilhelmstrasse: A Study of German Diplomats under the Nazi Regime*, pp. 71–73.

5. PA: Büro des RAM—Palästina, Nr.Polit. 16/37, 22.Mär.1937. This report is considered in more detail below.

6. PA: Pol.Abt.III, Politik 5—Palästina, Bd.5, "Das jüdische National-heim in Palästina," von Dr. Julius Ruppel, III o 1952–33, Mai 1933.

7. *Jüdische Rundschau*, 4.Okt.1933.

8. Marcus, "German Foreign Office," p. 183.

9. Ibid.

10. PA: Pol.Abt.III—Wirtschaft, Palästina, Finanzwesen 3, Bd.1, DGK/Jerusalem an AA/Berlin, Nr.Expf. 49/34, 3.Jul.1934, and AA/Berlin (Pilger) an RWM bzw. Reichsstelle für Devisenbewirtschaftung, III o 2572, 30.Jul.1934.

11. PA: Pol.Abt.III, Politik 2—Palästina, Bd.2, DGK/Jerusalem an AA/Berlin, Nr.Mild. 1/34, 5.Apr.1934.

12. See Browning, *Final Solution*, p. 12. The impact of Referat-D on German foreign policy appears to have been negligible prior to Ribbentrop's assumption of office in 1938, after which it was redundant. According to Werner-Otto von Hentig of the Orient-Abteilung, Referat-D had no real impact on foreign policy decisions, least of all in the question of Palestine (interview with von Hentig at Seibersbach bei Bingen, November 27, 1974). Referat-D played no part in the Haavara negotiations, an arrangement that set the tone for German policy toward the Zionists. From 1933 through 1936, it supported the line already established by the Orient-Abteilung and other government ministries. During the debate over Palestine in 1937 and 1938, considered below, Hentig and the Orient-Abteilung seem to have had the upper hand in Palestine policy.

13. PA: Inland II A/B, 83–21, Bd.1, Aufzeichnung des Ref.D, "Die Entwicklung der Judenfrage in Deutschland und ihre Rückwirkung im Ausland," an sämtliche Missionen und Berufskonsulate, 83–21 28/2, 28.Feb. 1934. Memoranda originating in Referat-D and issued to German consular missions abroad were done so with the authorization of the Politische Abteilung and the Foreign Minister. Circulars issued to overseas posts began as drafts in particular Foreign Office sections. They circulated in the Foreign Office and were edited and approved by other departments, including the Politische Abteilung and the foreign minister, before being sent out. They contained policies or directives that were naturally those of the Foreign Office as a whole, and not merely of a particular section.

14. Bülow-Schwante was obviously referring to the Haavara agreement, and to the participation of the Foreign Office, the Economics Ministry and the Reichsbank.

15. PA: Referat-D, Po5 NE adh6, Nr.4, Bd.1, Ref.D an RIM, Ref.D 3160, 4.Aug.1933. See also Inland II A/B, 83–29, Bd.1, RIM an AA/Berlin, Nr.I A1113/5012, 5.Jan.1935, and AA/Berlin an RIM, 83–29 5/1, 10.Jan.1935.

16. PA: Inland II A/B, 83–29, Bd.1, Zweiter Bericht über den Verlauf des Zionistenkongresses in Luzern, 4.Sept.1935.

17. Ibid.

18. *Jüdische Rundschau*, 4.Okt.1933.

19. Ibid., Nr.97, 3.Dez.1935, Aufsatz des Ministerialrats Dr. Lösener, "Die Hauptprobleme der Nürnberger Grundgesetze und ihrer ersten Ausführungsverordnungen," in *Reichsverwaltungsblatt*, 23.Nov.1935.

20. PA: Inland II A/B, 83–21, Bd.3, Ref.D an RIM, zu 83–21 28/8, 6.Sept.1935.

21. Göring created the Secret State Police, or Gestapo, in Prussia in April, 1933. By the spring of 1934, the SS under Himmler had assumed control over the police in every one of the German states, including Prussia, giving Himmler and his deputy, Reinhard Heydrich, control over the German police system. Under Himmler and within the SS, Heydrich became chief of the Sicherheitsdienst (SD), the police agency of the Party, and of the Gestapo, the official state secret police. A June, 1936, decree by Hitler formalized all of this, making Himmler Reichsführer-SS and Chief of German Police (see Adam, *Judenpolitik*, pp. 197–203; Schlomo Aronson, *Reinhard Heydrich und die Frühgeschichte von Gestapo und SS*, chaps. 5–6; Heinz Höhne, *Der Orden unter dem Totenkopf: Die Geschichte der SS*, chaps. 5–6, 8–9).

22. In the SA publication *Der SA-Mann*, an article appeared in August, 1936, that was critical of SS support for Jewish emigration as a solution to the Jewish question. It noted: "The Jewish question cannot be easily resolved through emigration or expulsions. It will perhaps be even better, in many cases, that a Jew remains under the supervision of the Reich, rather than being permitted to agitate against his former host nation. The Jew must be rendered harmless for our people." This article was reprinted in the *Jüdische Rundschau*, 25.Aug.1936. Dr. Karl Severing, the Social Democratic minister of the interior in Prussia until May, 1933, testified at the Nürnberg trials in 1946 on the terror and pogrom tactics of the SA (IMT: Testimony of Dr. Karl Severing, May 21, 1946, vol. 14, p. 273).

23. The emigration process was controlled by the Reichsstelle für das Auswanderungswesen in the Ministry of the Interior. The Jewish side of the process was organized by the Hilfsverein der deutschen Juden (Relief Agency of German Jews) for Jews emigrating to countries other than Palestine, and the Palästinaamt for those going to Palestine. According to Arthur Prinz of the Hilfsverein, the Interior Ministry proceeded in a legal, orderly manner. He observed that the Reichsstelle was run by civil servants who were "extremely accommodating and did everything to make our work at the *Hilfsverein* easier" (Prinz, "Role of the Gestapo," p. 206). For a complete account of the organization and operation of the Hilfsverein and the Palästinaamt, see S. Adler-Rudel, *Jüdische Selbsthilfe unter dem Naziregime 1933–1939*, pp. 72–120.

24. NA: T–175/408, Reichsführer-SS, Chef des Sicherheitsamtes: Lagebericht—Mai/Juni, 1934, "Die Judenfrage," 2932496–503.

25. The Syrian option was one of the many alternatives to Palestine considered throughout the 1930s due to Palestine's limited size and political unrest. This particular option was never seriously pursued. There was also a

scheme involving Ecuador in 1936, as well as more serious proposals after 1938 for mass Jewish emigration from all of Europe to destinations such as Madagascar, Angola, Guyana and elsewhere. According to Felix Kersten, Himmler's physician, the SS chief was serious about solving the Jewish question through the forcible resettlement of Jews outside of Europe (Kersten, *Totenkopf und Treue: Heinrich Himmler ohne Uniform: Aus den Tagebüchern des Finnischen Medizinalrats*, pp. 200–201). For more on the Ecuador idea of 1936, as well as SS enthusiasm for any sort of mass emigration scheme, see Prinz, "Role of the Gestapo," p. 209.

26. Helmut Krausnick and Martin Broszat, *Anatomy of the SS State*, trans. Dorothy Lang and Marian Jackson, pp. 46–47. See also Kurt Grossmann, "Zionists and Non-Zionists under Nazi Rule in the 1930's," *Herzl Yearbook* 4 (1961–1962), 331ff.

27. Hans Mommsen, "Dokumentation: Der nationalsozialistische Polizeistaat und die Judenverfolgung vor 1938," *Vierteljahrshefte für Zeitgeschichte* 10 (1962), Nr.2, 78–79.

28. BA: R/58–276, Geheime Staatspolizei (Heydrich) an alle Staatspolizeistellen, II 1 B2–60934/J.191/35, 10.Feb.1935. See also Mommsen, "Dokumentation," Nr.3, pp. 79–80.

29. See Mommsen, "Dokumentation," Nr.8, 10, pp. 82–84; BA: R/58–276, Geheimes Staatspolizeiamt an alle Staatspolizeistellen, II 1 B2–J235/35, 29.Okt.1935, and Geheimes Staatspolizeiamt an den Schriftleiter der Zeitung des Reichsbund jüdischer Frontsoldaten, *Schild*, Dr. Hans Wollenberg, II 1 B2–J1454/35, 21.Okt.1935; Ball-Kaduri, *Das Leben*, p. 147.

30. BA: R/58–276, Geheimes Staatspolizeiamt (Dr. Werner Best, i.A.) an alle Staatspolizeistellen, II 1 B2–J589/35–IV, 31.Mai 1935.

31. The *Staatszionisten* were the small Revisionist Zionist party in Germany, which came into existence in 1933 and separated from the ZVfD that same year. As part of the larger international Revisionist movement, but with no formal affiliation, they tended to be more extreme in their nationalism, more militaristic, more to the right in their politics, more ambitious territorially in Palestine and more uncompromising toward Great Britain and the Arabs. Many differed from Revisionists abroad on the issue of the anti-German boycott. Jabotinsky's movement, which formally seceded from the World Zionist Organization in 1935, renaming itself the New Zionist Organization, avidly pursued the boycott approach. This eventually undermined SS support for the *Staatszionisten* in Germany after 1937, and led to the group's dissolution in 1938 (see PA: Inland II A/B, 83–20, Bd.3, Geheimes Staatspolizeiamt an AA/Berlin, B.Nr. II 1 B2–60625/J.2435, 29.Jan.1935). The estimated membership of the Staatszionistische Vereinigung as of December, 1937, was 1,000, and their influence appears to have been minimal (see CZA: S/5–549, ZVfD/Berlin an das Jewish Agency in Jerusalem, 24.Dez.1937; Lichtheim, *Geschichte*, pp. 241–242).

32. BA: Schumacher File, 240/I, Bayerische Politische Polizei an Polizeidirektionen, Staatspolizeiämter, Bezirksämter, Bezirksamtsaussen-

stellen, Stadtkommissäre und Kreisregierungen, B.Nr. 17929/35 IIb, 13.Apr.1935. This is also printed in Mommsen, "Dokumentation," Nr.5, pp. 80–81.

33. See CAHJP: P/82–12a (Kareski Files), letter of Georg Kareski to *Israelitische Wochenblatt für die Schweiz*, 28.Sept.1937; Lichtheim, *Geschichte*, p. 259.

34. CAHJP: P/82–17 (Kareski Files), Unterredung eines deutschen Schriftleiters mit dem Präsidenten der Staatszionistischen Organisation, Georg Kareski/Berlin zu veröffentlichen, die mit Genehmigung der für die Überwachung der kulturellen Betätigung der Juden in Deutschland zuständigen Reichsbehörde stattfand, Okt.1935. It should also be noted here that Dr. Leo Plaut of the *Staatszionisten* hinted in February, 1936, that contacts had been made in 1932 between Zionists and members of the NSDAP. However, I have not been able to verify the alleged contact (see CAHJP: P/82–36 [Kareski Files], "Zwei Jahre Reichsvertretung in ihrem Verhältnis zur ZVfD: Rechenschaftsbericht des Politischen Referenten der Reichsvertretung an die ZVfD," von Dr. Leo Plaut, Feb.1969).

35. *Das Schwarze Korps*, 14.Mai 1935.

36. The Judenreferat in Heydrich's Sicherheitsdienst was Abteilung II/112, established in late 1935. It was divided into three offices: II/112–1 was responsible for all of the liberal/assimilationist and German-nationalist Jewish organizations such as the Centralverein deutscher Staatsbürger jüdischen Glaubens, the Reichsbund jüdischer Frontsoldaten (National League of Jewish Combat Veterans) and the Verband nationaldeutscher Juden; II/112–2 handled the religious groups; and II/112–3 was responsible for the Zionist organizations. Adolf Eichmann was attached to II/112–3 and became head of this office in July, 1937 (see BA: R/58–991, Lagebericht der Abt. II/112, 25.Jun.1936).

Abt. II/112 worked in close cooperation with Abt. II/B–4, the Judenreferat in the Gestapo. They shared networks of spies and informers, and although both were subordinate to Heydrich and Himmler, they maintained their separate existence until September, 1939, when the state and Party police functions under Heydrich were formally merged into a massive administrative unit, the Reichssicherheitshauptamt (Reich Security Headquarters) under Heydrich. Abt. II/112 of the SD and II/B–4 of the Gestapo were merged into section IV/B–4 of the RSHA under Eichmann (see NA: T–175/410 [Himmler File], Tätigkeitsbericht vom 16.2.37–5.7.37, II/112.65/4, 2934480, 5.Jul.1937, and Tätigkeitsbericht vom 1.7.–31.12.37, II/112.65/4, 2935001, 15.Jan.1938; see also NA: T–175/508, II/1 an II/112 im Hause, 9373880, 16.Jun.1937). Eichmann himself gave a detailed account of the organization and development of the Jewish sections in the SD and the Gestapo in his pretrial interrogation by Israeli police in 1960–1961 (see Jochen von Lang, ed., *Eichmann Interrogated: Transcripts from the Archives of the Israeli Police*, trans. Ralph Manheim, pp. 20ff.). For a list of Zionist and affiliated organizations under the supervision of section II/112 in the SD, see appendix 10.

37. *Das Schwarze Korps*, 26.Sept.1935.

38. PA: Inland II A/B, 83–21, Bd.3, Geheimes Staatspolizeiamt an RIM, B.Nr.II 1 B2–64640/J.577/35, 18.Mai 1935. Approval of the move from the Foreign Office (Referat-D) and from the Interior Ministry is indicated in PA: Inland II A/B, 83–21, Bd.3, Ref.D an RIM, 83–21 9/7, 25.Jul.1935. In November, 1935, the Verband nationaldeutscher Juden was disbanded. The Centralverein deutscher Staatsbürger jüdischen Glaubens was forced to change its name to the Centralverein der Juden in Deutschland and to curtail any assimilationist tendencies. The Reichsbund jüdischer Frontsoldaten was slowly eliminated over the following three years.

39. BA: R/43 II–602, RIM an die Landesregierungen, IIIp 3710/59, 20.Aug.1935.

40. David Yisraeli, "The Third Reich and Palestine," *Middle Eastern Studies* 7 (1971), 347. Yisraeli gives as his source the files of the Ministry of Economics at the Bundesarchiv in Koblenz, but does not identify a document.

41. IfZ: Eichmannprozess—Beweisdokumente, Nr.742, March, 1957.

42. See appendix 11. The Hechaluz was the youth organization of the ZVfD.

43. Mommsen, "Dokumentation," Nr.2, pp.78–79. See also Lichtheim, *Geschichte*, p.263.

44. PA: Referat-D, Po5 NE adh6, Bd.3, Schnellbrief, AA/Berlin an das RIM, das Preussische Ministerium des Innern, und das Polizeipräsidium, 18.Jul.1933, RIM an AA/Berlin, Nr. IA 2000/18.8, 28.Aug.1933, Preussische Ministerium des Innern an den Herrn Regierungspräsidenten und den Herrn Polizeipräsidenten in Berlin, V.E. 1086, 7.Okt.1933.

45. PA: Inland II A/B, 83–21, Bd.1, RIM an den Herrn Reichsminister für Ernährung und Landwirtschaft, IV5012/11.5, 83–21 13/6, 13.Jun.1934.

46. PA: Inland II A/B, 83–21, Bd.3, Reichsministerium für Ernährung und Landwirtschaft an das RIM, IV/6–2517, 19.Jun.1935.

47. PA: Inland II A/B, 83–21, Bd.3, Der Arbeitsminister an den Reichsminister des Innern, IIc 7096/35, 13.Sept.1935.

48. PA: Inland II A/B, 83–21, Bd.5, Memorandum of the British Embassy/Berlin, April 3, 1935.

49. See ISA: 67/1145, DGK/Jerusalem an Gestapo/Berlin, Nr.Sic.70/36, 6.Jun.1936, Gestapo/Berlin an DGK/Jerusalem, Nr.II 1 B2–1499/35–J, 14.Jul.1936, and DGK/Jerusalem an Gestapo/Berlin, Nr.Sic.70/76 and 130/36, 6.Aug.1936.

50. BA: R/58–276, Geheimes Staatspolizeiamt an alle Staatspolizeistellen, B.Nr. II 1 B2–J.317/36II, 4.Apr.1936.

51. Lichtheim, *Geschichte*, p.264.

52. Nora Levin, *The Holocaust: The Destruction of European Jewry, 1933–1945*, pp.64–66.

53. Marvin Lowenthal, *The Jews of Germany: The Story of Sixteen Centuries*, p.402.

54. NA: T–175/508, "Die augenblickliche Lage des Judentums in Deutschland," II/112–6, 62/3, 9374090, 13.Sept.1936.

55. CZA: AM501/49, Benno Cohen/ZVfD to the Jewish Agency for Palestine/Jerusalem, March 18, 1937. See also NA: T–175/411, Die Organisation der Judenheit, ihre Verbindungen und politische Bedeutung, 2936225, 23.Sept.1938; Lichtheim, *Geschichte*, pp. 263–264.

56. See BA: R/58–955, "Die Zionistische Weltorganisation," Teile I, II, II/112, 20.Okt.1936.

57. NA: T–175/R588, II/112–18/1, 000373, 12.Mär.1937.

58. Joachim von Ribbentrop, *Zwischen London und Moskau: Erinnerungen und letzte Aufzeichnungen*, ed. A. von Ribbentrop, pp. 128–129. The late Dr. Fritz Grobba, the German ambassador to Iraq from 1932 to 1939, told me in an interview in Bad Godesberg on June 30, 1973, that SD agents were constantly watching him and his staff in Baghdad.

59. PA: Pol.Abt.III, Politik 12—Palästina, Bd.1, DGK/Jerusalem an AA/Berlin, Nr.Empf. 40/35, 8.Jul.1935. See also Yisraeli, "Transfer Agreement," pp. 131–132.

60. IfZ: Eichmannprozess—Beweisdokumente, Nr.2, Bericht über die Palästina–Ägyptenreise von SS-Hptscharf. Eichmann und St-O'Scharf. Hagen, 4.Nov.1937. Eichmann asserted that a personal antipathy existed between Reichert and Döhle and that Döhle resented Reichert's sympathy for the Zionists.

61. See PA: Pol.Abt.III, Politik 12—Palästina, Bd.1, DNB-Auslandsabteilung/Berlin an AA/Berlin, III o 674, 5.Feb.1936, AA/Berlin an DGK/Jerusalem, zu III o 674/36, 10.Feb.1936, DGK/Jerusalem an AA/Berlin, Nr. Post. 9/36, III o 1040, 18.Feb.1936, and AA/Berlin an DNB-Auslandsabteilung/Berlin, zu III o 1040/36, 7.Mär.1936.

62. BA: R/58–991, Tätigkeitsbericht von II/112, 6.6.–5.10.37.

63. BA: R/58–991, Tätigkeitsbericht von II/112, 1.7.–31.12.37. The Hagana was an underground Jewish paramilitary organization created in the early 1920s to defend Jewish settlements in Palestine against Arab attacks.

64. NA: T–175/R588, II/112–18/1, B.Nr. 160/37, 000435–436, 7.Mai 1937.

65. NA: T–175/411 (Himmler File), II/112, Geheime Kommandosache 98i/37, 17.Jun.1937, 2936189–194. Polkes was to be sent on a mission to Europe and America anyway to seek contributions for the Hagana. His position and importance in the Hagana remain a mystery. It is not certain that he was acting in an official capacity for the Hagana, or even whether he was still an active member. It is therefore difficult to ascertain whether he was a credible bargaining partner. It is important, however, that II/112 thought he was. There is a file on Polkes in the Hagana Archives in Tel Aviv, access to which has been denied to me. See also von Lang, *Eichmann Interrogated*, pp. 31–46.

66. NA: T–175/411 (Himmler File), II/112, Geheime Kommandosache 98i/37, 17.Jun.1937, 2936189–194.

67. Ibid.

68. See IfZ: Eichmannprozess—Beweisdokumente, Nr.2, Bericht über die Palästina–Ägyptenreise von SS-Hptscharf. Eichmann und St-O'Scharf. Hagen, 4.Nov.1937.

69. See NA: T–175/411, Die Zionistische Weltorganisation, Teil II, 2935445, 20.Okt.1936.

70. NA: T–175/R588, Bericht betr. Feivel Polkes, 000437–438, 7.Mai 1937.

71. E. Dekel, *SHAI: The Exploits of Hagana Intelligence*, pp. 50–53.

72. Letter from the Mauser-Jagdwaffen GmbH to me, December 22, 1975.

73. During his meeting with Polkes in Cairo in October, 1937, Eichmann revealed that a Hagana weapons-smuggling ring had been uncovered in Hamburg and that a Hagana agent named Schalomi had been taken into custody. According to Eichmann, Schalomi was held only in order to pressure Polkes into providing information on the Gustloff assassination (see IfZ: Eichmannprozess—Beweisdokumente, Nr.2).

74. *Der Angriff*, 29.Sept.1934.

75. Ibid., 9.Okt.1934.

76. Seabury, *Wilhelmstrasse*, p. 37. See also Reinhard Bollmus, *Das Amt Rosenberg und seine Gegner: Zum Machtkampf im Nationalsozialistischen Herrschaftssystem*, pp. 19–20.

77. For a complete account of the establishment and the subsequent insignificance of the APA, see Jacobsen, *Nationalsozialistische Aussenpolitik*, pp. 45–89; Schubert, *Anfänge*, pp. 228–233; Seabury, *Wilhelmstrasse*, pp. 33–37; Fritz Wiedemann, *Der Mann der Feldherr Werden Wollte: Erlebnisse und Erfahrungen des Vorgesetzten Hitlers im Ersten Weltkrieg und seinen späteren persönlichen Adjutanten*, pp. 146–147. See also SD-DF: 862.00/3510, Dodd/Berlin to State Department, May 27, 1935.

78. CDJC: CXLV–623.

79. *Völkischer Beobachter*, 1.Dez.1934.

## 5. The Role of England in Hitler's Foreign Policy Plans

1. See Aigner, *Das Ringen*; Fest, *Hitler*; Jäckel, *Hitlers Weltanschauung*; Kuhn, *Programm*; Hugh Trevor-Roper, "Hitlers Kriegsziele," *Vierteljahrshefte für Zeitgeschichte* 8 (1960), 121–133. All but Trevor-Roper rely for the most part on Hitler's foreign policy pronouncements in *Mein Kampf* and in his *Secret Book*, and less so on subsequent policies and pronouncements.

2. See Josef Henke, *England in Hitlers politischem Kalkül 1935–1939*; Klaus Hildebrand, *Vom Reich zum Weltreich: Hitler, NSDAP und Kolonialfrage 1919–1945*, and *The Foreign Policy of the Third Reich*, trans. Anthony Fothergill; Andreas Hillgruber, *Hitlers Strategie: Politik und Kriegführung 1940–1941*, *Deutschlands Rolle in der Vorgeschichte der Beiden Weltkriege*, and "England's Place in Hitler's Plans for World Domination," *Journal of Contemporary History* 9 (1974), 5–22; Jochen Thies, *Architekt der Weltherrschaft: Die Endziele Hitlers*; Gerhard Weinberg, *The Foreign Policy of Hitler's Germany, 1933–1939*.

3. See Jacobsen, *Nationalsozialistische Aussenpolitik*, pp. 613ff.; Hildebrand, *Foreign Policy*, pp. 29–30.

4. K. D. Bracher, "Das Anfangsstadium der Hitlerschen Aussenpolitik," *Vierteljahrshefte für Zeitgeschichte* 5 (1957), 65ff. See also Schubert, *Anfänge*, pp. 226, 239; Ernst von Weizsäcker, *Memoirs*, trans. John Andrews, pp. 107–108.

5. Kuhn, *Programm*, pp. 11–12.

6. Schubert, *Anfänge*, pp. 181–182.

7. Hildebrand, *Foreign Policy*, pp. 12–13.

8. Ibid., pp. 12–23.

9. See Kuhn, *Programm*, pp. 47–48, 56; Hildebrand, *Foreign Policy*, p. 18, and *Weltreich*, pp. 72–74.

10. Phelps, "Parteiredner," Nr. 1, p. 290, and Nr. 3, pp. 297–298.

11. Ibid., Nr. 9, p. 308. See also Kuhn, *Programm*, pp. 61–62. In *Mein Kampf*, Hitler claimed that with the Bolshevik victory in Russia, that country was divested of its former German ruling class and was, therefore, no longer fit to be an ally of Germany. He further asserted that the new rulers of Russia were part of the Jewish conspiracy to rule the world, in keeping with Rosenberg's theories on Bolshevism as an arm of the alleged Jewish conspiracy (*Mein Kampf*, pp. 951–952, 957–958; Jäckel, *Hitlers Weltanschauung*, p. 46).

12. *Völkischer Beobachter*, 29.Mai 1921. See also Weinberg, *Foreign Policy*, vol. 1, p. 15.

13. See Wolfgang Horn, "Ein unbekannter Aufsatz Hitlers aus dem Frühjahr 1924," *Vierteljahrshefte für Zeitgeschichte* 16 (1968), 280ff.

14. Thilo Vogelsang, "Hitlers Brief an Reichenau vom 4. Dezember 1932," *Vierteljahrshefte für Zeitgeschichte* 7 (1959), 435.

15. Luedecke, *I Knew Hitler*, p. 77.

16. See Alfred Rosenberg, *Der Zukunftsweg einer deutschen Aussenpolitik*, pp. 20–21.

17. See Jäckel, *Hitlers Weltanschauung*, pp. 35–36; Hillgruber, "Hitler's Plans," pp. 8–9; Kuhn, *Programm*, p. 269; Schubert, *Anfänge*, pp. 58ff.; Henke, *England*, p. 20. Hitler later referred to the significance of the Ruhr crisis in his attitude toward England in *Mein Kampf*, pp. 979–981.

18. Hitler's interest in the Italian alliance can be traced back to 1920, two years before Mussolini's assumption of power (see Jäckel, *Hitlers Weltanschauung*, pp. 33–34; Kuhn, *Programm*, pp. 42–43, 45–48).

19. Schubert, *Anfänge*, p. 81.

20. Hitler, *Mein Kampf*, pp. 902–903, 907–908, 964.

21. Henke, *England*, p. 20; Weinberg, *Foreign Policy*, vol. 1, p. 15.

22. Hitler, *Mein Kampf*, p. 181.

23. Henke, *England*, p. 21. See also Hitler, *Mein Kampf*, pp. 899ff., and *Secret Book*, pp. 149–153.

24. Hitler, *Mein Kampf*, p. 183.

25. Ibid., pp. 928–929. See also Hitler, *Secret Book*, p. 209; Henke, *England*, p. 27; Hillgruber, "Hitler's Plans," pp. 9–12.

26. BA: R/43–1399, Ministerbesprechung über die aussenpolitische Lage am 7.Apr.1933.

27. Erich Raeder, *Mein Leben*, vol. 1, p. 281.

28. Ibid., pp. 282–283.

29. See Henke, *England*, p. 30; Erich Kordt, *Nicht aus den Akten: Die Wilhelmstrasse in Frieden und Krieg: Erlebnisse, Begegnungen, Eindrücke*, p. 109; Kuhn, *Programm*, pp. 172–176; Ribbentrop, *Erinnerungen*, p. 67.

30. Hitler, *Mein Kampf*, p. 181. See also W. W. Schmokel, *Dream of Empire: German Colonialism, 1919–1945*, pp. 1–3, 17–18. The best account of Hitler's position on colonies during the 1920s is Hildebrand, *Weltreich*, chaps. 1–2.

31. *Daily Telegraph*, May 5, 1933. See also Domarus, *Hitler*, vol. 1/1, pp. 264–265.

32. See Henke, *England*, pp. 30–34; Hildebrand, *Weltreich*, pp. 459–463; Kuhn, *Programm*, pp. 144, 146–148; Raeder, *Mein Leben*, vol. 2, p. 108; Albert Speer, *Inside the Third Reich*, trans. Richard and Clara Winston, p. 71.

33. ADAP: C, III/2, Nr.555. For further analysis of the Simon talks, see Henke, *England*, p. 38; Kuhn, *Programm*, p. 164; Schmokel, *Dream of Empire*, pp. 18–19; Hildebrand, *Weltreich*, pp. 465ff.; Right Hon. Earl of Avon, *The Eden Memoirs: Facing the Dictators*, pp. 132–138.

34. BA: R/43–I: 627, Schacht an Ritter von Epp, 19.Mär.1935.

35. Hildebrand, *Foreign Policy*, pp. 39–43, and *Weltreich*, pp. 343ff., 469. See also Hillgruber, *Strategie*, pp. 242–243.

36. Hildebrand, *Foreign Policy*, p. 43.

37. BA: R/43–II: 991a, VIII. Reichsparteitag/Nürnberg, 9.Sept.1936.

38. BA: R/43–I: 627, Der St.S und Chef der Reichskanzlei an Reichsstatthalter in Bayern Gen. Ritter von Epp, 25.Nov.1935.

39. See Henke, *England*, pp. 31ff.; Hildebrand, *Weltreich*, p. 491; Kuhn, *Programm*, pp. 191–194.

40. Ribbentrop, *Erinnerungen*, p. 93.

41. Ibid., pp. 66ff. For more on Hitler's alliance offers to Britain, see Thomas Jones, *A Diary with Letters, 1931–1950*, pp. 201–202.

42. Hans-Günther Seraphim, ed., *Das politische Tagebuch Alfred Rosenbergs aus den Jahren 1934–1935 und 1939–1940*, pp. 4, 17, 20, and appendix 2, pp. 138–140. See also Jacobsen, *Nationalsozialistische Aussenpolitik*, pp. 45ff.

43. Hitler, *Secret Book*, pp. 67–68.

44. Jens Petersen, *Mussolini-Hitler: Die Entstehung der Achse Rom-Berlin 1933–1936*, p. 61.

45. Ibid., chaps. 6–9. Correspondence between the German ambassador in Rome, von Hassell, and the Foreign Office in Berlin indicates that both were totally opposed to a German-Italian alliance at that time so as not to antagonize the powers of Europe, especially Britain. See PA: Geheim-Akten 1920–1936, Italien—Pol.2, Bd.3, AA/Berlin an DB/Rom, 20.Feb.1933, and DB/Rom an AA/Berlin, 6.Mär.1933.

46. Henke, *England*, p. 75.

47. Wiedemann, *Mann*, pp. 150–151.

48. Ribbentrop, *Erinnerungen*, p. 43.

49. Speer, *Third Reich*, p. 71. See also Henke, *England*, pp. 95–96.

50. Speer, *Third Reich*, pp. 71–72. See also Wiedemann, *Mann*, p. 151; Rahn, *Leben*, p. 122; Henke, *England*, pp. 40–43; Kuhn, *Programm*, pp. 178–181; Petersen, *Mussolini-Hitler*, chap. 12; Ferdinand Siebert, *Italiens Weg in den Zweiten Weltkrieg*, pp. 31–36.

51. PA: Dienststelle Ribbentrop, Vertrauliche Berichte 1935–1939, Teil I, Vortragsnotiz, Dezember 1937.

52. Henke, *England*, pp. 38, 71–72. See also Hildebrand, *Weltreich*, p. 518.

53. See Henke, *England*, pp. 50–51, 77; Aigner, *Das Ringen*, pp. 141ff., 146ff., 151ff., 172ff., 179ff., 294ff., 309ff.

54. Hildebrand, *Foreign Policy*, p. 39. See also Henke, *England*, pp. 53, 79; Avon, *Eden Memoirs*, pp. 133, 135.

55. Oswald Hauser, *England und das Dritte Reich*, vol. 1, pp. 261–265.

56. NA: T–120/738, Telegramm von Hoesch an den Herrn RAM, Nr.132, 15.Mai 1933, 366977–980.

57. BA: R/43–II: 1433, DB/London an AA/Berlin, A.3234, 12.Sept. 1934. See also NA: T–120/738, Aufzeichnung des Reichsaussenministers von Neurath vom 27.Nov.1934, 367043–045.

58. BA: R/43–II: 1432a, Thomsen (Reichskanzlei) an Lammers (Reichskanzlei), Rk. 13146, 16.Nov.1933.

59. BA: R/43–II: 1434, St.S u. Chef der Reichskanzlei (Lammers) an Ribbentrop, Rk. 10455/35, 11.Dez.1935.

60. Jacobsen, *Nationalsozialistische Aussenpolitik*, p. 785; Henke, *England*, p. 37; Hildebrand, *Weltreich*, pp. 460, 570ff.; Bracher et al., *Machtergreifung*, pp. 749ff.

61. See Henke, *England*, pp. 43–44; Jacobsen, *Nationalsozialistische Aussenpolitik*, p. 352; Speer, *Third Reich*, pp. 71–72.

62. Henke, *England*, pp. 56–65.

63. Ibid., pp. 77–78.

64. Hildebrand, *Weltreich*, pp. 491–511.

65. Wilhelm Treue, "Hitlers Denkschrift zum Vierjahresplan," *Vierteljahrshefte für Zeitgeschichte* 3 (1955), 204–210.

66. Hildebrand, *Weltreich*, pp. 494ff.; Henke, *England*, p. 83.

67. Henke, *England*, p. 84.

68. See Kuhn, *Programm*, pp. 202–205; Henke, *England*, pp. 91–95; Wiedemann, *Mann*, pp. 156–157.

69. ADAP: D, I, Nr.19. This document is a memorandum on the meeting prepared by Hossbach on November 10.

70. See Henke, *England*, pp. 105–107; Hildebrand, *Foreign Policy*, pp. 51–53, and *Weltreich*, pp. 523–526; Hillgruber, *Strategie*, pp. 28–29; Kuhn, *Programm*, pp. 209–212. For an account of the origin and composition of the Hossbach memorandum, see W. Bussmann, "Zur Entstehung und Überlieferung der Hossbach-Niederschrift," *Vierteljahrshefte für Zeitgeschichte* 16 (1968), 373ff.

71. ADAP: D, I, Nr.31 mit Anlage. See also Earl of Halifax, *Fullness of Days*, pp. 184–190; Henke, *England*, pp. 109–117; Hildebrand, *Weltreich*, pp. 531ff., and *Foreign Policy*, pp. 55–56.

72. Halifax claimed Hitler told him that Germany did not want colonies in troubled areas such as North Africa or the Mediterranean because of Anglo-French-Italian rivalries. This would indicate Hitler's lack of interest in the Levant (Halifax, *Fullness of Days*, pp. 187–188).

73. Ibid. A similar observation was made by Hitler's interpreter, Dr. Paul-Otto Schmidt, in *Statist auf diplomatischer Bühne 1923–1945: Erlebnisse des Chefdolmetschers im Auswärtigen Amt mit den Staatsmänner Europas*, p. 378.

74. Henke, *England*, pp. 69–70; Hillgruber, *Strategie*, pp. 144ff.

75. Malcolm Muggeridge, ed., *The Ciano Diaries, 1939–1943*, p. 265, and *Ciano's Diplomatic Papers*, p. 373.

76. Hillgruber, *Strategie*, p. 151.

77. Phelps, "Parteiredner," Nr.3, p. 297.

78. See Henke, *England*, pp. 22–23; Kuhn, *Programm*, pp. 45ff.

79. Hitler, *Mein Kampf*, p. 956.

80. Ibid., p. 959. Hitler also told Otto Strasser that the inferior Hindu "race" in India could never be independent of the superior Anglo-Nordic "race" (see Strasser, *Hitler and I*, p. 118).

81. Schubert, *Anfänge*, pp. 132, 222. See also BA: Schumacher File, 124, "Die kulturelle und politische Mission der vier europäischen Grossmächte," Rede von Alfred Rosenberg, 30.Okt.1937.

82. Aigner, *Das Ringen*, p. 13.

83. BA: NS/26–60, Rede Hitlers vor dem NS Studentenbund in München am 26.Jan.1936.

## 6. The Rejection of an Arab Connection, 1933–1937

1. Nicosia, "Arab Nationalism," pp. 352–354.

2. The earliest indication of this can be found in PA: Pol.Abt.III, Politik 2—Palästina, Bd.1, DGK/Jerusalem an AA/Berlin, Nr.Polit. 3/33, 20.Mär.1933.

3. PA: Pol.Abt.III, Politik 2—Palästina, Bd.1, DGK/Jerusalem an AA/Berlin, Telegramm Nr.5, 31.Mär.1933. The Mufti's three biographers cannot be relied upon for an account of German involvement in Palestine during the 1930s. Their conclusions on German policy, particularly on the position of the German Christian communities, are not well documented and are largely inaccurate. See Maurice Pearlman, *Mufti of Jerusalem: The Story of Haj Amin el-Husseini*; Joseph Schechtman, *The Mufti and the Führer: The Rise and Fall of Haj Amin el-Husseini*; Simon Wiesenthal, *Grossmufti: Grossagent der Achse: Tatsachenbericht*.

4. PA: Abt. IV—Kultur, Minderheiten, Nr.14, Bd.1, DGK/Jerusalem an AA/Berlin, Nr.Polit. 24/33, 20.Apr.1933.

5. PA: Botschaft Rom, Pol.3—Palästina, Bd.1, DGK/Jerusalem an AA/Berlin, Nr.Unr. 2/33, 30.Okt.1933.

6. PA: Botschaft Rom, Pol.3—Palästina, Bd.1, DGK/Jerusalem an AA/Berlin, Nr.Polit. 3/34, "Politische Übersicht über das Jahr 1933," 15.Jan.1934.

7. PA: Pol.Abt.III, Politik 2—Palästina, Bd.2, Der St.S in der Reichs-kanzlei an AA/Berlin, RK.6878, 2.Aug.1934.

8. PA: Pol.Abt.III, Politik 2—Palästina, Bd.2, Promi an AA/Berlin, VII/7074/16.3.34, 10.Apr.1934. There is a great need for further research in the area of Arab responses to events in Germany in Palestine and in other Arab states, particularly involving Arabic sources.

9. PA: Pol.Abt.III, Politik 26—Palästina, Bd.1, DK/Jaffa an AA/Berlin, J.N. 4043/35, 14.Aug.1935.

10. PA: HaPol Abt., Handakten Clodius—Palästina, DGK/Jerusalem an AA/Berlin, Nr.Polit. 111/33, 25.Aug.1933.

11. PA: Pol.Abt.III, Politik 11—Palästina, Nr.3, Bd.1, DGK/Jerusalem an AA/Berlin, Nr.Polit. 55/34, "Politisches Programm des Emirs für seine Besprechungen in London," 7.Jun.1934.

12. Ibid.

13. PA: Pol.Abt.III—Jüdische Angelegenheiten, Jüd.Pol.1, Bd.13, AA/Berlin an DK/Genf, III o 3856, 26.Okt.1933. For a complete account of Arslan's activities, see William L. Cleveland, *Islam against the West.*

14. PA: Geheim-Akten 1920–1936, Syrien—Pol.2, Aufzeichnung Prü-fers, III o 4210, 7.Nov.1934.

15. Ibid.

16. BA: R/43–II: 1420, Vermerk, Rk. 9952, 10.Nov.1934.

17. See Grobba, *Männer*, pp. 96–104.

18. PA: Pol.Abt.III, Politik 4—Pan-Arab. Bund, DG/Bagdad an AA/Ber-lin, III o 574, 2.Feb.1935.

19. PA: Pol.Abt.III, Politik 4—Pan-Arab. Bund, AA/Berlin an DG/Bag-dad, Telegramm Nr.2, 12.Feb.1935.

20. PA: Pol.Abt.III, Politik 2—Syrien, Bd.1, DGK/Jerusalem an AA/Ber-lin, 1/J.N.978, 12.Apr.1935.

21. PA: Pol.Abt.III, Politik 2—Palästina, Bd.1, Joseph Francis/Jaffa an DGK/Jerusalem, 13.Apr.1933.

22. PA: Referat-D, Po5 NE adh7, DG/Bagdad an AA/Berlin, Nr.1130, 10.Aug.1933.

23. PA: Pol.Abt.III, Politik 2—Palästina, Bd.1, DGK/Jerusalem an AA/Berlin, Nr.Polit. 74/33, 27.Jun.1933.

24. PA: Pol.Abt.III, Politik 2—Palästina, Bd.1, Aufzeichnung der Abteilung III, zu III o 2362, 7.Jul.1933.

25. PA: Pol.Abt.III, Politik 2—Palästina, Bd.1, AA/Berlin an DGK/Jeru-salem, zu III o 2362, 31.Jul.1933.

26. PA: Inland II A/B, 82–03, AO der NSDAP an AA/Berlin, Nr.82–02 1/6, 1.Jun.1934. According to Albert Speer, Hitler was opposed to the idea of exporting National Socialism to other countries because he feared it might strengthen their own nationalism and thus weaken Germany's ability to deal with them; there must have been the obvious racial reasons as well (Speer, *Third Reich*, p. 122).

27. BA: R/43–II: 1399, Ministerbesprechung über die aussen-politische Lage am 7.Apr.1933.

28. BA: R/43–I: 626*a*, Aufzeichnung Hitlers vom 14.Jun.1934.

29. PA: Inland II A/B, 82–02, Bd.2, Aufsatz der AO-Hamburg der NSDAP, Ernst-Wilhelm Bohle, veröffentlicht im *Hamburger Tageblatt*, Weltpost-Ausgabe, 1.Apr.1934.

In May, 1930, an Auslandsabteilung (Foreign Section) of the NSDAP was established in Hamburg. On March 15, 1933, the Abteilung für Deutsche im Ausland was created by the Oberste Leitung der Parteiorganisation (High Command of the Party Organization). Ernst Bohle was named director on May 8, and the entire organization was placed under the authority of Rudolf Hess and the office of the Stellvertreter des Führers on October 3. On January 19, 1934, its name was officially changed to Auslandsorganisation der NSDAP, and it continued as the Party agency responsible for relations between overseas Germans and the fatherland. In March, 1935, the AO moved its headquarters from Hamburg to Berlin. On April 1, the AO was declared a Gau, and Bohle became the Gauleiter of all overseas Germans. The term *Auslandsdeutsche* applied to both *Reichsdeutsche* (German citizens abroad) and *Volksdeutsche* (ethnic Germans who were citizens of other countries). Both were the responsibility of the AO and both were eligible for Party membership. The history of the AO is covered in detail in Emil Ehrich, *Die Auslandsorganisation der NSDAP*. See also Jacobsen, *Nationalsozialistische Aussenpolitik*, pp. 90ff.; Seabury, *Wilhelmstrasse*, pp. 32–33.

30. Bohle's words were: "Wer heute deutsch sein will, muss Nationalsozialist sein" (anyone who wants to be German today must be a National Socialist).

31. BA: Schumacher Collection/293, NSDAP-Reichsleitung/München an die Abt. für Deutsche im Ausland, Anordnung 1/33, 30.Mär.1933.

32. BA: Schumacher Collection/293, Rundschreiben Nr.53 an sämtliche Auslandsgruppen der NSDAP, 3.Okt.1933. See also Jacobsen, *Nationalsozialistische Aussenpolitik*, pp. 102–103.

33. PA: Abt.IV—Kultur, Deutschtum im Ausland, Allgemeines, Bd.18, Aufzeichnung des V.L.R. Roediger, IVA–1782, 13.Apr.1935.

34. See PA: Büro des Chefs der AO, Runderlass A.O.6: Strafdrohung gegen die Einmischung Reichsdeutscher in die innere Politik ausländischer Staaten, 5.Okt.1937.

35. See Francis R. Nicosia, "National Socialism and the Demise of the German-Christian Communities in Palestine during the Nineteen Thirties," *Canadian Journal of History* 14 (1979), 235–255. The best of the remaining works is H. D. Schmidt, "The Nazi Party in Palestine and the Levant, 1932–1939," *International Affairs* 28 (1952), 460–469. Schmidt's essay relies solely on the remnants of the files of the Nazi party of Palestine and is limited by its exclusive reliance on that valuable source. There are two brief articles that do no justice whatever to the topic: Tsvi Erez, "Germans in Palestine: Nazis and Templars," *Wiener Library Bulletin* 17 (1963), 25, is a one-page condemnation of the German settlers as Nazi agents who lent full support to the Arab rebellion; and Siegfried Braun, "Die Deutsche Tempelgesellschaft in Palästina," *Tribune* 1 (1962), 376–386, suffers from the same shortcomings. A work that depicts the Germans in Palestine as an

arm of German imperialism in the Middle East is Heinz Tillmann, *Deutschlands Araberpolitik im Zweiten Weltkrieg.* Tillmann's book follows a strictly Marxist interpretation that attributes German Middle East policy after 1933 to imperialist designs on that part of the world. Several works that deal with Germany and Palestine but virtually ignore the Palästinadeutsche are Lukasz Hirszowicz, *The Third Reich and the Arab East;* Robert Melka, "The Axis and the Arab Middle East, 1930–1945"; Bernd Schröder, *Deutschland und der Mittlere Osten im Zweiten Weltkrieg;* Josef Schröder, "Die Beziehungen der Achsenmächte zur arabischen Welt," *Zeitschrift für Politik* 18 (1971), 80–95; Yisraeli, "Third Reich and Palestine," pp. 343–353.

36. Letter from Dr. Richard Otto Hoffmann, director of the Temple Society of Australia, to me, May 8, 1975. This figure is also accepted by Schmidt, "Nazi Party," p. 41. Dr. Hoffmann is a descendant of Christoph Hoffmann, the leader of the Temple Society when it first left Württemberg for Palestine in 1867.

By the end of 1937, the total German Christian population in Palestine had risen to some 2,500, after which it began to decline due to the conscription of young German males for military service in Germany (see PA: Büro des Reichsaussenministers—Palästina, DGK/Jerusalem an AA/Berlin, Nr.Polit. 16/37, 22.Mär.1937).

37. Hoffmann letter, May 8, 1975. Dr. von Hentig observes that the Templers were enthusiastic about the rise to power of National Socialism (Hentig, "Palästina," p. 118).

38. TG: *Die Warte des Tempels*, 15.Dez.1933. This newspaper was published in Jerusalem until 1917, when publication was interrupted by World War I. It resumed publication in Stuttgart in 1921 and continued to be published there until it returned to Jerusalem in 1936. Its usefulness as a source is limited because of the obvious pressures to which it was exposed, in Germany after 1933, and in Palestine from 1936 on. Since it could not afford to antagonize the regime in Germany after 1933—or the British, Arabs and Jews in Palestine after 1936—its articles were consistently neutral in the Arab-Jewish conflict, supportive of the British Mandate and generally in agreement with the policies of the German government.

39. Hoffmann letter, May 8, 1975. See also Sauer, *Beilharz-Chronik*, p. 178.

40. Schmidt, "Nazi Party," p. 462.

41. TG: *Die Warte des Tempels*, 15.Aug.1935.

42. Hoffmann letter, May 8, 1975.

43. Schmidt, "Nazi Party," pp. 461–462.

44. YV: NSDAP/Landesgruppe-Palästina, 1934–1939, Mitgliedstand vom April 1937. By December, 1937, membership had risen to 312. There appears to have been some discrepancy in membership figures between the files of the NSDAP/Landesgruppe-Palästina that are housed at Yad Vashem in Jerusalem and the files of the Büro des Chefs der Auslandsorganisation (Office of the Chief of the Overseas Organization) at the Foreign Office Archives in Bonn. The figures given here are from the former, as are those used

by Schmidt, who gives a membership total of 250 for the end of 1935. The records of the latter show a membership total of 228 as of June, 1937; this is the number used by Jacobsen (Schmidt, "Nazi Party," p. 465; PA: Büro des Chefs der Auslandsorganisation, Statistik, Bd.28, Mitgliedstand vom 30.Jun.1937; Jacobsen, *Nationalsozialistische Aussenpolitik,* Übersicht Nr.26, pp. 662–666). For the organization of the Landesgruppe-Palästina, see appendix 12.

45. The Propaganda Ministry provided Dr. Reichert, the DNB correspondent in Jerusalem, with a new radio receiver in late 1934. The Foreign Office gave its approval (see PA: Pol.Abt.III, Politik 26—Palästina, Bd.1, Promi/Berlin an AA/Berlin, VII7082/6.5.34, 26.Sept.1934, and AA/Berlin an Promi/Berlin, zu III o 3620, 6.Dez.1934).

46. ISA: 67/1362, AA/Berlin an sämtliche diplomatische und konsularische Vertretungen im Ausland, Nr.VI S 7097, 27.Jun.1935, and AA/Berlin an sämtliche diplomatische und konsularische Vertretungen im Ausland, Kult. S–739, 24.Feb.1938.

47. Schmidt, "Nazi Party," p. 464.

48. Ibid., p. 465.

49. Ibid., p. 466.

50. Ibid., pp. 466–468.

51. Letters from Dr. Richard Otto Hoffmann to me, April 16 and May 8, 1975.

52. The Temple Society had originally broken away from the Lutheran Church in Württemberg in the early nineteenth century. According to Dr. Hoffmann, the Lutherans had continually tried to bring the Templers back into the Lutheran Church. I have not been able to verify Hoffmann's contention. The question of relations among the various German communities in Palestine during the interwar period needs further research.

53. Hoffmann letter, May 8, 1975.

54. PA: Pol.Abt.III, Politik 2—Palästina, Bd.2, DGK/Jerusalem an AA/Berlin, 17/34, 9.Mär.1934, and AA/Berlin an AO/NSDAP, 963, 22.Mär.1934.

55. BA: R/43–II: 1421a, DGK/Jerusalem an AA/Berlin, 25/37, 4.Jun.1937.

56. PA: Inland II A/B, 83–20, Bd.1, Promi/Berlin an AA/Berlin, VII/7074/3.III.34, 15.Mai 1934. The AO prevailed upon the Propaganda Ministry to provide some material so that Germans in Palestine would have something to offset their exposure to the Jewish press in Palestine.

57. YV: NSDAP/Landesgruppe-Palästina, 1934–1939.

58. YV: NSDAP/Landesgruppe-Palästina, 1934–1939, Schwarz/Jaffa an die Leitung der AO der NSDAP, 3.Mär.1937.

59. PA: Pol.Abt.III, Politik 26—Palästina, Bd.1, DB/London an AA/Berlin, 6.Jun.1934.

60. PRO: FO371/17878–E4468, Police Summary no.9/34, June 15, 1934.

61. YV: NSDAP/Landesgruppe-Palästina, 1934–1939, Wagner/Haifa an Schwarz/Jaffa, 31.Jan.1937.

62. There is a great deal of literature that provides ample coverage of the Arab revolt from 1936 to 1939. It includes Esco Foundation for Palestine Inc., *Palestine: A Study of Jewish, Arab and British Policies*, vol. 2, chaps. 11 and 12; J. C. Hurewitz, *The Struggle for Palestine*, pp. 67ff.; John Marlowe, *The Seat of Pilate: An Account of the Palestine Mandate*, p. 138; Sykes, *Crossroads*, pp. 148ff.

63. Marlowe, *Pilate*, p. 138.

64. An Arab delegation, headed by the Mufti and consisting of leaders of various Arab political parties, formally asked the British high commissioner to forward to London the following demands: a democratic government with a sovereign Parliament and an Arab majority; a ban on land sales to Jews; an immediate cessation of Jewish immigration (see Marlowe, *Pilate*, pp. 134–135; Hurewitz, *Struggle*, pp. 67–70; Sykes, *Crossroads*, p. 144).

65. This was the assessment of Consul-General Döhle in June, 1936 (see PA: Pol.Abt.VII, Politik 5—Palästina, Bd.1, DGK/Jerusalem an AA/Berlin, Nr.Polit. 26/36, 30.Jun.1936). See also Norman Anthony Rose, "The Arab Rulers and Palestine, 1936: The British Reaction," *Journal of Modern History* 44 (1972), 217; Howard Sachar, *Europe Leaves the Middle East, 1936–1954*, p. 67.

66. See appendix 7. These figures do not include Jewish immigrants who entered Palestine illegally during the 1930s. It is estimated that some 10,000 entered illegally each year (see Sachar, *Europe*, p. 69; Esco Foundation, *Palestine*, vol. 2, pp. 680–684). According to the Jabotinsky Institute in Tel Aviv, the various organizations of the Revisionist Zionist movement were responsible for bringing into Palestine 72 illegal immigrants in 1937, 3,524 in 1938, 14,476 in 1939 and 3,609 in 1940. This information was given to me in a letter, no. 469, of September 28, 1976.

67. Marlowe, *Pilate*, p. 130.

68. See Esco Foundation, *Palestine*, vol. 2, p. 665; David Horowitz and Rita Hendon, *Economic Survey of Palestine, with Special Reference to the Years 1936–1937*, p. 33; Sachar, *Europe*, p. 32; Sykes, *Crossroads*, p. 163. The Arab population of Palestine (Muslim, Christian, Druze) grew from about 660,000 in 1922 to almost 1.3 million in 1946, when the Jewish population reached some 608,000.

69. Rose, "Arab Rulers," p. 217. The Peel Commission estimated that with an annual Jewish immigration of 30,000, the Jewish population would surpass the Arab population by the year 1960. With an annual immigration of 60,000, a Jewish majority would be realized by 1947 (see Great Britain, *Palestine Royal Commission Report*, Cmd. 5479, p. 208).

70. See Hurewitz, *Struggle*, p. 67; Sykes, *Crossroads*, pp. 139–141.

71. PRO: FO371/20020–E3048, British Embassy/Berlin to Foreign Office/London, Telegramme No. 127, May 27, 1936.

72. *Völkischer Beobachter*, 4.Jun.1936. Phipps commented favorably on this article in a note to Anthony Eden (see PRO: FO371/20020–E3327, Phipps/Berlin to Eden/London, June 4, 1936). An article in *Der Angriff* in October of that year reasoned that Jewish immigration and the resulting dis-

placement of Arabs were the cause of Arab violence. Phipps commented that this argument was essentially correct (see PRO: FO371/20028–E6609, Phipps/Berlin to Eden/London, October 15, 1936).

73. PA: Pol.Abt.II, Politik 3—England, Bd.1, DG/Bagdad an AA/Berlin, Nr.3121, 17.Dez.1936. See also PA: Botschaft Rom, Politik 3—Palästina, DG/Bagdad an AA/Berlin, Nr.1335, 30.Mai 1936; PA: Pol.Abt.VII, Politik 5—Palästina, Bd.1, DG/Bagdad an AA/Berlin, Nr.1671, 30.Jun.1936.

74. PA: Pol.Abt.VII, Politik 2—Palästina, Bd.1, DG/Bagdad an AA/Berlin, Pol.VII 116–37, 5.Jan.1937.

75. Grobba was personally very sympathetic toward the Arab cause in Palestine and throughout the Middle East, but strictly adhered to the German policy of nonintervention throughout 1936 and 1937 as the only means of ensuring friendly relations with Great Britain in the Middle East (Grobba, *Männer*, p. 106). His sympathy for the Arabs stemmed from his academic and professional interests and experiences rather than from any anti-Jewish inclinations.

76. PA: Pol.Abt.VII, Politik 2—Palästina, Bd.1, AA/Berlin an DG/Bagdad, zu Pol.VII 116, Telegramm, 5.Jan.1937.

77. PRO: FO371/20021–E4329, Report of the Deputy Inspector-General in Palestine, June 8, 1936. For more details on Egyptian involvement and support, see James Jankowski, "Egyptian Responses to the Palestine Problem in the Interwar Period," *International Journal of Middle East Studies* 12 (1980), 12ff.

78. PA: Pol.Abt.VII, Politik 5—Palästina, Bd.1, DGK/Jerusalem an AA/Berlin, Nr.Polit. 34/36, 12.Jul.1936.

79. PA: Pol.Abt.VII, Politik 5—Irak, Bd.1, DG/Bagdad an AA/Berlin, Nr.2569, 3.Okt.1936. Grobba also reported that some of the cargo had been unloaded in Syria before the final discharge at a Saudi port on the Red Sea and that those weapons had also made their way to Palestine.

80. PA: Pol.Abt.II, Politik 3—England, Bd.1, DB/London an AA/Berlin, A.2539, 22.Jun.1936. This debate on Palestine is published in its entirety in Great Britain, *Parliamentary Debates* (5th series, Commons), 313 (1936), pp. 1310–1395.

81. PA: Pol.Abt.VII, Politik 5—Palästina, Bd.1, DGK/Jerusalem an AA/Berlin, Nr.Polit. 26/36, 30.Jun.1936. The late Dr. Fritz Grobba told me on June 30, 1973, that the Soviet Union was a major source of arms for the Palestinian Arabs between 1936 and 1939.

82. PA: Pol.Abt.VII, Politik 5—Palästina, Bd.1, Pol.VII 153/37, 6.Feb. 1937. It is possible that the author of this report was Dr. Reichert of the DNB in Jerusalem, who seems to have been everyone's secret agent in Palestine. On February 17, 1937, Döhle noted his suspicions and those of British authorities in Palestine that the USSR had been providing money and arms to Arab rebels (see PA: Pol.Abt.VII, Politik 5—Palästina, Bd.1, DGK/Jerusalem an AA/Berlin, Nr.Polit. 6/37, 17.Feb.1937).

83. PRO: FO371/20022–E4858, Colonial Office/London, July 28, 1936.

84. Muggeridge, *Ciano's Diplomatic Papers*, pp. 49, 51.

85. PA: Pol.Abt.VII, Politik 5—Palästina, Bd.1, DG/Bagdad an AA/Berlin, Nr.3121, 17.Dez.1936. Italy had always been held in low regard in the Arab world, where public opinion had been aroused by the harshness of Italian colonial rule in Libya and fears of Italian colonial ambitions in the eastern Mediterranean (see Hirszowicz, *Third Reich*, p. 14).

86. Seth Arsenian, "Wartime Propaganda in the Middle East," *Middle East Journal* 2 (1948), 419ff. See also Avon, *Eden Memoirs*, pp. 431, 448–449, 474–475; Hirszowicz, *Third Reich*, p. 15.

87. PA: Botschaft Rom (Quir)—Geheim Akten, 44/1: Vorschläge des Grossmuftis betr. Syrien, Palästina u. Transjordanien, DB/Rom an AA/Berlin, Telegramm Nr.1677, 14.Sept.1940. By 1938, French intelligence in Beirut was aware of Italian financial support for the Arab insurgents in Palestine (see PRO: FO371/21887–E3046, British Embassy/Rome to FO/London, May 21, 1938).

88. ADAP: D, VI, Nr.211. In early 1938, the British secretary of state for colonies told the Parliament in London that most of the arms captured from insurgents in Palestine had reached the country via Syria (see PRO: FO371/21874–E1598).

89. PA: HaPol Abt.—Kriegsgerät (Geheim), Handel mit Kriegsgerät—Allgemeines, Bd.1, from *Reichsgesetzblatt*, Teil I, 1927, vom 27.Jul.1927, p. 239.

90. PA: Pol.Abt.I, Handel für Pol.I, Waffenhandel und Waffenherstellung, "Gesetz über Aus- und Einfuhr von Kriegsgerät vom 6.XI.35," signed by Hitler, Blomberg, Bülow and Schacht, from *Reichsgesetzblatt*, Teil I, 1935, Nr.126 vom 15.Nov.1935, p. 1337. This law nullified the law of 1927.

91. The Reichskommissar für Aus- und Einfuhrbewilligung was responsible for regulating arms exports (see PA: Pol.Abt.I, Handel für Pol.I, Waffenhandel und Waffenherstellung, "Deutscher Reichsanzeiger und Preussischer Staatsanzeiger," Nr.270, 18.Nov.1935).

92. See appendix 13.

93. Yemen, and to some extent Saudi Arabia, had a degree of independence from Britain and France not shared by other Arab states. While British influence remained strong in Saudi Arabia, Yemen was the only Arab state able to break away from the general pattern of British domination. In 1926, Yemen signed a treaty of friendship with Italy, which was renewed in 1937. Because of the relative absence of British influence in Yemen, Italian influence there was not insignificant. Thus, Italy and to a lesser extent Germany were able to sell weapons there in appreciable quantities (see Hirszowicz, *Third Reich*, pp. 10, 14).

94. This view is generally accepted by Melka, Hirszowicz, Yisraeli and Josef Schröder. Even Tillmann admits that such tendencies did not begin until the summer of 1937 (Tillmann, *Araberpolitik*, pp. 60–61). Both the late Drs. Grobba and von Hentig gave the same views in conversations with me at Bad Godesberg on June 30, 1973, and at Seibersbach on November 27, 1974, respectively.

95. TG: *Die Warte des Tempels*, 30.Jun.1936.

96. Hentig, "Palästina," p. 118. See also Schmidt, "Nazi Party," p. 467.

97. PA: Pol.Abt.VII, Politik 2—Palästina, Bd.1, DGK/Jerusalem an AA/ Berlin, Nr.Polit. 27/36, 7.Jul.1936.

98. See ISA: 67/1383, DGK/Jerusalem an Bürgermeister Ernst Blaich/ Betlehem, Nr.Templr. 24/36, 27.Mai 1936, NSDAP-Ortsgruppe/Haifa an DGK/Jerusalem, 9.Jun.1936, NSDAP-Ortsgruppe/Haifa an DGK/Jerusalem, 10.Jun.1936, DGK/Jerusalem an Herrn Bürgermeister Blaich/Betlehem, Nr. 3/36, 12.Jun.1936, and Tempelgemeinde/Betlehem an DGK/Jerusalem, 14.Jun.1936. See also Schmidt, "Nazi Party," pp. 467–468.

99. ISA: 67/1383, Inspector-General, Palestine Police to the German Consulate-General/Jerusalem, p. 6/127/5, May 25, 1936.

100. See ISA: 67/1383, DGK/Jerusalem an Konsul Wurst/Jaffa, Nr. Templr. 27/36, 15.Jun.1936.

101. See PA: Pol.Abt.VII, Politik 5—Palästina, Bd.1, DGK/Jerusalem an AA/Berlin, Nr.Secr. 1/36, 4.Jul.1936.

### 7. The Peel Partition Plan and the Question of a Jewish State

1. The Commission was composed of the following members: Lord Peel (chairman), conservative politician and former secretary for Indian affairs; Sir Horace Rumbold, diplomat, former ambassador to Germany; Sir Lucas Hammond, former provincial governor in India; Sir William Morris Carter, former judge on the Kenya Supreme Court; Sir Harold Morris, former presiding justice, Court of Industrial Disputes; and Professor Sir Reginald Coupland of All Souls College, Oxford, historian and colonial administration expert.

2. Great Britain, *Commission Report*, Cmd. 5479, p. ix.

3. A complete account of the Jewish and Arab cases presented to the Royal Commission can be found in Esco Foundation, *Palestine*, vol. 2, pp. 799–818.

4. Great Britain, *Commission Report*, Cmd. 5479, p. 77.

5. Ibid., pp. 78–80, 271–272.

6. Ibid., pp. 272–274.

7. Ibid., pp. 280–281.

8. Esco Foundation, *Palestine*, vol. 2, pp. 852–861. See also Marlowe, *Pilate*, pp. 144ff.; Sykes, *Crossroads*, pp. 170ff.

9. PA: Pol.Abt.VII, Politik 5a—Palästina, Bd.1, DGK/Jerusalem an AA/Berlin, Nr.Pol. 38/37, 13.Jul.1937.

10. See Marlowe, *Pilate*, p. 150; Sykes, *Crossroads*, p. 177.

11. See Esco Foundation, *Palestine*, vol. 2, pp. 861–874; Marlowe, *Pilate*, p. 150.

12. BA: R/18–5514, Vermerk über die Besprechung am 29.Sept.1936 (author unknown). The Interior Ministry still claimed primary authority in all matters relating to Jewish policy. According to a circular issued by State Secretary Pfundtner of the Interior Ministry on December 7, 1936, Hitler himself had accorded the Ministry of the Interior primary authority in the formulation of Jewish policy (see Adam, *Judenpolitik*, pp. 158–159).

13. PA: Inland II A/B, 83–21*a*, Bd.1*a*, Aufzeichnung des Referat Deutschlands (Hinrichs) vom 9.Jan.1937.

14. PA: Büro des Chefs der AO, Judenstaat Palästina, Aufzeichnung des Referat-D (Bülow-Schwante) vom 27.Apr.1937. Throughout the ensuing debate over a Jewish state in 1937–1938, government and Party agencies and officials did not fall back on old theories about the inability of Jews, for racial and historical reasons, to build their own state.

15. PA: Inland II A/B, 83–21*a*, Bd.1*a*, RIM an AA, IB3 25978/15042, 16.Jan.1937.

16. PA: Inland II A/B, 83–21*a*, Bd.1*a*, AA an RIM, zu 83–21*a*, A.16/1, 21.Jan.1937.

17. PA: Inland II A/B, 83–21*a*, Bd.1*a*, Aufzeichnung Pol.VII vom 22.Jan.1937.

18. PA: Pol.Abt.VII, Politik 5—Palästina, Bd.1, DGK/Jerusalem an AA/Berlin, Nr.Polit. 2/37, 25.Jan.1937.

19. PA: Büro des Reichsaussenministers—Palästina, DGK/Jerusalem an AA/Berlin, Nr.Polit. 16/37, "Prüfung der Frage, ob unsere Palästina gegenüber bisher verfolgte Richtlinie beibehalten werden kann oder ob sie eine Änderung erfahren muss," 22.Mär.1937.

20. PA: Inland II A/B, 83–21*a*, Bd.1*a*, Ref.D an RAM, zu 83–21*a* 16/1, 17.Feb.1937.

21. PA: Inland II A/B, 83–21*a*, Bd.1*a*, Ref.D an Promi, 83–21*a* 16/3, 30.Mär.1937.

22. PA: Pol.Abt.II, Politik 3—England, Bd.2, DG/Bagdad an AA/Berlin, Nr.799, 8.Apr.1937.

23. For the text of the *Führer-Erlass* (Führer's Decree) of January 30, 1937, incorporating the Auslandsorganisation into the Foreign Office, see *Reichsgesetzblatt*, Teil I, 1937, Nr.18, pp. 187–188. See also PA: Inland II A/B, 82–00*c*, Bd.1, RAM an alle Missionen und Berufskonsulate, Nr.Pers. M694, 26.Feb.1937; Jacobsen, *Nationalsozialistische Aussenpolitik*, pp. 132ff.

24. ADAP: D, V, Nr.562.

25. PA: Inland II A/B, 83–21*a*, Bd.1*a*, Aufzeichnung Pol.VII (Pilger) zu 83–21*a* K/4, 8.Mai 1937. See also PA: Büro des St.S, Irak: Aufzeichnung von Ref.D (Bülow-Schwante), zu 83–21*a* 4/6, 11.Jun.1937; PA: Büro des Chefs der AO, Judenstaat Palästina, Aufzeichnung von Fischer, 8.Mai 1937.

26. PA: Inland II A/B, 83–21*a*, Bd.1*a*, Aufzeichnung von W III (HaPol Abt.—Clodius) an Ref.D, zu 83–21*a* 16/4, 11.Jun.1937.

27. PA: Büro des Chefs der AO, Judenstaat Palästina, Aufzeichnung des Referat-D (Bülow-Schwante) vom 27.Apr.1937.

28. Ibid. See also PA: Inland II A/B, 83–21*a*, Bd.1*a*, Aufzeichnung des Referat-D, zu 83–21*a* 25/5, 25.Mai 1937.

29. PA: Inland II A/B, 83–21*a*, Bd.1*a*, Aufzeichnung des Referat-D, zu 83–21*a* 25/5, 25.Mai 1937. See also PA: Inland II A/B, 83–21*a*, Bd.1*a*, Aufzeichnung des Referat-D, zu 83–21*a* 20/5, 26.Mai 1937.

30. See Adam, *Judenpolitik*, pp. 157–158. The formulation of Jewish

policy remained for the most part in the hands of the responsible government ministries through 1937 and most of 1938. SD positions on Palestine and the question of a Jewish state merely reflect the decisions taken by government ministries. Both the SD and Rosenberg's APA made cooperative efforts in the summer and autumn of 1937 to overcome their virtual exclusion from the decision-making process and to play a greater role in the debate on emigration policies and Palestine. This matter is dealt with in greater detail below. See NA: T–175/R588, 000521: II/112 an II/1, 10.Aug.1937.

31. ADAP: D, V, Nr.561.

32. Dr. Eduard Selzam of the German Embassy in London called on Anthony Eden on June 8 and informed him of Germany's concern over the possible establishment of a Jewish state in Palestine. Selzam tried to get advance information from Eden on the contents of the Peel Commission report which was due to be published shortly. Eden told him that the British Foreign Office was unaware of what the report would contain. This was not true, however, as King Ibn-Saud of Saudi Arabia and Dr. Chaim Weizmann of the Zionist Organization had already been informed by the British Foreign Office as to what the Commission recommendations would be (see PRO: FO371/20807–E3171, FO Memorandum, June 8, 1937; PRO: FO371/20806–E2435, FO Memorandum, May, 1937).

33. ADAP: D, V, Nr.564.

34. Ibid., Nr.567, and n. 1.

35. Ibid., Nr.566.

36. Ibid., p. 638, n. 2.

37. Ibid., p. 638, n. 5. Werner-Otto von Hentig replaced Hans Pilger as head of Politische Abteilung VII in late July, 1937.

38. ADAP: D, V, Nr.571. The memorandum was circulated in the Politische Abteilung.

39. Ibid., p. 644, n. 1.

40. Ibid., Nr.570.

41. See issues of the *Völkischer Beobachter* for the summer and autumn of 1937. See also PRO: FO371/21884–E6725.

42. See Aigner, *Das Ringen*, pp. 310–317.

43. ADAP: D, V, Nr.572.

44. Ibid., Nr.573.

45. See PA: Pol.Abt.I—Völkerbund, Mandate: Tätigkeit der Mandatskommission, DK/Genf an AA/Berlin, Telegramm Nr.114/6, 6.Okt.1936; Mandate: Allgemeines, Bd.1, DK/Genf an AA/Berlin, Nr.1940, 10.Nov.1936; Länderakten, Palästina, Bd.1, DK/Genf an AA/Berlin, Nr.1334, 11.Okt. 1937; Inland II A/B, 83–26 Polen, DB/Warschau an AA/Berlin, P I 11a/1.37, 22.Jan.1937. See also PRO: FO371/20605–E1601, FO Memorandum, March 20, 1937; FO371/20806–E2435, FO Memorandum, May, 1937. For more information, see Waclaw Jedrzejewicz, ed., *Diplomat in Berlin, 1933–1939: Papers and Memoirs of Josef Lipski, Ambassador of Poland*, p. 411; *Jüdische Rundschau* (letter of Polish Foreign Minister Beck to Leib Jaffe, director of the Keren Hajessod), 17.Dez.1935.

46. PA: Pol.Abt.V, Politik 1—Allgemeine auswärtige Politik Polens, Bd.1, DB/London an AA/Berlin, A.4042, 14.Okt.1936, and Exposé des Ministers Beck im Auswärtigen Ausschuss des Senats am 18.Dez.1936, Pol.V 6600/36.

47. Taras Hunczak, "Polish Colonial Ambitions in the Inter-War Period," *Slavic Review* 26 (1967), 648–656. See also PA: Büro des Reichsaussenministers—Polen, Bd.1, Aufzeichnung des Auswärtigen Amts (author unknown), 12.Sept.1936; Pol.Abt.II, Politik 3—Frankreich-Polen, Bd.2, DK/Genf an AA/Berlin, Telegramm Nr.92, 26.Sept.1936, and Aufzeichnung Papens, Pol.II 3306, 12.Dez.1937.

48. Philip Friedman, "The Lublin Reservation and the Madagascar Plan: Two Aspects of Nazi Jewish Policy during the World War," *Yivo Annual of Jewish Social Studies* 8 (1953), 165–166.

49. PA: Pol.Abt.V, Politik 36: Judenfrage in Polen, "Die Frage der Teilung in polnischem Licht," DNB-Bericht, 5.Jul.1937.

50. PA: Gesandtschaft Bukarest, I A 3 (Fach 37), Bd.1, DG/Bukarest an AA/Berlin, Tgb.Nr.1946/37 (XE–13), 28.Jul.1937.

51. PRO: FO371/20812–E5138, British Embassy/Bucharest to FO/London, August 27, 1937.

52. In an interview on November 27, 1974, at Seibersbach, Dr. von Hentig told me that the Foreign Office in Berlin had approved of Polish and Rumanian support of Zionist emigration to Palestine up to 1937 and refrained from applying pressure on them in 1937 and thereafter to end that support.

53. PA: Gesandtschaft Bukarest I A 3 (Fach 37), Bd.1, DG/Bukarest an AA/Berlin, Tgb.Nr. 1946/37 (XE–13), 28.Jul.1937.

54. ADAP: D, V, Nr.572.

55. PA: Inland II A/B, 83–21*a*, Bd.1*a*, AA an RIM, 83–21*a* 17/8, 17.Aug.1937.

56. PA: Pol.Abt.VII, Politik 5*a*–Palästina, Bd.1, Ref.D an Pol.VII, 19.Aug.1937.

57. Hentig again took this position in his memorandum of August 21. See PA: Pol.Abt.VII, Politik 5*a*—Palästina, Bd.1, Aufzeichnung zu Pol.VII 910, 21.Aug.1937.

58. PA: Pol.Abt.VII, Politik 5*a*—Palästina, Bd.1, Ref.D an Pol.VII, 24.Aug.1937.

59. Hentig told me that no such moves were ever made. He was probably right in asserting that no amount of pressure could have dissuaded Poland and Rumania from promoting large-scale Jewish emigration to Palestine. So committed was the Polish government to supporting the Zionist option in its own Jewish policy that it maintained better relations with Jabotinsky's Revisionist Zionists, who claimed all of Palestine and more for the immediate establishment of an independent Jewish state, than with the Majority Zionists, who, with reservations and reluctance, accepted the concept of partition. According to former Polish Ambassador Lipski, Poland provided the militant Irgun Tsevai Leumi, the outlawed military branch of the Revisionist Zionist movement in Palestine, with military training and

equipment in Poland (see Jedrzejewicz, *Diplomat*, p. 412; see also Nicholas Bethell, *The Palestine Triangle*, pp. 41–42).

60. See appendix 7. See also BA: R/57–25, Reichsstelle für das Auswanderungswesen, "Bericht des Assessors Dr. Wilmanns über seine Reise nach Palästina," G.Z. B2400, 10.Jun.1937.

61. ADAP: D, V, Nr.562. This memorandum was taken from a position paper compiled by the Aussenhandelsamt der AO, and forwarded to Ernst Bohle, chief of the AO, in late May (see PA: Büro des Chefs der AO, Judenstaat Palästina, Aussenhandelsamt Buch Nr. 81445, 26.Mai 1937).

62. PA: Pol.Abt.III—Wirtschaft, Palästina, Handel 11, Nr.1: DGK/Jerusalem an AA/Berlin, Nr.Temp. 1/36, 15.Jan.1936.

63. See ISA: 67/1253, DGK/Jerusalem an Reichsstelle für Devisenbewirtschaftung, 15.Aug.1936, DGK/Jerusalem an AA/Berlin, Nr.Haav. 23/36 11.Aug.1936, and DGK/Jerusalem an AA/Berlin, Nr.Wirtber. 3/36, 22.Sept.1936. See also ISA: 67/1272, Deutsche Orient-Verein e.V. an DGK/Jerusalem, 17.Nov.1936.

64. ISA: 67/1253, Arab Chamber of Commerce/Jerusalem to the German Consulate-General, September 16, 1936.

65. ISA: 67/1251, German Consulate-General to the Arab Chamber of Commerce/Jerusalem, Nr.Arabco. 16/36, November 28, 1936.

66. See PA: Pol.Abt.III—Wirtschaft, Palästina, Handel 11, Nr.1: DGK/Jerusalem an AA/Berlin, Nr.Temp. 1/36, 15.Jan.1936. See also Hentig, "Palästina," p. 111; Feilchenfeld et al., *Haavara-Transfer*, pp. 51–53.

In his letter to me on April 16, 1975, Dr. Richard Otto Hoffmann noted that the AO was anti-Haavara because the pact had been negotiated by government ministries in Berlin, without Party participation. He also noted that the Palästinadeutsche were fearful that the Arabs would take action against them because Haavara might be viewed as a joint German-Jewish scheme to bring Jewish immigrants into the country. However, Consul-General Döhle insisted that the main problem for the German colonists was economic. German exports were usually subsidized in order to make them competitive with the generally cheaper exports of other industrialized countries. Since exports to Palestine via Haavara did not earn their full value in foreign currency or an equivalent in raw materials, the government subsidy was not applied to those exports. Instead, German goods entering Palestine through Haavara were subsidized by Haavara Ltd. in order to make them competitive with goods from other countries. Thus, buying German goods outside of the Haavara system meant paying a higher price because they were subsidized by no one.

67. PA: Pol.Abt.III—Wirtschaft, Palästina, Handel 11, Nr.1: Aufzeichnung des Auswärtigen Amts, zu III o 392/36, Februar 1936, and Besprechung im AA zwischen Legationssekretär Rahn, Generalkonsul Döhle, Reichsbankrat Utermöhle, und Assessor Dr. Wilmanns, und Feilchenfeld, Moses und Beermann von Haavara, zu III o 1686/36, 3.Apr.1936.

68. PA: Pol.Abt.III—Wirtschaft, Palästina, Handel 11, Nr.1: Aussenhandelsamt der AO der NSDAP an die Reichsstelle für Devisenbewirtschaftung, Buch-Nr.42, 675.Schw./G., 6.Apr.1936.

69. ISA: 67/1272, Reichsstelle für Devisenbewirtschaftung an AA/Berlin, Dev.A4/58430/36, 21.Nov.1936.

70. See ADAP: D, V, Nr.562.

71. YV: NSDAP/Landesgruppe-Palästina, 1934–1939, R 3/1–1: NSDAP/Landesgruppe-Palästina an AO-NSDAP/Berlin, 25.Apr.1937.

72. PA: Pol.Abt.VII, Politik 2—Palästina, Bd.1, Bericht des Assessors Wilmanns, Pol.VII 483/37 (no date). According to a note of section II/112 of the Sicherheitsdienst, this report had been issued on May 11 (see BA: R/58: 1239, Aktennotiz betr. Assessor Wilmanns, 11.Mai 1937). Two other reports by Wilmanns regarding his stay in Palestine were filed that same month (see BA: R/57–25, Reichsstelle für das Auswanderungswesen, G.Z. B2400, 10.Jun.1937).

73. PA: Pol.Abt.VII, Politik 5a—Palästina, Bd.1, Aufzeichnung von Pol. VII, zu Pol.VII 910, 21.Aug.1937.

74. PA: Pol.Abt.VII, Politik 2—Palästina, Bd.1, Aufzeichnung von Pol. VII (no date). Most of this was repeated to me by Dr. von Hentig himself at Seibersbach on September 14, 1973, and November 27, 1974. See also Werner-Otto von Hentig, *Mein Leben, Eine Dienstreise*, p. 339.

Hentig's position was conditioned by his personal antipathy to the National Socialist regime. He was repulsed by the anti-Semitic philosophy and policies of the regime. His support for Zionist efforts and for the Haavara idea was not motivated by the anti-Semitic desire to remove Jews from Germany, which had been the basis of German policy before 1937; rather, his efforts were the result of his personal sympathy for the plight of German Jewry and for Zionist efforts to rescue German Jews from a deteriorating situation. All of this has been verified by the late Dr. Ernst Marcus, a former Zionist official in Germany and friend of the late Dr. von Hentig, as well as by Dr. Werner Feilchenfeld, formerly of Haavara Ltd. See Marcus, "German Foreign Office," pp. 191–192, 204; Feilchenfeld et al., *Haavara-Transfer*, pp. 30–31. Dr. Feilchenfeld also attested to Hentig's strong support for Haavara in a letter to me of April 17, 1974.

75. PA: Pol.Abt.VII, Politik 2—Palästina, Bd.1, Aufzeichnung von Pol.VII über die Besprechung betr. Haavara am 29.Jul.1937, zu WIII SE 7115, 3.Aug.1937.

76. PA: Pol.Abt.VII, Politik 2—Palästina, Bd.1, Schnellbrief des Auswärtigen Amts, Nr. WIII SE 7115 (no date).

77. PA: HaPol Abt., Handakten Clodius—Palästina, Aufzeichnung über die Besprechung am 21.Sept.1937 betr. Haavara, zu WIII SE 766/37, 25.Sept.1937.

78. Ibid.

79. Ibid.

80. PA: Büro des Chefs der AO, Judenstaat Palästina, Aufzeichnung über die Ressortbesprechungen betr. Haavara im AA und RWM am 21.Sept. und 22.Sept.1937, 23.Sept.1937.

81. Goods requiring large amounts of imported raw materials in the production process were made available for export only in return for foreign currency. Since German exports to Palestine via Haavara were compensated

for the most part by Jewish assets in Germany, many German products were excluded from the Palestine market (see Feilchenfeld et al., *Haavara-Transfer*, pp. 51–52). Wilmanns suggested that more of these goods be made available to German importers in Palestine.

82. PA: Büro des Chefs der AO, Judenstaat Palästina, Aufzeichnung über die Ressortbesprechungen betr. Haavara im AA und RWM am 21.Sept. und 22.Sept.1937, 23.Sept.1937. Döhle and the AO had been joined in their campaign for the revision of Haavara by Göring in his capacity as Beauftragter für den Vierjahresplan. However, representatives from his office did not attend the September meetings on Haavara. See PA: Büro des Chefs der AO, Judenstaat Palästina, Ministerpräsident Generaloberst Göring, Beauftragter für den Vierjahresplan, Gruppe für Aussenhandelsgeschäfte/Berlin an das Aussenhandelsamt der AO, 20.Sept.1937.

83. See appendix 7. The Peel Commission Report had recommended a limit of 12,000 Jewish immigrants per year, and the British high commissioner in Palestine began to follow that limit strictly in August, 1937. For the period between August 1, 1937, and March 31, 1938, 1,000 Jewish immigrants per month were allowed to enter Palestine legally (see PA: Inland II A/B, 83–24*a*, Bd.1, DGK/Jerusalem an AA/Berlin, Nr.492/38, 5.Jul.1938).

84. BA: R/18–5514, RIM an Stellvertreter d. Führers, AA, RWM und SD, IB 191*g*/5012*d*, 7.Okt.1937.

85. BA: R/18–5514, RIM an RWM, Nr. IB 191 IV*g*/5012*d*, 14.Okt.1937.

86. IfZ: F71/4–9 (Lösener Handakten), Vermerk über die Besprechung am 18.Okt.1937, Nr. IB 191 VI/5012*dg*, 28.Okt.1937. In a July 13 memorandum, the Reichsstelle für das Auswanderungswesen had already expressed its alarm over declining Jewish emigration from Germany to Palestine. The reasons cited for the decline were Arab unrest, future political uncertainty in Palestine and growing difficulties in the Haavara system (see PA: Inland II A/B, 83–21*a*, Bd.1, Aufzeichnung der Reichsstelle für das Auswanderungswesen, C.Z.A. 1002/8.7.37, 13.Jul.1937).

87. IfZ: F71/4–9 (Lösener Handakten), Vermerk über die Besprechung am 18.Okt.1937, Nr. IB 191 VI/5012*dg*, 28.Okt.1937.

88. Ibid.

89. PA: Büro des Chefs der AO, Judenstaat Palästina, Aufzeichnung der AO, "Förderung der Auswanderung von Juden nach Palästina, Haavara," 27.Okt.1937.

90. IfZ: F71/4–9 (Lösener Handakten), Schnellbrief, RWM an AA zur Kenntnis an: Stell.Vert. d. Führ., Beauftragter für den Vierjahresplan, AO der NSDAP, Reichsbank-Direktorium, und RIM, VI (bev) 769/37, 29.Okt.1937.

91. ADAP: D, V, Nr.575 (Anlage).

92. PA: Pol.Abt.VII, Politik 2—Palästina, Bd.1, Aufzeichnung von Pol.VII (Hentig), Pol.VII–92 (no date).

93. See ADAP: D, V, Nr.579, and p. 661, n. 1; PA: Büro des U.St.S, Palästina-Frage: Weizsäcker an Pol.VII, zu 83–24 Ag 13/1, 19.Jan.1938; PA: Pol.Abt.VII, Politik 5*a*—Palästina, Bd.3, DGK/Jerusalem an AA/Berlin, Nr.Pol. 96/37, 29.Dez.1937.

94. BA: R/57–25, Aufzeichnung der Reichsstelle für das Auswanderungswesen, G.Z. C2120/1.12.37, 14.Dez.1937.

95. ADAP: D, V, Nr.579.

96. PA: Pol.Abt.VII, Politik 2—Palästina, Bd.1, Aufzeichnung Weizsäckers an das Aussenpolitisches Amt, Pol.VII–92, Januar 1938.

97. GStA: Rep. 335/11/481, NG 3580 (Office of the Chief Counsel for War Crimes). This document is also available in PA: Inland II A/B, 83–24a, Bd.1, Aussenhandelsamt der AO der NSDAP an den Leiter der AO im Auswärtigen Amt, Ag. 13/1, 1.Feb.1938.

98. Marcus, "German Foreign Office," p. 193.

99. *Transcript of the Trial in the Case of the Attorney General of the Government of Israel v. Adolf, the Son of Karl Adolf Eichmann, in the District Court of Jerusalem.* Criminal Case No. 40/61, card No. 16, 15th session, April 25, 1961.

100. Feilchenfeld et al., *Haavara-Transfer,* p. 32.

101. LBI/N.Y.: Weltsch Papers, "Vertrauliche Bericht über das Ergebnis der Berliner Besprechungen vom 2. bis 9.Juli 1939," Dr. W. Feilchenfeld/Budapest, 11.Jul.1939.

102. BA: Schumacher Collection 240/II, Geheime Staatspolizei/Staatspolizeistelle Würzburg, B Nr. 1130/38 IIB, 28.Feb.1938; PA: Inland II A/B, 83–24a, Bd.2, Geheime Staatspolizei an AA/Berlin, Nr. IIB 3–F.455, 29.Mär.1938.

103. PA: Inland II A/B, 83–24a, Bd.2, ZVfD/Berlin an AA/Berlin, 21.Feb.1938.

104. PA: Inland II A/B, 83–24a, Bd.1, Ministerium für Innere und Kulturelle Angelegenheiten (Wanderungsamt) in Wien an AA/Berlin, 20.Jul.1938.

105. See PA: Inland II A/B, 83–24a, Bd.2, Geheimstaatspolizei/Berlin an AA/Berlin, II B3–F.455, 29.Mär.1938.

106. Hildegard von Kotze, ed., *Heeresadjutant bei Hitler 1938–1943: Aufzeichnungen des Majors Engel,* p. 65. These remarks are taken from Engel's entry for October 8, 1939. In his entry for February 2, 1941, Engel again referred to Hitler's alleged offer to England to send German Jews to Palestine as laborers.

107. Letter from General Gerhard Engel to me, May 18, 1976.

108. It has not been possible to verify Engel's assertions. Evidence of such an offer to England and an English response has not been found either in the British Foreign Office records in London or in the German Foreign Office records in Bonn. It is possible that an offer was communicated through a Party agency or a Party official close to Hitler, although it seems likely that such an offer made under those circumstances would have turned up in the British records. Hitler was inclined to bypass his Foreign Office on occasion, as he did in the case of the Anglo-German Naval Pact in 1935. Yet neither the records of Ribbentrop's Dienststelle nor those of Rosenberg's Aussenpolitisches Amt contain any evidence that would verify Engel's claim. Nor do the Party and government records in Koblenz provide information that would in any way substantiate Engel's assertions. The late Dr. von Hen-

tig as well as Dr. Ernst Woermann, former undersecretary of state in the German Foreign Office, informed me that they never had knowledge of such an offer and that they would have been aware of it had such an offer been made through official channels (letters to me from Dr. Werner-Otto von Hentig, July 15, 1975, and from Dr. Ernst Woermann, March 17, 1976). Neither Schacht nor Henderson mentioned the offer in their respective memoirs.

109. Engel's reliability as a source is not beyond question. Many of his entries were made subsequent to their dates in the diary. Moreover, he claimed he no longer possessed his original notes. According to the Institut für Zeitgeschichte in Munich, Engel delivered a completed manuscript for publication. Nor did Engel explain the source of the information contained in his correspondence with me. Nevertheless, his claims cannot be easily dismissed, because they not only fail to contradict what we do know, but also provide a plausible augmentation of that knowledge. The late Dr. Albert Speer informed me that, with few exceptions, Engel's overall observations in his diaries appear to be accurate (letter to me from Albert Speer, February 24, 1976). Moreover, Dr. Werner Naumann, formerly of the Propaganda Ministry, also supported Engel's overall accuracy (letter from Dr. Werner Naumann to Mr. Richard Schulze-Kossens, Ribbentrop's SS-Adjutant, as forwarded to me, November 4, 1975).

110. While the number of Jewish immigrants into Palestine from Germany increased sharply in 1938 and 1939 after a steep decline in 1937, the amount of Jewish capital transferred to Palestine via Haavara decreased considerably during those two years (see appendices 7 and 8).

## 8. Continuation of the Zionist Option

1. Adam, *Judenpolitik*, pp. 159ff.

2. See Lucy Dawidowicz, *The War against the Jews, 1933–1945,* pp. 88ff.; Genschel, *Verdrängung*, pp. 140–141; Hildebrand, *Foreign Policy,* pp. 75–76; Andreas Hillgruber, "Die Endlösung und das deutsche Ostimperium als Kernstück des rassenideologischen Programms des Nationalsozialismus," *Vierteljahrshefte für Zeitgeschichte* 20 (1972), 133–153; Jacobsen, *Nationalsozialistische Aussenpolitik*, pp. 598–619; Gerald Reitlinger, *The Final Solution: The Attempt to Exterminate the Jews of Europe, 1939–1945*, p. 8; Thies, *Architekt*, pp. 10, 28–30.

3. ADAP: D, V, Nr.664. This circular was issued to all consular missions abroad.

4. Bernhard Lösener, "Als Rassereferent im Reichsministerium des Innern," *Vierteljahrshefte für Zeitgeschichte* 9 (1961), 281.

5. Treue, "Denkschrift," pp. 204–210.

6. ADAP: D, I, Nr.29.

7. Schacht had become distressed over Göring's increasing power and influence in economic affairs, a result of the latter's appointment as plenipotentiary for the Four-Year Plan in 1936. While Schacht was one of the driving forces behind German rearmament, he was alarmed at the strains it was placing on the economy. Moreover, he favored arms equality with the west-

ern powers, not a war against them. Hitler would neither remove Göring from economic affairs and rearmament, nor reduce the pace of rearmament (see Adam, *Judenpolitik*, p. 172; Genschel, *Verdrängung*, p. 141; Jacobsen, *Nationalsozialistische Aussenpolitik*, pp. 433–435).

8. For more on the controversy surrounding the removal of Blomberg, Fritsch and Neurath, see Alan Bullock, *Hitler: A Study in Tyranny*, pp. 413ff.; Domarus, *Hitler*, vol. 1/2, pp. 769–770; Peter Hoffmann, *Widerstand Staatsstreich Attentat: Der Kampf der Opposition gegen Hitler*, pp. 56–60; Jacobsen, *Nationalsozialistische Aussenpolitik*, p. 434.

9. Jacobsen, *Nationalsozialistische Aussenpolitik*, p. 434.

10. Horn, "Ein unbekannter Aufsatz," p. 281.

11. Phelps, "Parteiredner," Nr. 4, p. 300.

12. Hitler, *Secret Book*, pp. 45–47. See also Hillgruber, "Die Endlösung," pp. 135ff.

13. Domarus, *Hitler*, vol. 1/2, pp. 666–667.

14. Ibid., p. 839.

15. Hitler, *Mein Kampf*, chaps. 4, 5, 6, 7.

16. Domarus, *Hitler*, vol. 1/2, p. 805.

17. A complete list and description of the anti-Jewish legislation enacted between 1933 and 1935 can be found in BA: R/18–5515, Übersicht über die Gesetze und Verordnungen in denen Anforderungen an die Reinheit des Blutes gestellt werden, Nr. IA 2111/5015, 3.Jun.1936. See also Adam, *Judenpolitik*, chaps. 1, 2, 3; Dawidowicz, *War*, chap. 3.

18. See Adam, *Judenpolitik*, pp. 172ff.; Genschel, *Verdrängung*, pp. 139–142.

19. Werner Rosenstock, "Exodus 1933–1939: A Survey of Jewish Emigration from Germany," *Yearbook of the Leo Baeck Institute*, vol. 1, 1956, pp. 373–390. See also Wischnitzer, "Jewish Emigration," pp. 23–44; Genschel, *Verdrängung*, p. 136.

20. *Das Schwarze Korps*, 23.Nov.1938 and 24.Nov.1938.

21. Browning, *Final Solution*, pp. 11–12.

22. Dawidowicz, *War*, p. 82; Prinz, "Role," pp. 205ff.

23. Adam, *Judenpolitik*, p. 166.

24. Domarus, *Hitler*, vol. 1/2, p. 525.

25. Genschel, *Verdrängung*, pp. 139ff.

26. Ibid., pp. 136–137. See also Dawidowicz, *War*, pp. 95–96.

27. Genschel, *Verdrängung*, p. 136; Dawidowicz, *War*, p. 96.

28. Gottfried Feder, *Hitler's Official Program and Its Fundamental Ideas*, p. 39.

29. Phelps, "Hitlers grundlegende Rede," p. 415.

30. Adam, *Judenpolitik*, pp. 173–174.

31. See Genschel, *Verdrängung*, pp. 139–140.

32. Ibid.

33. Treue, "Denkschrift," p. 210. See also Genschel, *Verdrängung*, p. 141, n. 5.

34. The best and most comprehensive analysis of the elimination of

the Jews from the German economy can be found in Genschel, *Verdrängung*, chaps. 8, 9, 10, 11. See also Adam, *Judenpolitik*, chaps. 4, 5; Dawidowicz, *War*, pp. 95ff.

35. von Kotze, ed., *Heeresadjutant*, 13.Aug.1938, pp. 31–32.

36. BA: R/58–956, Aufzeichnung des SD (II/112), "Zum Judenproblem," Jan.1937. The report is unsigned, but the probable author is Eichmann. At his trial in Jerusalem in 1961, Eichmann referred to the growing efforts of II/112 in 1937 to centralize Jewish policy under the authority of the SS. See *Eichmann Trial*: card 87, Session 75, June 20, 1961. More evidence on the efforts of Eichmann and II/112 to centralize Jewish policy under the SS in 1937 can be found in NA: T–175/410, 2935004, 2934988–90, and T–175/280, 2774476–77; BA: R/58–1242, Vermerk von II/112–3 (Wisliceny and Hagen) an II/1, betr. Richtlinien und Forderungen an die Oberabschnitte, 21.Apr.1937.

37. The agencies of the SS consistently promoted Jewish emigration to Palestine throughout the 1930s. They do not appear to have been fearful that concentration in Palestine would inevitably lead to the establishment of a Jewish state or power base for the so-called Jewish conspiracy. The documents do not indicate whether this lack of concern was attributable to the old theory of Jewish incompetence in *Staatenbildung*, or to the obstacles to the realization of an independent Jewish state in Palestine at that time, namely, Arab resistance and British reluctance.

38. NA: T–175/R588, Aufzeichnung von II/112 (Wisliceny), 000388–90, 7.Apr.1937.

39. NA: T–175/R588, Richtlinien und Forderungen an die Oberabschnitte, II/112.145/37, 000400–409, 21.Apr.1937.

40. NA: T–175/410, Tätigkeitsbericht der Abt. II/112 vom 1.1–30.6.38, GII–112/65–4, 2935014. For more information on Eichmann's activities in Vienna, see Adam, *Judenpolitik*, pp. 201ff.; Höhne, *Orden*, pp. 310ff.; Robert Kempner, *Eichmann und Komplizen*, pp. 41ff.; Schleunes, *Road to Auschwitz*, pp. 229ff.

41. BA: R/58–1253, Der Sicherheitsdienst des RFSS und der SD-Führer des SS-Oberabschnittes/Donau (Eichmann) (no date).

42. See Adam, *Judenpolitik*, p. 201.

43. Höhne, *Orden*, pp. 310ff.

44. Ibid., p. 311. See also Genschel, *Verdrängung*, p. 260.

45. Much testimony on the Eichmann emigration operation in Austria was given at the Eichmann trial in Jerusalem in 1961. Eichmann denied responsibility for the Zentralstelle and its procedures, claiming that it was under Gestapo control (see *Eichmann Trial*: card 94, Session 81, June 28, 1961, and card 118, Session 106, July 21, 1961). Descriptions of the operation were also given by former representatives of the Berlin Palästinaamt who were sent to Vienna late in 1938 to observe Eichmann's methods (see *Eichmann Trial*: card 17, Session 15, April 25, 1961, and card 19, Session 17, April 26, 1961).

46. NA: T–175/410, Tätigkeitsbericht der Abt. II/112 vom 1.1.–30.6.38, G II–112/65–4, 2935020–21. See also BA: R/58: 1242, Aufzeich-

nung des Vertreters II/112 (Dannecker) über eine Besprechung bei Ministerialrat Lösener am 4.April 1938 in Anwesenheit von Vertretern der Orpo und Sipo sowie der Abt. IV und V des Ministeriums, as cited in Adam, *Judenpolitik*, pp. 185, n. 229, 198; BA: R/58: 984, Rücksprache mit Reichsbankrat Wolff, II/112 (Hagen), 25.Mai 1938.

47. Lösener, "Rassereferent," p. 288.

48. More information on the intra-Party competition for control over Jewish policy in 1938 can be found in Adam, *Judenpolitik*, pp. 204ff.; Dawidowicz, *War*, pp. 100ff.; Höhne, *Orden*, pp. 311ff.; Schleunes, *Road to Auschwitz*, pp. 234ff.

49. Adam, *Judenpolitik*, pp. 205–207; Dawidowicz, *War*, p. 100; Höhne, *Orden*, p. 313; Speer, *Third Reich*, p. 112.

50. By November, 1938, the Zentralstelle in Vienna had forced the emigration of some 50,000 Austrian Jews. In little over half a year, the Eichmann system had secured the removal of considerably more Jews from Austria than had ever been secured in the *Altreich* in an entire year (see BA: R/58: 1253, Zentralstelle für jüdische Auswanderung/Wien [Eichmann] an das SS-Hauptamt, II/112.G1–Bbr. 952/38, 21.Okt.1938; see also Hannah Arendt, *Eichmann in Jerusalem: A Report on the Banality of Evil*, p. 72; Genschel, *Verdrängung*, pp. 260, n. 19, 263, n. 38; Höhne, *Orden*, p. 311).

51. Adam, *Judenpolitik*, pp. 207ff.; Dawidowicz, *War*, pp. 101ff.; Höhne, *Orden*, pp. 314ff. See also Seraphim, *Tagebuch Alfred Rosenbergs*, p. 65.

52. Carl J. Burckhardt, *Meine Danziger Mission 1937–1939*, pp. 227–230; Höhne, *Orden*, pp. 316–317; J. D. Rosenkranz, "The Kristallnacht in Austria in the Light of the Historical Sources," *Yad Vashem Studies* 14 (1964), 41; Walter Schellenberg, *Memoiren*, ed. Gita Petersen, p. 59.

53. IMT: Testimony of Walther Funk, vol. 13, p. 131, and testimony of Hermann Göring, vol. 9, p. 313.

54. A partial record of the meeting can be found in IMT: vol. 28, 1816–PS, pp. 499–540. Additional memoranda on the proceedings by two officials who attended, Bernhard Lösener of the Interior Ministry and Ernst Woermann of the Foreign Office, can be found in Lösener, "Rassereferent," pp. 288ff.; ADAP: D, V, Nr.649. See also Adam, *Judenpolitik*, pp. 209ff.

55. Adam, *Judenpolitik*, p. 209, n. 30.

56. PA: Inland II A/B, 83–32 Sdh: Der Beauftragte für den Vierjahresplan an die Obersten Reichsbehörden, St.M.Bev.8772, 14.Dez.1938. The U.S. Embassy in Berlin reported in December, 1938, that there had been and still existed conflicting viewpoints within the Party and government regarding Jewish policy, but that Göring appeared to be in control (see SD-DF: 862.4016/2015, Gilbert/Berlin to State Department/Washington, Telegram 720, December 14, 1938).

57. Inland II A/B, 83–24, Bd.1, Der Chef der Sicherheitspolizei/Berlin (Heydrich) an AA/Berlin, Schnellbrief S–VI Nr.703/38–151–V.A.W., 83–24B 15/11, 15.Nov.1938.

58. PA: Dienststelle Ribbentrop, Vertrauliche Berichte 1935–1939, Teil II, Vertraulicher Bericht vom 30.Nov.1938.

59. NA: T–175/410, Tätigkeitsbericht der Abt. II/112 vom 1.7.–31.12.38, G II 112/65–4, 2935034, 1.Mär.1939.

60. PA: Inland II A/B, 83–24, Bd.1, Der Beauftragte für den Vierjahresplan, Generalfeldmarschall Göring, an den Herrn Reichsminister des Innern, 83–24B 11/2, 24.Jan.1939.

61. BA: Schumacher Collection, 240/II, Chef der Sicherheitspolizei an RIM, RAM, RWM und RFM, S-pp-II, 11.Feb.1939. See also Adam, *Judenpolitik*, p. 229. The Reichszentrale was to be run by a committee made up of representatives of the SD, two appointees of Göring (Ambassador Eisenlohr and Ministry Director Wohltat), Dr. Schumburg of Referat-D in the Foreign Office, Gotthardt from the Ministry of Economics, Dr. Schwandt of the Finance Ministry and Dr. Lösener of the Ministry of the Interior. The general secretary was SS-Standartenführer Heinrich Müller.

62. *Eichmann Trial*: card 104, Session 90, July 10, 1961, and card 88, Session 76, June 21, 1961.

63. See Adam, *Judenpolitik*, pp. 228–229.

64. Dawidowicz, *War*, p. 189. See also Graml, "Auswanderung," pp. 79ff.

65. Dawidowicz, *War*, pp. 189–190.

66. Wischnitzer, "Emigration," pp. 33ff.; Rosenstock, "Exodus," p. 376.

67. BA: R/43–II: 1400, AA/Berlin an RIM, RFM, RWM, RMVP, Reichsbankdirektorium und Gestapo, Nr. V 728, 18.Jan.1936.

68. Adequate documentation on the Evian conference and its futile efforts thereafter to reach an agreement with Germany can be found in ADAP: D, V, chap. 10; PA: Inland II A/B, 83–24, 83–24*a* and HaPol Abt., Handakten Wiehl (entire file); PRO: FO 371: 21659–C14812; SD-DF: 840.48 Refugees, 862.00, 862.4016 and 862.5151. See also Adam, *Judenpolitik*, pp. 226ff.; Dawidowicz, *War*, p. 190; Genschel, *Verdrängung*, pp. 261ff.; Levin, *Holocaust*, pp. 76–77; Marcus, "German Foreign Office," pp. 193ff.

69. See Rosenstock, "Exodus," p. 376. In a memorandum of November 2, 1938, State Secretary von Weizsäcker referred to the continuing immigration restrictions of other countries as an impediment to the speedy removal of Jews from Germany (see PA: Inland II A/B, 83–24, Bd.1, Aufzeichnung des St.S von Weizsäcker, e.o. 83–24B 2/11, 2.Nov.1938; Wischnitzer, "Emigration," pp. 33ff.).

70. PA: Pol.Abt.VII, Politik 2—Palästina, Bd.1, AA/Berlin an DB/London, 8.Jul.1938.

71. ADAP: D, V, Nr.664. The circular was put together by Emil Schumburg, who had succeeded Vicco von Bülow-Schwante as head of Referat-Deutschland in the summer of 1938.

72. BA: R/58: 982, II/112 (Six) an den SD-Führer des SS-Oberabschnittes Österreich, II/112/Wien, Funkspruch Nr.3352, 21.Jun.1938. For more on SS efforts to prevent Jewish emigration to other European countries, see PA: Pol.Abt.IV, Politik 36: Ungarn, RFSS und Chef der Deutschen Polizei an AA/Berlin, S-V 7Nr. 510/38–509–37, 7.Apr.1938; BA: R/58: 276,

Geheimes Staatspolizeiamt an verschiedene Staatspolizeileitstellen, IIB4–A 220/J, 23.Dez.1938.

73. ADAP: D, V, Nr.664.

74. BA: R/58: 956, Sicherheitsdienst des RFSS: SD-Hauptamt, Aufzeichnung von Herbert Hagen, "Judentum" (no date).

75. NA: T–175/411, "Die Organisation der Judenheit, ihre Verbindungen und politische Bedeutungen," Aufzeichnung von Herbert Hagen, II/112, 23.Sept.1938.

76. Illegal immigration into Palestine from Arab lands and from eastern Europe had begun early in the 1920s (see Kurt Jacob Ball-Kaduri, "Die illegale Einwanderung der deutschen Juden in Palästina, 1939–1940," *Jahrbuch des Instituts für Deutsche Geschichte* 4 [1975], 388–389).

77. IMT: Vol. 28, 1816–PS, p. 532.

78. ADAP: D, V, Nr.665. See also Adam, *Judenpolitik*, p. 229.

79. Rosenbluth, *Go Forth and Serve*, p. 271.

80. *Eichmann Trial*: card 17, Session 15, April 25, 1961.

81. IfZ: Beweisdokumente—Eichmannprozess, Nr. 742, interview with Dr. Kurt Jacob Ball-Kaduri by Hans Friedenthal, March, 1957.

82. Jon Kimche and David Kimche, *The Secret Roads: The Illegal Migration of a People, 1938–1948*, pp. 23ff.

83. Ibid., pp. 26ff. See also Höhne, *Orden*, pp. 318ff. The chief Mossad agent in Berlin was Pino Ginzburg, while in Vienna there appear to have been several personalities who emerged from time to time, including Moshe Auerbach and Ehud Avriel.

84. Arendt, *Eichmann in Jerusalem*, pp. 60–61; Ball-Kaduri, "Einwanderung," pp. 390ff.; Dawidowicz, *War*, p. 190.

85. Ehud Avriel, *Open the Gates*, p. 28.

86. Arendt, *Eichmann in Jerusalem*, p. 61; Kimche and Kimche, *Secret Roads*, pp. 18–19, 32.

87. Avriel, *Gates*, pp. 42ff.

88. Ibid., pp. 71–72, 89, 91. See also Quentin Reynolds, *Minister of Death: The Adolf Eichmann Story*, pp. 84–85.

89. Kimche and Kimche, *Secret Roads*, pp. 38ff. See also Leni Yahil, ed., "Selected British Documents on the Illegal Immigration to Palestine, 1939–1940," *Yad Vashem Studies* 10 (1974), 241–276.

90. *Eichmann Trial*: card 20, Session 19, April 27, 1961; Höhne, *Orden*, p. 319; Kimche and Kimche, *Secret Roads*, p. 32. On March 1, 1939, the U.S. Embassy in Berlin reported that German authorities were demanding the removal of greater numbers of Jews, with estimates ranging up to 100 per day. It was reported that Jews were being forced out without valid entry papers for other countries (see SD-DF: 840.48 Refugees/1463, Geist/Berlin to State Dept./Washington, Telegrams 146 and 285, March 1, 1939).

91. SD-DF: 840.48 Refugees/489, U.S. Consulate/Vienna to State Dept./Washington, No. 296, June 21, 1938, and 840.48 Refugees/671, U.S. Consulate/Vienna to State Dept./Washington, No. 351, July 30, 1938.

92. PRO: FO 371/21888–E4405, British Consul-General/Vienna to

Foreign Office/London, No. 25, July 23, 1938; FO 371/21888–E5244, British Legation/Athens to Lord Halifax/London, No. 308, September 6, 1938. See also PA: Inland II A/B, 83–24a, Bd.1, DB/London an AA/Berlin, A2684, 4.Jul.1939; Bernard Wasserstein, *Britain and the Jews of Europe, 1939–1945*, pp. 26–27.

93. *Eichmann Trial*: card 55, Session 48, May 23, 1961.

94. SD-DF: 840.48 Refugees/717, U.S. Consulate-General/Jerusalem to State Dept./Washington, No. 672, August 6, 1938.

95. Esco Foundation, *Palestine*, vol. 2, p. 943. Bernard Wasserstein notes that out of a total of 27,561 Jewish immigrants to Palestine in 1939, 11,156 were illegal arrivals (Wasserstein, *Britain*, p. 26).

96. PRO: FO 371/25238–W7663848, "Jewish Illegal Immigration into Palestine," memorandum prepared jointly by the Foreign Office and the Colonial Office, Dec. 1939–Jan. 1940.

97. Kimche and Kimche, *Secret Roads*, p. 15.

98. PA: Inland II A/B, 83–24a, Bd.2, Geheime Staatspolizei an das AA/Berlin, Schnellbrief IIB4–F.115j, 12.Apr.1938.

99. *Eichmann Trial*: card 20, Session 19, April 27, 1961. German and Austrian Jews had also been allowed to send delegates to the Evian conference in France in July, 1938. See also Dawidowicz, *War*, p. 190.

100. NA: T–175/411, II/1 an II/112, Nachrichten-Übermittlung Nr.36026, 2935765–67, 31.Mai 1938, and Aufzeichnung von II/112 betr. Auswanderung aus Österreich, 2935776, 20.Jun.1938.

101. PA: Pol.Abt.VII, Politik 2—Palästina, Bd.1, Aufzeichnung Schumburgs, 12.Okt.1938; ADAP: D, V, Nr.665, n. 77.

102. PA: Pol.Abt.VII, Politik 5a—Palästina, Bd.3, DGK/Jerusalem an AA/Berlin, J.Nr. 2071/38, 20.Okt.1938.

103. PA: Pol.Abt.VII, Politik 36—Palästina, Aufzeichnung von Hentigs, Pol.VII 1643, 21.Nov.1938; Politik 2—Palästina, Bd.1, AA/Berlin an Promi, Pol.VII 1340, 30.Nov.1938, and Hentig an Herren St.S und U.St.S, zu Pol. VII 1380, 11.Okt.1938. Hentig also acted as intermediary between the Zionist organization in Germany and Britain in the fall of 1938. He relayed an appeal from Dr. Hans Friedenthal of the ZVfD to Malcolm MacDonald of the British Colonial Office in October. The appeal described the worsening situation for Jews in Germany and called for an easing of immigration restrictions in Palestine (see PA: Pol.Abt.II, Politik 3—England, Bd.2, Letter of Dr. Hans Friedenthal to Mr. Malcolm MacDonald in London, October 7, 1938).

104. PA: Inland II A/B, 83–24a, Bd.1, DB/London an AA/Berlin, A.700, 17.Feb.1939. Dirksen's assessment was correct. Britain published a white paper on Palestine in May, 1939, that would in effect place a ceiling on future Jewish immigration over the next five years at 75,000, end the Mandate in ten years and result in a binational state with a permanent Arab majority.

105. PA: Inland II A/B, 83–24, Bd.1, Aufzeichnung des U.St.S Woermann, zu 83–24B 24/6, 1.Jul.1939, and Aufzeichnung des Ref.D (Schumburg), zu 83–24B 7/7, 13.Jul.1939.

106. PA: Inland II A/B, 83–21, Bd.8, Der Bürgermeister als Ortspolizeibehörde/Paderborn an AA/Berlin, G.Z.11, 10.Aug.1939, Ref.D an RIM,

26.Aug.1939, and Chef der Sicherheitspolizei und des SD an AA/Berlin, S–IV (XI Rz) 497/39, 15.Jan.1940.

107. PA: Inland II A/B, 83–24, Bd.3. This file contains references to ships leaving Rumanian and Bulgarian ports, bound for Palestine with illegal immigrants, with the full knowledge and apparent approval of German officials.

108. *Eichmann Trial*: card 93, Session 80, June 27, 1961.

109. ADAP: D, V, Nr.664.

110. Domarus, *Hitler*, vol. 2/1, p. 1057.

111. The idea of Madagascar as a destination for the resettlement of European Jews is considered in detail in Browning, *Final Solution*, pp. 35ff.; Friedman, "Madagascar," pp. 151–177; Eugene Hevesi, "Hitler's Plan for Madagascar," *Contemporary Jewish Record* 4 (1941), 381–395; Leni Yahil, "Madagascar: Phantom of a Solution for the Jewish Question," in *Jews and Non-Jews in Eastern Europe, 1918–1945*, ed. Bela Vago and G. L. Mosse, pp. 315–334.

112. PRO: FO 371/21876–E2570, Ormsby-Gore/Colonial Office to Halifax/Foreign Office, April 26, 1938.

113. PRO: FO 371/21592–C14652, notes on a meeting in Paris between Chamberlain and Daladier on November 24, 1938.

114. Ibid.

115. PA: Pol.Abt.V: Politik 1: Allgemeine auswärtige Politik Polens, Bd.1, Aufzeichnung über die Unterredung des Herrn RAM mit dem polnischen Aussenminister Beck, Pol.V 234a, 11.Jan.1938.

116. IMT: Vol. 41, Document Streicher 13, pp. 556–557, and Document Streicher 14, pp. 557–558.

117. *Das Schwarze Korps*, 10.Feb.1938.

118. Kersten, *Totenkopf*, p. 201. This claim has never been verified.

119. *Eichmann Trial*: card 105, Session 91, July 11, 1961.

120. BA: R/58: 979, G II–113/47, Hagen an II/112–3, 5.Mär.1938.

121. PA: Parteidienststellen/Aussenpolitisches Amt, Rosenberg 2: Korrespondenz, Glückwünsche, Manuskripte für Reden 1936–1944, Vortrag von Reichsleiter Rosenberg auf dem Empfang am 7.Feb.1939 für die Diplomaten und ausländische Presse. For more on Rosenberg's support of the Madagascar option, see *Völkischer Beobachter*, 16.Jan.1939 and 23.Mär.1939; CDJC: CXLIII–326, *Völkischer Beobachter* (Seibert) an APA (Rosenberg), Aussenpolitik Dr.S./P., 14.Feb.1939.

122. IMT: vol. 28, 1816–PS, pp. 538–539; PA: Büro des U.St.S, Judenfrage, Woermann an Ribbentrop, 23.Nov.1938.

123. Jedrzejewicz, *Diplomat*, Doc. No. 99, p. 411. See also Friedman, "Madagascar," pp. 168–169.

124. See Browning, *Final Solution*, pp. 35ff.; Friedman, "Madagascar," pp. 171ff.

125. See PA: Inland II A/B, 83–24, Bd.2, Der Chef der Sicherheitspolizei und des SD an AA/Berlin, S–IV (II Rz.) 538/39, 14.Okt.1939; Inland II A/B, 83–24c: Judenreservat in Polen, Aufzeichnung des Ref.D vom 17.Okt.1939; Inland II A/B, 83–24 SdhIV: Auswanderung jüdischer Hochschullehrer usw.,

Der Chef der Sicherheitspolizei und des SD an AA/Berlin, S–IV (II Rz.), 583/39, 14.Nov.1939.

## 9. Germany, Palestine, and the Middle East, 1938–1939

1. There was, however, opposition to the *Anschluss* in the British press, from Churchill and the right and from elements in the Labor Party on the left (see Aigner, *Das Ringen*, pp. 322ff.).

2. Ulrich Eichstädt, *Von Dolfuss zu Hitler: Geschichte des Anschlusses Österreichs 1933–1938*, pp. 383ff. See also Henke, *England*, pp. 137–138; Hildebrand, *Weltreich*, pp. 556ff.

3. ADAP: D, I, Nr.145, 146, 147, 149.

4. Ibid., Nr.19.

5. Henke, *England*, pp. 143ff.; Hildebrand, *Weltreich*, pp. 572ff.; Kuhn, *Aussenpolitisches Programm*, pp. 227ff.

6. ADAP: D, II, Nr.221 (Anlage). See also Henke, *England*, pp. 153–154; Kordt, *Wilhelmstrasse*, p. 460. *Fall Grün* and the destruction of Czechoslovakia were topics of discussion during a Hitler-Keitel meeting on April 21, 1938 (see ADAP: D, II, Nr.133).

7. Ibid., Nr.154 (Anlage); Henke, *England*, pp. 147–149; Hildebrand, *Foreign Policy*, pp. 67–68, and *Weltreich*, p. 567.

8. ADAP: D, II, Nr.154 (Anlage).

9. See ibid., Nr.185, 191. The May crisis of 1938 was the result of a decision by the Czech government on May 20 to mobilize the Czech armed forces in response to rumors of German troop concentrations on the German-Czech border. There is still much uncertainty surrounding the origins of the crisis (see Henke, *England*, p. 150, n. 87; Gerhard Weinberg, "The May Crisis of 1938," *Journal of Modern History* 29 [1957], 213–225).

10. Henke, *England*, pp. 158ff.

11. ADAP: D, II, Nr.132.

12. Aigner, *Das Ringen*, p. 321; Henke, *England*, p. 161; Theo Sommer, *Deutschland und Japan zwischen den Mächten 1935–1940: Vom Antikominternpakt zum Dreimächtepakt*, pp. 116ff.

13. ADAP: D, II, Nr.282.

14. See ibid., Nr.264, 278, and D, VII, Anhang III/H–I, II, III, IV, V, pp. 538ff.; Wiedemann, *Mann*, p. 160; DBFP: 3, I, No. 510, and 3, VII, appendix IV, No. IV.

15. In July, a British mission under Lord Runciman was dispatched to Prague at the request of the Czech government to mediate in the negotiations taking place between the Czech government and leaders of the Sudeten German Party. The German government refused to recognize the Runciman mission and treated it as a purely British matter (see ADAP: D, II, Nr.323, 325, 379; Weizsäcker, *Memoirs*, p. 145).

16. ADAP: D, II, Nr.573. See also Leonidas Hill, ed., *Die Weizsäcker Papiere 1933–1950*, p. 145.

17. ADAP: D, II, Nr.572, 574, 583, 619.

18. Ibid., Nr.634. Dr. Paul-Otto Schmidt claimed that Hitler grew un-

sure of himself after the meeting with Wilson and began to back off from a collision course with Great Britain over Czechoslovakia (Schmidt, *Statist*, pp. 409–410). Horace Wilson, technically chief industrial adviser, became Chamberlain's closest adviser on most issues in 1938, especially in foreign affairs.

19. ADAP: D, II, Nr.657. On September 28, Finance Minister Schwerin von Krosigk, along with Göring and Neurath, warned Hitler that Germany's financial position was critical and that the country was in no position to wage war (see Ulrich von Hassell, *Vom anderen Deutschland: Aus den nachgelassenen Tagebüchern 1938–1944*, p. 24).

20. Henke, *England*, p. 182.

21. Hill, *Weizsäcker Papiere*, p. 145; Schmidt, *Statist*, p. 412.

22. Weizsäcker, *Memoirs*, p. 187.

23. Schmidt, *Statist*, p. 410. Schmidt described the impact of the incident on Hitler as follows: "The completely apathetic and depressed reaction of the Berlin population, which Hitler observed from a window in the Reichskanzlei, impressed him deeply." Similarly, Hill, *Weizsäcker Papiere*, p. 145; William Shirer, *Berlin Diary*, pp. 142–143.

24. Keith Feiling, *The Life of Neville Chamberlain*, p. 390; Hassell, *Deutschland*, p. 27; Henke, *England*, pp. 187ff.; Hildebrand, *Foreign Policy*, pp. 73–74; Schmidt, *Statist*, pp. 419ff.

25. Henke, *England*, p. 191, n. 25, 26.

26. Domarus, *Hitler*, vol. 1/2, pp. 956, 964, 968.

27. Wilhelm Treue, "Rede Hitlers vor der deutschen Presse (10. November 1938)," *Vierteljahrshefte für Zeitgeschichte* 6 (1958), 175–191. See also PA: Dienststelle Ribbentrop, Vertrauliche Berichte, Teil II, Niederschrift zur Rede des Führers am 10.Nov.1938 vor der deutschen Presse im Führerbau zu München.

28. On December 16, 1938, Weizsäcker told Hassell, the German ambassador in Rome, that Hitler and Ribbentrop were resigned to war with England to achieve German aims in Europe (see Hassell, *Deutschland*, p. 37). In October of that year, Hitler had informed Admiral Raeder that the German navy would have to embark upon a program of massive buildup (see Raeder, *Mein Leben*, vol. 2, p. 154).

29. Henke, *England*, p. 205.

30. Henke, *England*, pp. 204ff.; Hillgruber, "Hitler's Plans," p. 15.

31. ADAP: D, IV, Nr.411.

32. Ibid., Nr.433.

33. See Hill, *Weizsäcker Papiere*, p. 154.

34. Burckhardt, *Mission*, p. 348.

35. ADAP: D, VII, p. 200.

36. Ibid., p. 265.

37. See *Kriegstagebuch des Oberkommandos der Wehrmacht* (Wehrmachtführungsstab), vol. 1, 1.Aug.1939–31.Dez.1941, p. 50E.

38. Hillgruber, *Strategie*, pp. 145, 151.

39. PRO: FO 371/22988–C551618, Report of the Press Attaché of the

British Embassy in Berlin, December 28, 1938. See also Aigner, *Das Ringen*, p. 334; Henke, *England*, pp. 201ff.; Jacobsen, *Nationalsozialistische Aussenpolitik*, pp. 402–404.

40. See *Völkischer Beobachter*, 8.–13., 26.Jul.1938, 2., 9., 21.Aug.1938, 15.Sept.1938, 12., 19., 23.Okt.1938, and 15.–23., 25.Nov.1938.

41. Arsenian, "Wartime Propaganda," pp. 419–421. See also Robert Baker, *Oil, Blood and Sand*, pp. 102–107.

42. PRO: FO 371/21665–C14758, FO Memorandum of November 22, 1938, and FO 371/23232–E2274, War Office memoranda of March 2 and May 7, 1939.

43. Domarus, *Hitler*, vol. 1/2, p. 800.

44. Ibid., pp. 904–905.

45. Ibid., p. 956.

46. Ibid., p. 969.

47. Ibid., vol. 2/1, pp. 1121–1122.

48. Hentig, *Mein Leben*, p. 335.

49. Muggeridge, *Ciano's Diplomatic Papers*, p. 44.

50. PA: Pol.Abt.IV, Politik 2–3: Italien: AA/Berlin an alle Botschaften und europäischen diplomatischen Missionen sowie Konsultat Genf, Pol.IV–4936, 30.Sept.1937.

51. Muggeridge, *Ciano's Diplomatic Papers*, p. 278.

52. BA: R/43–II: 1450, AA/Berlin an sämtliche Reichsministerien, Stellvertreter des Führers und Chef der Reichskanzlei, Rk.8447b, 25.Mär. 1939. The question of authority in the conduct of German foreign policy in the Middle East became a point of friction between the German Foreign Office and Rosenberg's Aussenpolitisches Amt in 1938 and 1939. This is considered below.

53. PA: Pol.Abt.VII, Politik 2—Palästina, Bd.1, DGK/Jerusalem an AA/Berlin, J.Nr.2289, 2.Nov.1938.

54. Schröder, "Die Beziehungen," p. 81; Ferdinand Siebert, *Italiens Weg in den Zweiten Weltkrieg*, pp. 18–19.

55. PA: Botschaft Ankara, Politik 3: Palästina, 1924–1938, DGK/Jerusalem an das AA/Berlin, J.N.2735/27, 31.Dez.1927; Pol.Abt.III, Politik 5—Palästina, Bd.2, DB/Rom an AA/Berlin, 13171, III o 4682, 5.Sept.1929. See also Gaetano Salvemeni, *Mussolini Diplomatico, 1922–1932*, p. 120; Siebert, *Italiens Weg*, pp. 23–24.

56. Schröder, *Deutschland und der Mittlere Osten*, p. 28.

57. PA: Pol.Abt.III, Politik 2a—Palästina, Bd.1, Aufzeichnung Sobernheims, III o 2784, 9.Jun.1927; *Jüdische Rundschau*, 16.Jun.1933, and 12.Sept.1933; PRO: FO 371/17876–E1279, British Embassy/Rome to Foreign Office/London, February 19, 1934; Chaim Weizmann, *Trial and Error: The Autobiography of Chaim Weizmann*, p. 370. In June, 1935, Consul-General Wolff reported from Jerusalem his view that Italy had no aims in Palestine and that Rome was especially supportive of Jabotinsky's Revisionist Zionists (see PA: Pol.Abt.III, Politik 3—Palästina, Bd.1, DGK/Jerusalem an AA/Berlin, Nr.Polit. 29/35, 7.Jun.1935).

58. Siebert, *Italiens Weg*, pp. 29–31.

59. PRO: FO 371/20820–E6816, Henderson/Berlin to FO/London, November 17, 1937.

60. Kuhn, *Programm*, p. 201.

61. The new Chamberlain government in Britain was anxious to reach an understanding with Italy in 1937 in spite of the continuation of anti-British propaganda from Bari and in the Italian press, and in spite of continuing Italian intrigue in the Middle East. See Avon, *Eden Memoirs*, pp. 486, 662; Keith Feiling, *The Life of Neville Chamberlain*, p. 335. See also PA: Inland II A/B, 83–21a, Bd.1a, Aufzeichnung von Pol.IV, zu 83–21a 5/8, 18.Aug.1937.

62. PA: Inland II A/B, 83–21a, Bd.1a, Telegramm Nr.269, AA/Berlin an DB/Rom, 23.Aug.1937.

63. See ADAP: D, IV, Nr.409; Neville Chamberlain, *In Search of Peace*, pp. 105ff.; Muggeridge, *Ciano's Diplomatic Papers*, pp. 190–191, 220; Siebert, *Italiens Weg*, pp. 68ff.; SD-DF: 867N.01/1057, Phillips/Rome to State Dept./Washington, Telegram No. 93, April 23, 1938.

64. ADAP: D, I, Nr.742.

65. Ibid., Nr.755.

66. Henke, *England*, p. 249.

67. Hill, *Weizsäcker Papiere*, p. 154.

68. ADAP: D, VI, Nr.52.

69. Schmidt, *Statist*, p. 434. Italy had no intention of starting a conflict with Britain and France in 1939. On several occasions, the Italian government communicated to Berlin its policy of avoiding war with the west for a period of up to three years (see ADAP: D, VI, Nr.52, 205, 211, 341, 459 [Anhang]; Hassell, *Deutschland*, pp. 56–57; Hill, *Weizsäcker Papiere*, pp. 157–158; Schmidt, *Statist*, pp. 438ff.).

70. ADAP: D, VI, Nr.205, 211, 341.

71. PA: Pol.Abt.VII, Politik 5a—Palästina, Bd.2, DGK/Beirut an AA/Berlin, 22.Sept.1937, and AA/Berlin (Hentig) an DGK/Beirut, 8.Okt.1937.

72. PA: Pol.Abt.VII, Politik 2—Palästina, Bd.1, DG/Bagdad (Grobba) an AA/Berlin, Nr.2633, 9.Nov.1937.

73. PA: Pol.Abt.VII, Politik 2—Saudisch-Arabien, Bd.1, DG/Bagdad an AA/Berlin, Nr.27, 7.Jan.1938.

74. PRO: FO 371/21998–E1355, British Embassy/Rome to FO/London, No. 330, March 31, 1938.

75. This group included companies such as Electroacustic, Krupp, Siemens, C. G. Haenel, Mauser-Werke A.G., Rheinmetall-Borsig, Deutsche Waffen- u. Munition, Carl Zeiss, Polte, Lignose Sprengstoffe A.G., Stoltzenberg, Ernst Leitz, Zeiss-Jena, Hensoldt u. Söhne and others.

76. According to the annual report of the Reichsgruppe Industrie: Ausfuhrgemeinschaft für Kriegsgerät for 1937, its task was as follows: "In accordance with the instructions of the Beauftragter für den Vierjahresplan, the AGK endeavors strongly to promote the export of weapons within the framework of political realities, and to realize the highest economic return, that is, to generate hard currency" (see PA: HaPol Abt.—Kriegsgerät [Geheim], Handel mit Kriegsgerät—Allgemeines, Bd.3, Reichsgruppe Industrie: Aus-

fuhrgemeinschaft für Kriegsgerät, Jahresbericht für 1937, Nr. B–4; PA: Pol. Abt.I—Völkerbund, Abrüst.: Waffenhandel und Waffenherstellung, Aufzeichnung von VLR von Kamphoevener, e.o. Pol.I 2347g, 10.Mai 1937).

77. PA: HaPol Abt.—Kriegsgerät (Geheim), Handel mit Kriegsgerät—Allgemeines, Bd.3, Bericht der Handelspolitischen Abteilung vom 25.Jan. 1938, and Göring an das AA, RWM und Reichsgruppe Industrie, 775g, 5.Apr.1938.

78. PA: HaPol Abt.—Kriegsgerät (Geheim), Handel mit Kriegsgerät—Allgemeines, Bd.3, Statistik über K.G.-Ausfuhr im Jahre 1937.

79. PA: HaPol Abt.—Handakten Wiehl, Afghanistan, Bd.1, Aktenvermerk des Ministerialdirektors Ritter im AA, D549000, 16.Okt.1936.

80. Rosenberg's APA began to devote considerable attention to the Near and Middle East after 1937. It favored an active, aggressive policy by Germany in that part of the world and concentrated on those countries with the greatest degree of independence from Britain, namely, Afghanistan, Iran and Saudi Arabia. This policy resulted in feuds with the responsible authorities in the German Foreign Office, particularly with Hentig's Pol.VII, which was more cautious about pushing the German presence too far and more mindful of British power in the Middle East (see IMT: Vol. 25, 007-PS; Grobba, *Männer*, p. 188; Hentig, *Mein Leben*, p. 319; PA: Partei Dienststellen/Aussenpolitisches Amt, Allgemein: Afghanistan, Zielsetzung des APA des NSDAP, 18.Dez.1939).

81. PA: Partei Dienststellen/Aussenpolitisches Amt, Politische Berichte: Afghanistan, Amt für Vorderasien, Aktennotiz betr. Afghanistan, 13.Jun.1939.

82. Grobba, *Männer*, p. 188; NA: T–120/747, Entwicklung in Afghanistan seit 1918, 352660–676, 1.Dez.1939; PA: Partei Dienststellen/Aussenpolitisches Amt, Allgemein: Zielsetzung des APA des NSDAP, 18.Dez.1939, and Fortschreitende Zusammenarbeit mit der jetzigen afghanischen Regierung (Anlage, o.D.); PA: Pol.Abt.VII, Politik 2—Iran, Bd.1, DG/Teheran an AA/Berlin, Nr.A.28 (I.A.2), 22.Jan.1938.

83. Majid Khadduri, *Independent Iraq, 1932–1958: A Study in Iraqi Politics*, pp. 310–312.

84. Ibid., pp. 69ff.

85. Ibid., pp. 172ff. See also Grobba, *Männer*, pp. 157–158.

86. Grobba, *Männer*, p. 158.

87. PA: HaPol Abt.—Kriegsgerät (Geheim), Kriegsgerät: Handel mit Kriegsgerät—Irak, Bd.1, DG/Bagdad an AA/Berlin, Telegramm Nr.6, 8.Mär.1937.

88. PA: HaPol Abt.—Kriegsgerät (Geheim), Kriegsgerät: Handel mit Kriegsgerät—Irak, Bd.1, Friedrich Krupp A.G. an AA/Berlin, Nr. 32532/Pba/Va, 8.Mär.1937, and DG/Bagdad an AA/Berlin, Nr.679, 20.Mär.1937.

89. PA: HaPol Abt.—Kriegsgerät (Geheim), Kriegsgerät: Handel mit Kriegsgerät—Irak, Bd.1, Reichskriegsministerium an AA/Berlin, Pol.I 1973, 3.Apr.1937.

90. PA: HaPol Abt.—Kriegsgerät (Geheim), Kriegsgerät: Handel mit Kriegsgerät—Irak, Bd.1, RWM an AA/Berlin, II301/37g, 29.Mai 1937, and

Aufzeichnung zur Randnotiz auf dem Bericht des Deutschen Gesandten in Bagdad vom 24.Jul.1937, Nr.823, von L. S. von der Damerau-Dambrowski, 29.Jul.1937.

91. PA: HaPol Abt.—Kriegsgerät (Geheim), Kriegsgerät: Handel mit Kriegsgerät—Irak, Bd.1, DG/Bagdad an AA/Berlin, Telegramm Nr.26, 12.Mai 1937.

92. PA: Büro des Chefs der AO, Irak, 1937–1941, Bd.92, DG/Bagdad an Chef der AO im AA, EWB/RO, 19.Jun.1937.

93. PA: HaPol Abt.—Kriegsgerät (Geheim), Kriegsgerät: Handel mit Kriegsgerät—Irak, Bd.2, DG/Bagdad an AA/Berlin, Nr.1717, 15.Jul.1937, and DG/Bagdad an AA/Berlin, Nr.1823, 24.Jul.1937.

94. PA: HaPol Abt.—Kriegsgerät (Geheim), Kriegsgerät: Handel mit Kriegsgerät—Irak, Bd.2, DG/Bagdad an AA/Berlin, Nr.2921, 12.Dez.1937. See also appendix 13.

95. PRO: FO 371/20911–J4567, War Office memorandum of October, 1937.

96. PA: HaPol Abt.—Kriegsgerät (Geheim), Kriegsgerät: Handel mit Kriegsgerät—Allgemeines, Bd.3, "Kriegslieferungsverträge" (Geheim) e.o. W746g, 10.Aug.1938. See also appendix 13. According to this document, the British government approved the September, 1938, transaction.

97. This information was relayed by General Walther von Brauchitsch to Ian Colvin, a British journalist who spent much time in Germany during the late 1930s, and who had contacts with important personalities in Nazi Germany. Colvin writes that the meeting was held "around" July 14 (see Ian Colvin, *Vansittart in Office: An Historical Survey of the Origins of the Second World War Based on the Papers of Sir Robert Vansittart*, p. 220). Mr. H. Fitzgerald Harley, a British subject and member of the British Union of Fascists, went to Germany in October, 1937, and stayed there until mid-July, 1938. On July 22, 1938, Harley told the British Embassy in Paris that he saw the minutes of the July meeting in the office of Dr. Karl Schmidt of the Gestapo and that it had been decided at the meeting to provide the Arabs with money in order to provoke agitation against the Jews in Palestine (see PRO: FO 371/21782–C7624, British Embassy/Paris to FO/London, July 22, 1938).

98. Some interest in supporting Arab unrest in Syria as a means of distracting France from central Europe was expressed by II/112 in the SD. After receiving a report from Franz Reichert, the DNB agent in Jerusalem, that new waves of unrest against French rule in Syria were expected, Herbert Hagen of II/112 suggested increasing German propaganda among the Syrian Arabs. However, there is no evidence that Hagen's suggestion led to any form of German political activity in Syria (see NA: T–175/R588, Aufzeichnung Hagens, G–II/112–18/1, 000629. 3.Mai 1938).

99. Helmuth Groscurth, *Tagebücher eines Abwehroffiziers 1938–1940*, p. 106.

100. Karl-Heinz Abshagen, *Canaris*, trans. Alan Houghton Broderick, p. 208; Oscar Reile, *Geheime Ostfront: Die deutsche Abwehr im Osten 1921–1945*, p. 174.

101. IfZ: Nürnberg Dokument PS–792, as cited in Melka, "Axis," p. 53.

102. Interview with Dr. Fritz Grobba at Bad Godesberg, June 30, 1973. These words were taken from some papers Dr. Grobba permitted me to examine. Because of his advanced age and declining health at that time, it was very difficult to discuss these matters with him. It has not been possible for me to determine the exact date of Dr. Grobba's meeting with Musa el Alami in Damascus, nor the exact source of the money in Germany. The meeting is presumed to have taken place either late in 1938 or sometime during the first several months of 1939 and the Abwehr is assumed to be the source of the £800. It was not until July, 1939, that the British government began to have suspicions about Grobba's activities in the Middle East (see PRO: FO 371/23238–E5101, Colonial Office memorandum [Baxter], July 14, 1939, and FO 371/23191–E5128, Foreign Office minute to the British Embassy in Baghdad, July 18, 1939).

103. ADAP: D, V, Nr.590. The Saudi government had shown an interest as early as 1937 in purchasing German weapons for the Arab cause in Palestine. See PA: HaPol Abt.—Kriegsgerät (Geheim), Kriegsgerät: Handel mit Kriegsgerät—Irak, Bd.1, DG/Kairo an AA/Berlin, zu Pol.I 1068g, 5.Feb.1937. According to the late Dr. Grobba, Ibn-Saud was in contact with the Mufti in 1938 and 1939 and favored using Saudi Arabia as a base for smuggling weapons to the Arabs in Palestine (Grobba, *Männer*, p. 112). Britain's awareness of Ibn-Saud's intentions is evident in PRO: FO 371/21878–E4188, Foreign Office memorandum, July, 1938; SD-DF: 867N.01/1485 (CF), U.S. Embassy/London to State Dept./Washington, Telegram No. 368, March 20, 1939. Nevertheless, it appears that Ibn-Saud was not willing to push the British too far over Palestine and hoped to reach an understanding with London whereby one of his sons would replace Amir Abdullah of Transjordan (see PA: Pol.Abt.VII, Politik 2—Saudisch-Arabien, Bd.1, DG/Bagdad an AA/Berlin, Nr.1687, 4.Jul.1937).

104. ADAP: D, VI, Nr.313. Hentig also referred briefly to the unfortunate use of Fuad Hamza as a middle man for conveying money and arms to the Arab movement in Palestine (see ADAP: D, VI, Nr.422).

105. PRO: FO 371/21877–E3137, Report of the High Commissioner for Palestine, May, 1938; FO 371/21887–E4838, Foreign Office memorandum of August 12, 1938; FO 371/21872–E7560, Foreign Office memorandum of December 14, 1938; FO 371/21871–E7394, Foreign Office memorandum of December, 1938.

106. SD-DF: 867N.01/1329, Memorandum of Paul Alling, Chief, Division of Near Eastern Affairs at the Department of State/Washington, October 21, 1938.

107. PA: Pol.Abt.VII, Politik 2—Palästina, Bd.1, DNB-Bericht Br.303, Blatt 12, Jerusalem, 3.Nov.1938.

108. Grobba, *Männer*, p. 105.

109. PA: Pol.Abt.VII, Politik 5a—Palästina, Bd.3, DG/Bagdad an AA/Berlin, Nr.2765, 21.Nov.1937.

110. PA: Partei Dienststellen/Aussenpolitisches Amt: Politische Be-

richte: Saudisch-Arabien, Aktennotiz (Harder) betr. Besprechungen mit al-Hud, 17.Mär.1938.

111. PA: Pol.Abt.VII, Politik 2—Saudisch Arabien, Bd.1, Aufzeichnung des APA, Pol.VII 1061, 23.Jul.1938. For more on APA policy regarding Saudi Arabia, see Seraphim, *Tagebuch Alfred Rosenbergs*, appendix 14, pp. 191–193.

112. PA: Pol.Abt.VII, Politik 2—Saudisch Arabien, Bd.1, Hentig an U.St.S Woermann, zu Pol.VII 1263, 6.Sept.1938.

113. PA: Pol.Abt.VII, Politik 2—Saudisch Arabien, Bd.1, Hentig an Malletke (APA), no date, and Woermann an Hentig, zu Pol.VII 1263, 26.Sept.1938.

114. PA: Pol.Abt.VII, Politik 2—Saudisch Arabien, Bd.1, DG/Djidda an AA/Berlin, Nr. Dj9, 27.Jan.1939; PA: Partei Dienststellen/Aussenpolitisches Amt: Allgemein: Vertrauliche Aufzeichnungen betr. England, Berichte und Notizen bezügl. Italien 1933–1942, Amt für Aussenhandel, 13.Feb.1939.

115. PA: Pol.Abt.VII, Politik 2—Saudisch Arabien, Bd.1, DG/Bagdad an AA/Berlin, Nr. Dj44, 18.Feb.1939.

116. PA: Büro des Reichsaussenministers—Irak, Aufzeichnung von Hentig, 24.Feb.1939.

117. ADAP: D, V, Nr.590.

118. PA: Partei Dienststellen/Aussenpolitisches Amt: Politische Berichte: Saudisch Arabien, Aktennotiz des Amts für Vorderasien, 12.Jun.1939.

119. ADAP: D, VI, Nr.313. Woermann made the following marginal comment on this document: "Ich habe mich durch diesen Brief überzeugen lassen" (this letter has convinced me).

120. Ibid., Nr.422. Ribbentrop made a marginal note agreeing with Hentig's arguments. Hentig again outlined his new position in another memorandum to Ribbentrop on June 9 (see PA: Pol.Abt.VII, Politik 2—Saudisch Arabien, Bd.1, Hentig an RAM, Pol.VII 949, 9.Jun.1939).

121. Hentig was referring to the Anglo-French-Turkish negotiations that resulted in the signing of a mutual assistance pact among the three countries on June 23, 1939 (see Sachar, *Europe*, p. 55).

122. See Marlowe, *Pilate*, pp. 154ff.

123. ADAP: D, VI, Nr.498.

124. Ibid., Nr.541.

125. PA: Pol.Abt.VII, Politik 2—Saudisch Arabien, Bd.1, Aufzeichnung von Hentig, Pol.VII 1059, 20.Jun.1939. See also Grobba, *Männer*, pp. 109–110.

126. PA: Pol.Abt.VII, Politik 2—Saudisch Arabien, Bd.1, Aufzeichnung von Hentig, Pol.VII 1163, 4.Jul.1939, Pol.VII 1155, 4.Jul.1939, and Woermann an al-Hud, 1186, 12.Jul.1939.

127. PA: HaPol Abt.—Kriegsgerät (Geheim), Kriegsgerät: Handel mit Kriegsgerät—Allgemeines, Bd.4, OKW an AA/Berlin, Nr.6147/39g, 22.Jul.1939.

128. See appendix 13.

129. Grobba, *Männer*, pp. 317–318.

130. NA: MS/P–207, "German Exploitation of the Arab Nationalist Movements in World War II," by General der Flieger a.D. Hellmuth Felmy and General der Artillerie a.D. Walter Warlimont, U.S. Army–Europe, Foreign Ministry Study Branch, no date.

131. In April, 1939, Mussolini and Göring agreed that while the Axis could create complications for Britain in the Middle East, it was impossible really to threaten the British position seriously (see ADAP: D, VI, Nr.211).

132. Ibid., Nr.541.

133. ADAP: D, V, Nr.577.

134. PA: Generalkonsulat Beirut, Paket 63: Palästina und Transjordanien, Bd.2, DG/Bagdad an AA/Berlin, Nr.2950, 16.Nov.1938.

135. See PA: Inland II A/B, 83–26: Polen, Aufzeichnung von Hentig, Pol.VII 1041, 19.Jun.1939, and Referat-D (Hinrichs) an Gestapo (Lischka), zu 83–26 19/6, 10.Jul.1939.

136. PA: Pol.Abt.VII, Politik 2—Saudisch Arabien, Bd.1, DG/Bagdad an AA/Berlin, Nr. 796, 7.Mär.1939.

# Bibliography

**Primary Sources—Unpublished**

*Archival*

Politisches Archiv des Auswärtigen Amts/Bonn
1. Büro des Reichsaussenministers:
   Polen, Bd.1 (1.36–12.38).
   Irak (5.38–5.43).
   Palästina (3.37–2.41).
2. Büro des Staatssekretärs:
   X: Kolonialfragen (Mandatsgebiete), Bd.1 (4.24–2.30).
   Irak, Bd.1 (8.39–5.41).
3. Büro des Unterstaatssekretärs:
   Palästina-Frage (6.37–4.38).
   Judenfrage (7.38–9.42).
4. Politische Abteilung III:
   England. Politik 3 Länder Politische Beziehungen zwischen England
   und Palästina, Bde.1,2 (12.20–12.31).
   Palästina. Politik 1: Die politische Verhältnisse im allgemeinen, Bd.1
   (11.20–8.22).
   Palästina. Politik 2: Politische Beziehungen Palästinas zu Deutsch-
   land, Bde.1,2 (9.20–5.36).
   Palästina. Politik 2a: Pro-Palästina Komitee, Bde.1,2 (10.26–6.32).
   Palästina. Politik 3: Politische Beziehungen zwischen fremden
   Staaten, Bd.1 (11.22–9.30).
   Palästina. Politik 4—Pan-Arab. Bund: Panarabischer Bund, Bd.1
   (10.20–8.35).
   Palästina. Politik 5: Innere Politik, Parlaments- und Parteiwesen in
   Palästina, Bde.1,2,3,5 (4.20–4.36).
   Palästina. Politik 6: Nationalitätenfrage, Fremdvölker, Bd.1 (1.21–7.32).
   Palästina. Politik 10: Deutsche diplomatische und konsularische Ver-
   tretungen, Bde.1,2, (5.21–4.34).
   Palästina. Politik 11, Nr.3: Personalien, Staatsmänner in Palästina,
   Bd.1 (8.25–2.31).
   Palästina. Politik 12: Pressewesen, Bd.1 (11.27–3.36).

Palästina. Politik 16: Religions- und Kirchenwesen, Bd.1 (1.21–8.35).
Palästina. Politik 17: Unterrichtswesen, Bd.1 (9.23–9.31).
Palästina. Politik 26: Politische und kulturelle Propaganda, Bd.1
   (2.26–8.35).
Palästina. Rechtswesen 19, Nr.1: Beschlagnahme deutsch. Eigentums
   in Palästina, Bd.1 (11.20–2.36).
Palästina. Innere Verwaltung 14: Heimschaffung, Übernahme (Paläs-
   tina), Bd.1 (4.20–5.35).
Syrien. Politik 2: Politische Beziehungen Syriens zu Deutschland, Bd.1
   (11.20–1.36).
Akten aus dem Nachlass Prof. Sobernheims. Jüd. Angelegenheiten:
   Prof. Sobernheim III Verschiedenes, Bd.1 (1929–1932).
Akten aus dem Nachlass Prof. Sobernheims. Jüd. Angelegenheiten:
   Deutsches Komitee Pro-Palästina, Bd.1 (1926–1928).
Jüdische Angelegenheiten. Jüd.Pol.1: Allgemeines, Bde.6,13 (1.25–5.36).
5. Politische Abteilung III—Wirtschaft:
Palästina. Allgemeines 3: Allgemeines, Bd.1 (1.29–2.35).
Palästina. Finanzwesen 3: Finanzielle Beziehungen Palästinas zu
   Deutschland, Bd.1 (7.34–11.34).
Palästina. Handel 11: Handelsbeziehungen zu Deutschland, Bd.1
   (4.22–4.35).
Palästina. Handel 11, Nr.1: Ein-, Aus- und Durchfuhr. Allgemeines
   und Grundsätzliches (anti-Dumping), Bd.1 (3.21–5.36).
Palästina. Wirtschaft 7: Wirtschaftliche Beziehungen zu fremden
   Staaten, Bd.1 (11.27–4.31).
Palästina. Wirtschaft 21: Weltwirtschaftskonferenz, Bd.1 (6.33).
Saudisch-Arabien. Wirtschaft 6: Wirtschaftliche Beziehungen zu
   Deutschland, Bd.1 (6.33–10.33).
Irak. Handel 11: Handelsbeziehungen zu Deutschland, Bd.1
   (6.26–5.36).
Irak. Rohstoffe und Waren: Petroleum, Bde. 2,3 (1.26–5.36).
6. Sonderreferat—Wirtschaft:
Finanzwesen 16: Devisenangelegenheiten mit Palästina, Bde.1,2,3,4
   (1.32–5.36).
Rohstoffe und Waren: Petroleum, Bde.6,7 (1.21–12.35).
7. Geheim-Akten, 1920–1936:
Syrien. Politik 2: Politische Beziehungen zu Deutschland (4.27–11.34).
Palästina. Politik 2: Politische Beziehungen zu Deutschland
   (3.27–9.34).
Italien. Politik 2: Politische Beziehungen zu Deutschland, Bd.3
   (1.31–5.36).
II FK.33: Kriegsgerät Allgemeines—Geheimsachen (1.36–5.36).
II FK.30: Gesetz über Aus- und Einfuhr von Kriegsgerät von 24.9.35,
   Bd.9 (7.35–8.37).
II FK.120: Aus- und Einfuhr von Kriegsgerät nach aussereuropäischen
   Ländern (10.35–6.36).

8. Abteilung IV—Kultur:
   Deutschtum im Ausland. Allgemeines: Förderung des Deutschtums
      im Ausland, Allgemeines, Bd.18 (1929–1934).
   Minderheiten. Nr.14: Minderheiten und Judenfragen, Bd.1
      (1933–1934).
9. Politische Abteilung I:
   Handel für Pol.I, Waffenhandel und Waffenherstellung (4.37–6.38).
10. Politische Abteilung I—Völkerbund:
    Abrüstung. Abrüst.: Waffenhandel und Waffenherstellung, Bd.1
       (8.36–4.38).
    Mandate. Mandate: Allgemeines, Bd.1 (5.36–6.40).
    Mandate. Mandate: Tätigkeit der Mandatskommission, Bd.1
       (6.36–1.40).
    Länderakten. Palästina, Bd.1 (2.37–5.39).
    Länderakten. Irak, Bd.1 (5.36–8.39).
11. Politische Abteilung II:
    Politik 3—England: Politische Beziehungen zwischen England und
       Palästina, Bde.1,2 (5.36–4.40).
    Politik 3—Frankreich-Polen: Politische Beziehungen zwischen Frank-
       reich und Polen, Bd.2 (6.36–12.39).
12. Politische Abteilung IV:
    Politik 2–3—Italien: Besuch Mussolinis in Deutschland in September,
       1937, Deutsche Presse-Stimmen (9.37–11.37).
    Politik 36—Ungarn: Judenfragen (2.38–1.43).
13. Politische Abteilung V:
    Politik 1: Allgemeine auswärtige Politik Polens, Bd.1 (7.36–3.41).
    Politik 36: Judenfrage in Polen, Bd.1 (5.36–10.42).
14. Politische Abteilung VII:
    Politik 2—Palästina: Politische Beziehungen Palästinas zu Deutsch-
       land, Bd.1 (7.36–12.38).
    Politik 5—Palästina: Innere Politik, Parlaments- und Parteiwesen,
       Palästina, Bd.1 (5.36–2.37).
    Politik 5a—Palästina: Plan der Aufteilung Palästinas und Stellung-
       nahme der fremden Länder dazu, Bde.1,2,3 (6.37–12.38).
    Politik 36—Palästina: Judenfrage (8.36–5.43).
    Politik 2—Saudisch Arabien: Politische Beziehungen Saudisch Ara-
       biens zu Deutschland, Bd.1 (11.37–9.39).
    Politik 5—Irak: Innere Politik, Parlaments- und Parteiwesen, Bd.1
       (5.36–1.39).
    Politik 2—Iran: Politische Beziehungen Irans zu Deutschland, Bd.1
       (7.36–12.40).
15. Handelspolitische Abteilung:
    Kriegsgerät (Geheim). Kriegsgerät: Handel mit Kriegsgerät—Allge-
       meines, Bde.1,3,4 (5.36–2.40).
    Kriegsgerät (Geheim). Kriegsgerät: Handel mit Kriegsgerät—Irak, Bde.
       1,2 (3.37–12.37).

Handakten Wiehl. Vierjahresplan, Bd.1.

Handakten Wiehl. Afghanistan, Bd.1 (9.25–7.40).

Handakten Wiehl. Palästina (3.41–4.41).

Handakten Clodius. Ägypten (2.33–3.39).

Handakten Clodius. Palästina (8.33–12.37).

16. Partei Dienststellen/Aussenpolitisches Amt:
Rosenberg 2: Korrespondenz, Glückwünsche, Manuskripte für Reden
   (1936–1944).
Allgemein: Vertrauliche Aufzeichnungen betr. England, Berichte und
   Notizen bzgl. Italien, Österreich, Rumänien und Ungarn.
   Beschlüsse der Politbüro der WKPB, Notizen für den Führer
   bzgl. des "Marquess of Londonderry," u.a. (1933–1942).
Allgemein: Afghanistan, Zielsetzung des APA der NSDAP.
Politische Berichte: Afghanistan (1933–1939).
Politische Berichte: Saudisch Arabien (1933–1939).

17. Dienststelle Ribbentrop:
Vertrauliche Berichte, Teil I, Teil II (1935–1939).

18. Büro des Chefs der Auslandsorganisation:
Judenstaat Palästina (1937–1938).
Palästina, Haavara, Juden, Bd.57 (1938–1939).
Irak, Bd.92 (1937–1941).
Runderlass A.O.6: Richtlinien für die Zusammenarbeit von Partei-
   stellen und Vertretungen im Ausland, Bd.131 (1937–1938).
Statistik, Bd.28 (1937).

19. Referat Deutschland:
Po5 NE adh1 Nr.1: Boykottauswirkung auf den deutschen Aus-
   senhandel, Bde. 1,2 (3.33–12.33).
Po5 NE adh2 allg.: Bekämpfung der Hetz- und Greuelpropaganda sowie
   Boykottabwehr, Bd.1 (3.33–1.34).
Po5 NE adh6: Die Judenfrage, allgemeines, Bd.3 (7.32–1.34).
Po5 NE adh6 Nr.4: Judenfrage (Auslandsstimmen), Bde.1,2
   (2.33–12.33).
Po5 NE adh7: Nationalsozialistische Bewegungen in anderen Ländern,
   Bd.1 (4.33–12.33).
Po5 NE allg.Nr.6: Auswirkung der nationalen Erhebung auf die deut-
   schen Kolonien im Amtsbezirk der deutschen Auslands-
   vertretungen, Bde.1,2 (3.33–12.33).

20. Inland II A/B:
82–00c: Chef der Auslandsorganisation im Auswärtigen Amt, Bd.1
   (1937–1938).
82–02: Nationalsozialistische Ortsgruppen im Ausland, Bd.2
   (1933–1936).
82–03: Gesuche von Ausländern in die NSDAP (1934–1939).
82–32: Sdh: Judengesetzgebung (1938–1941).
83–20: Das Judentum, allg., Bde.1,3,3/2 (1934–1940).
83–21: Das Judentum in Deutschland, Bde.1,3,5,8 (1934–1941).

83–21a: Auswanderung der Juden aus Deutschland, Bde.1,1a
    (1936–1937).
83–24: Judenauswanderung, allgemeines, Bde.1,2,3 (1938–1940).
83–24a: Gründung eines Palästinastaates, Bde.1,2 (1937–1944).
83–24c: Judenreservat in Polen.
83–24: SdhIV: Auswanderung jüdischer Hochschullehrer, usw.
83–26: Polen: Juden in Polen, General-Gouvernement (1933–1944).
83–29: Judenkongresse im Ausland, Bd.1 (1934–1944).
83–63: Boykott der deutschen Wirtschaft im Ausland, Bde.1,3
    (1933–1935).
21. Gesandtschaft Bukarest:
    I A 3: Beziehungen Rumänien und Deutschland, Bd.1 (1932–1939).
22. Botschaft Ankara:
    Politik 3: Palästina (1924–1938).
23. Gesandtschaft Bern:
    Palästina: Palästina, Bd.1 (1922–1937).
24. Botschaft Rom (Quir)—Geheim-Akten:
    44/1: Vorschläge des Grossmuftis betr. Syrien, Palästina und Transjor-
        danien (o.D.).
25. Botschaft Rom:
    Politik 3: Palästina, Bd.1 (1920–1939).
26. Botschaft beim Heiligen Stuhl:
    51: Palästina-Zionismus, Bd.2 (1919–1943).
27. Generalkonsulat Beirut:
    63: Palästina und Transjordanien, Bd.2 (1927–1939).
Bundesarchiv/Koblenz
    1. Reichskanzlei (R/43):
        Auswärtige Angelegenheiten. R/43–II: 1399, 1400, 1420, 1421a,
            1432a, 1433, 1434, 1450.
        Judentum. R/43–II: 329, 540, 600, 602.
        Kolonien. R/43–I: 626a, 627.
        Reichskanzlei. R/43–II: 991a.
    2. NSDAP-Hauptarchiv (NS/26):
        Hitler persönlich. NS/26: 2, 2/1, 51, 53, 60.
        Rassenfrage. NS/26: 508.
    3. Schumacher Collection:
        124, 240/I, 240/II, 293.
    4. Reichssicherheitshauptamt (R/58):
        Verfolgung der Juden. R/58: 276, 955, 956, 979, 982, 984, 991, 1239,
            1242, 1253.
    5. Deutsches Auslands-Institut/Stuttgart (R/57):
        R/57–25.
    6. Reichsministerium des Innern (R/18):
        R/18–5514.
    7. Reichswirtschaftsministerium (R/7):
        Handelsverbindungen mit Irak. R/7–VI: 222/2.

Handelsverbindungen mit Palästina. R/7–VI: 326/1.
8. Reichsfinanzministerium (R/2):
   R/2–225.
Geheimes Staatsarchiv/Berlin
   1. Rep. 335/11/481, NG 3580 (Office of the Chief Counsel for War
      Crimes).
National Archives/Washington, D.C.
   1. State Department, Decimal Files, 1930–1939:
      762.67n: Relations, Treaties, Germany and Palestine.
      840.48: Refugees, Refugee Questions.
      862.00: General Political, Germany.
      862.4016: Race Problems, Germany.
      862.5151: Germany, Financial.
      867n.01: General Political, Palestine.
   2. German Records on Microfilm:
      Von Hentig Nachlass. T–120/747.
      Von Etzdorf Nachlass. T–120/738.
      Reichsführer-SS und Chef der Deutschen Polizei.
            T–175/280,408,410,411,508,R588.
   3. MS/P–207: "German Exploitation of the Arab Nationalist Movements
      in World War II," by General der Flieger a.D. Helmuth Felmy
      and General der Artillerie a.D. Walter Warlimont, with a
      foreword by Generaloberst a.D. Franz Halder (Historical Di-
      vision, Headquarters, U.S. Army–Europe).
   4. "Transcripts of the Pre-Trial Interrogations of Vicco von Bülow-
      Schwante," Interrogation No. 2122, October 8, 1947, and of
      Emil Schumburg, No. 4226, July 21, and October 21, 1947.
Israel State Archives/Jerusalem
   1. Files of the German Consulate-General/Jerusalem, 1926–1939:
      Personalien und Amtsbetrieb des Konsulats: 954.
      Staatsangehörigkeit und Passwesen: 1145.
      Rechtswesen und Polizeiwesen: 1235.
      Wirtschaftssachen und Landwirtschaft: 1242, 1246, 1247, 1251, 1252,
            1253, 1254, 1272.
      Kultur und Schulwesen: 1358, 1359, 1362, 1383.
      Deutschtum und Deutsche Anstalten in Palästina und Transjordanien:
            1421, 1434.
Central Archives for the History of the Jewish People, Hebrew
University/Jerusalem
   1. The Papers of Georg Kareski: P/82–12a, 17, 36.
Central Zionist Archives/Jerusalem
   1. The Jewish Agency Executive, London (Z/4).
   2. The Jewish Agency Organization Department (S/5).
   3. The Jewish Agency Office, Geneva (L/22).
   4. The Private Papers of Alfred Klee (A/142).

Yad Vashem Institute for the Study of the European Jewish
Catastrophe/Jerusalem
  1. Remnants of the Files of the NSDAP/Landesgruppe-Palästina,
       1934–1939.
Centre de Documentation Juive Contemporaine/Paris
  1. The Rosenberg Collection: CXLIII/326, CXLV/623.
Public Record Office/London
  1. General Correspondence of the Foreign Office, 1933–1939 (FO/371):
       FO 371/17876–E1279, 17878–E4468, 20020–E3048, 20020–E3327,
            20021–E4329, 20022–E4858, 20028–E6609, 20605–E1601,
            20806–E2435, 20807–E3171, 20812–E5138, 20816–E5874,
            20820–E6816, 20911–J4567, 21592–C14652,
            21659–C14812, 21665–C14758, 21782–C7624,
            21871–E7394, 21872–E7560, 21874–E1598, 21876–E2570,
            21877–E3137, 21878–E4188, 21884–E6725, 21887–E3046,
            21887–E4838, 21888–E4405, 21888–E5244, 21998–E1355,
            22988–C551618, 23191–E5128, 23232–E2274,
            23238–E5101, 25238–W7663848.
Institut für Zeitgeschichte/Munich
  1. Akten des Eichmannprozesses—Beweisdokumente: 2, 742, 1429.
  2. Lösener Handakten: F–71/3, 4–9, Emigr. IV–2 Palästina.
Die Tempelgesellschaft in Deutschland/Stuttgart-Degerloch
  1. *Die Warte des Tempels*. Halbmonatsschrift zur Vertiefung in die
       Fragen und Aufgaben des Menschenlebens, 1933–1939.
Concordia University/Montreal
  1. Transcript of the Trial in the Case of the Attorney General of the Gov-
       ernment of Israel v. Adolf, the Son of Karl Adolf Eichmann,
       in the District Court of Jerusalem. Criminal Case No. 40/61
       (an unedited and unrevised transcript of the simultaneous
       translation), Washington, D.C.: Microcard Editions, 1962.
Leo Baeck Institute/New York
  1. The Weltsch Papers.

*Interviews, Correspondence*

Interviews:
Dr. Werner-Otto von Hentig, Seibersbach bei Bingen. September 14, 1973;
       and November 27, 1974.
Dr. Fritz Grobba, Bad Godesberg. June 30, 1973.
Correspondence:
General Gerhard Engel: May 18, 1976.
Dr. Werner Feilchenfeld: April 17, October 24, 1974.
Walter Frentz: April 2, 1976.
Otto Günsche: January 5, 1976.
Dr. Werner-Otto von Hentig: February 25, March 15, April 16, 1974; July
       15, 1975; January 10, April 3, 1976.
Dr. Richard Otto Hoffmann: April 16, May 8, 1975; March 12, 1976.

Jabotinsky Institute/Tel Aviv, No. 469: September 28, 1976.
Mauser-Jagdwaffen GmbH: December 22, 1975.
Dr. Werner Naumann to Mr. Richard Schulze-Kossens: November 4, 1975.
Col. Hans Roschmann: March 23, 1976.
Richard Schulze-Kossens: November 26, 1975; January 7, 1976.
Dr. Franz Sonnleithner: January 4, 1976.
Dr. Albert Speer: February 24, 1976.
Dr. Ernst Woermann: March 17, 1976.

**Primary Sources—Published**

*Documents and Papers*

Deuerlein, Ernst. "Hitlers Eintritt in die Politik und die Reichswehr." *Vierteljahrshefte für Zeitgeschichte* 7, 1959.

Domarus, Max. *Hitler: Reden und Proklamationen 1932–1945.* 4 vols. München: Süddeutsche Verlag, 1965.

Feder, Gottfried. *Hitler's Official Program and Its Fundamental Ideas.* New York: Howard Fertig, 1971.

Federal Republic of Germany. *Akten zur deutschen auswärtigen Politik 1918–1945.* Serie C, Vols. 1/2, 3/2. Göttingen, 1971–1973. Serie D, Vols. 1, 2, 4, 5, 6, 7. Baden-Baden, 1950–1956.

Great Britain. *Documents on British Foreign Policy, 1919–1939.* Third Series, Vols. 1, 7. London, 1949, 1953.

———. *Palestine Royal Commission Report.* Cmd. 5479. London: H.M. Stationery Office, 1937.

———. *Parliamentary Debates* (5th Series). (Commons) Vol. 313. London: H.M. Stationery Office, 1936.

Hill, Leonidas (ed.). *Die Weizsäcker Papiere 1933–1950.* Berlin: Propyläen Verlag, 1975.

Hurewitz, J. C. (ed.). *Diplomacy in the Near and Middle East: A Documentary Record, 1914–1955.* 2 vols. New York: D. Van Nostrand, 1956.

Ingrams, Doreen. *Palestine Papers, 1917–1922: Seeds of Conflict.* London: John Murray, 1972.

International Military Tribunal. *Trial of the Major War Criminals before the International Military Tribunal, Nürnberg, 14 November, 1945 to 1 October, 1946.* Vols. 9, 13, 14, Proceedings 14/11/45–1/10/46, 3/5–15/5/46, 16/5–28/5/46, Nürnberg, 1947–1948. Vols. 25, 28, 41, Documents in Evidence. Nürnberg, 1947–1949.

*Kriegstagebuch des Oberkommandos der Wehrmacht (Wehrmachtführungsstab).* Vol. 1, 1.Aug.1939–31.Dez.1941. Frankfurt/Main: Bernhard Graefe Verlag für Wehrwesen, 1965.

Lang, Jochen von (ed.). *Eichmann Interrogated: Transcripts from the Archives of the Israeli Police.* Translated by Ralph Manheim. New York: Farrar, Straus and Giroux, 1983.

Mommsen, Hans. "Dokumentation: Der nationalsozialistische Polizeistaat

und die Judenverfolgung vor 1938." *Vierteljahrshefte für Zeitgeschichte* 10, 1962.

Muggeridge, Malcolm (ed.). *Ciano's Diplomatic Papers.* Translated by Stuart Hood. London: Odhams Press, 1948.

Phelps, Reginald. "Hitler als Parteiredner im Jahre 1920." *Vierteljahrshefte für Zeitgeschichte* 11, 1963.

———. "Hitlers grundlegende Rede über den Antisemitismus." *Vierteljahrshefte für Zeitgeschichte* 16, 1968.

Treue, Wilhelm. "Hitlers Denkschrift zum Vierjahresplan." *Vierteljahrshefte für Zeitgeschichte* 3, 1955.

———. "Rede Hitlers vor der deutschen Presse (10. November 1938)." *Vierteljahrshefte für Zeitgeschichte* 6, 1958.

Yahil, Leni (ed.). "Selected British Documents on the Illegal Immigration to Palestine, 1939–1940." *Yad Vashem Studies* 10, 1974.

*Diaries and Memoirs*

Avon, Rt. Hon. Earl of. *The Eden Memoirs: Facing the Dictators.* London: Cassell, 1962.

Bernstorff, J. H. Graf von. *Memoirs of Count Bernstorff.* New York: Random House, 1936.

Blumenfeld, Kurt. *Erlebte Judenfrage: Ein Vierteljahrhundert deutscher Zionismus.* Stuttgart: Deutsche Verlags-Anstalt, 1962.

Burckhardt, Carl J. *Meine Danziger Mission 1937–1939.* München: Verlag Georg D. W. Callwey, 1960.

Chamberlain, Neville. *In Search of Peace.* New York: G. Putnam, 1939.

Grobba, Fritz. *Männer und Mächte im Orient: 25 Jahre Diplomatischer Tätigkeit im Orient.* Göttingen: Musterschmidt Verlag, 1967.

Groscurth, Helmuth. *Tagebücher eines Abwehroffiziers 1938–1940.* Stuttgart: Deutsche Verlags-Anstalt, 1970.

Halifax, Earl of. *Fullness of Days.* London: Collins, 1957.

Hanfstaengl, Ernst. *Hitler, The Missing Years.* London: Eyre and Spottiswoode, 1957.

Hassell, Ulrich von. *Vom anderen Deutschland: Aus den nachgelassenen Tagebüchern 1938–1944.* Frankfurt/Main: Fischer Bücherei, 1964.

Henderson, Neville. *Failure of a Mission, 1937–1939.* New York: G. P. Putnam's Sons, 1940.

Hentig, Werner-Otto von. *Mein Leben, Eine Dienstreise.* Göttingen: Vandenhoeck and Ruprecht, 1962.

Hitler, Adolf. *Mein Kampf.* New York: Reynal and Hitchcock, 1941.

———. *The Secret Book.* Translated by Salvator Attanasio. New York: Grove Press, 1961.

Jones, Thomas. *A Diary with Letters, 1931–1950.* London: Oxford University Press, 1954.

Kersten, Felix. *Totenkopf und Treue: Heinrich Himmler ohne Uniform: Aus den Tagebüchern des finnischen Medizinalrats.* Hamburg: Robert Mölich Verlag, 1952.

Kordt, Erich. *Nicht aus den Akten: Die Wilhelmstrasse in Frieden und Krieg: Erlebnisse, Begegnungen, Eindrücke.* Stuttgart: Union Deutsche Verlagsgesellschaft, 1950.

Kotze, Hildegard von (ed.). *Heeresadjutant bei Hitler 1938–1943: Aufzeichnungen des Majors Engel.* Stuttgart: Deutsche Verlags-Anstalt, 1974.

Kubizek, August. *Adolf Hitler, Mein Jugendfreund.* Graz: Leopold Stocker Verlag, 1953.

Jedrzejewicz, Waclaw (ed.). *Diplomat in Berlin, 1933–1939: Papers and Memoirs of Josef Lipski, Ambassador of Poland.* New York: Columbia University Press, 1968.

Lichtheim, Richard. *Rückkehr: Lebenserinnerungen aus der Frühzeit des deutschen Zionismus.* Stuttgart: Deutsche Verlags-Anstalt, 1970.

Luedecke, Kurt. *I Knew Hitler.* New York: Scribners, 1937.

Muggeridge, Malcolm (ed.). *The Ciano Diaries, 1937–1938.* London: Methuen, 1952.

———. *The Ciano Diaries, 1939–1943.* London: W. Heinemann, 1947.

Pünder, Hermann. *Von Preussen nach Europa: Lebenserinnerungen.* Stuttgart: Deutsche Verlags-Anstalt, 1968.

Raeder, Erich. *Mein Leben.* 2 vols. Tübingen: Verlag Fritz Schlichtenmayer, 1956.

Rahn, Rudolf. *Ruheloses Leben: Aufzeichnungen und Erinnerungen.* Düsseldorf: Diederichs Verlag, 1949.

Ribbentrop, Joachim von. *Zwischen London und Moskau: Erinnerungen und letzte Aufzeichnungen.* Edited by A. von Ribbentrop. Leoni am Starnbergersee: Druffel Verlag, 1953.

Rosenbluth, Martin. *Go Forth and Serve: Early Years and Public Life.* New York: Herzl Press, 1961.

Schacht, Hjalmar. *My First Seventy-Six Years.* Translated by Diana Pyke. London: Allan Wingate, 1955.

Schellenberg, Walter. *Memoiren.* Edited by Gita Petersen. Köln: Verlag für Politik und Wirtschaft, 1959.

Schmidt, Paul-Otto. *Statist auf diplomatischer Bühne 1923–1945: Erlebnisse des Chefdolmetschers im Auswärtigen Amt mit den Staatsmänner Europas.* Bonn: Athenäum-Verlag, 1949.

Seraphim, Hans-Günther (ed.). *Das politische Tagebuch Alfred Rosenbergs aus den Jahren 1934–1935 und 1939–1940.* Göttingen: Musterschmidt Verlag, 1956.

Shirer, William. *Berlin Diary.* New York: Alfred A. Knopf, 1941.

Speer, Albert. *Inside the Third Reich.* Translated by Richard and Clara Winston. New York: Macmillan, 1970.

Strasser, Otto. *Hitler and I.* Translated by Gwenda David and Erich Mosbacher. London: Jonathan Cape, 1940.

Weizmann, Chaim. *Trial and Error: The Autobiography of Chaim Weizmann.* New York: Harper, 1949.

Weizsäcker, Ernst von. *Memoirs.* Translated by John Andrews. Chicago: H. Regnery, 1951.

Wiedemann, Fritz. *Der Mann der Feldherr Werden Wollte: Erlebnisse und Erfahrungen des Vorgesetzten Hitlers im Ersten Weltkrieg und seinen späteren persönlichen Adjutanten.* Velbert/Kettwig: Blick und Bild Verlag, 1964.

*Newspapers*

*Der Angriff*
*Jüdische Rundschau*
*Das Schwarze Korps*
*Völkischer Beobachter*
*Die Warte des Tempels*

**Secondary Sources (Books and Articles)**

Abshagen, Karl-Heinz. *Canaris.* Translated by Alan Houghton Broderick. London: Hutchinson, 1956.

Adam, Uwe Dietrich. *Judenpolitik im Dritten Reich.* Düsseldorf: Droste Verlag, 1972.

Adler, H. G. *Die Juden in Deutschland von der Aufklärung bis zum Nationalsozialismus.* München: Kosel Verlag, 1960.

Adler-Rudel, S. "The Evian Conference," *Yearbook of the Leo Baeck Institute* 13, 1968.

———. *Jüdische Selbsthilfe unter dem Naziregime 1933–1939.* Schriftenreihe wissenschaftlicher Abhandlungen des Leo Baeck Instituts 29. Tübingen: Mohr Verlag, 1974.

Aigner, Dietrich. *Das Ringen um England: Das deutsch-britische Verhältnis: Die öffentliche Meinung, Tragödie zweier Völker.* München: Bechtle Verlag, 1969.

Arendt, Hannah. *Eichmann in Jerusalem: A Report on the Banality of Evil.* New York: Viking Press, 1963.

———. *The Origins of Totalitarianism.* New York: Harcourt Brace Jovanovich, 1973.

Aronson, Schlomo. *Reinhard Heydrich und die Frühgeschichte von Gestapo und SD.* Stuttgart: Deutsche Verlags-Anstalt, 1971.

Arsenian, Seth. "Wartime Propaganda in the Middle East," *Middle East Journal* 2, 1948.

Avriel, Ehud. *Open the Gates.* New York: Atheneum, 1975.

Baker, Robert. *Oil, Blood and Sand.* New York: D. Appleton-Century, 1942.

Ball-Kaduri, Kurt Jacob. "Die illegale Einwanderung der deutschen Juden in Palästina, 1939–1940." *Jahrbuch des Instituts für Deutsche Geschichte* 4, 1975.

———. *Das Leben der Juden in Deutschland.* Frankfurt/Main: Europäische Verlags-Anstalt, 1963.

Ben Elissar, Eliahu. *La Diplomatie du IIIe Reich et les Juifs 1933–1939.* Paris: Julliard, 1969.

Bethell, Nicholas. *The Palestine Triangle.* New York: Putnam, 1979.

Black, Edwin. *The Transfer Agreement: The Untold Story of the Secret Pact between the Third Reich and Jewish Palestine.* New York: Macmillan, 1984.

Böhm, Adolf. *Die Zionistische Bewegung.* 2 vols. Berlin: Jüdischer Verlag, 1935.

Bollmus, Reinhard. *Das Amt Rosenberg und seine Gegner: Zum Machtkampf im Nationalsozialistischen Herrschaftssystem.* Stuttgart: Deutsche Verlags-Anstalt, 1970.

Bracher, K. D. "Das Anfangsstadium der Hitlerschen Aussenpolitik." *Vierteljahrshefte für Zeitgeschichte* 5, 1957.

———, W. Sauer and G. Schulz. *Die Nationalsozialistische Machtergreifung: Studien zur Errichtung des totalitären Herrschaftssystems in Deutschland 1933–1934.* Köln: Westdeutscher Verlag, 1960.

Braun, Siegfried. "Die Deutsche Tempelgesellschaft in Palästina." *Tribune* 1, 1962.

Brenner, Lenni. *Zionism in the Age of the Dictators.* Westport, Conn.: Lawrence Hill, 1983.

Broszat, Martin. *Der Nationalsozialismus: Weltanschauung, Programm und Wirklichkeit.* Stuttgart: Deutsche Verlags-Anstalt, 1961.

———. *Der Staat Hitlers: Grundlegung und Entwicklung seiner inneren Verfassung.* München: Deutsche Taschenbuch-Verlag, 1969.

Browning, Christopher. *The Final Solution and the German Foreign Office.* New York: Holmes and Meier, 1979.

Bullock, Alan. *Hitler: A Study in Tyranny.* New York: Harper and Row, 1963.

Bussmann, W. "Zur Entstehung und Überlieferung der Hossbach-Niederschrift." *Vierteljahrshefte für Zeitgeschichte* 16, 1968.

Carmel, Alex. "Die deutsche Palästinapolitik, 1871–1914." *Jahrbuch des Instituts für Deutsche Geschichte* 4, 1975.

———. *Die Siedlungen der württembergischen Templer in Palästina 1868–1918.* Stuttgart: W. Kohlhammer Verlag, 1973.

Cecil, Lamar. "Wilhelm II. und die Juden." In *Juden im Wilhelminischen Deutschland 1890–1914.* Schriftenreihe wissenschaftlicher Abhandlungen des Leo Baeck Instituts 33. Tübingen: Mohr Verlag, 1976.

Cecil, Robert. *The Myth of the Master Race: Alfred Rosenberg and Nazi Ideology.* London: Batsford, 1972.

Chamberlain, Houston Stewart. *Die Grundlagen des 19. Jahrhunderts.* 23rd ed., 2 vols. München: F. Bruckmann K.G., 1938.

Cleveland, William L. *Islam against the West: Shakib Arslan and the Campaign for Islamic Nationalism.* Austin: University of Texas Press, 1985.

Cohn, Norman. *Warrant for Genocide: The Myth of the Jewish World Conspiracy and the "Protocols of the Elders of Zion".* New York: Harper and Row, 1966.

Colvin, Ian. *Vansittart in Office: An Historical Survey of the Origins of the Second World War Based on the Papers of Sir Robert Vansittart.* London: Victor Gollancz, 1965.

Dawidowicz, Lucy. *The War against the Jews, 1933–1945.* New York: Holt, Rinehart, Winston, 1975.

Dekel, E. *SHAI: The Exploits of Hagana Intelligence.* New York: Thomas Yoseloff, 1959.

Dessouki, Mohamed-Kamal el. "Hitler und der Nahe Osten 1940–1941." Diss. Berlin, 1963.

Doering, Dörte. "Deutsche Aussenwirtschaftspolitik 1933–1935: Die Gleichschaltung der Aussenwirtschaft in der Frühphase des National-sozialistischen Regimes." Diss. Berlin, 1969.

Dühring, Eugen. *Die Judenfrage als Frage der Rassenschädlichkeit für Existenz, Sitte und Kultur der Völker.* 4th ed. Berlin: Reuther und Reichard, 1892.

Ehrich, Emil. *Die Auslandsorganisation der NSDAP.* Berlin: Junker und Dünnhaupt, 1937.

Eichstädt, Ulrich. *Von Dolfuss zu Hitler: Geschichte des Anschlusses Österreichs 1933–1938.* Wiesbaden: Franz Steiner Verlag, 1955.

Erbe, René. *Die Nationalsozialistische Wirtschaftspolitik 1933–1939 im Lichte der modernen Theorie.* Zürich: Polygraphischer Verlag, 1958.

Erez, Tsvi. "Germans in Palestine: Nazis and Templars." *Wiener Library Bulletin* 17, 1963.

Ergang, Robert. *Herder and the Foundations of German Nationalism.* New York: Columbia University Press, 1931.

Esco Foundation for Palestine Inc. *Palestine: A Study of Jewish, Arab and British Policies.* 2 vols. New Haven: Yale University Press, 1947.

Feilchenfeld, Werner, Dolf Michaelis and Ludwig Pinner. *Haavara-Transfer nach Palästina und Einwanderung deutscher Juden 1933–1939.* Schriftenreihe wissenschaftlicher Abhandlungen des Leo Baeck Instituts 26. Tübingen: Mohr Verlag, 1972.

Feiling, Keith. *The Life of Neville Chamberlain.* London: Macmillan, 1970.

Fest, Joachim. *Hitler.* Translated by Richard and Clara Winston. New York: Harcourt Brace Jovanovich, 1973.

Fischer, Wolfram. *Deutsche Wirtschaftspolitik 1918–1945.* Opladen: C. W. Leske Verlag, 1968.

Friedman, Isaiah. *Germany, Turkey and Zionism, 1897–1918.* Oxford: Oxford University Press, 1977.

———. *The Question of Palestine, 1914–1918: British-Jewish-Arab Relations.* London: Routledge and Kegan Paul, 1973.

Friedman, Philip. "The Lublin Reservation and the Madagascar Plan: Two Aspects of Nazi Jewish Policy during the World War." *Yivo Annual of Jewish Social Studies* 8, 1953.

Fritsch, Theodor. *Handbuch der Judenfrage.* 26th ed. Hamburg: Hanseat. Druck- und Verlagsanstalt, 1907.

Genschel, Helmut. *Die Verdrängung der Juden aus der Wirtschaft im Dritten Reich.* Göttingen: Musterschmidt Verlag, 1966.

Gordon, Sarah. *Hitler, Germans and the "Jewish Question."* Princeton: Princeton University Press, 1984.

Graml, Hermann. "Die Auswanderung der Juden aus Deutschland zwischen

1933 und 1939." In *Gutachten des Instituts für Zeitgeschichte.* Stuttgart: Deutsche Verlags-Anstalt, 1966.

Grossmann, Kurt. "Zionists and Non-Zionists under Nazi Rule in the 1930's." *Herzl Yearbook* 4, 1961–1962.

Halpern, Ben. *The Idea of a Jewish State.* Cambridge, Mass.: Harvard University Press, 1969.

Hauser, Oswald. *England und das Dritte Reich.* 2 vols. Stuttgart: Seewald, 1972.

Heiden, Konrad. *Der Fuehrer.* Translated by Ralph Manheim. Boston: Houghton Mifflin, 1944.

———. *A History of National Socialism.* London: Methuen, 1934.

Henke, Josef. *England in Hitlers politischem Kalkül 1935–1939.* Boppard am Rhein: Boldt, 1973.

Hentig, Werner-Otto von. "Palästina." In *Jahrbuch der Hochschule für Politik.* Berlin: Junker und Dünnhaupt Verlag, 1940.

Herrmann, Klaus. *Das Dritte Reich und die deutsch-jüdischen Organisationen 1933–1934.* Köln: Heymann, 1969.

———. "Political Response to the Balfour Declaration in Imperial Germany: German Judaism." *Middle East Journal* 19, 1965.

Herzl, Theodor. *The Jewish State: An Attempt at a Modern Solution of the Jewish Question.* New York: Scopus Publishing, 1943.

Hess, Moses. *Rome and Jerusalem: A Study in Jewish Nationalism.* Translated by Rabbi Maurice J. Bloom. New York: Philosophical Library, 1958.

Hevesi, Eugene. "Hitler's Plan for Madagascar." *Contemporary Jewish Record* 4, 1941.

Hilberg, Raul. *The Destruction of the European Jews.* Chicago: Quadrangle Books, 1961.

Hildebrand, Klaus. *The Foreign Policy of the Third Reich.* Translated by Anthony Fothergill. Berkeley: University of California Press, 1973.

———. *Vom Reich zum Weltreich: Hitler, NSDAP und Kolonialfrage 1919–1945.* München: Wilhelm Fink Verlag, 1969.

Hillgruber, Andreas. *Deutschlands Rolle in der Vorgeschichte der beiden Weltkriege.* Göttingen: Vandenhoeck und Ruprecht, 1967.

———. "Die Endlösung und das deutsche Ostimperium als Kernstück des rassenideologischen Programms des Nationalsozialismus." *Vierteljahrshefte für Zeitgeschichte* 20, 1972.

———. "England's Place in Hitler's Plans for World Domination." *Journal of Contemporary History* 9, 1974.

———. *Hitlers Strategie: Politik und Kriegführung 1940–1941.* Frankfurt/Main: Bernhard Graefe Verlag für Wehrwesen, 1965.

Hirszowicz, Lukasz. *The Third Reich and the Arab East.* London: Routledge and Kegan Paul, 1966.

Hoffmann, Peter. *Widerstand Staatsstreich Attentat: Der Kampf der Opposition gegen Hitler.* München: R. Piper Verlag, 1970.

Höhne, Heinz. *Der Orden unter dem Totenkopf: Die Geschichte der SS.* Gütersloh: Sigbert Mohn Verlag, 1967.

Horn, Wolfgang. "Ein unbekannter Aufsatz Hitlers aus dem Frühjahr 1924." *Vierteljahrshefte für Zeitgeschichte* 16, 1968.

Horowitz, David and Rita Hendon. *Economic Survey of Palestine, with Special Reference to the Years 1936–1937.* Tel Aviv: Economic Research Institute of the Jewish Agency for Palestine, 1938.

Hunczak, Taras. "Polish Colonial Ambitions in the Inter-War Period." *Slavic Review* 26, 1967.

Hurewitz, J. C. *The Struggle for Palestine.* New York: Greenwood, 1968.

Jäckel, Eberhard. *Hitlers Weltanschauung: Entwurf einer Herrschaft.* Tübingen: Rainer Wunderlich Verlag Hermann Leins, 1969.

Jacobsen, Hans-Adolf. *Nationalsozialistische Aussenpolitik 1933–1938.* Frankfurt/Main: Alfred Metzner Verlag, 1968.

Jankowski, James. "Egyptian Responses to the Palestine Problem in the Interwar Period." *International Journal of Middle East Studies* 12, 1980.

Katz, Jacob. *From Prejudice to Destruction: Anti-Semitism, 1700–1933.* Cambridge, Mass.: Harvard University Press, 1980.

Katz, Shlomo. "Public Opinion in Western Europe and the Evian Conference of July, 1938." *Yad Vashem Studies* 9, 1973.

Kempner, Robert. *Eichmann und Komplizen.* Zürich: Europa Verlag, 1961.

Khadduri, Majid. *Independent Iraq, 1932–1958: A Study in Iraqi Politics.* London: Oxford University Press, 1960.

Kimche, Jon and David Kimche. *The Secret Roads: The Illegal Migration of a People, 1938–1948.* London: Secker and Warburg, 1954.

Krausnick, Helmut and Martin Broszat. *Anatomy of the SS State.* Translated by Dorothy Lang and Marian Jackson. London: Paladin: 1970.

Kuhn, Axel. *Hitlers aussenpolitisches Programm.* Stuttgart: Klett Verlag, 1970.

Laqueur, Walter. *History of Zionism.* New York: Holt, Rinehart and Winston, 1972.

Levin, Nora. *The Holocaust: The Destruction of European Jewry, 1933–1945.* New York: Schocken Books, 1973.

Lichtheim, Richard. *Die Geschichte des deutschen Zionismus.* Jerusalem: R. Maas, 1954.

Lösener, Bernhard. "Als Rassereferent im Reichsministerium des Innern." *Vierteljahrshefte für Zeitgeschichte* 9, 1961.

Lowenthal, Marvin. *The Jews of Germany: The Story of Sixteen Centuries.* New York: Russell and Russell, 1970.

Marcus, Ernst. "The German Foreign Office and the Palestine Question in the Period 1933–1939." *Yad Vashem Studies* 2, 1958.

Marlowe, John. *The Seat of Pilate: An Account of the Palestine Mandate.* London: Cresset Press, 1959.

Marr, Wilhelm. *Der Sieg des Judenthums über das Germanenthum: Vom nicht confessionellen Standpunkt aus betrachtet.* Bern: Rudolf Costenoble, 1879.

Maser, Werner. *Die Frühgeschichte der NSDAP: Hitlers Weg bis 1924.* Frankfurt/Main: Athenäum Verlag, 1965.

Massing, Paul. *Rehearsal for Destruction: A Study of Political Anti-Semitism in Imperial Germany.* New York: Harper, 1949.

Melka, Robert. "The Axis and the Arab Middle East, 1930–1945." Diss. University of Minnesota, 1966.

Mosse, G. L. *Toward the Final Solution: A History of European Racism.* New York: Harper and Row, 1978.

Mosse, Werner E. (ed.). *Deutsches Judentum in Krieg und Revolution 1916–1923.* Mitwirkung von Arnold Paucker. Schriftenreihe wissenschaftlicher Abhandlungen des Leo Baeck Instituts 25. Tübingen: Mohr Verlag, 1971.

———. *Entscheidungsjahr 1932: Zur Judenfrage in der Endphase der Weimarer Republik.* Mitwirkung von Arnold Paucker. Schriftenreihe wissenschaftlicher Abhandlungen des Leo Baeck Instituts 13. Tübingen: Mohr Verlag, 1966.

———. *Juden im Wilhelminischen Deutschland 1890–1914.* Mitwirkung von Arnold Paucker. Schriftenreihe wissenschaftlicher Abhandlungen des Leo Baeck Instituts 33. Tübingen: Mohr Verlag, 1976.

Neubert, Friedrich Paul Harald. "Die deutsche Politik im Palästinakonflikt 1937–1938." Diss. Bonn, 1977.

Nicosia, Francis R. "Arab Nationalism and National Socialist Germany, 1933–1939: Ideological and Strategic Incompatibility." *International Journal of Middle East Studies* 12, 1980.

———. "National Socialism and the Demise of the German-Christian Communities in Palestine during the Nineteen Thirties." *Canadian Journal of History* 14, 1979.

———. "Weimar Germany and the Palestine Question." *Yearbook of the Leo Baeck Institute* 24, 1979.

Niewyk, Donald. *The Jews in Weimar Germany.* Baton Rouge: Louisiana State University Press, 1980.

Nolte, Ernst. "Eine frühe Quelle zu Hitlers Antisemitismus." *Historische Zeitschrift* 192, 1961.

———. *Three Faces of Fascism.* Translated by Leila Vennewitz. New York: New American Library, 1969.

Paucker, Arnold. *Der jüdische Abwehrkampf gegen Antisemitismus und Nationalsozialismus in den letzten Jahren der Weimarer Republik.* Hamburg: Leibniz, 1969.

———. "Zur Problematik einer jüdischen Abwehrstrategie in der deutschen Gesellschaft." In *Juden im Wilhelminischen Deutschland 1890–1914.* Schriftenreihe wissenschaftlicher Abhandlungen des Leo Baeck Instituts 33. Tübingen: Mohr Verlag, 1976.

Pearlman, Maurice. *Mufti of Jerusalem: The Story of Haj Amin el-Husseini.* London: Victor Gollancz Ltd., 1947.

Petersen, Jens. *Mussolini-Hitler: Die Entstehung der Achse Rom-Berlin 1933–1936.* Tübingen: Max Niemeyer Verlag, 1973.

Petzina, Dieter. *Autarkiepolitik im Dritten Reich: Der Nationalsozialistische Vierjahresplan.* Stuttgart: Deutsche Verlags-Anstalt, 1968.

————. "Hauptprobleme der deutschen Wirtschaftspolitik 1932–1933." *Vierteljahrshefte für Zeitgeschichte* 15, 1967.

Phelps, Reginald. "Before Hitler Came: Thule Society and Germanen Orden." *Journal of Modern History* 35, 1963.

————. "Hitler and the Deutsche Arbeiterpartei." *American Historical Review* 68, 1963.

Pinsker, Leo. *Autoemanzipation*. Berlin: Commissions-Verlag von W. Issleib, 1882.

Poliakov, Leon. *The History of Anti-Semitism: From Voltaire to Wagner.* Vol. 3. Translated by Miriam Kochan. London: Routledge and Kegan Paul, 1975.

Poppel, Stephen. *Zionism in Germany, 1897–1933: The Shaping of a Jewish Identity.* Philadelphia: Jewish Publication Society of America, 1977.

Prinz, Arthur. "The Role of the Gestapo in Obstructing and Promoting Jewish Emigration." *Yad Vashem Studies* 2, 1958.

Pulzer, Peter. *The Rise of Political Anti-Semitism in Germany and Austria.* New York: John Wiley and Sons, 1964.

Reichmann, Eva. *Die Flucht in den Hass: Die Ursachen der deutschen Judenkatastrophe.* Frankfurt/Main: Europa Verlags-Anstalt, 1956.

Reile, Oscar. *Geheime Ostfront: Die deutsche Abwehr im Osten 1921–1945.* München: Verlag Welsermuhl, 1963.

Reinharz, Jehuda. *Fatherland or Promised Land: The Dilemma of the German Jew, 1893–1914.* Ann Arbor: University of Michigan Press, 1975.

Reitlinger, Gerald. *The Final Solution: The Attempt to Exterminate the Jews of Europe, 1939–1945.* New York: A. S. Barnes, 1961.

Reynolds, Quentin. *Minister of Death: The Adolf Eichmann Story.* New York: Viking Press, 1960.

Rose, Norman Anthony. "The Arab Rulers of Palestine, 1936: The British Reaction." *Journal of Modern History* 44, 1972.

Rosenberg, Alfred. *Houston Stewart Chamberlain als Verkünder und Begründer einer deutschen Zukunft.* München: Bruckmann, 1927.

————. *Der Mythus des 20. Jahrhunderts: Eine Wertung der seelisch-geistigen Gestaltenkämpfe unserer Zeit.* München: Verlag Franz Eher Nachf., 1930.

————. *Pest in Russland! Der Bolschewismus, Seine Häupter, Handlanger und Opfer.* München: Deutscher Volksverlag, 1922.

————. *Die Protokolle der Weisen von Zion und die jüdische Weltpolitik.* 6th ed. München: Deutscher Volksverlag, 1933.

————. *Die Spur des Juden im Wandel der Zeiten.* München: Deutscher Volksverlag, 1920.

————. *Der staatsfeindliche Zionismus.* Hamburg: Deutschvölkische Verlagsanstalt, 1922.

————. *Totengräber Russlands.* München: Deutscher Volksverlag, 1921.

————. *Unmoral im Talmud.* München: Deutscher Volksverlag, 1920.

————. *Der Weltverschwörerkongress zu Basel.* München: Verlag Franz Eher Nachf., 1927.

————. *Der Zukunftsweg einer deutschen Aussenpolitik.* München: Verlag Franz Eher Nachf., 1927.

Rosenkranz, J. D. "The Kristallnacht in Austria in the Light of the Historical Sources." *Yad Vashem Studies* 14, 1964.

Rosenstock, Werner. "Exodus 1933–1939: A Survey of Jewish Emigration from Germany." *Yearbook of the Leo Baeck Institute* 1, 1956.

Sachar, Howard. *Europe Leaves the Middle East, 1936–1954.* New York: Alfred Knopf, 1972.

Salvemeni, Gaetano. *Mussolini Diplomatico, 1922–1932.* Bari: Gius Laterza e Figli, 1952.

Sauer, Paul. *Beilharz-Chronik: Die Geschichte eines Schwarzwälder Bauern- und Handwerkergeschlechts vom 15. Jahrhundert bis Heute in Deutschland, Palästina und Australien.* Ulm: Süddeutsche Verlagsgesellschaft, 1975.

Schechtman, Joseph. *The Mufti and the Führer: The Rise and Fall of Haj Amin el-Husseini.* New York: Thomas Yoseloff, 1965.

Schleunes, Karl. *The Twisted Road to Auschwitz: Nazi Policy toward German Jews, 1933–1939.* Urbana: University of Illinois Press, 1970.

Schmidt, H. D. "The Nazi Party in Palestine and the Levant, 1932–1939." *International Affairs* 28, 1952.

Schmokel, W. W. *Dream of Empire: German Colonialism, 1919–1945.* New Haven: Yale University Press, 1964.

Schölch, Alexander. "Drittes Reich, zionistische Bewegung und Palästina-Konflikt." *Vierteljahrshefte für Zeitgeschichte* 31, 1983.

Schöllgen, Gregor. *Imperialismus und Gleichgewicht: Deutschland, England und die orientalische Frage 1871–1914.* München: R. Oldenbourg Verlag, 1984.

Schorsch, Ismar. *Jewish Reactions to German Anti-Semitism, 1870–1914.* New York: Columbia University Press, 1972.

Schröder, Bernd. *Deutschland und der Mittlere Osten im Zweiten Weltkrieg.* Göttingen: Musterschmidt Verlag, 1975.

Schröder, Hans-Jürgen. *Deutschland und die Vereinigten Staaten 1933–1939. Wirtschaft und Politik in der Entwicklung des deutsch-amerikanischen Gegensatzes.* Wiesbaden: Franz Steiner Verlag, 1970.

Schröder, Josef. "Die Beziehungen der Achsenmächte zur arabischen Welt." *Zeitschrift für Politik* 18, 1971.

Schubert, Günter. *Anfänge nationalsozialistischer Aussenpolitik.* Köln: Verlag Wissenschaft und Politik, 1963.

Seabury, Paul. *The Wilhelmstrasse: A Study of German Diplomats under the Nazi Regime.* Berkeley: University of California Press, 1954.

Seibt, Hans. "Moderne Kolonisation in Palästina." Diss. Leipzig, 1933.

Siebert, Ferdinand. *Italiens Weg in den Zweiten Weltkrieg.* Bonn: Athenäum Verlag, 1962.

Sokolov, Nahum. *History of Zionism, 1600–1918.* 2 vols. London: Longmans, Green, 1919.

Sommer, Theo. *Deutschland und Japan zwischen den Mächten 1935–*

*1940: Vom Antikominternpakt zum Dreimächtepakt*. Tübingen: Mohr Verlag, 1962.

Stein, Alexander. *Adolf Hitler, Schüler der Weisen von Zion*. Karlsbad: Verlags-Anstalt Graphia, 1936.

Stein, Leonard. *The Balfour Declaration*. New York: Simon and Schuster, 1961.

Stern, Fritz. *The Politics of Cultural Despair*. Berkeley: Anchor Books, 1965.

Straus, Walter. "Das Reichsministerium des Innern und Judengesetzgebung: Aufzeichnung von Bernhard Lösener." *Vierteljahrshefte für Zeitgeschichte* 9, 1961.

Sykes, Christopher. *Crossroads to Israel*. London: Collins, 1965.

Thies, Jochen. *Architekt der Weltherrschaft: Die Endziele Hitlers*. Düsseldorf: Droste Verlag, 1976.

Tillmann, Heinz. *Deutschlands Araberpolitik im Zweiten Weltkrieg*. Berlin: Deutscher Verlag für Wissenschaft, 1965.

Trevor-Roper, Hugh. "Hitlers Kriegsziele." *Vierteljahrshefte für Zeitgeschichte* 8, 1960.

Trumpener, Ulrich. *Germany and the Ottoman Empire, 1914–1918*. Princeton: Princeton University Press, 1968.

Vital, David. *The Origins of Zionism*. Oxford: Oxford University Press, 1975.

———. *Zionism: The Formative Years*. Oxford: Oxford University Press, 1982.

Vogelsang, Thilo. "Hitlers Brief an Reichenau vom 4. Dezember 1932." *Vierteljahrshefte für Zeitgeschichte* 7, 1959.

Volkov, Shulamit. *The Rise of Popular Anti-Modernism in Germany: The Urban Master Artisans, 1873–1896*. Princeton: Princeton University Press, 1978.

Wahrmund, Adolf. *Das Gesetz des Nomadentums und die heutige Judenschaft*. Berlin: Reuther und Reichard, 1892.

Walk, Joseph. "Das Deutsche Komitee Pro-Palästina, 1926–1933." *Bulletin des Leo Baeck Instituts* 15, 1976.

Wasserstein, Bernard. *Britain and the Jews of Europe, 1939–1945*. New York: Oxford University Press, 1979.

Weinberg, Gerhard. *The Foreign Policy of Hitler's Germany, 1933–1939*. 2 vols. Chicago: University of Chicago Press, 1970, 1980.

———. "The May Crisis of 1938." *Journal of Modern History* 29, 1957.

Weltmann, Saadia. "Germany, Turkey and the Zionist Movement, 1914–1918." *Review of Politics* 23, 1961.

Wiesenthal, Simon. *Grossmufti: Grossagent der Achse: Tatsachenbericht*. Salzburg: Ried-Verlag, 1947.

Wischnitzer, Mark. "Jewish Emigration from Germany, 1933–1938." *Jewish Social Studies* 2, 1940.

Yahil, Leni. "Madagascar: Phantom of a Solution for the Jewish Question." In *Jews and Non-Jews in Eastern Europe, 1918–1945*. Edited by Bela Vago and G. L. Mosse. New York: John Wiley and Sons, 1974.

Yisraeli, David. "The Third Reich and Palestine." *Middle Eastern Studies* 7, 1971.

———. "The Third Reich and the Transfer Agreement." *Journal of Contemporary History* 6, 1972.

Zechlin, Egmont. *Die deutsche Politik und die Juden im Ersten Weltkrieg.* Göttingen: Vandenhoeck und Ruprecht, 1969.

Zimmermann, Moshe. "Two Generations of German Anti-Semitism: The Letters of Theodor Fritsch to Wilhelm Marr." *Yearbook of the Leo Baeck Institut* 23, 1978.

# Index

icy toward Britain, 179, 248n.45; and Italian policy on Palestine, 179; and Anglo-Italian agreement (1938), 179–180; and German arms exports to the Middle East, 182–185; and German intervention in Palestine (1938), 185–186, 279n.97, 280n.102; and German arms exports to Saudi Arabia, 187–190; and risk of war with Britain (1939), 188; view of Arab states and Britain in event of war, 189; and Jewish policy, 234n.30; Foreign Service officers and NSDAP membership, 236n.60; and Polish and Rumanian support for Zionism, 261n.52, 261n.58; friction with Foreign Policy Office/NSDAP over Middle East, 276n.52, 278n.80

German Industry and Trade Convention, 30

German Jews: liberal/assimilationist inclinations of, 1, 54; Zionist–anti-Zionist cleavages, 10; liberal opposition to Pro-Palestine Committee, 12; Zionist hopes for gains among, 41–42; early Nazi persecution of (1933), 43; early emigration difficulties, 43–44; early hopes for end to Nazi regime, 50; and emigration to other European countries, 50; growth of Zionism among, 60, 194; and Propaganda Ministry, 65; and Foreign Policy Office/NSDAP, 65–66; and Nazi emigration policy, 112–113, 115, 193; in Jewish population in Palestine, 127; in Hitler's view of Jewish conspiracy, 147–148, 193; and dissimilation of, 148–149; and elimination from German economy, 148–151, 200; and Kristallnacht, 154–155; and declining immigration opportunities abroad, 157; increased number of going to Palestine

(1938–39), 163; and Palestine immigration regulations, 238n.81, 238n.87; and worsening situation in Germany (1938), 272n.103

German Labor Front, 96

German Pro-Palestine Committee, 210–211; first Pro-Palestine Committee (1918), 6–7, 225–226n.21; reestablishment of (1926), 11; program of, 11; membership of, 11–12, 227n.37; efforts to counter anti-Zionist arguments among German Jews, 12; conservative politicians support for, 20

German Workers' party, 16, 23

German Zionists: accused by Rosenberg of treachery, 24; Rosenberg's encouragement of, 25–26; efforts to stop anti-German boycott, 35, 53; list of groups in Germany, 215–216; and Revisionists, 242n.31. *See also* Zionist Organization for Germany

Gesetz über Aus- und Einfuhr von Kriegsgerät (1935), 105

Gestapo, 151, 241n.21, 243n.36; cooperation with Zionist Organization for Germany, 53; ban on non-Zionist Jewish group activities, 55; dissolution of non-Zionist Jewish organizations, 57; and occupational retraining centers, 59; and Jewish Agency for Palestine, 60; and Franz Reichert, 62; and Feivel Polkes, 63; and Jewish emigration to Palestine, 142, 200; and disenchantment with Jewish emigration policy, 151–153; and Central Office for Jewish Emigration/Vienna, 156, 268n.45; and illegal immigration into Palestine, 160–163, 200; and Mossad, 161; and 21st Zionist Congress (1939), 162–163. *See also* Abteilung II/B-4; Schutzstaffel

86, 98, 118, 254n.45, 254n.56
Ministry of the Interior: coopera-
tion with the Zionist Organiza-
tion for Germany, 53, 194; sup-
port for occupational retraining
centers, 58–59; and Mauser
pistols for Palestine, 64; and Peel
Partition Plan, 112, 114–115; and
emigration policy, 112, 114–115,
117, 120, 148, 194, 241n.23; and
debate over Haavara and Jewish
emigration, 127–140; criticism
of, by II/112 of SD, 151–152; and
decline of role in Jewish emigra-
tion, 154; and Central Office for
Jewish Emigration/Vienna, 156;
and Jewish policy, 234n.30,
258n.12; and anti-German boy-
cott, 236n.58
Ministry of War, 184–185
Morocco, 88
Mossad le Aliya Bet, 160–161,
271n.83
Müller, Heinrich, 156, 270n.61
Munich Pact, 172
Mussolini, Benito, 75, 80–81, 104,
118, 171, 177–178, 180. *See also*
Italy

Nathanya, 51
National Socialist Teachers' Al-
liance, 96
*Nation Arabe, La*, 88
Navy League, 69
Nazi-Soviet Pact, 164, 174
Netherlands, 174
Neurath, Constantin von, 15, 31,
33, 36, 45, 76, 79–80, 89, 118,
121, 123, 146, 154, 165, 197, 199,
275n.19
New Plan, 31–32
New Zionist Organization, 125,
242n.31. *See also* Revisionist
Zionists
Nice, 178
Nord, Erich, 12
NSDAP-Directorate, 92–93

NSDAP-Palestine, 91, 96–99, 131,
218, 236n.60, 252–253n.35,
253–254n.44
NSDAP-Reichsleitung, 92–93
Nürnberg Racial Laws, 56–57, 60,
150–151

Oberkommando der Wehrmacht
(OKW), 173, 188–190
Occupational Retraining Centers,
55, 58–60, 112, 137, 163–164,
194, 217
Office for the Near East/
APA-NSDAP, 188
Olympic Games (1936), 143
Operation Green, 170–171
Ormsby-Gore, William, 165
Ostjuden, 21
Ottoman Empire, 1–2, 5, 225n.19
Overseas Germans, 92–93, 138. *See
also* NSDAP-Palestine; Overseas
Organization/NSDAP; Palestin-
ian Germans; Temple Society
Overseas Organization/NSDAP,
91–93, 96, 119–120, 181,
252n.29, 254n.56; and debate
over Haavara and Jewish emi-
gration, 127–140, 197–198,
262n.66, 264n.82; criticism of,
by II/112 of SD, 151–152; Foreign
Service officers and NSDAP
membership, 236n.60. *See also*
Bohle, Ernst

Palästinaamt, 160, 241n.23
Palästinadeutsche. *See* Palestinian
Germans
Palästina-Treuhandstelle zur
Beratung deutscher Juden GmbH,
47, 237n.76
Palestine: role in German export
policy, 37; and world economic
crisis, 38; and anti-German boy-
cott, 38; and emigration oppor-
tunities, 44; impact of Haavara
on German exports to, 49; less
attractive as destination for